Château Higginson

Château Higginson

SOCIAL LIFE IN BOSTON'S BACK BAY, 1870-1920

MARGO MILLER

AMERICA
THROUGH TIME®
ADDING COLOR TO AMERICAN HISTORY

AMERICA THROUGH TIME® is an imprint of Fonthill Media LLC
www.through-time.com
office@through-time.com

Published by Arcadia Publishing by arrangement with Fonthill Media LLC
For all general information, please contact Arcadia Publishing:
Telephone: 843-853-2070
Fax: 843-853-0044
E-mail: sales@arcadiapublishing.com
For customer service and orders:
Toll-Free 1-888-313-2665

www.arcadiapublishing.com

First published 2017
Reprinted 2019

Copyright © Margo Miller 2017, 2019

ISBN 978-1-63499-035-6

All rights reserved. No part of this publication may be reproduced, stored in a retrieval system or transmitted in any form or by any means, electronic, mechanical, photocopying, recording or otherwise, without prior permission in writing from Fonthill Media LLC

Typeset in 10.5pt on 13pt Sabon
Printed and bound in England

For my family

CONTENTS

	Connecting Threads	9
	Introduction	13
1	Landlord Higginson	19
2	"Bully Hig"	32
3	Money	47
4	Water, Water	64
5	Hotel Agassiz	79
6	The Fairchilds at Large	103
7	Father and Son	119
8	Horses	133
9	Entertainments	159
10	Outdoors	175
11	Taste	190
12	Clover Adams	208
13	John Singer Sargent Plays the Piano	225
14	The Fairchilds at Home	241
	Acknowledgements	266
	Endnotes	269
	Bibliography	289
	Index	294

Connecting Threads

Bonds of friendship and family link the names listed below. They peopled the Hotel Agassiz, the first major apartment house in America when it opened in 1873, and they watched Boston's Back Bay grow from smelly tidal marsh to the city's newest elite neighborhood. Several appear in chapters named for them.

Adams, Henry (1838-1918). Writer and historian, descendent of two U.S. Presidents. A boyhood friend of Henry Lee Higginson, he and his wife Clover had hoped to rent an apartment in the Hotel Agassiz. Negotiated for Higginson for bronzes by Auguste Rodin.

Adams, Marian Hooper, called Clover (1843-1885). Photographer. Wife of Henry Adams. Her letters home provide a tart view of social life in Boston and abroad. An old friend of Henry Lee Higginson, she helped him shop for French furniture in Paris. See "Clover" and "Taste."

Agassiz, Alexander (1835-1910). Son of Louis Agassiz, the geologist who would make the copper fortune of Henry Lee Higginson and Quincy Adams Shaw, and would partner with Henry and his father George in commissioning the Hotel Agassiz. See "Money."

Agassiz, Elizabeth Cabot Cary (1822-1907). Boston-born second wife of Louis Agassiz, and step-mother of Alexander, Ida, and Pauline Agassiz. President of what would become Radcliffe College at Harvard; childhood friend of Henry Lee Higginson, who would become the fledgling school's treasurer.

Agassiz, Ida (1837-1935). Daughter of Louis Agassiz; see Higginson.

Agassiz, Louis (1807-1873). Famed professor of zoology at Harvard. Founder of a school for girls which would lay the seed for the foundation of Radcliffe College at Harvard.

Agassiz, Pauline (1841-1917). Younger daughter of Louis Agassiz. Married Quincy Adams Shaw. Founded a co-ed day school in Boston's Back Bay, which was attended by the Fairchild children. Introduced the kindergarten, a German idea for childhood education, to Boston.

Fairchild, Charles (1838-1910). Partner of Henry Lee Higginson in Lee, Higginson & Company, investment bankers, where he was a salesman. Early tenant of Higginson's Hotel Agassiz. Raised in Madison, Wisconsin, where his father was the city's first mayor, and came east for two years at Harvard. Fought in the Civil War. Prospected for gold. Came east to Boston, where he would head the Warren Paper Company. Joined Lee, Higginson, and, when eventually eased out, he set up on his own in New York City and failed in the Bank Panic of 1907. Friend of "bohemians" such as novelist Robert Louis Stevenson and artist John Singer Sargent from whom he commissioned Sargent's portrait of Stevenson for his wife. Knew London's theater royalty Henry Irving and Ellen Terry. See "Money" as well as "The Fairchilds At Large" and "The Fairchilds At Home."

Fairchild, Elizabeth Nelson, called Lily (1845-1924). Wife of Charles, mother of seven, poet, painted by Sargent. Her letters about Boston and family life are the basis for this book.

Fairchild, Sally, called Satty (1882-1969). Boston debutante, who ran an early kindergarten in the Back Bay. Travelled in England, where George Bernard Shaw read his plays to her. Sargent painted her three times, called her his favorite model.

Fairchild, Lucia (1872-1924). American painter of miniatures and a mural in the Women's Building at the 1893 Columbian Exposition, the Chicago World's Fair. When she married Henry Brown Fuller and moved to New York City, her mother Lily wrote her weekly letters. See "John Singer Sargent Plays the Piano" for her diary about his visits to the Hotel Agassiz and her family in England and Paris.

Fairchild, Charles Nelson, called Charley (1872-1933). Harvard graduate, who followed his father into business.

Fairchild, John Cummings, called Jack (1874-1924). President of his Harvard Class of 1896, varsity rower, businessman.

Fairchild, Blair (1877-1933). Composer who commissioned Stravinsky's violin concerto.

Fairchild, Nelson, called Neil (1879-1906). Frail as a child, later a consular officer in China.

Fairchild, Gordon (1882-1932). His boyhood letters to his sister Lucia give a picture of growing up in Boston. Painted twice by Sargent.

Fairchild, Lucius (1831-1896). Elder brother of Charles. Politician who lost left arm near Gettysburg in the Civil War and was painted by Sargent, as emblem of the "empty sleeve." Lucia Fairchild named for him.

Fuller, Henry Brown (1867-1934). American painter, husband of painter Lucia Fairchild.

Higginson, Alexander Henry (1876-1958). Son of Henry Lee Higginson and Ida Agassiz, whose adult life was devoted to country sports, such as fox-hunting and hound-breeding, in America and England, where he ended his days. See "Father and Son."

Higginson, Henry Lee (1834-1919). Only known for founding the Boston Symphony Orchestra in 1881 and his benefactions in Boston and for Harvard. In 1872, when he partnered in building the Hotel Agassiz in Boston's Back Bay, he created a new way of living in America, the apartment house. Painted by Sargent. As a noted horseman, theater-goer, art collector, investment banker, and indulgent father, he also appears in chapters devoted to those topics.

Higginson, Ida Agassiz (1837-1945). Swiss-born, she was raised in Cambridge among the good and great of Harvard, and, as wife of Henry Lee Higginson, was in on the creation of his orchestra. Portrait drawn by Sargent.

Howells, William Dean (1837-1920). American realist novelist, critic, playwright, and editor of *The Atlantic Monthly*, 1871-1881. With his wife, Elinor, became friends of the Fairchilds after they gave them land on their country property on which to build a house.

Lapham, Silas. No less real for being the fictional creation of William Dean Howells whose 1885 novel, *The Rise of Silas Lapham* chronicles the desire of a successful paint manufacturer to move his family from Boston's South End to the much more fashionable "water side" Beacon Street in the Back Bay. A vivid picture of Boston social life, including the joys of driving a fine harness mare.

Nelson, Judge Albert Hobart (1812-1858). Father of Lily Fairchild. For his career, see endnote for "The Fairchilds at Large."

Nelson, Elizabeth Phinney (?-?). Mother of Lily Nelson Fairchild, and, as grandmother to the Fairchild children, called "the faithful Gam."

Sargent, John S., later called John Singer Sargent (1856-1925). A leading portraitist in America and England. Born in Italy to American parents from Philadelphia, he led an itinerant life painting society figures as well as great names in literature and the arts. Close friend of the Fairchild family whom he painted seven times. See "John Singer Sargent Plays the Piano."

Stevenson, Robert Louis (1850-1894). Popular novelist and writer, born in Scotland, died in Samoa. Became a friend of the Fairchild family when Lily wrote him a fan letter for *Treasure Island* (1883) and her husband Charles then commissioned Sargent to paint Stevenson as a present for her. Letters exchanged, hers lost, his brimming with life.

Introduction

The first working title for this book was *Connections*. That seemed over broad, even mechanical. Next came *The Right Connections*. That was inflated to *All the Right Connections*. Well, yes, because it was to be a book about connective tissue of birth, education, social class. But where was Boston in this mix? The same connections shape cities from Duluth to Dallas. And where was the building that served as the armature for the story? Thus the next stab at a title: *The Hotel Agassiz: Social Life in Boston's Back Bay, 1870-1920*. As the truism goes, "a name favors a sale," and Agassiz resonated in Harvard-centric Boston. Louis Agassiz was its famed professor of zoology, and his daughter Ida had married Henry Lee Higginson who had built the Agassiz. Higginson is better known as the founder of the Boston Symphony Orchestra in 1881 and as one of Harvard's most noble benefactors.

What none of his biographers mention is his role in giving Bostonians—and eventually all of America—a new way of living. This book is the untold tale of Higginson borrowing from Europe to invent the apartment house. Unless so poor we were crammed into tenements, Americans did not live stacked up over one another. Europeans did; or rather, they rented apartments or "French flats" in the unused rooms, even whole wings, of a grand residence that was the city mansion of aristocratic (or rich) families. Higginson had known the like in his student years abroad. In 1872, he took the chance it would catch on here. And it did: within decades, every street in Boston's Back Bay had its own Agassiz. By century's end, there were apartment houses in most big cities.

The Back Bay was the fallow field for new life. Colonial Boston was tiny, and always crowded, because its mercantile and residential areas were bounded by water on three sides. To the east was the deep inner harbor,

but wharfs could reach out only so far to support shipping offices. Eyes fell on the "back" bay, to the west of town. At low tide, it was marshland. By the mid-1850s, private and public interests consorted to fill the bay with gravel brought by rail from a suburb. Now meriting the capital letters of the Back Bay, its 850 acres made up a new residential neighborhood. In theory, anyone could settle on the new land. A form of snob zoning applied: to live there, one had to build or own or lease a row house. That pretty much ruled out the immigrant Irish (except as servants).

So Higginson took the plunge with his father, George, and another Agassiz, his brother-in-law, Alexander. They bought a corner lot, 10,458 square feet, on Commonwealth Avenue at Exeter Street. They found an architectural firm that also did construction. They took out a mortgage. In 1873, people began to move in, Henry and Ida Higginson among them. Each family had one floor, and, a luxury for the time, three toilets. The building was six stories high. It had two elevators, passenger and freight, and a "boy" to run them. It had running hot water, and two "firemen" to stoke the boilers. While it was rather plain on the outside—Higginson liked the "severe" in buildings (and women)—it was big and important. So to call it the Hotel Agassiz was a reference to the city mansions in Europe named for their owners. To tease its creator, it was also called "Château Higginson." That fancy word fronting a Yankee name made an irresistible title for this book.

Why did apartment living succeed? For one thing, most of the Agassiz tenants went away in the summer, to a country place, or to one of the new resorts on the seacoast or in the mountains. The Agassiz was for the winter, for men to walk to work downtown, for children to go to school. People living in row houses did that, too.

The Agassiz, and the apartment houses that soon followed, triumphed because of the economy of space that such construction allowed. As much as a quarter of the typical row house was given to the staircase that snaked up the parti-wall from basement to attic. No such wasted space in an apartment house. Up the tenants walked on the grand central staircase or took the elevator. They opened their own grand front door to find the same number of rooms—let's say a dozen—that a row house had. The differences were huge: Agassiz was net space. And it was effortless. Gone, the constant stair climbing. Here, everything was on one floor, the triumph of the horizontal over the vertical. This would lead in the next century to the high-rise, and to the condominium.

Higginson was the landlord at the Agassiz. So it is only right to begin the tale with the woes of his first tenants. It cannot have been easy for him. He was related to most by blood, Harvard, the Civil War, and business. As this was the Age of the Letter, they put their complaints in writing.

Letters are a boon for the storyteller and the historian, as very little of this correspondence has been published. And so the social life of the Back Bay flows from the pens of all sorts of people. A mother writes to a married daughter about family doings. A young artist tells her diary about a house guest who was the portrait painter John Singer Sargent. It was the Age of the Horse, and Higginson was a keen horseman, devoted to riding and driving, breeding and dealing. All entertainment was live: Agassiz people go to Shakespeare and Buffalo Bill. There are the rituals of society: girls are "presented" as "buds," or debutantes, and their Harvard brothers intend to whip Yale in football or rowing. Then comes the craze for bicycles. When a working man making only $500 a year could plunge five dollars on a cycle, democracy rolled the length of the Back Bay and out through America.

A Personal Geography of Houses

I have always loved houses. And what a variety has come my way—from my own childhood log cabin, chinked with sphagnum moss in the New Hampshire woods, to the French château of English friends with historical ties to the courtesan Ninon de Lenclos (1620-1705) and the composer Vincent D'Indy. Houses were another connective tissue, when they were the houses of friends and family. None of us were house proud, but we did enjoy talking about them; they were characters in our own lives. Among such friends you could exchange tales of far-off houses encountered in travels. Closer to home, a daughter of friends brokered New Hampshire sheep fleece that went to make yurts for hedge fund herders. Another family has a Japanese house with sliding paper panels for walls. I know well its opposite in England, the solid seventeenth-century manor house on my ancestral acres at Fairstead in Essex. Visiting Greenwich Village, when I was about ten, I had lunch in my first row house. How strange that people walked by as we ate, and did not look in the windows. In London, the late eighteenth-century row house of music friends in Highbury Terrace was almost country with a long back lawn with trees and birdsong.

Every bend in the road in Massachusetts, in my native Berkshires, seemed to have a dwelling worth pondering connections. One was the farmstead in Pittsfield where Melville wrote *Moby-Dick,* and defended his massive central chimney against his wife's yen for the more fashionable center-hall house. A mile or two away, in the 1930s, my parents had built just such a house. Their architect adapted it from center-halls all the fashion in 1812, or a century before my mother was born (as she liked to say). The inspiration for our living room came from yet an earlier period,

from the original house (long gone) built for the local magistrate in the 1770s with a wing for his courtroom. Near Melville's little farm was the grander house called Holmesdale, Victorian-Georgian, where, as we will see, Oliver Wendell Holmes, Sr. taught the young Henry Lee Higginson about elm trees. Still later, on that property I learned to ride and became the horse-crazy girl I still am.

Also on my map is the Italianate villa of my great uncle and aunt. This was a formal affair, set in its own acre of gardens, a city dwelling in the central Massachusetts city of Worcester. On the roof was a lantern the size of a room, with colored glass windowpanes, and my brothers and I would race up three floors to view the city in turquoise and yellow and brown. There was a carriage house out back, and an earlier owner had made the hayloft into a ballroom with garlands of flowers painted between the windows. When my aunt died, a developer bought the land for an apartment complex of excoriating dullness.

The houses of my very oldest friend, Lucilla, spanned several generations of architects. That big Dutch gable clapboard on her family's island in Maine would not have looked out of place on Brattle Street in Cambridge, and, in fact, was designed by Alexander Longfellow, son of the poet. She spent her married life in Puerto Rico in modern houses designed by her husband, architect Tom Marvel, and so I was introduced to the "conversation pit" of the early 1960s and rum to drink, and "Happenings" in their patio-yard. The textures of those houses were very different from our native New England: walls of poured concrete, tile floors, the rooms open and airy, and noisy caroling lizards. Avocados fell off trees. Puerto Rico was too hot for garden lettuces to survive so she grew them in hydroponic brews on the roof.

Except for my little cabin, the houses I've cherished have had light, streams of it. The Château du Fëy was a marvel. Its footprint was the Roman capital letter I, so it was just one grand room wide, with tall windows on each side. On the ground floor, the *grand salon* and *salle à manger*. Also, the bedchamber, linked by lore to Ninon, with its own entrance. Inferences must not be drawn. And in the wonderful way that good houses can be adapted, "Ninon" later served as the student dining room for the cooking school, *L'ecole de cuisine Lavarenne,* founded and run by my old friends, Anne Willan and Mark Cherniavsky. Le Fëy had been a wine château, barging barrels on the nearby Yonne River up to Paris. In the 1860s, *phylloxera* would blight most French vines. By the time Le Fëy could replant, the railroad was speeding better and cheaper wines to Paris. That the château land was always farmed saved it. You still drive in through the farm yard. On one side, the farmer's cottage, cowshed, hen run, rabbit cages; on the other, an older source of food, the *pigeonière*. A

walled garden, the *potager*, was a full acre of vegetables, fruit trees, berry bushes, herbs and flowers. My gift of seed for corn-on-the-cob was met with scorn by the French gardener. *Mais* is for pigs, he said.

Which is not to say that Château du Fëy with its watercolor palette was very like Higginson's stout brick Agassiz, a varnished oil painting if ever there was. But they have several things in common. They were well thought out, rational, efficient, and adaptable. So that when, many decades ago, the grand floors of the Agassiz were broken up for smaller apartments, the old back bedrooms served very nicely as the new living rooms. Mine is almost the size of "Ninon." A short stroll away, in Copley Square, is a pop-up *potager*, the weekly farmer's market with its flowers and herbs and fresh baked goods, and carrots and beets in unnatural colors.

<div style="text-align: center;">Margo Miller, Boston and New Hampshire, June 2017</div>

1
Landlord Higginson

"if you were a housekeeper … "

By all accounts, Henry Lee Higginson (1834-1919) was a fine fellow. He was good company. He was old Boston, Harvard (though his only degree was honorary) and bore his Civil War scars bravely. He had a keen eye for a horse in an age when that counted. A lover of music but a failed composer, he would found the Boston Symphony Orchestra. By general agreement, alas, he was not much of a businessman. After disappointing ventures in the Midwest and South, he had come back to Boston, his path eased by a legacy in a grandfather's will and a partnership in the family's investment bank. The newest challenge was very close to home. He and his father and his brother-in-law had gone in on a real estate venture that would change the way Americans lived. One autumn day he would be severely tested.

The date is 26 October 1875, and the days are drawing in. The air has sharpened. The young trees on the grassy Commonwealth Avenue Mall are mere sticks, so new to autumn they have scant leaves to litter. It's the season when smells change. The east wind, moist with salt in summer, gives way to the tang of smoke from chimneys. It will only get colder. Families are beginning to move into the Hotel Agassiz, the big brick fastness that Higginson has built on Commonwealth Avenue at the corner of Exeter Street. They include the Bartletts, for whom not much is going well.

"Going home this afternoon I find the only room where I can have a fire is filled with smoke and my new carpet being slowly ruined. As there is no steam in the house, and I can only choose between smoke and cold, (and my wife & child can stand neither) I shall very likely have to move out this

evening." Thus, N. S. Bartlett to "Col. Henry Higginson,"[1] who was not only his landlord but his neighbor in the building.

Higginson, now 41, had already lost money in several business endeavors. Oil in Ohio had not come in where he thought it should. He fled back north when cotton farming in Georgia failed his expectations. Now here he was, back in Boston, and the landlord of a tenement, not of course, squalid habitation for the lower classes and immigrants, but that new way of living in America, the apartment house. Here, in the Hotel Agassiz as it was called, lived six families, including his own. In the tidy Boston way, he was, moreover, related to most of them by blood, education, or business. As their landlord, their problems were his.

The aggrieved tenant was Nelson Slater Bartlett (1848-1921), Harvard Class of 1871, some fourteen years Higginson's junior. After a year in Europe, Bartlett had set himself up in business as pig iron and coke merchant, importing English and Scottish iron for rails and beams, and prospered as America built railroads and put up office buildings. He was exactly the right sort envisioned for the future of the Back Bay. It was a new neighborhood created for the city's social and business elite who would come to define the new Boston. As a successful merchant Bartlett could afford the lease of $2,500 a year. The pedigree of his wife's money, as well as her family connections, placed them high in Boston regard, commercial and social. For, on 26 June 1873, he had married Isabel Hazard Bullock (1849-1896), and the baby mentioned in the letter to Higginson was Elvira, born 1 April 1875.[2] The young Mrs. Bartlett was not only a new mother but rich. Attention must be paid.

Lucky is the urban historian who happens on letters to landlords. Those to Higginson are an archeology of the Back Bay.[3] They are rich in detail about living arrangements from the disposition of rooms to the decorating tastes of unhappy tenants. Loss of money only quickens the tenant's pen, sharpens the picture. We learn even more about how a building the size of the Agassiz actually worked, or did not. With its six floors it was like an ordinary row house in height, but it had the width of four. Its chimney flues were external as well as internal, and some drew better than others. There were skylights, the small over the elevators, the large over the grand, cast-iron central staircase. Water would leak in, and as water will, travel every which way, vertically as well as horizontally. So to complain of ceiling leaks was not necessarily to know the origin of the problem. And we may imagine the assault of errant water on the senses: the sour damp of wetted plaster and the starch of wallpaper paste, smoke from fireplace coal that stung the eye, and soot which gagged the throat and, moreover, spread an oily film. Let us not even think of the arsenic, which helped color many 19th-century wallpapers green.

However grandly they expected to live, the early Agassiz tenants were pioneers on Boston's residential frontier. The Back Bay's empty landscape could only improve. Built on some 850 acres, on what remains the largest residential landfill in America, by 1875 the job was by no means done. While roads had been laid out and building lots excavated, few row houses had yet appeared. There were long stretches of vacant land, clouds of dirt swirling in the wind that splashed mud when wet. And now, within the Agassiz, there were troubles with the very amenities that had promised gracious living.

Bartlett had been paying his rent since the first of October "and at no period since that date have the rooms been habitable," he wrote Higginson. "As it was costing me seventy-five dollars and more a week to board, I naturally would have gone [into the Agassiz] as soon as possible. After four weeks waiting I find they are still uninhabitable. I think I shall have a just claim of allowance on my first quarterly payment. This however will not begin to pay me for the trouble I have been at. After papering my rooms at an expense your allowance will not half cover, I have to bear the disappointment of seeing my papers wetted and soiled, by the leaking roof, and this worst of all is that the roof is still, (as far as I can discover to the contrary) in the same condition."

There was more: "You said when I took the rooms that they were all ready. As it is, as my wife after spending several thousands of dollars[4] has the satisfaction of seeing her things exposed to ruins, and for that matter, two of our new carpets are already partially spoiled. The fact is I cannot (nor would you or any reasonable man,) stand this sort of thing any longer, and I think something ought to be done at once. I do not feel I have been treated handsomely in these matters."

Bartlett's phrase "any reasonable man" hints at a lawsuit. There was worse to come. November was to prove cold; the record minus two degrees in 1875 was still standing in 2017. Did pipes burst at the Agassiz? On 11 November 1875, the roof leaked in new places and the deluge so bad "we caught about one gallon of water!!" Bartlett wrote, underlining every word. He has had to take down his dining room curtains and take up his carpet. He has had to sit up to keep watch during the night. Suppose what might have happened if he had been away! He can no longer bear this way of life. He wants to know the worst. If exposed to further water, "I shall take up my carpets, remove my shades and curtains and leave the rooms till the roof is made tight." During roof repairs, "my rent must cease." If nothing can be done at present, "I shall leave the apartment, store my furniture, and when the place is habitable underlet [sub-let] it; and try in the mean time to find some place for a permanent residence." If the repairs are successful, "I shall want my papers and ceilings put in order."

Bartlett apparently sticks it out for a year. On 20 December 1876, he writes of a new problem: Wind blowing soot down chimneys in his dining room and nursery. "We are dependent on open fires in these rooms and it is simply impossible to get the fire out and the dampers shut in time to prevent the soot from coming down." Last night's blow completely spoiled his carpet and it will have to be taken up and cleaned. He realizes Higginson has done what he "could to make the chimneys right, but is it just possible there may be some arrangement which will help me." As we will see, the Fairchild family suffered soot, too. The Bartletts leave the Agassiz sometime in 1877 or 1878. An infant daughter, unnamed in Bartlett's sixth Harvard class report,[5] lived but five weeks, dying on 28 February 1877.

As if the building wasn't fraught with structural problems, as landlord, Higginson had to tread lightly through local entanglements. He, too, lived in the Agassiz, with his wife Ida. Their first child, the treasured little Cécile, died there in 1875, aged five. Their only son, Alexander Henry Higginson, called Alex, would be born there in 1876. The Back Bay had been designed as a neighborhood for the city's business engine, professional men and merchants, like the Bartletts, who expected housing that reflected their station in life. If Higginson failed with the Agassiz, word would spread, dooming rentals from the very people he hoped to attract.

It being Boston, there was the usual connective tissue of blood—and education, which was the crimson tide of Harvard. Like Higginson, the early Agassiz tenants were almost entirely Harvard men. Many had fought, officers like Higginson, in the Civil War. Charles Fairchild was both, and, moreover, was in business with Higginson, at Lee, Higginson & Company, investment bankers. Solomon Lincoln would act as Higginson's lawyer in other real estate ventures, and serve the public as trustee and president of the new Boston Public Library in Copley Square. Ties of blood connected three Agassiz families through the three Russell sisters. Elizabeth married Theodore Lyman, who had been a Harvard student of the famed zoologist Louis Agassiz, Ida Higginson's father. Emily married Charles Lawrence Peirson, Harvard 1853 (who, like Nelson Bartlett, was an iron merchant). And although they lived in Cambridge, Anna was married to Alexander Agassiz, Higginson's partner in building the Agassiz. (Their brother Henry Sturgis Russell would end his days at the Agassiz in 1905.) There were links, too, among the servants. The Peirsons and Edward Jackson employed a nurse named Rosie Christofferson, 27 years old in the 1880 US Census, born in Sweden, as were the Jackson servants. Chatter among the Agassiz servants (there were more than twenty)[6] would spread word of the building's problems, for it fell to them to clean up messes.

The only foreigners were the Townes, mother and daughter, natives of Philadelphia. They were outreaching newcomers who sent "love" to Ida Higginson, invited her and baby Alex to stay in the salubrious sea air of their summer place at Nahant, and Higginson would sell young Alice a saddle horse. She would marry into the building, when she wed Roland Crocker Lincoln, a connection of the older Solomon Lincoln.

And there was S. Parkman Blake. If not in residence at the Agassiz, he was Higginson's class at Harvard (1851) and he was married to Higginson's sister, Mary. He had intimate acquaintance with the owners and tenants, for his firm handled the building's leases. Even with Parkman as mediator, aggrieved tenants felt it their right to write directly to the owner. At times Higginson must have wearied of interior decoration plans that required landlord approval. Mrs. Nathaniel Whiting would live at the Agassiz only for 1897, perhaps for the debutante season of a daughter. She felt much needed done to the apartment being vacated after eight years by Mr. and Mrs. Albert L. Coolidge. "Mrs. Whiting says she asked to have the two back chambers papered & painted, which was agreed to," wrote Blake's office. "She now says she meant to have the 2 back rooms <u>painted</u> (i.e. woodwork a buff shade) and the 2 front chambers papered. This change we take it will make no difference to owners. She speaks also of the parlor paper which is very much soiled where Mrs. Coolidge's pictures are removed. This she would expect to be papered or put in proper condition. The mantelpiece claimed by Mrs. Coolidge she wishes replaced by a new one suitable to the suite. Leases will be signed if above is satisfactory."

So with all those connections, Higginson had to be mindful when the roof leaked and the chimneys blew soot and the toilets stank. Not that these domestic disfigurements were unknown in row houses or the corner mansions of the Back Bay. A difference was the Agassiz was an apartment house, and any nuisance a public matter. Tongues wagged, counsel was taken and notes written, and remedy urged on Higginson lest delay would endanger "the safety of the whole building." Two shrewd ladies, Mrs. Fairchild and Miss Towne, teamed up to see to that. So, of course, one can only speculate why Higginson eventually moved into a row house abutting the Agassiz, and used the apartment building's front door and lobby as his own. The public reason was that without wasting footage on his own entrance and vestibule, he gained space for a music room that ran some 70 feet from the avenue to the alley. He was thus of the Agassiz but not in it, able to dodge—again, speculation—the complaints and problems of his tenantry.

We will see Higginson dealing also with the elevators, with workmen, with a possible tax revolt, with the defection of tenants; the city already knew his cavalier attitude toward construction rules. In hindsight we

can say, if he built it, they could come. And they did, only to complain of cold floors, leaking radiators, faulty steam heat, inadequate water traps for the toilets. Storm windows on a north bedroom will be, however, "a great comfort to the servants, as two women, one of whom is delicate, are to occupy [it], where hitherto we have always put the man-servant." Settled law applied in certain landlord-tenant situations. Others evolved. Higginson did charge for taxes, would eventually charge for water. That those storm windows were a responsibility of the building continued down the years to the age of the condominium and our own arcana about what constitutes "common area."

We can have a vivid idea of building shortcomings from 1878 to 1882 from letters to Higginson from young Alice North Towne, who was nineteen when she moved into the Agassiz with her widowed mother.[7] On behalf of her mother, young Alice would deal with Higginson about the toilets, or "closets," as WCs, were called.

For each Agassiz family to have three water closets on the same floor was a luxury unknown in row houses, which might have one or two toilets to serve six floors and a basement privy for the help.

"My dear Mr. Higginson," Alice wrote on 22 February 1879, "We find our apartment so nearly perfect that I am very sorry to have to complain to you about anything, and yet I must say that this winter we have been annoyed by the drainage, which it seems to me needs attention. We have been constantly troubled with disagreeable odors from all the closets, especially early in the mornings, when it seems as if gas had generated during the night. This has been especially the case during the past two weeks, and we have tried copperas [green vitriol] with only temporary effect. Yesterday I went to see Mrs. Fairchild to ask if they were troubled in the same way, but she says they have not noticed any odor." The Fairchilds had lived in the Agassiz for three years, since 1876. "She advised me to try boiling water, of which I had never heard, though we have tried soap-suds. Yesterday afternoon we made the experiment, but this morning there was the same unpleasant odor as soon as the stop cock was pulled up. There may not be any cause for uneasiness, but I thought I had better write to you about it, especially as I expect my sister-in-law and her little boy who has been ill. Of course I do not want them to come if there is anything the matter with the drains. One of the closets was disagreeable last year, but, as you know, the plumbers could find nothing, and, even now the odor is not permanent, but only very bad at times. I ought perhaps to add that Mrs. Fairchild advised me most earnestly to write to you as she said she felt that trouble in any one apartment endangered the safety of the whole house." Alice apologizes for troubling "so constantly busy" a man—and sends love to Mrs. Higginson.

Higginson was not persuaded as to the cause, but also not unmindful of risk. "What do you think of this?" he writes in an undated note to an unidentified recipient. "I doubt it as a defect of <u>air</u> but suspect it may be their carelessness—Still I'm bound to report it to my Dr."

That the doctor was Henry Harris Aubrey Beach (1843-1910) adds an unexpected footnote to music history. As a good friend and associate of Dr. Oliver Wendell Holmes, he moved in polite society.[8] But as Dr. H. H. A. Beach, he is only known these days as the husband of the composer and pianist Amy Marcy Cheney Beach (1867-1944), and hissed at for insisting she perform under her married name, Mrs. H. H. A. Beach. We will meet them both at tea in the chapter called "The Fairchilds at Home," he quite condescending, she placating. But asked a medical question in 1879, he tried to be helpful and reassuring, writing to Charles Fairchild he was "quite sure [Higginson] would like to leave no stone unturned to make the building absolutely safe."

A little snooping has located vestiges of the Agassiz's original WCs. Dr. Beach's letter, excerpted below, confirms their typical placement around air shafts and stairwells. They were certainly not where the Agassiz bathrooms are now. Today's were converted from small bedrooms, each with a tall window giving on the Back Bay, and some have hot tubs, even Jacuzzis. Luxe indeed compared to the common American bathroom of the late 20th century. While this had achieved a window, it was still a small, compact affair—single sink, shower in the tub, toilet—and was shared by the family. In short, bathrooms were for hygiene not today's water parks for recreation. Tubs were not even for hygiene as the young Henry Higginson discovered in Dresden on his first trip to Europe in 1852. He and six other students boarded with a professor's family. "Of course there were no habits of washing, and when I asked for a bathtub I had to buy one. I sat on the floor and was measured, and they brought me a nice wooden tub, which was put under my bed." When the tub disappeared, he found it used for the family laundry during the day. "I was allowed to have it at night."[9]

By 1918, the Agassiz had achieved the first modern bathrooms. A new tenant on the third floor was startled by an unexpected caller on their first day there. "An elderly, white-haired man [opened] the front door without a signal of any kind and [walked] deliberately from one room to another. It was Major Higginson himself, come down from his own apartment above to investigate … He lingered for many minutes in the newly white-tiled master's bathroom, seating himself opposite to stare at the gleaming bathtub on clawed feet, a six-foot tub recently installed."[10]

Placement of the toilets is confirmed by Dr. Beach's 1879 letter: "I know how carefully Mr. Higginson has attended to all the details of

[WC] drainage, so that I have no question about that common source of trouble—but one point has occurred to me and that is the ventilation of the central [stair] well into which the closets open. It is all right at the roof and may be at the basement. How is fresh air introduced at the base? I believe that it is important for an adequate ventilation of the shaft, that fresh warm or cold air should be constantly supplied at the foot of the shaft. Warm air would be preferable, since it would tend to maintain an upward currant. Ventilation at the roof only, is hardly sufficient to be protective."

How the early Agassiz toilets worked (or why they didn't) can't be known for certain. A toilet with its own overhead cistern activated by chain is one possibility. This writer used one on Marlborough Street from 1962 to 1977. The bathroom had a sash window, painted over and inoperable, which once gave on the main airshaft. And so sash-windows (or casements) on air shafts or stair or elevator wells are the clue to placement. Whether shaft or well, the tall column of space afforded WCs ventilation and light. Floor plans for the Cluny, a long-gone residential hotel on Copley Square built, and but a few years younger than the Agassiz, show WCs clustered around the building's core of elevator/stair.[11]

True also at the Agassiz. Just the same configuration was found during a 2013 renovation of a second floor condo at the Agassiz. Its windows (cubicle as well as anteroom) opened into the air shaft into which was set—in its own stairwell—the grand cast-iron staircase. Steps away from the staircase were the formal entrance doors to each apartment. The reception, dining and family rooms were served by the WC nearest the front door, or what was referred to as the "long entry," or internal corridor that served the bedrooms. Perhaps near that WC was another for the master bedroom. A pull-chain toilet might just fit the tall, windowed cubicle. A third known WC was ventilated by the back stairwell, and was handy doubtless for family use and servants.

If only we knew what floor the Townes occupied, we might have a guess what clogged the toilet's soil pipe, but city directories of the time did not record the floor of occupancy. Alice Towne, or more likely her plumber, did try copperas, or the equivalent of Clorox's Liquid Plumbr for clogged sinks, to counter the stink. Also called green vitriol and "copper water," this was ferrous sulphate, green, crystalline and astringent. Fear of disease from raw sewage had propelled draining the Back Bay, and even on filled land, doctors worried about infection and mothers feared for their babies. An 1890 lecture for plumbers and engineers on practical sanitation included "domestic sanitary drainage." In 1894, and closer to home, the "New Woman," whether bachelor girl or spinster or housewife, could consult *The Woman's Book: Dealing Practically with the Modern*

Conditions for soil pipes. And it may not have been Higginson's fault at all but the nature of the tidal waters under the Back Bay.[12]

Higginson must have dealt with the plumbing stink for, that spring, young Alice Towne writes sunnily to him about a riding horse he sold her for $125.

But he is not quite free of her. On 3 November 1880, when Alice is 27, she marries Roland Crocker Lincoln, a lawyer, then 37, Harvard Class of 1865. They will have no children. Her mother is listed at the Agassiz until 1885. Perhaps Alice and Roland lived with her. They, or rather, Alice, will ask to break her Agassiz lease in 1885 (and pay $1,900 remaining on the year) to move to a grand residence, Pinebank, on Jamaica Pond.[13] But that's to anticipate. "My dear Mr. Higginson," Alice Lincoln writes on 10 November 1882, to renew her lease at the Agassiz for the usual $2,500 plus taxes. Plumbing is still on her mind, but so is re-decoration, and those storm windows to warm her female servants. The two long letters are worth excerpting for they also bear on the taste of the time.

Then, as now, tenants were not entirely free to decorate as they wished, and who among us does not remember apartments painted in depressing "landlord white." Not good enough for Alice Lincoln, now 29, who wishes to wallpaper a ceiling and "whiten" others. She has trouble getting Higginson's attention, and on 10 November 1882, she writes how sorry she was that he could not spare "a few minutes yesterday" to learn her plans. He was perhaps occupied with the opening of the second season of the orchestra he founded, the Boston Symphony. Mrs. Lincoln has consulted "two experts in the matter" and they assure her that papering "will not injure or weaken" the ceiling. "Therefore it is to be done today—at our expense, of course." She is acting because she is "assured that you can have this paper removed at any time without the slightest damage to the plastering."

There is more. She has procured an estimate of what it would cost to whiten and repair other ceilings, and encloses it (sadly, not filed with her letter). "I hope you will allow us to attend to the matter at once. We are very uncomfortable as things are at present." Unless Higginson objects, work will begin immediately. "We found on examination that more whitening was needed than we had supposed. Except in the sitting room, which I myself ordered done four years ago, none of the ceilings have been whitened since we took the house, except the kitchen, which you have just put in order."

Until Boston converted in the mid 20th century to oil heat, the Back Bay was as grimy as train travel, and for the same reason: coal-burning furnaces and boilers. Not to mention, open fireplaces in most rooms. And

not just any old white paint. "I neglected to mention that the estimate for whitening included 'tinting to harmonize with walls and surroundings,' but I was much obliged for your suggestions in regard to color." As for the dining room, "we also are prepared to put a costly (and we think handsome) paper" on it, and she will be sure to ask Mrs. Higginson's opinion "for no one could be a better judge of its fitness or merits." To involve the landlord's wife was a brilliant strategy.

Heating and plumbing remain problems. Alice Lincoln is quite willing to accept blame for the "refrigerator," perhaps an ice chest that leaked, but not for the "malfunctioning steam." Radiators had leaked because the steam pipes were "ill-packed." The "steam is so entirely a house matter that I took the responsibility of asking the man [engineer] to put the packings in order at once."

Back to toilets. The worst is the WC in the long entry, with smells reaching the dining room, and, left unsaid, its new paper. As Higginson has already gone to considerable expense on other plumbing matters, she will pay for a new door for that WC and for boxing its pipes. "But we wish to have some arrangement made for ventilating the closet with a different water-trap near the dining room." Her husband is too busy to deal with these matters, "and I know that it is the same with you." She asks simply for the authority "to see that they are done," and she promises always to consult the "house plumber" about the "water-works." Alice Lincoln exhibits the organizational drive of the social worker she would become. To Higginson: "I am sure that if you were a housekeeper you would realize how trying it is to have the whole house upside down and waiting for workmen to begin."

The Agassiz cast Higginson for the first time in his life in the role of urban landlord. As he lived in the Agassiz himself, he was hardly an absentee landlord. But as revealed in an 1898 letter, almost a quarter century after the Agassiz opened, he was a sharp businessman when it came to the costs of running the building.

While Higginson did not go up on the annual lease for an Agassiz apartment during the building's first quarter century, he did charge tenants for costs to the building. One item was real estate taxes. This came as a shock to the father of Dudley Leavitt Pickman, who had moved into the Agassiz with his bride in 1885. His father was apparently standing the rent for his son, for on 15 January 1886, William Pickman writes Higginson to protest a bill for taxes. "I thought $2,500 a full price for the rooms, and should not have taken them had I supposed taxes were to be added." He did recall Higginson mentioning "a few small charges" but nothing else. "I should probably have asked about it, but the custom of collecting taxes from the tenant, as far as my observation goes, is now so unusual as to be

nearly obsolete." The young Pickmans and their two little sons stay until 1889.

Sometime in the late 1870s, Higginson was charging tenants for water to run the hydraulic elevator, and we will see later how that was calculated. By 1898, he was charging for heat as well, and this letter to Alexander Agassiz, his brother-in-law, business partner, and co-owner with the Agassiz, argues why. The "Charley" mentioned was more likely Charles Fairchild than Charles Peirson.

The undated letter, filed with 1898 correspondence, was written in such cold weather that Higginson feared pipes and food might freeze. The figures are missing, but two details concerning the building's servants are of interest. One was the full-time messenger, there being little citywide telephone service and thus the need for someone to take a note and wait for an answer. When Agassiz families went away for the summer, as all did to escape the still-smelly Back Bay, one or more servants were left behind, and, as was customary, were put on "board wages," which was merely bed and food.

"Dear Alex, I drew off these figures the other day, & have kept them, expecting to see you. Now I send them. Charley was not content with his bill, tho he did not complain. I see no reason why we should not charge him the full cost of heat & water except, that the heater being half-full, we could not measure it rightly. I esteem as not a point to be argued that the tenants should pay the cost of the elevator, as well a full price for heat in which should be included the cost (to us) of house-service. It is no small matter, that every tenant is saved all direct chores but shoe-cleaning—& all cost of keeping a servant in the house during summer. Also that a messenger is constantly at hand. Therefore I don't think it right to receive less than the cost as above. Am I right? Look at my figures & tell me when we meet, which calculation seems to you fairest. But remember that in such a snap of cold as the present no one can possibly save his water-works, his provisions, himself from freezing if some heat beyond a common fire-place were not to be had. And if used, this should be pd for."

Until electrification was general, elevators were water-powered, using a hydraulic system which lifted the car by means of a hydraulic ram, a fluid-driven piston mounted inside a cylinder the length of the elevator shaft. The Agassiz had two elevators, passenger and freight. They had cost $6,400 to install. The passenger elevator rose 61 feet, that is, from the inner lobby to the sixth floor. The "freight or goods" elevator started in the basement and so rose 71 feet. Each platform would sustain over eight tons, according to the proposal letter from Campbell, Whittier & Company, the manufacturers at 1176 Tremont Street, Boston, on 28 June 1872. "The wire rope #10 ½ Roebling's best, made specially for hoisting

purposes," and readers of David McCullough's splendid book on building the Brooklyn Bridge (1972) will remember how father and son, John Augustus and Washington Augustus Roebling, learned how to perfect spinning wire for cable. Neither Agassiz elevator was large, only about four feet by six. The passenger car was to be finished in black walnut and ash, lighted though the top.

Mindful of expenses to the building, Alexander Agassiz, in an undated note, but probably February 1876, asks Higginson to find out what water was costing to run them, apparently with the idea that steam might be cheaper.

The manager of Campbell, Whittier & Co., manufacturers of steam engines, boilers, elevators and machinery, with offices at 1176 Tremont Street, Boston, replied in longhand on 2 March 1876: "It is reported that your passenger elevator at 191 Commonwealth Avenue made in 7 days ending last Monday 165 trips. For each full trip the machine consumes 12 cubic feet of water. For the 165 trips then 1,980 cubic feet of water were used. Multiply 1,980 by 7 ½ , the gallons in 1 cubic foot, and we have 14,850 gallons used in the week. The freight elevator made in the same time 90 trips. It consumes 14 cubic ft of water per full trip or 1,260 cubic feet for the 90 trips. Multiply 1,260 by 7 ½ and we have 9,450 gallons for the week. Adding the water used by the two machines together we have 24,300 gallons costing at $3 per hundred gallons $7.29 for the week's work, or $1.04 per day—A very favorable showing for the work done we think cannot but be satisfactory to you."

There would come a time for refitting the elevators. The Whittier Machine Company, as it now was, sent their Mr. Perkins to take a look in his capacity as superintendent of outside construction. The news was good and bad. "The safety apparatus on both elevators is in complete working order," Whittier signed a typewritten letter on 19 August 1890. "The ropes of the Freight elevator are nearly new, and are in good condition. The ropes of the Passenger elevator are considerably worn and although they do not appear to be in a dangerous condition, they have been used for some time, and we advise that a new set of ropes be provided for this elevator. The cylinders seem to be in good condition as far as can be determined by emaxination. These cylinders are of an old type not now manufactured by us, and are lined with brass. This lining has necessarily worn somewhat during the long period the elevators have been in use, and is probably very thin in spots. It seems to us on while, considering the period of service, &c., that it would be a wise precaution to remove the present cylinders at a period not later than next season, and replace them by those of cast iron, bored out and then rubbed smooth on the inside." To which, on the back, H. L. Higginson wrote

and signed "Does this imply that the cylinders should be changed this year?"

By the early decades of the new century the original elevator was considered impossibly slow. The Agassiz was home after the Great War to John and Gladys Rice Saltonstall who rented the third floor in 1918. With their three little daughters and son, they were the first young family in the building for many a year, and with pram and pets added to internal traffic. The front elevator "became a real part of our lives," she wrote in her memoir,[14] carrying us and its resigned attendant at a leisurely pace beyond the two lower floors to the austere hallway of our own third floor ... Now and then we had to await the ascent during many long moments, ringing in vain for the sound of the pulley rope as the elevator moved between floors. All was silence save for muffled human voices far above. Then, finally, when the door opened at ground level, an old gentleman came forth, cane in hand, attired for the outdoors, a courteous kind of gentleman who bowed his greeting as the elevator attendant went to open the street door.

"'Sorry to keep you waiting, Ma'am,' the attendant said as he took me upward. 'Colonel Peirson needed help with his rubbers. He didn't care to chance the rain today with all them clouds in the sky.'"

2
"Bully Hig"

Of gillyflowers and potatoes

Little in the early life of Henry Lee Higginson (1834-1919) would have predicted his middle years as a landlord of an apartment building. Like most other Americans, he had lived in a single-family house, albeit in a comfy nest of cousins in a part of old Boston. In many respects he never left that.

It will be a further theme of this book that what he helped create as a new way for urban Bostonians—and Americans—to live was obsolete not long after his death. The automobile had replaced the horse, and the suburbs the city. The "media" in its myriad forms, from television to the hand-held devices, would be beyond his comprehension. His was the day of physical and direct personal communication. Ours less so. He wrote letters, some at length; he did not tweet. His every amusement was live entertainment, from riding or driving horses, to the orchestral concerts that were his passion and to the operas and stage plays he attended and the performers he enjoyed meeting. Social life always involved people, whether reading aloud at home or acting in theatricals at the house of friends. Life was a good deal more formal: there was an understood line between private and public behavior and, accordingly, dress and language and décor. It was not necessarily a time of leisure. Leisure of the mind, perhaps, but not of the body. It simply took longer to do anything, to cook, to travel, to dress. No AAA batteries were included with baby Higginson.

Let us begin with his nickname.

Time was in the English language, and its American cousin, when the word "bully" was high praise. It was an endearment connoting vigor and heart, and so his Harvard friends and Civil War comrades, often one

and the same, called him "Bully Hig." Of old Boston by breeding, and clubbable by nature, he was also a music lover, horseman, philanthropist, and patriot. If an inattentive businessman and perplexed landlord, he was an ardent capitalist and thrilled to an investment coup. If today he is remembered by name, it is as founder of the Boston Symphony Orchestra in 1881. Always ranked one of America's "top five," it continues to draw admiring audiences wherever it concertizes, coast to coast, Europe to Asia. To house it, in 1900 he built Symphony Hall, whose acoustic continues to marvel. A bronze plaque saluting Higginson's creations is attached to the right of the doorway at 191 Commonwealth Avenue in Boston. It was his residence from 1874 to his death.

To the left, a plaque identifies the building as The Agassiz. When Higginson commissioned it 1872, it was called the Hotel Agassiz, the name marking, in the European tradition, the city residence of an aristocratic (or rich) family. His co-conspirator and brother-in-law, Alexander Agassiz, jokingly called it "Château 191" and "Hotel Higginson." To others it was "Château Hig." The Hotel Agassiz will have a chapter to itself.

To his tactful biographer, "Bully Hig" was of "middling" height. To his admiring but tall son Alex, he was on the short side. It's agreed he stood about five feet, eight inches, and his weight was a steady 170 pounds. He had, moreover, the build of a horseman. Horses were a passion, and that made a bond between the investment banker father and the son who did not care for the business life.

He had been a cavalry major in the Civil War. He was wounded in battle, invalided for two years. A saber scar, creasing his right cheek, is visible in the 1902 portrait by Sargent. "I do not think [the war] left any very vivid impression on his mind," Alex recalled in his 1951 autobiography. "He spoke often of it, in my youth, and he always kept in close touch with his army comrades, but he was not a military man and I think he looked back on his wartime experiences more with the feeling of a duty well-done than as a treasured memory."[1]

In 1862, officers had to ride in order to lead, and they had to provide their own horses. Higginson's oldest brother, George, who farmed in the Berkshires at Lenox, looked at likely cavalry mounts to buy and ship south. One mare was a failure. Higginson sent her back north to his sister Mary (called Molly), to ride. She "will take you over the ground a little faster than you ever went with horseflesh." Trouble was, the mare didn't take well to other horses. "We don't like to trot here, you know, but do like to canter. The mare can trot very well and very fast, but she gets into a great fret if another horse comes near her, and then she will break into a gallop and run like a wild-cat." The mare's replacement was a beauty, part Arabian. Not so the horse he called Rats, short for Rats-in-

a-Barrel. Rats was "handy," meaning flexible and responsive, good in a horse, but otherwise Rats was big, light, strong and ugly, and could run fast for a short distance. Higginson hoped to come in first when brother officers raced their mounts. He wrote lovingly of other favorites, Piggy and Nutmeg, and a bigger horse called Grater.[2] To call horses Nutmeg and Grater was a pun his friends called "Higgisms."[3]

Higginson had his photograph taken in 1863. He sits in profile. He had a good strong straight nose, a mustache that curls down to a little jut of beard. (Rather more facial hair in his 1835 class photo.) "My hair and beard are as short as scissors can cut them," he writes to Molly. He thought he made a "beautiful effect," with two rows of shiny buttons on his uniform jacket and figure-eights of braid curling up the sleeves. "I've a real pretty cap and beautiful boots and spurs." Attention to dress would please his father. "Do let me know that you have a wardrobe becoming a well-provided and well-dressed gentleman," his father wrote to Henry, then a wandering student in Dresden in 1852. Henry: "To dress better than those around me except in the matter of clean underclothes would be bad taste."[4]

He assured his sister his manners were better among fellow officers. "I don't swear so much as when I do directly with the men."[5] At the start of war, the governor of Massachusetts was John Albion Andrew (1818-1876). An anti-abolitionist, he helped form the first African-American regiment, including the tragic 54th, memorialized in the Saint-Gaudens monument which Higginson would commission for Boston Common.[6] But for now, in 1861, Andrew determined on raising a cavalry regiment to add to the mere five that the Union Army could muster. Higginson and the other volunteers assembled at Readville on the Boston outskirts, trained a bit, and sailed south. "I was as ignorant as a baby of horses" at Readville. But he was a quick learner, and leader of men. "Infantry drill once learned," he wrote home, "is monotonous, but riding is a lasting excitement and delight."

In this, the age of the horse, Higginson was happily built to ride and drive, and horses gave him a lifetime's pleasure. He had powerful legs for the saddle and long arms for handling driving reins. His chest was notably deep, which, perhaps in his youth, had encouraged him in the singing career that was not to be.

There would be other disappointments. He lost his mother to tuberculosis at fifteen. He did not graduate from Harvard. His young adult life was strewn with business failures. His first child died at five. It was his own fault he lost much of his fortune, and a friend took over his yearly subsidizing of the Boston Symphony. When he died, friends had to rally to pay off bequests and see his widow safe. That most decorous

of biographers, Bliss Perry—the filtering hand of one gentleman writing about another—would tell some home truths, in a public speech, but well after Higginson was dead.[7] And we will see in the chapter called "Father and Son" how Higginson's love of music came before family life.

But the glory years were good. Higginson was not the first important Boston philanthropist. On far less money, men like textile magnate Abbott Lawrence Lowell also accomplished great things, establishing at Harvard, in 1847, the Lawrence Scientific School. In the tidy Boston way, this would benefit Higginson himself by training the man who made his copper fortune and would become his brother-in-law, Alexander Agassiz. But in his chosen benefactions "Bully Hig" was without peer. True that in their physical manifestations they only straddled the Charles River, which is to say Harvard and Boston, but they had legs that took them far beyond. He founded, he built, he sponsored, he enjoyed, he inspired. We have mentioned the world-class symphony orchestra and the acoustic marvel of its hall. In 1890 came the first of the gifts to Harvard. Soldiers Field was the playing-ground for football that memorialized six dear friends lost in the Civil War. It led others, in 1903, to build Harvard Stadium. This was not only America's first athletic stadium but an engineering first, a large complex built of concrete. Higginson's position in Boston society was at the top, yet he worried that boys of modest birth would be shunned by Harvard's "gold coast" crowd, and so he paid for the Harvard Union, an eating hall that hoped to mix students of all backgrounds. Boston was divided on the need for the Civil War. He felt preservation of the Union was the immediate need; from it would follow the abolition of slavery. His commission of the great Civil War monument to the black soldiers who perished, in needless battle, in the Massachusetts 54th would later inspire the greatest poem about Boston's later frictions (by a twentieth-century Lowell). All these benefactions were planned and carried out during the years he lived at The Agassiz.

New York City was, however, his birthplace, on 18 November 1834. His mother was of old Boston lineage, Mary Cabot Lee, and in the usual way of naming children, maiden or surnames were used as middle names. Thus, Henry Lee Higginson, "Bully Hig" to boyhood friends, and in family letters he sometimes signed himself "Hal." When Henry was four, his father George moved them back to Boston. George had been one of thirteen children, and, like a tale out of Dickens, was put to work in an office when he was twelve. He stayed in business in Boston—he was a partner in the investment bank, Lee, Higginson & Company—till he was

70. Henry, who had lots of houses and horses, would marvel that his father never owned either, always renting them, till near the end of his life.

A photograph of George Higginson (1804-1889) in middle years seems to show the beginnings of a smile. Henry remembered him as a "very kindly, industrious, sensible man, with a remarkable 'nose' for character, scrupulously honest, and disinterested to a high degree." Even when earning little, he gave away what he could, "any spare pennies" in charitable work. An engraving of Mary Lee Higginson (1811-1849) captures both the beauty that delighted family and friends and the slight melancholy hinted at in a 1893 letter from her brother to Henry: "She was born with too clear a sight for comfort, she toiled to accomplish, for those she loved, impossibilities, and died of the overstrain." In 1883, Henry mused "Do you suppose that as a child I did not heed the words of my mother about slavery?"[8]

George Higginson's Boston start was modest. When the town was a major port, a living could be made in commission business, that is, fees from sales, and he had a little office on India Wharf. Together with dozens of cousins, the family lived in Chauncy Place and in Bedford Place, colonial Boston streets long since buried under skyscrapers.

The early Boston years were lived close to the bone. "Everything was done in a very small way, and my father and mother worked pretty hard." Food was Yankee frugal: "We had meat—chiefly corned beef—about five times in the week at dinner, had no butter, never saw an egg, had plenty of potatoes, and baked apples, and milk."[9]

By one of those cultural reversals, corned beef and (cabbage) and potatoes came to be associated with the Irish and were thought suitable fare for St. Patrick's Day. Irish will tell you, however, it was not an Irish dish at all, but what Yankees fed the Irish help as cheap food. It fed the Higginsons themselves. Picking over potatoes was one of Henry's chores. Very tiring and dirty it was: he had spilled them on the cellar floor, must stoop to sort them, and was quite cold "because I went without my jacket so that I would not dirty it and I did not have my frock on."[10]

The Higginson children—in order, George, Henry, James, Mary (Molly), and Francis—had old Boston for their neighborhood. They skated on the Common's Frog Pond and sledded down the Park Street mall. Winter meant Henry had to chip ice off their sidewalk and put hot sand on it.[11] Very little clothing was ready made, and last year's clothes became this year's, and so a seamstress cut up Henry's blue pantaloons and made him a jacket. Dancing school was so popular that "we had to stand for the last 2 or 3 hours ... unless we were willing to sit down on the floor which I did part of the time I was so tired."

Not a church-goer as a grown man,[12] he went to King's Chapel as a boy. One Sunday morning at nine he watched the Reverend Ephraim Peabody christen four babies, all Higginson cousins. He "took cousin Lydia's baby and christened it Sarah. Then he took Harriet Minot's and christened it Sarah Cabot. Next cousin Lucy Morse's oldest and christened it Charles Jackson. Next her youngest and christened it Eben Rollins."[13]

There were visits in the countryside. One was to Pittsfield, in the Berkshires, to Oliver Wendell Holmes, doctor, father of the future Supreme Court justice, and the essayist known for *The Autocrat of the Breakfast-Table*. He called his place Holmesdale. It sat, and still does, on a drumlin high above the Housatonic, "but you cannot see the river," Henry wrote home in August 1849. Half a mile down the road was Arrowhead, where Melville would publish *Moby-Dick* in 1851. Holmes farmed 268 acres and had "a great many horses, cows, pigs, fowls, etc." He must have talked trees, specifically elms, to Henry. They agreed that he needed trees around his house. There was a science lesson, too, for the fifteen year old. "In the town, there is an elm … of the ancient forest that extended all over the countryside," which, when it was cut down, "this tree was left, and, if you will notice, you will see that the trees growing in a wood do not throw out any limbs, till they reach the light, so this tree grew eighty-six feet high, before it threw out any limbs."[14]

With excursions like this one, and his wander years in Europe, Higginson's come-what-may education made up for the dismal beginnings. Like other children in his family's circle, he went first to a "dame school." The curriculum was basic, the setting homey, women teaching reading, writing and figuring in their parlor; one "dame" was the sister of Hawthorne's wife. Then, for Henry, on to a schoolmaster who taught growing boys. Then to Boston Latin on Bedford Street. This was the first public school in America, founded in 1635. It still thrives, a prestigious exam school, with everything a private high school offers, and its campus on the sylvan Fens is well away from the grim building Henry knew. That one was noisy, dark, and fetid. His five unpleasant years were a "waste of time." In 1919, he recalled that "nobody ever taught me anything, the boys being allowed to learn their lessons or not as they chose, and being punished accordingly." And his eyes began to go bad. So for a while, he was transferred to Dixwell's, a private "fitting-school" for fitting boys for Harvard, founded by a former Latin School headmaster, Epes Sargent Dixwell (1807-1899). He was admitted to Harvard in September 1851, on the condition he pass exams in Latin Composition, Compounded Proportions and Interest in Arithmetic, and Equations in Algebra.

Fellow sufferers at Boston Latin were also admitted, and among the joys of Higginson's life were his enduring school and college friendships.

The freshman courses were prescribed: Latin, Greek, mathematics, history. His eyes went bad again. He withdrew from Harvard after his first year, and took the water cure that had attracted many a Bostonian to Dr. Wesselhoeft's establishment in Brattleboro, Vermont.[15] His wife's family, the intellectual Agassizes, saw bad eyes as an excuse for lack of brains, and were not in favor of Ida marrying Henry, but, as we shall see in the chapter called "Money," she did.[16]

Henry's older brother, George, had not even entered Harvard, preferring "the better education of a practical life" as a farmer. In fact, Henry was the family's first collegian, and the only one in the direct paternal line to hold a degree, albeit honorary, since the family's first immigrant. Francis Higginson had graduated from Jesus College, Cambridge, in 1611.[17]

* * * * * *

It might be well here to look back at that Higginson. He was a Puritan minister, but also a "planter" whose eye for the bottom line would extend down nine generations. The Higginsons did not fall far from the tree.

"Here we saw yellow gillyflowers on the sea." Thus, the Reverend Francis Higginson, as he arrived in America from England. It is Tuesday, 24 June 1629, nearing the end of 45 days at sea. Cape Ann, north of Boston, is in sight. Salem harbor is their destination. Whales come near the ship. "Their greatness did astonish us that saw them not before; their backs appeared like a little island." At Naimkecke (Naumkeg) men go ashore and bring back ripe strawberries and gooseberries and sweet single roses. "Thus God was merciful in giving us a taste and smell of the sweet fruit as an earnest of his bountiful goodness to welcome us at our first arrival."

As part of this adventure, Higginson will write two accounts—the Journal and the Diary[18]—of what he saw and did in the "new England," the new paradise. Together they can be read as the history and justification for the kind of capitalism that built the Back Bay and Henry Lee Higginson's Hotel Agassiz. The first two generations of his Higginsons in America were the last as churchmen. Then follow the merchants and traders who will become Lee, Higginson & Company, the investment banking firm of which Henry and his father George were partners.

The Journal entries describe what Higginson called "our long and tedious journey through the greatest sea in the world," and are told in real time, many events dated. The Diary is not a diary at all but a manifesto published in London in 1630 and called *New-Englands Plantation*, and is a marketing piece for future colonization. Higginson writes about what he found ashore at Salem, and why the Godly should take ship to join him. The operative words are "planters" and "planting" and "plantations."

Every Puritan was a Planter, whether he planted for the King or for God.

What a voyage it was! The fleet took endless days just traversing the English Channel to get to open sea. They sail from town to town, and at one point Anne Higginson, a daughter, "and two maids," perhaps young daughters of friends, even go ashore to wash linens. Higginson is invited to preach along the way. The King's navy impressed two of their seamen, taking them by force to serve as sailors; they got one back "by entreaty." On the first Sabbath at sea, a "Biscayner's ship, a man-of-war, that made toward us, and manned his boat to view us; but finding us too strong for him, he durst not venture to assault us, but made off." Like many churches, the Puritans gave a day to fasting and reflection. Their mariners thought it the first-ever sea-fast and were grateful for the gale that broke becalming. "Manifest evidence of God's hearing our prayers."

Gales became storms. That recorded on 27 May brings shivers. They see icebergs. In fogs they lose sight of a companion ship, *Lion's Whelp*. "We drummed for them, and they shot off a great piece of ordnance; but we heard not one another." There is sickness aboard, scurvy among the crew, and small pox. Higginson's young son Samuel will recover. Five-year-old Mary will not.

The Journal begins with a majestic clearing of the throat. "A true Relation of the last Voyage to New England, made the last summer, begun the 25th of April, being Saturday, Anno Domini, 1629." Higginson's writings are among the first "testimonials" in and about America, and he writes he is at pains to assure the reader he tells the truth. The bad, as well as the good, in *New-Englands Plantation*, and why the shiftless Indians are contrary to God's plan. First off, the reason for the voyage: "The Company of New England, consisting of many worthy gentlemen in the city of London, Dorchester and other places, aiming at the glory of God, the propagation of the Gospel of Christ, the conversion of the Indians, and the enlargement of the King's Majesty's dominions in America, and being authorized by his royal patents for that end, at their very great costs and charge furnished five ships to go to New-England, for the further settling of the English Plantation that they had already begun there."

The very next year, 1630, would see a group of Puritan planters who would grab more history than Higginson's. The Winthrop Fleet of ships with the future first governor of the Massachusetts Bay Colony aboard the *Arbella* would also bring the Saltonstalls, who, in 1918, would move into the Agassiz to Henry Higginson's bemusement.

Who was this first immigrant ancestor of Henry Lee Higginson? What did he look like? In his Diary he tells us what he wore when he was ill, and, what he then wore when restored to health in New England.

Although born in 1588, Higginson was in one respect still a medieval man, defining himself by medieval medicine's belief that the humors, or four body liquids, tempered or determined heath but also personality.[19] Melancholic was how Higginson saw himself. Of "a cold, melancholy, phlegmatic, rheumatic temper of body," he left England a sickly man, "continually in physic, being much troubled with a tormenting pain through an extraordinary weakness of my stomach, and abundance of melancholic humours." He finds himself now in "perfect health." He is "free from pain and vomitings, having a stomach to digest the hardest and coarsest fare who before could not eat finest meat." Even New England's water agrees with him.

And what a change in his apparel: "I that have not gone without a cap for many years together, neither durst leave off the same, have now cast away my cap, and do wear none at all in the day time." He used to be so cold: "And whereas beforetimes I clothed myself with double clothes and thick waistcoats to keep me warm even in the summer times, I do now go as thin clad as any, wearing a light stuff cassock upon my shirt and stuff breeches of one thickness without linings."

Good news, then, about his health for his family and friends in England, but as we shall see, a testimonial not without motive. Salem tradition says Francis Higginson was slender and erect, but not tall, rather like our Henry. There is a portrait of Reverend Higginson in the State House at Boston. But which man, and where was it painted? If it was painted in London, before he sailed in 1629, then it could be Francis. But as he dies in 1630, carried off by fever that swept New England, it is more likely a likeness of his eldest son John, later minister at Salem. The portrait shows a serious, kindly, wistful face, with firm nose and chin, the sort of man people take to and want in a leader. To go with this face, Bliss Perry, Henry Lee Higginson's biographer, nicely provides the soundtrack should it be Francis. "A charming voice," said a more famous Puritan, Cotton Mather, of him, "which rendered him unto his hearers, in all his exercises, another Ezekiel, for 'Lo, he was unto them as a very lovely song of one that hath a pleasant voice and can play well upon an instrument.'" Perry sees this music carry down to Henry.[20] Voice was important. The Puritan church was a Bible-reading church, and preachers lectured on the Bible.[21] A "lecture" service lasted two or more hours; the devout went twice on Sunday. The Word—preaching—was one of the sacraments, God brought to the people, and so the voice was in aid of that, especially when not all parishioners knew how to read. Salem had no organized church. Upon landing, Higginson became the new parish's lecturer and fellow cleric, Samuel Skelton, the minister. The right voice could persuade. Within four months of landing at Salem, Higginson helped achieve a working

relationship between the old and new governors of the little colony, and their followers, and the people fresh off the boat.

Higginson's was an age of exploration, of venturers, as England grew into the British Empire. With global warming, arctic ice may melt to allow ships to sail the Northwest Passage to the Orient that traders had sought since the sixteenth century. Venturers brought back tales of the seen, the unseen, and the suspected. Sea monsters filled the corners of maps, part decoration, part warning. On a 1513 chart, two men light a fire on the back of a whale they think is an island.[22]

Higginson was a gifted writer, and something of a stylist. A truth was in his eye, and in his telling. Here is his Journal account of the great sea storm, which began on Tuesday, 26 May. He manages to suggest he is quite human, comforted by Scripture as a preacher, but more glad as a "landman" to have been told about the nature of ships.

> About ten of the clock in the morning, whilst we were at prayers, a strong and sudden blast came from the north, that hoisted up the waves, and tossed us more than ever before, and held all the day till towards night, and then abated by little and little till it was calm. This day Mr. Goffe's great dog fell overboard and could not be recovered.

Wednesday dawned calm, the wind still north.

> But about noon there arose a south wind which increased more and more, so that it seemed to us, that are landmen, a sore and terrible storm; for the wind blew mightily, the rain fell vehemently, the sea roared and the waves tossed us horribly; besides, it was fearful dark, and the mariners' mate was afraid, and noise on the other side, with their running here and there, loud crying to one another to pull at the this and that rope. The waves poured themselves over the ship, that two boats were filled with water, that they were fain to strike holes in the midst of them to let the water out. Yea, by the violence of the waves the long-boat's cord, which held it, was broken and it had like to have been washed overboard, had not the mariners, with much pain and danger, recovered the same. But this lasted not many hours, after which it became a calmish day.

Where was Higginson during the worst?

> I lay close and warm in my cabin, but far from list to sleep; with Jonah i.5 —"Then the mariners were afraid, and cried every man unto his god, and cast forth the wares that were in the ship into the sea, to lighten it of them. But Jonah was gone down in the sides of the ship; and he lay, and

was fast asleep"—and my thoughts otherwise employed, as the time and place required. Then I saw the truth of the Scriptures, Psalm cvii. from the 23d—"They that go down to the sea in ships, that do business in the great waters"—to the 32d; and my fear at this time was the less, when I remembered what a loving friend of mine, a minister, accustomed to sea storms said to me, that I might not be dismayed at such storms, for they were ordinary at sea, and it seldom falls out that a ship perished at them if it have sea room; which I the rather write, that others as well as myself, by the knowledge hereof, may be encouraged and prepared against these ordinary sea-storms.

If the Journal is real time, the Diary called "New-Englands' Plantations" talks of the future. As Puritan propaganda, it was tailored to their hopes and pocketbooks: here in America is comfortable living, here is money to be made. He pledges to write only of what he sees, or what he has heard tell from others, and he assures the readers they are Godly others, "whose testimonies I do believe as myself."

Higginson is that man of probity on whose word much of America was built. The early settlers relied on him and his kind for reliable information. Lions there may be in Salem, but as he has not seen one, Higginson will only pass on a rumored sighting. If he has not seen certain animals himself, he has seen proof: skins of foxes, beavers, otter, martin, and great wild cats. That would interest the fur traders. He hears of a great beast called a molke, or moose. He hears of squirrels that fly between trees. He sees three other kinds of squirrels: the smallest may be the chipmunk, unknown in Britain. There are snakes, too, and "serpents." One such is the rattle snake, which must be new to him, for he dwells thrillingly on how it killed an Indian despite his chewing "snake weed." But that was three years ago, he assures the reader, and has not happened since.

By now old England knew quite a bit about the new. Every English ship that dropped off colonists—the *Mayflower* in 1620—carried letters and diaries for friends and family back home. That Higginson had been invited (we would say recruited or headhunted) to lead an expedition to the new world meant his Diary would not remain private for long.

Spotting its value for the Puritan cause, a London bookseller named Michael Sparke had excerpts printed in 1630. The title is probably Sparke's own: *New-Englands Plantation, or a Short and True Description of the Commodities and Discommodities of That Country*. Sparke supported other Puritan viewpoints at some cost to himself. For selling a thousand-page diatribe on the English theater and pagan holidays such as Christmas—William Prynne's *Histriomastix* of 1632—Sparke faced the pillory, fine, and imprisonment. Lest the reader think Higginson is sparing

"Bully Hig"

of the truth, Sparke turns pitchman to vouch for him, and pens one of the earliest publisher's blurb to reach America:

> But here read the truth, and that thou shalt find without any bumbasted words, or any quaint new devised additions, only as it was written (not intended for the Press) by a reverend Divine now there living, who only sent it to some friends here, which were desirous of his Relations; which is an Epitome of their proceeding in the Plantation. And for thy part, if thou meanest to be no Planter nor Venturer but do lend thy good Prayers for the furtherance of it. Ands so I rest a well-wisher to all the good designs—both of them which are gone, and of them that are to go. — M. S.

Higginson's message was that God favored enterprise. The land teems with good things. The sea, too: he is sated eating lobster. Gardens flourish: "Green peas as good as ever I ate in England." The natives are friendly (and "wear something before their privates"). The natives, moreover, are helpful. Higginson encloses examples of their pinewood tapers as a substitute for candles, as tallow was not yet available here. Work will reward. Higginson runs the figures on one man's corn crop, which he trades to the natives for beaver skins, and concludes, "wherefore you may see how God blessed industry in this land." That last promise makes "Planters" of them all, whether they came to the new world for commercial or religious reasons. It was to the benefit of Crown and Country to settle colonists to "plant" a colony whose riches could be exploited for financial gain.

For immigrants like Higginson who had left the ever-forgiving Anglican church for the hard-earned salvation of the stern Puritan corrective, it was a Plantation of their making, one that would be tolerant of their religious beliefs. But not of the beliefs of all others: When Higginson said he was a "preacher of truth," he meant, with no apology, the Puritan truth.

Flowers lined their way to Salem. "Sometimes scattered abroad, sometimes joined in sheets nine or ten yards long, which we supposed to be brought from the low meadows by the tide ... These yellow flowers painting the sea made us desirous to see our new paradise of New England." The name Salem derives from two words for "peace," the Hellenized Arabic *salaam* and the Hebrew *shalom*. Higginson writes home they named the town for Psalms 76:2. God is great. "In Salem also is his tabernacle." God smiles on the successful, he argues, and on the cooperative. To reconcile all, Higginson composed a statement of faith, a covenant which 30 persons in Salem assented to on 6 August 1629: "We covenant with the Lord and one with an other, and doe bynd our selves in

the presence of God, to walke together in all his waies, according as he is blessed to reveale himselfe unto us in his Blessed word of truth."

New-Englands Plantation is a sales pitch. That must not lessen our appreciation of Higginson's keen eye for what he saw on the ground or his feeling for being alive in God's bounty. If not of farm stock, he had lived among farmers—as most English did—and knew what word to send back. "The fertility of the soil is to be admired at, as appeareth in the abundance of grass that growth everywhere, both very thick, very long, and very high in divers places. But it growth very wildly with a great stalk and a broad and rank blade, because it never had been eaten by cattle, nor mowed with a scythe, and seldom trampled by foot. It is scarce to be believed how our kine and goats, horses and hogs do thrive and prosper and like well this country." As it happened, the rankness of this native grass would prove a digestive problem for English cattle. By happy accident, as John R. Stilgoe relates in *Common Landscape of America, 1580-1845,* English grass seed carried across the Atlantic in cow manure took immediately to the new land. The newcomers saw the bounty, sent for seed from home, and soon good grass spread like green wildfire.

The fleet must have carried some sheep. Higginson appeals to the next wave of the Godly to bring even more "to make use of the fruitful land." Little did he know that wool sheep would be the one animal that fitted the New England economy like a glove—it could graze anywhere—and its fleece made fortunes for the enterprising who built textile mills after damming New England's many rivers and streams. Little did he know that New England's limitations for farming crops excluded corn. One Salem farmer's profit raising Indian corn was an astonishment. "Yea, Joseph's increase in Egypt is here outstripped with us," he writes as preacher. "The abundant increase of corn proves this country to be a wonderment." Higginson the trader provides more detail than the modern reader may care to follow: the very colors of corn kernels are new, red, blue and yellow. "And of one corn there springeth four or five hundred. I have sent you many ears of divers colors that you may see the truth of it." The crop yield amazes: An increase of "thirty, forty, fifty, sixty [fold] are ordinary here ... Our planters hope to have more than a hundred fold this year, and all this while I am within compass—what will you say of two-hundred fold and upward? It is almost incredible what great gain some of our English planters have had by our Indian corn." He has it from the farmer himself, or as he puts it, "the party of it himself announced the truth of it to me, that from the setting of 13 gallons of corn, he hath had an increase of 52 hogsheads, every hogshead holding seven bushels of London measure, and every bushel was by him sold and trusted to the Indians for so much beaver as was worth 18 shillings, and so of this 13 gallons of corn which was

worth six shillings 8 pence, he made about £327 of it the year following, as by reckoning it will appear; wherefore you may see how God blesseth industry in this land."

Labor is cheap: "Little children here by planting corn may earn much more than their own maintenance." This was a selling point for large families. There are so many fish, skate, and thornback, and "an abundance of lobsters, that the least boy in the plantation may both catch and eat what he will of them." Growing conditions favored a cornucopia of vegetables, many superior to England's. There were pot-herbs, sweet and medicinal: pennyroyal, winter savory, sorrel, brooklime, liverwort, carvel, and watercresses. There are two unnamed herbs, "which bear two kinds of flowers very sweet, which they say, are as good to make cordage or cloth as any hemp or flax we have." That would interest boat wrights as local sources for rope and sailcloth. For tanners: "sumac trees, which are good for dying and tanning of leather." There are color-fast dyes for cloth: "roots and berries wherewith the Indians dye excellent holiday colors that no rain nor washing can alter." The *Talbot* had carried two big barrels of soap. That could now be made ashore from rainwater, the lye from wood ash, and animal fats. Salt was necessary to life, and Salem should prove "of an excellent temper for the making of salt." Fishermen "found it candied"—a pungent verb—"by the standing of the seawater and the heat of the sun." Lux fiat: fish oil lit lamps. Of consequence when the next generation of immigrants would find the Indians less friendly: "We have materials to make ... saltpeter in abundance." Occurring naturally as potassium nitrate, saltpeter is used to make gunpowder.

When the Higginson fleet arrived in Salem they found only five dwelling houses and one—boasting two stories—was the residence of the governor (those peas came from his garden), and Higginson spent his first nights ashore there. We can imagine the summer of 1629 was spent building accommodations for the winter. There was ample land for the newcomers. But who got the best and the most was subject to one's standing. Prominent citizens received land grants they could farm off and exploit. For services rendered to Salem, their new minister, the Reverand Samuel Skelton, was given 213 acres in Danversport, a peninsula to become known as Skelton's Neck. The land that comprised Salem was huge: its boundaries took in modern Danvers and Marblehead and reached up the North Shore to Cape Ann and Gloucester.

Higginson's "diary" was a manifesto. Even the sickness of a son had a lesson for immigration. This child "was formerly most lamentably handled with sores breaking out of both his hands and feet of the kings-evil, but since he came hither he is very well ever he was, and there is hope of perfect recovery shortly, even by the very wholesomeness of the air,

altering, digesting and drying up the cold and crude humors of the body. And therefore I think it is a wise course for all cold complextions to come to take physic in New England: for a sip of New England's air is better than a whole draft of old England's ale."

But the Journal entry for the death of little Mary is raw, lived in the moment. She had never been a well child. On Sunday, Mary and her brother Samuel had exhibited signs of small pox and the purples, infections brought on board by a passenger. On Tuesday, Higginson, though worried, went with the *Talbot's* master for "bountiful entertainment" on the *Lion's Whelp*. "Toward night, my daughter grew sicker, and many blue spots were seen on her breast, which affrighted us. At first we thought they had been the plague tokens; but we found afterwards that it was only a high measure of the infection of the pocks, which were struck again into the child; and so it was God's will the child died about five of the clock at night, being the first in the ship that was buried in the bowels of the great Atlantic sea."

A grief to her parents and a terror to passengers fearing contagious disease, but, said Higginson, "it pleased God to remember mercy in the child, in freeing it from a world of misery, wherein otherwise she had lived all her days." Then: "For being about four years old, a year since, we know not by what means," Mary fell ill, "swayed in the back, so that it was broken and grew crooked and the joints of her hips were loosed, and her knees went crooked, pitiful to see. Since which time she hath had a most lamentable pain in her belly, and would often cry out in the day in her sleep also, 'My belly!' which declared some extraordinary distemper. So in that respect of her we had cause to take her death as a blessing from the Lord to shorten her misery."

That account in 1629 will stand in for the death in 1874 of Henry and Ida Higginson's first child and only daughter, Cécile, her fever blamed on Charles River sewage that flowed on the northern edge of the Back Bay.

3

Money

"constant frights and uncertainties"

Higginson did not marry into money, for the Agassizes had none. He did something that turned out wiser. He married the sister of the man who made him the fortune that put him on his way. Copper in far-off Michigan would make possible the Hotel Agassiz and much else.

The wedding was on 5 December 1863, in Harvard's Appleton Chapel, then the university's church. Born on 8 August 1837, the bride was a mature 25, the bridegroom 29 and still convalescent from his Civil War injuries. His gift to her was a pearl cross.[1] The ceremony united Henry Lee Higginson, a son of old Boston and merchant lineage, with Ida Olympe Frederika Agassiz, a daughter of families of intellectual, scientific, and theological attainment in Germanic Europe.

One of her grandfathers was a pastor serving a tiny Protestant community surrounded by Catholic Switzerland in the Bernese Alps, and the other, a doctor from a banking family. This would produce her father, Louis Agassiz (1807-1873). He, too, was Swiss, raised at Môtier on the shores of Lac Morat in the French-speaking western part. His family scrimped to send him to university in Lausanne and on to the medical school in Zürich, and a calling to medicine would have best pleased his family. But, in the way of European students, he went university to university, making up his own curriculum. In München he heard the foremost modernists on astronomy, zoology, botany, and mineralogy. At Heidelberg he fell for botany and zoology just as the old theology of God's Plan for Nature was being challenged by the new science. By weighing and measuring, by observation and deduction, the new science discovered much new about the natural world—mineral and animal, geology

and zoology—that was useful especially to the new-world American pragmaticists. With vast stretches of America to explore, and fortunes to make, they welcomed reliable data for mining and fossil fuel interests. In marrying Ida, Henry also got her brother, Alexander Agassiz, whose study of geology and mining would make the Higginson fortune in Michigan copper.

Harvard, too, was interested in the new science and had invited Louis Agassiz to give the Lowell Lectures in 1846-1847. Called "Plan of the Universe," the talks were free, popular, standing room only, at Boston's Tremont Temple.[2] Harvard's starry names turned out to hear him, Longfellow among them, and finding him charming, and sociable, they entertained him. To his surprise and delight, the poet heard Agassiz "extolling my description of the Glacier du Phone in *Hyperion* which is pleasant in the mouth of a Swiss who has a Glacier Theory of his own." With Harvard in his corner, he was elected to the Saturday Club.[3]

At a Cambridge supper party, the widowed Agassiz would meet his second wife. Harvard soon appointed him to the faculty. A poor boy, who had to hand-copy the texts he could not afford to own, he found Harvard less a university of mature inquiry than a college for shallow boys.[4] As would happen, Agassiz's science did have much to offer, and Harvard would house his zoological museum, but his reputation would not survive the secular attack of the Darwinists. The young William James studied under Agassiz, and was puzzled by his mixture: French fire for drama coupled with Germanic rigor. "There is more charlatanerie and humbug about him and solid worth about him, too, than you often meet with," James wrote. It was not duplicitous quackery, but "the unconscious, childish kind that you can't condemn him for ... He wishes to be omniscient, but his personal fascination is very remarkable."[5] That Agassiz is for another book. The Agassiz of this book is the co-founder of a remarkable school that began in his parlor (and bathtub) and led to the foundation of Radcliffe College at Harvard.

Ida Agassiz chose her wedding date to mark the birthday of her stepmother, Elizabeth Cabot Cary (1822-1907). This was a remarkable woman, loving, resilient, adventurous, far-seeing. Born and raised in Boston's Temple Place, in a grander nest of cousins than the Higginsons, she was called Lizzie, which became "LeeeZee" in the mouth of her husband. She was pretty, her hair fashionably ringleted, and her eyes like "the water of a brook running over a bed of autumn leaves," which, to say, were brown. She sang well. He could not carry a tune and was rumored to yodel.[6]

It was the local custom to look over worshippers at King's Chapel for potential husbands. In the pew of the Lowell family who had sponsored the lectures was a handsome newcomer. Fine Roman nose, curling hair, full and generous mouth, brilliant dark eyes that promised laughter. Yes, dear reader, she, married him. As the Cary family liked to tell the story, Lizzie's mother spotted the stranger as the first man she'd seen that she wanted her daughter to marry. Hopeless, replied Lizzie. "Mr. Agassiz has a wife and three children in Switzerland."[7]

There were three children, but their mother, Cécile Braun Agassiz, would die the summer of 1848 of tuberculosis. Shuttled around the Braun family, Alex, Ida, and Pauline would not be soon reunited as a family with their father. Alex came first, by himself the summer of 1849, 45 days by sail. His sisters did not arrive till after their father married Lizzie Cary on 25 April 1850. She wore "green silk, white camel-hair shawl, straw bonnet with white and feathers on each side." The Reverend Ephraim Peabody, that marathon christener of Higginson cousins, presided in King's Chapel. Eight days later, visitors to Oxford Street, in Cambridge, where the married couple lived in Agassiz's house, found him smoking a cigar, and she hemming a crash towel.[8] They never had children; his children became hers.

They arrived knowing no English. Alex told of talking in Latin to boys he was invited to visit and swim "Roman" at Nahant.[9] He was thirteen, Ida about twelve, Pauline, seven. In age and exuberance, their stepmother was more an older sister or young aunt, without the melancholy that clouded their mother's last years. Their father would come and go on his scientific expeditions. Cambridge, and Harvard (for Alex) were anchors.

In the European way, Ida pronounced her name Eeda.[10] Her son said she retained a slight foreign accent "though I myself could barely detect it."[11] She was a quick study, "growing more interesting every day," Lizzie thought. They read the poems of Sir Walter Scott in the evenings. The "Scottish phraseology" baffled Ida, till it was decoded. "I have never seen any person of her age enter into them with such delight. So quick and just an appreciation of poetry in her own language would be unusual, and when you consider that she knew nothing of English 18 months ago ... it certainly shows more than common intelligence."

We will meet the beautiful Pauline Agassiz (1841-1917), later Mrs. Quincy Shaw, in connection with the education of the Fairchild children who lived at the Agassiz, and we will see a fair amount of Alexander Agassiz (1835-1910) in the company of Henry Lee Higginson. A Cambridge classmate, Ralph Waldo Emerson's daughter Ellen remembered "Ida, with her wonderful whiteness and the pretty brown of her hair."[12]

As preparation for Harvard, boys had Boston Latin or fitting schools like Dixwell's. Girls had nothing much, perhaps a governess for reading and sewing, a *Mademoiselle* for French lessons, a piano teacher, and someone for voice. Pauline Agassiz Shaw would found a day school in Boston, remarkable for enrolling girls with boys. In their teens, however, she and sister Ida were in on the beginnings of higher education for women. It was called the Agassiz School, after their parents. Like earlier schools for girls, its classes took place in the homey setting of a private house. Where it was truly different was the faculty. Harvard professors taught several subjects.[13] For along with three stepchildren to raise, the new Mrs. Louis Agassiz had to house and feed her husband's acolytes, many wandering here from France and Germany. Temple Place, lukewarm on Lizzie's marriage, was not disposed to help with bills. And there were the snakes. Marriage to a naturalist came with specimens. One Sunday, reaching for her church-going shoes, she surprised a serpent. Her sleepy husband: "I brought several home in my handkerchief last night." When all were rounded up, "he had the audacity to call upon me to admire their beauty."[14] Lizzie would travel with Louis on expeditions, setting up house for the family in South Carolina, Alabama, Florida, and Louisiana. Her bolthole was her family's place at seaside Nahant. There, her husband would build a marine laboratory for his continuing study of fishes.

And he had another private laboratory in the new house built on Quincy Street in Cambridge, in 1851, the year after they married. To stabilize the pedestal for his microscope, it was set in concrete. Lizzie's father paid for the land, abutting Harvard Yard. Henry Greenough (1807-1883), back from studies in Paris and newly set up as an architect, drew three sets of plans before Lizzie was satisfied. Long since razed, it was a big house and modern for the times. It had the usual New England clapboards. Instead of the pitched gable roof of such houses, its was hipped, or curved, and had a flattish top, making it a Mansard, named after François Mansart (1598-1666), a French architect whose classicism starched the wilder curves of the baroque.[15] And so Lizzie's first classrooms, on the top floor at Quincy Street, were made possible by French elegance.

It was a house that encouraged sociability, conversation. Agassiz's study had a big stone fireplace which warmed the talk of friends who gathered to settle the problems of the universe. Lizzie, who had been cold in her husband's Oxford Street house, had fireplaces in the parlor, dining room, and her sitting room. The sunny dining room "flower window" was a conservatory brightened by her geraniums. While not a mansion in size or social pretensions, it cost money to run. Agassiz paid his student assistants from his own pocketbook lest they would have to leave school. The school for girls was founded as much for income as education. Lizzie's father said

she could draw on him for 2,000 dollars whenever she needed. When she presented her plan to Agassiz, he was enthusiastic, said he would teach, and put his name on the brochure. The school opened on 16 September 1855. He would come to call it his "milk cow." Agassiz's name was a draw—and the need for a high school for girls so apparent—that the school was a quick success. Pupils enrolled in such numbers that classes in the rooms under the Mansard roof spilled into the dining room. Classes met at 8:30 and let out at 2:00. Cambridge girls walked to class, or rode horses. A chartered omnibus, drawn by four horses, brought the Brookline and Boston girls. The commute took Clover Hooper, the future Mrs. Henry Adams, 40 minutes from the Back Bay. Concord girls took an early train, arriving by 8:00, Ellen Emerson recalled. As the train back did not leave till late, they brought a cold lunch, and Lizzie provided hot mutton broth.

To us the Agassiz might look like homeschooling before its time. Certainly it was progressive. "Some of the studies may be made elective, as I disapprove of binding every mind to the same kind of straining and should prefer to adapt the education, so far as may be consistent with the order of a school, to individual character," Agassiz wrote. He would give daily lectures on physical geography, natural history, and botany, and these would be illustrated by models, maps, and drawings, as well as by specimens. As Lizzie and the young Agassizes well knew, the family bathtub was nursery to the egg-laying turtles studied under Louis's microscope. The first faculty was drawn from the home team, some more enthusiastic than others. The reluctant Alex Agassiz, twenty when the school opened and a graduate student at Harvard's Lawrence Scientific School studying mining, was told to teach math and Latin, subjects later taken over by Harvard professors. He would marry one of his students, Anna Russell, in 1860. Ida, on the other hand, joined right in. Lizzie: "Ida is only too glad to have her desire to assist her father ... by teaching, put into a tangible shape and one that seems to promise success." The school would, moreover, give her occupation. She was almost nineteen. Lizzie: "She seems to find a genuine delight in the idea of finding full exercise for her superfluous energies." Teaching would figure in her early married life to Henry Higginson. For now, her father assigned her to teach French and German as well as what he called "some of the English branches." A Harvard professor would eventually teach English composition, and another, Greek. Lizzie tutored girls in French. Ellen Emerson reminiscing to Lizzie 50 years later: "You never taught me, but you let me pronounce French to you. I wonder if you remember what you usually said after it. 'Surprising—the perfect Yankee sound of it, though you keep all the rules.'"[16]

The school lasted for nine years, closing in 1864. It had brought in about 19,000 dollars. For the rest of his life, ended by stroke in 1873, Agassiz would be preoccupied with building a zoological museum at Harvard. Lizzie lived to be 85, dying in 1907, president emerita of Radcliffe College, incorporated on 25 September 1882 as The Society for the Collegiate Instruction for Women. The treasurer was Henry Lee Higginson, who, the year before, had founded the Boston Symphony Orchestra and heard its first concert that 22 October.

* * * * * *

With her stepmother, Lizzie, to guide her youth, Ida Agassiz learned English, and how to be an American, and she was soon on the juvenile party circuit. She wore a white dress to Mrs. David Sears's house in Boston; she and Pauline danced reels in Charleston, when the family visited South Carolina. The cousinage would help. If people know one ditty about Boston, it is "the Lowells speak only to Cabots, and Cabots only to God." The Lowells, who showed off Louis Agassiz in their pew at King's Chapel, were also among the most hospitable families in Cambridge. Bully Hig was often there: Charlie Lowell was a dear friend from Boston boyhood and their Harvard days. "He and I went everywhere together, coasted on the Common, skated, cut up all sort of pranks," Higginson recalled.[17] There were private theatricals, some in German, along with German lessons. There was singing.[18] After a long "intermission" for musical study abroad and aborted military service in the Civil War, Higginson would be back on the Cambridge scene, and a regular caller at the Quincy Street home of the Agassizes. His mother was a Cabot, making him a cousin of Lizzie Cary Agassiz. He spoke German and French, he was musical and sang, he loved chaffing, and uttering Higgisms. By the autumn of 1863 he was engaged to Ida. As had his family, she called him Hal.

Congratulations arrived in every mail. Higginson's younger brother James, jailed in the Confederate Army's notorious Libby Prison, offered teasing lines from Schiller about the rebellious young man who returns home, parks his *Wanderstab* (Henry's walking stick) in the corner, and lights a pipe on which to ruminate the future. Henry Adams was full of his usual bombast: "As a general principle and in the most offensive sense of the word, I consider him who marries to be an unmitigated and immitigable ignoramus and ruffian." But a case could be made for choosing Miss Agassiz, whom Adams did not know: "She is a person whom weak minded men like you and me instantaneously, profoundly and irredeemably adore." The bride was lucky, too, to be congratulated "for getting for a husband one of the curiously small number of men

whom I have ever seen, for whom I have morally a certain degree of respect."[19]

The bride wore white. The wedding was "quiet, simple, and sacred," and the honeymoon, spent in Waltham in a house lent by a Lowell. Christmas was back at Quincy Street. Spring found them at the Agassiz cottage in Nahant. Henry fretted that his war injuries—three saber cuts and two pistol shots—did not heal. The least of them was the saber slash on his right cheek. He could not ride without great pain. From his battlefield letters home, we can feel his need to be in on victory. Impetuous, he returned to war service too soon. His brother James told him the Union had more officers now than it needed. Another Adams, Colonel Charles Francis Adams, told him it was time for a married man to settle down: "Don't waste any more time in aimless pursuits."[20] The question was what he should do with his life.

* * * * * *

Henry Lee Higginson was not a natural businessman. Late in life, looking back on his years in investment banking, he talked of the desperate years, the "constant frights and uncertainties, which gave gamblers a great chance if they could guess right, and ... kept decent men in doubt and often in agony." Banks failed. Money dried up. Railroads went under. "There was a great deal of soda-water in business at that time, grave doubts, great extravagance, and certainly great waste." There was the "silver craze," as he called it. He was against "Free Silver," that is, the free coinage of silver that the Democrats said could as easily back paper currency as bullion. To Higginson's fellow Republicans, William Jennings Bryant thundered, "You shall not crucify mankind on a cross of gold."

It was noticed he did not always like to take advice himself, "holding in that matter, as in many others, that it was more blessed to give than to receive." He would shoot letters off "to straighten out Presidents Roosevelt and Taft and Wilson, all of whom he liked personally, but whose official policies he frequently disapproved." If viewers of his portrait by Sargent thought he looked hard, ruthless, arrogant, and insolent, others knew the human face and knew him as modest, almost shy. Said a boyhood friend, Stephen Perkins, "Wherever you are, there is a hearth and roses bloom."[21]

As an investor, Higginson always said he profited by better men, the Boston giants in empire building. Among them, William Forbes, Theodore Vail, and the elder James Storrow, the latter who "battled the watch for the Telephone Company, beat Western Union—which was very strong—and established the patents for the Bell Telephone Company." Charles Coffin, "that wonderful trader," found a way to negotiate thickets to form

the General Electric Company. Shares in those companies made Higginson richer than ever. He was more the solo act, by nature, the speculator, and he was often wrong. Importing German wines was a failure. No silver in a silver mine. He prospected for oil: no wells came in. He had a soft spot for "promoters," visionaries, and gamblers, and liked telling of swindles on himself. His wealth was, of course, a magnet for people who wanted him to invest in their enterprises, and letters to him, now at Baker Library at the Harvard Business School, are a catalogue of late 19th-century endeavors. One will suffice, especially as it had two links to the Agassiz.

Chicago was the site in 1893 for the World's Columbian Exhibition to mark the 400th anniversary of Christopher Columbus's arrival in the New World. Fairgoers could marvel at replicas of his ships, the *Nina*, the *Pinta*, and the *Santa Maria*, and ride the first-ever Ferris wheel, the invention of George Washington Gale Ferris. On 630 lakeshore acres, laid out by, among others, Frederick Law Olmsted, stood the pavilions of 46 countries, as well as the grand, French-inspired neo-classical buildings whose gleaming paint gave the fair the name "White City." Another attraction was the Women's Building. For its opening, the Boston composer Amy Cheney Beach wrote her Festival Jubilate; we have met her husband, Dr. H. H. A. Beach, when he advised landlord Higginson on the smelly toilets at the Agassiz. Among the artists chosen to paint murals was Charles and Lily Fairchild's daughter, Lucia, then 23. Hers was the chaste view called "Women of Plymouth" and they are shown doing womanly things like tending babies and washing the family pewter.

So there was a great deal to see and ponder and enjoy, and people came by the trainload and on foot. Depending on the source, either 716,881 people, or 751,026 people, were at the fair on a single day, 9 October 1893, which commemorated the Great Chicago Fire of 1871. How possibly could such crowds move among the buildings? The answer was the first-ever "people-mover," guaranteed to transport hundreds safely and profitably, and now common in airports, such as London's Heathrow.

This "moving walkway" —as The Multiple Steam and Traction Company of Chicago called their invention—was hailed as the rapid transit of the future, and the firm now invited Higginson and other investors to come to the Casino Pier at the World's Fair "and examine our road on the spot." In his three-page letter of 5 August 1893, the firm's consulting engineer Max E. Schmidt told Higginson "hundreds of thousands of all ages and both sexes have already been carried without accident or delay" on the mile-long road. Noiseless, too, cheaper than an elevated railroad to build, and passengers would pay two or three cents a ride. "These low fares can be maintained and pay dividends on the investment."

Higginson's reply to this investment offer has not survived.

As a money man, he was not without some successes, quick to see the future lay in the telephone, the elevator, and electric power, all of which were made possible by the copper ore that made his first fortune. And he was bright enough, well travelled, well heeled, and well connected. Perhaps he had too many other things on his mind? He could not seem to pay attention to the sheer business end of investing. He had no special talent for finance, said "State Street," Boston's financial men. Surely, running the Boston Symphony diverted his attention from the money making it needed. And like everyone else in the investment world, he had to suffer through five Bank Panics in his lifetime: 1837, 1857, 1873, 1893, and 1907.

His beginnings in business were a dull plod. Too far behind in his studies to re-enter Harvard, he was put to work. He spent a year clerking on India Wharf with a firm of India merchants, a job his father found for him in March 1855. A ship arrived every month with goods from Calcutta, Manila, Java, and Australia. Henry was sole bookkeeper, learning on the job. He was shaky in arithmetic, too; writing to his father, he asked in which form he should keep the account book: "Which side is Dr. and which Cr.?" What he did for nineteen months is a picture of the minutia of 19th-century commerce. "I attended to the correspondence, kept the bank accounts, wrote copies of the foreign letters, examined the invoices, entered all the goods in the Custom House, made out the bills and collected them." From the first Tariff Bill of 1789 till the income tax was introduced about 1913, the federal government paid 95 percent of its bills from levies on imported goods. The money chain began with Henry's bosses, Samuel and Edward Austin, who made all the financial operations by securing letters of credit, buying remittances, and chartering ships.[22] That solution for English younger sons—finding fortune in India—did not appeal: he refused a job in the indigo trade,[23] then a conduit to the textile industry for blue dye and so profitable it was called "blue gold."

The Civil War was over, the nation returning to business. Henry then looked for oil in Ohio, and found none. Not his fault that the old way of prospecting by divining rod was still preferred to the new science of geological analysis that his brother-in-law Alexander Agassiz applied to the discovery of copper. Despite the oil disaster, he had four or five thousand dollars for a new venture. He knew friends who would go in as partners. There might be money to be made in cotton farming in Georgia. There was not.

He and Ida spent three miserable years on the Cottenham plantation near Savannah. After a long drive behind tired mules, the house appeared in near spring weather. Ida's diary for 9 February 1866: "The branches of the Cherokee roses were green already and there were pretty little yellow

flowers in the swamp." By bright firelight, the house appeared "much more low and homelike than I had imagined. The rooms looked clean but bare. The table looked quite pleasant, with Matilda standing near, grinning and curtseying at every turn, and Mary also."[24] Wages for house servants were not much different from the rural North. The women got twelve dollars a month, old laundry women 75 cents for each washing day. Their carpenter got 25 a month, house and fuel, rations for his family, but no land to cultivate. Another man, also paid by the month, milked the cows, cut wood, and blacked boots. Henry to his father: "Ida works very hard with her people. She has to teach them almost everything except the plainest cooking. Washing and ironing were unknown to them."

Home life among the plantation's black people was unfathomable to the gently raised Higginson. Brought up in the North, he expected work—whether in the field or in the house —to be done for wages paid. That was not local custom. Writing to his father: "Do you know, that these people eat at odd hours, standing up, sitting in the doorway, one by one, not together? The men very frequently say at ten o'clk, or sometimes as late as one or two o'clk, that they must go to their breakfasts, and I find that man and wife receive their wages separately, and spend them separately, not paying each other's debts at the [plantation] store nor sharing each other's money or food."

Higginson was to find that paying money outright for picking cotton was better appreciated than giving field hands a share in the crop they raised on their own patches. Even so, they did not understand the contract of work for money. He learned other lessons the hard way. One was weather: either drought or rain at the wrong time. Another lesson, the vagaries of the market for cotton: if not invisible, then soft. Henry to his father: "It has cost about $16,500 to make our crop, and we shall get $9000 to $10,000 for it, we hope."[25]

At Christmas there was a tree, candy for everybody, and presents for all the women and children. Little in the way of "expressions of delight from these imperturbable darks," Ida told her diary. "The more I see of them, the more inscrutable do they become, and the less do I like them."[26] The Higginsons had gone south, as victors with the best intentions. "We had done our best to upset the social conditions at the South, and helped free the negroes, and it seemed fair that we should try to help in their education," Higginson wrote of the Cottenham venture many years later.[27] While this meant education for the work place, it also meant book learning. Ida started with a school for the children, and she and Henry taught reading and writing to a class of fifteen. "They learn quickly, comprehend easily, both as regards work and in school," Henry wrote his father. "But their moral perceptions are deficit, either from nature or from

habit or from ignorance. They know that it is wrong to steal and lie, but they do it continually."[28]

Henry had known something of southern climate and landscape from his Civil War service. His and Ida's hearts may have been in the right place, their bodies not. She was from tidy, temperate Switzerland via Germany, had lived an orderly life in Cambridge, and, as a new bride caught up in her husband's adventure, went along with the year of oil prospecting in southeastern Ohio. On Duck Creek, a tributary of the Ohio, they lived in a log house. There were cherries and strawberries in the spring. They ate beef tongue and baked apples. Henry killed chickens. The cow gave 40 gallons of milk. In the evenings, Ida drew, and he read. They had tea, bread and butter and cheese, then returned to discussing John Stuart Mill's *Political Economy* (1848).[29]

At Cottenham they were closer to nature than accustomed. The plantation house, set well above the ground, was a refuge for pigs. They rubbed and squealed and fought, till Henry gave up. "We called all the negroes into the yard, and told them that each family was to have one large pig, one middle-sized pig and one little pig, and in that way we got rid of all of them." Next to go, the "nice-looking" cows that did not give much milk. They were killed and the beef divided among the families. True that the southern spring was lovely, and they rode their horses among fragrant wild azaleas and honeysuckle. Warm weather brought insects and snakes, and sickness, and more trials to bear. Smallpox had gone away, but now there was whooping cough. Quinine was of no help. Three died. Ida: "I have been struck with the cheerful way the negroes take death. One young woman lost her only child, and looked as bright as possible when I spoke to her about it. I don't think it is indifference, and don't know what it is." By May 1867, the Higginsons had had a long talk about going home. "It is pretty certain that we shall not come back again to stay. Henry at any rate means to try to get employment at the North," Ida wrote. "I am sorry, for I shall leave this place with a sense of utter failure."

Then Henry Higginson got lucky. His grandfather Lee had died in February 1867. He left a small fortune to Henry's father George in trust for George's five children. Two of the brothers were already in finance, James (Jim) as a broker, Francis as a partner in Lee, Higginson & Company.[30] Now with capital of his own, Henry quickly sold the Cottenham cotton plantation for 5,000 dollars, a quarter of what he had paid. The household was packed up, and subscriptions to the *New York Evening Post*, *The Nation*, *The Spectator*, and the *Revue des deux Mondes* forwarded to 44 State Street. On 1 January 1868, he joined Lee, Higginson as a partner. There was also the money from copper on which to build further fortunes.

* * * * * *

Shortly before the end of the Civil War in 1864, a Michigan state geologist named Edwin J. Hulbert (1829-1910) happened on a promising rock in the town of Calumet, in the Upper Michigan Peninsula, that would make Boston, and well beyond, a different place. In our day of fiber optics, it is difficult to imagine what copper wire made possible in everyday life, principally as the means of conveying electricity. The Calumet mine and its spinoff, the Hecla, would be the world's leading copper producer in the years 1869-1876, and supply half of America's needs.

The rock that Hulbert found was exceedingly rich, "great masses of copper tangled in their bed of conglomerate," Alexander Agassiz would write.[31] Eager to see the true yield, Hulbert quarried the rock haphazardly. Then, the impulsive man he was, he bought 100 teams of horses to drag the ore thirteen miles to the town of Hancock. Minerals have always lured investors, and one was Boston's Quincy Adams Shaw (1829-1908), already active in Lake Superior mining. One of Boston's richest men—his family was worth a million dollars in 1834—he was married to Pauline Agassiz (1841-1917), sister of Alexander Agassiz. Hulbert told fellow engineer Agassiz about his discovery, and Agassiz told kinsman Shaw that it looked a sure thing. The Calumet conglomerate, a stratum of felsitic porphyry some fourteen feet wide, was pure native copper, and its descent through the earth "singularly uniform," meaning easy to extract.[32]

In February 1867, while the Higginsons, Henry and Ida, were failing at raising cotton in Georgia, Agassiz, as president of Calumet, could crow about the "magnificent" quality of the ore and predict that in 1868 the mines would pay $15 a share, and may go to $30-40. Indeed, the mines did exceed expectations, paying out $72 million in shareholder dividends, more than any other company in the U.S. in those decades.

The mining life was not easy. The Keweenaw Peninsula was more inaccessible in summer than Alaska and shut off from the world in winter. Agassiz, who succeeded Shaw as Calumet president, took himself there to oversee production, Hulbert having proved an erratic manager. From the railroad terminus at Green Bay, Agassiz went by sleigh for many "long and trying" days. It was so cold and drafty in the log house, the only habitation that Agassiz could provide for his wife, the former Anna Russell, and infant son, that the baby "usually had to be kept in his crib." Out walking her son, Anna wore a revolver strapped to her wrist.[33] Extracting the copper was relatively simple: breakers broke the rock, and mills reduced it to little particles. Washing machines then flushed and agitated those bits of rock. Pure copper, being heavy, sank, and the useless particles floated away.[34]

Although Agassiz would leave the running of the mines and return to his real calling, the study of fishes, he remained the head of Calumet and Hecla till his death.

How speculators deal with bonanza often defines their way of doing business. Here was copper beyond the wildest dreams of copper men coming out of two far-off mines. But how that enterprise was managed counted more to the investment partners at Lee, Higginson & Company than sheer bulk excavation. In the conservative way of Boston, where family and shared interests mattered, they insisted that control rest with two men they knew, men whose word was their bond, the two brothers-in-law. With men like that in charge, even the ever-cautious George Higginson, Henry's father, was in favor of plunging into copper, perhaps as much as 2,000 dollars. "I should fancy Hecla at $50 cheaper than Calumet at $75." They had been offered for as little as five dollars a share; it would soar to 1,000.

The firm, as a friend would write in the elegantly opulent prose of the day, owed its success "in some measure to family alliances, its well-advised connections with the best financial enterprises of the day. Thus in the case of the great Calumet and Hecla Copper Mine, mother of fortunes and fruit of the resolute faith of Quincy Shaw, the scientific knowledge of Alexander Agassiz, the practical energy of both—these two brothers-in-law of Major Higginson naturally brought their gallant bird to deposit her golden (or copper) eggs in the nest at 44 State Street.[35]

Lee, Higginson was highly successful as an investment house. It raised funds in England, and major American cities. There were desk partners who stayed put in Boston, and partners, like Charles Fairchild, who travelled for the firm, sizing up investors and the markets. It was cautious and highly moral, judging men—whether partners or investors—by what a straight look in the eye would reveal. A man was as good as his word, and his handshake. Some partners fit the mold. Why others failed is more instructive.

In the year of his death, Higginson dictated his reminisces of the Lee, Higginson partners to his secretary, Mrs. Bertha O. Hinkley. A Harvard professor, Barrett Wendell, relied on them for a history of the firm from 1846 to 1918. It is a curious document, existing only in a typewritten text, one copy at the Massachusetts Historical Society (the paper crumbling to the touch) and the other at the Boston Athenaeum. How much is Higginson's prose and how much Wendell's cannot be known, but the flavor—whether tactful waffle or lapidary censure—can be enjoyed from sketches of examples of two men who failed as partners. One was Higginson's younger brother, Francis, Harvard 1863, who started out as a clerk. He "was at once more capable of prolong tenacity of attention, more

disposed to master and to remember hard facts, more uncompromising in his logical response, and by the very fact of his college training more skilled in his mastery of his faculties." But: "the intensity of his individuality combined with the occasional imperfection of his patience to make him a man who is at his best when more singly responsible." He left the firm in 1886 and went into railroading. He also served as treasurer of the Museum of Fine Arts.[36] And later bailed out his brother by taking over the Boston Symphony subsidy.

Then there was Charles Whittier, a brigadier general in the Civil War but brevetted, meaning he received the title but not the higher pay, and was given little to do. He joined Lee, Higginson in 1873. His "appearance and manners were dashing—if not precisely those of a man of quality, beyond question those of a man of fashion. He was popular at clubs, and on the Stock Exchange; his personal characteristics combined with his vigorous speculative daring to attract to the firm much business which might otherwise have gone elsewhere. Among his merits, was hardly that of prudence. After fifteen years, his partnership came to a somewhat abrupt end. His later years were passed in what was thought to be the more congenial atmosphere conventionally associated with Wall Street."[37] He re-upped in the Spanish American war, serving in the Philippines as inspector general, and, briefly, as collector of customs at Manila.

Another ousted partner was Charles Fairchild, whose family we will meet in two later chapters. "He doubtless attracted business to the firm; he was less fortunate in the command of confidence," Higginson recalled of his tenant and neighbor at the Agassiz. Made partner in 1880, he left for Wall Street in 1894. He had his worrisome side socially, "bohemian," as Higginson termed it. The proof: Fairchild "was a great friend of Robert Louis Stevenson."[38] Indeed he was, commissioning John Singer Sargent to paint the novelist as a present for his wife, Lily Fairchild. One might ask why this friendship was any more "bohemian" than Higginson's own tender involvement in the business affairs of the great Italian actress Eleonora Duse.

Perhaps Henry Higginson's major contribution to the firm was its physical salvation. Boston had burned in 1871, but nothing destroyed the old city like the Fire of 1872. An innovation at Lee, Higginson was the installation of a fireproof storage facility below the building, called the Union Safety Deposit Vaults. Here lay the paper proof of investments, the documents of ownership and the coupons to be clipped to cash out dividends.

One Lee, Higginson partner, George Lee, believed the mismanagement of deposits was worse than outright theft and was famous for spending his days in the vaults spying on clients handling paper. "His "habit of

spending time in the Safety Deposit Vaults had become so fixed that there was almost need of a more constant responsible presence in the upper air." This need was "quietly supplied" by James Jackson, a partner of the "elder type," that is, "a kinsman of the Lees and the Higginsons [who] inherited and maintained the regular traditions of Boston."[39]

Boston rectitude was little good against an act of nature. The Boston Fire of 1872 would put the vaults to a great physical test.

About eight on the night of 8 November, the Higginsons were at dinner when Henry saw the glare of the fire and heard riotous noise. The cousin who was in charge of the vaults was away. Henry fended off the crowd of men who'd come to open them and take their records and securities. Old George Higginson took the company's books to his house. So many fire horses were down with disease, the epizootic, they could not draw the engines. Tinder to flame, all the dry goods stores burned. In Exchange Place, a great liquor warehouse exploded. Henry implored Boston's mayor to assemble powder kegs to blow up the building to create a gap across which the fire could not jump. Military forts sent kegs to the end of Long Wharf. Commandeering a covered wagon, Henry drove them up State Street. The fire over, there was a hearing to determine the cause of the fire. Should powder have been used to blow up buildings before the fire actually reached them? Yes, to make a gap, Higginson testified. There had been confusion in the thick of fire. Although the kegs were under the jurisdiction of the Army, Higginson dealt only with the mayor. "I didn't tell General Benham, because he don't keep very quiet when there is any excitement. I knew him at the South. He gets a little worried."

The story of the Higginsons preventing a raid on the vault, where paper was safe in the heat and confusion of fire, became a legend of State Street, and Henry leading the cavalry charge, as of old.[40]

The era of safety deposit vaults would have a different challenge in the new century, as Higginson confided to an old friend, Henry Adams.

It has been said that no man or woman in good society needed a biographer once Adams began recording their thoughts in his letters. That descendent of Presidents, that historian of great movements, that man about Washington and London and Paris had hoped—with his wife Clover Adams—to be among the first to live at the Agassiz. She was, in fact, at the inaugural Boston Symphony concert in 1881. In the chapter called "Taste," we will see how Adams negotiated Higginson's purchase of bronzes from Rodin. He could afford them.

Quite apart from his other investments, Higginson could depend on his old copper money. In 1900, stock in the Calumet and Hecla mines was at a high of $840 a share—up from $60, and dividends on each share

paid $100. Then those Michigan lodes began to play out: the deeper that miners dug, the worse the quality of the ore. As early as 1894, investors had begun looking at copper elsewhere. Higginson and Agassiz declined a new venture dangled by the Anaconda Company in the promising west.[41]

As a money capital, Boston began to fade in the first decades of the new century, and Higginson would die poor. He could see it coming. In Paris in January 1902, he stayed with Adams and unburdened himself, bending his ear "chatting of things in Boston and investments in Virginia coal-lands, and histories of the past, which are so far past that we might be talking about the pyramids." Adams himself was not sanguine: "Positively my skin begins to curl when I look into the present century," and in an electrifying metaphor, added, "This great ghastly automobile of a country seem just about to roll over us all."[42]

In January 1903, the two men met in New York and talked till one in the morning. Higginson's health was a concern, as were his finances. His body was aging. As worrisome was the approaching change of who counted in the world of finance. "He says the doctors have given him his first call. He broke something in his brain this autumn, and had to stop. He suspects Pierpont Morgan is stopping too, and that the enormous sales of the stock exchange are the closing of his accounts. The Jews, he says, are all alert to jump on his leavings and divide them."[43]

The fact of the matter was that Morgan no longer needed Lee, Higginson & Company as his "Boston bank." "We used to sell all the Telephone bonds," Higginson wrote in 1910, "but now the company has outgrown us and passed into other hands." That was the House of Morgan, and with the help of one of Boston's own, investment banker T. Jefferson Coolidge, Jr. While Bostonians still occupied the "Boston seat" on boards of the giants they had helped finance, they had to defer to bigger, more aggressive money for deals. In 1913, GE's president Coffin inquired about Lee, Higginson underwriting a debenture issue. Henry Higginson: "We can not without disrespect to Messrs. Morgan, make any definite propositions to you until you have talked with those gentlemen—and those gentlemen means Jack Morgan," J. P.'s son. Later on, more groveling: "our relations with Messrs. Morgan & Company are entirely friendly, and we wish to do as they wish."[44]

This demotion must have hurt.

The Great War was another blow, especially felt by Higginson for its impact on the German culture that was the basis of the Boston Symphony. Patriotism was as divisive as it was healing. When the "enemy-alien" conductor Karl Muck was locked up for failing to play "The Star Spangled Banner," Higginson considered substituting a song by a local woman,

"The Battle Hymn of the Republic." "Mrs. Howe's hymn "has much more swing and much more charm than the national anthem."[45]

Higginson died regretting little. On 2 August 1918, he wrote to Sir Hugh Levick, a young partner in the London house of Lee, Higginson, on the value of putting the firm and more able men first. In Boston, "I have always played second fiddle or third fiddle," and was content. He saluted his forebears and partners. "I have merely followed in their path ... If, instead of spending all the money [I made] I had kept it, I should have five or six millions to-day, and very likely more."[46]

It was at a memorial to an earlier war, that Higginson on 10 June 1890 described his beliefs to Harvard students gathered for the dedication of "The Soldier's Field" that he gave in memory of six friends, comrades and kinsmen who fell in the Civil War. One of the dead was Charles Lowell, the boy he had pranked around with in old Boston. "Don't grow rich; if you once begin, you'll find it much more difficult to be a useful citizen," Lowell had written before his last battle. "Don't seek office; but don't 'disremember' that the useful citizen holds his time, his trouble, his money always ready at the hint of his country." It was advice Higginson did take as his beacon and he hoped always to be more useful than rich.

4

Water, Water

> "And twice each day the flowing sea
> Took Boston in its arms"

Thus said Ralph Waldo Emerson on 16 December 1873 in Boston's Faneuil Hall, reading his poem for the centenary of the Boston Tea Party.[1] The verse above unwittingly described the strength of the city and its predicament. Tiny to begin with, only about a thousand acres, water-girt Boston could only grow by making land to house the galloping population. A later, better poet, Robert Lowell, likened Boston's spiny (and moral) geology to a fishbone.[2]

Was Henry Lee Higginson in Emerson's audience that day, dark haired at 39, among the white-bearded civic leaders and money men? Peter Faneuil's hall, market place, and meeting house since 1743, was within his ambit as boy and youth. A few streets away, on the waterfront, he'd had his first job on India Wharf as a clerk to shipping merchants. Boston needed the sea. Unlike the Massachusetts cities that had room to manufacture—Lowell, say, and Worcester, with their mills—Boston could only deal in cargo. Ships came in, ships unloaded, ships went back to sea. Young Higginson sat on his clerk's stool checking invoices, keeping the books, and paying the bills. Little on the day of Emerson's poem would have sounded different. Water slapped and sucked at the wooden hulls, masts creaked, and dray horses lumbered the goods to market. On that day, a sea fog described as "toxic" shrouded the city. In certain quarters there lingered the still acrid evidence of the great fire the November before, raking Henry's boyhood streets. As that mercantile part of Boston still had its residential pockets, decent living space was at an even greater premium, and the Back Bay was ever more the solution as a new neighborhood.

By that December day, Higginson and his wife Ida and their little daughter Cécile had just moved into the Hotel Agassiz. Level land, graded but vacant, stretched from their Commonwealth Avenue corner at Exeter Street west to the Fens and east to the Public Garden. Would anything else get built? There was reason to worry.

The financial capitals of Europe and America were in crisis. The Panic of 1873 would become the Long Depression that did not lift till 1879. Everything imploded, a global train-wreck involving German silver currency (and American mines) and the Suez Canal (which changed shipping routes). Not unaffected were American railroads (dozens failed) and banks without number. Chicago already hurt from the Great Fire of 1871, and Boston would go up in flames twice. On 9 November 1872, in not quite twelve hours, 60 acres of prime downtown burned for a property loss of $75 million, and, as we have seen, with Higginson one of the heroes.[3]

As a partner in Lee, Higginson & Company, he could bless his luck: in London earlier that year he had raised solid money that would keep the firm comfortably afloat, and the copper mines—Calumet and Hecla—never passed a dividend. Investments in railroads continued to pay off.[4] But what about less fortunate folk, the suddenly hurting merchants and professional men at the mercy of the economy and without the wherewithal to build residences in the Back Bay?

Some population figures: the Boston of Emerson's birth in 1803 numbered fewer than 25,000, and even then people spoke of over crowding. By 1825, it was almost 60,000. When Higginson was born in 1834, it was almost 70,000. By 1850, it was not quite 140,000. By Emerson's poem in 1873, it was more than 250,000, of which many were the adult children of the Irish immigrants who had fled the Potato Famines of the 1840s. By 1881, when Higginson founded the Boston Symphony Orchestra, it was 363,000 and growing.[5] There is photographic evidence, too. On 13 October 1860, James Russell Black floated 1,200 feet above Boston in a balloon to take the first successful aerial photo in the United States. Ships in full sail dot the harbor, one a three-master. Tightly-clustered mercantile buildings fan out to the water.[6]

With the need for space, Boston began moving ahead on two fronts. During the decades it was reclaiming land under the Back Bay, it was busily acquiring whole towns, as a cheaper way to build the city. Call it land grab or call it annexation, it worked, the towns attracted by city services such as public transportation, water and sewer lines, and a broader tax base to pay for schools, police, fire, and hospitals. Part of Dorchester became Boston in 1804, and the rest in 1870. Roxbury followed in 1868, Charlestown and West Roxbury including Jamaica

Plain and Roslindale in 1873, Brighton including Allston in 1874, and Hyde Park in 1912.

Annexation was resisted, most notably by Brookline (with the help of Agassiz connections). Like a vast cove intruding into the big new Boston, it was the fish that got away. It still is a town, of almost 59,000 in the U.S. Census of 2010, but it was settled as a hamlet within Boston in 1638. Called Muddy River, it lay between that stream and Smelt Brook. Prosperous farmers moved to incorporate it as Brookline in 1705. As those farms increasingly became country estates for wealthy Bostonians, the white-collar elite hired blue-collar Irish as servants, stable hands, builders, and day laborers. An Agassiz developer George Higginson, father of Henry, had a Brookline estate, as did one of the earliest Agassiz residents, Theodore Lyman, who, the U.S. Census records, had an Irish coachman. Then Boston came knocking, having found annexation was cheaper and quicker than land reclamation. The lure of Brookline was ample space on cleared land for easy development, and Boston saw it as another Back Bay, but this time for the city's growing middle class. Annexation had appealed to Roxbury, for example, because it had no municipal provisions for water or sewage. Brookline had a reservoir, and, moreover, was sufficient unto itself, the gentry commuting to their Boston offices by rail, and the Irish working class—some 40 percent of the population—hunkering down. On 7 October 1873, annexation was put to the vote. Boston approved it 6,291 to 1,484. With no middle class in Brookline to make the case for annexation, a bloc of land owners prevailed, voting 707 to 299 to keep Brookline a town. This did not go unnoticed: Brookline was the first town in America to buck city takeover and it became a model for every swell suburb in the country. By a nice turn of fate, a grandson of George Higginson would buy up farmland near Chicago and develop the suburban estates of Winnetka. And what Henry Higginson knew as Brookline's "Longwood" section, would, as he feared, become a rival to the apartment living of the Agassiz.

* * * * * *

But in the 1840s Boston's solution was to build land by filling in some 850 acres of a shallow, noisome, polluted tidal marsh area along the Charles River. When high tide filled it twice daily, it looked like a bay, and smelled like a bay, and it was called the Back Bay because it was west, or back, of the town. As late as 1900, people dug for clams along the seawall on the Cambridge side of the river, which was not dammed till 1908 to make the basin we know today.[7]

Much is made of the power of public and private interests working together for the greater good. The Back Bay landfill was one, the product of state and city and private investors, from the beginning of the project in 1858 to its completion in 1890. The City of Boston could not act alone as developer. For one thing, states such as the Commonwealth of Massachusetts, by long-settled law, own the land under most bodies of water, and Roxbury (another Puritan plantation) had secured those land rights. The right to use that water can be sold, however, and well before 1821, a group of entrepreneurs called the Boston and Roxbury Mill Corporation had owned the rights to Back Bay water with the idea that tidal power could run the mills that would make Boston a major manufacturing center.

This was the century of water-powered mills. They changed the rural New England economy from subsistence farming to making goods for sale in national and international markets. Fortunes (many in Boston) came from harnessing northern New England's rivers and streams to water wheels and turbines to make textiles and paper. Sawmills and turning mills reduced trees to lumber for houses, and furniture and toys to put in them. Power from a well-dammed brook could turn out rolling pins, spindles for chairs, legs for tables, and spools for thread. And there were mills to make mill machinery, notably in Worcester.

Boston proper had no river worth the name. But it did have ten-foot tides that twice daily flowed west on the Charles River. It is now 1821. Let us now mount one of those Montgolfier hot air balloons—prettier than the Goodyear Blimp because made of bright wallpaper fastened with shoe buttons—and peer down at an engineering scheme that (in 1971) was called "the most advanced in all America." Like river water, tidal water would turn mill wheels, and it does. This was a "perpetual" system, and not just because of the tides, which could run twenty-four hours a day.[8]

From the air, we see that the Back Bay has been divided by barrier into two bodies of water. Near Kenmore Square is the Full Basin. East and south of that, the Receiving Basin. It's now high tide and at modern Bay State Road, sluice gates open to shunt the high tide into the Full Basin where it collects. Water now drops through millraces onto water wheels and, its work done, exits into the Receiving Basin and back into the Charles. By careful control of its water, the Full Basin was always full with enough to power mills till the next tide entered the sluices. From the balloon we see a system without flaw, gravity flow turning millwheels.

The most ambitious plan had called for 100 mills. The next most ambitious, for 81: 16 cotton (in competition with Waltham), 12 rolling and slitting to process iron, 8 woolen, 8 flour, 6 grist and 6 saw mills. Only 4 went on line. There was one manufacturing success. The iron

works produced enough to make the "Yankee" locomotive of the Boston & Worcester Railroad.

From the balloon we now see what helped doom the project. We see trains from Providence, Rhode Island, and from Worcester, chugging on rail lines built right across the Receiving Basin. Commuting to work is not a modern way of life. By 1848, a full twenty percent of Boston merchants traveled by rail from the suburbs via some 80 commuter stations located within a fifteen mile radius of the city.[9] In 1850, Elias Hasket Derby. Jr., of Salem, reputed to be America's first millionaire, noted how commuter trains allowed wealthy merchants to escape the squalid company of immigrants and flee to the leafy towns ringing Boston, including his own Salem. Travel by rail allowed them "to reach their stores and offices in the morning, and at night sleep with their wives in the suburbs. No time is lost, for they read in the morning and evening journals as they go and return." By 1850, commuter towns included Dedham, Milton, Quincy, Newton, Medford, Woburn and Winchester, and Dorchester and Brighton, which had not yet been annexed to become part of Boston itself.

Thus, in 1849 when the 15-year-old Henry Higginson took the train west to visit Dr. Oliver Wendell Holmes in Pittsfield, he could look down at the water covering his future neighborhood and home. In one of those ironies of progress, the mechanical power of the train engine hurt the older, natural power of tidal water. That is, while trains sped people in and out of Boston, the stone bridges and embanked trestles on which they travelled impeded the flow of water trying to exit from the Receiving Basin into the Charles River. As a result, pollution collected in the swampy marshland. It stank, and, on its way back to sea, it killed. In the hot months of summer, babies died of cholera; they will include Henry Lee Higginson's first born. Dysentery was equally fatal. The city fathers thundered and called the Back Bay a "great cesspool." Disease was in those days equated with "miasma," or rotten smell. "Every west wind sends its pestilential exhalation across the entire City."[10] By 1852 the Back Bay was seen as a serious health problem. The tides were adequate, but pollution overwhelmed the project, and the mills themselves had other problems and failed. Who would rid Boston of its pestilential bay?

The entrepreneurs, now reorganized as the Boston Water Power Company, joined in the landfill project as the private partner. They would undertake to create most of the land, which they could then sell to pay off their stockholders. For its part, the Commonwealth of Massachusetts formed the State Commission in 1852 to design and carry out the project, and reserved 100 acres of the 850 for distribution as it saw fit. A court had decided that the City of Boston had far less right to the submerged land

than Roxbury, and so Boston only got a triangle to enlarge the existing Public Garden. It would of course benefit from property taxes on the new houses.

It worked. The state would realize a $3.4 million profit.

This project, which lasted from 1858 to 1890, remains the greatest residential and commercial landfill in America. Some see it as the greatest land reclamation since God parted the waters. It relieved a sort of overcrowding by creating a new residential neighborhood. It was designed to attract the city's elite who might otherwise be tempted by the nascent suburbs, such as snooty Brookline. The lure was the luxury of space. It was flat and sunny, so unlike the steep climbs and black corners of Beacon Hill. The neighborhood park would be the expanded Boston Public Garden. Two plans envisioned a lake ringed by villas, "Lake Sears" the centerpiece named modestly for its developer. In the event, the Back Bay was laid out as a grid with the tree-lined Commonwealth Avenue Mall stretching east to west. Along the avenues and streets would rise tall row houses, one family to each. There would be mansions on every corner —or a church, or a school. And something new to the American city: the apartment building, Henry Lee Higginson's Hotel Agassiz.

The landfill also helped public transportation. Old Boston was connected to the outer world only by the road over the Mill Dam, now Beacon Street, and the bridge that carried horse traffic—ridden and driven—from Cambridge Street to Cambridge.

Then in 1852 came an invention that gave America the horse tram and city folk their first quick way of getting around town. If railroad cars could travel on tracks, the reasoning went, why not horse trams? And, so on level land, engineers sank iron track into flat streets. For this the Back Bay was perfect terrain. Tram wheels now eased over tracks, and with less strain on the horse-teams, trams could go faster—six to eight miles an hour—and further, and carry as many as 40 passengers. By 1860, horse cars were a way of life in New York, Baltimore, Philadelphia, Pittsburgh, Chicago, Cincinnati, and Boston. By the mid-1880s, horse cars carried 188 million people a year over some 6,000 miles of track.

One boon was jobs for immigrant labor, for the horse, by its nature, requires care and feeding, and Boston's newly arriving Irish found work as tram drivers and stable hands. (Farmers also found a ready market for their surplus horse stock.) The downside was that very nature of the horse: the manure and urine left on the streets. They required shelter; stables were on multi-levels, horses walking up and down ramps to their stalls. More fragile than mules and oxen, they could work only a four-hour shift. All were not equal in strength or temperament, and were a challenge to

pair up as teams. As soon as electricity could power street cars, the horse and attendant problems disappeared.[11]

All that remained for the Back Bay was a direct connection to Cambridge and the north. In 1891, the Charles River was spanned, in a bridge of low arches, beginning at Massachusetts Avenue, Boston. This was known as the Harvard Bridge, because it carried traffic into Harvard Square. Today, more democratically, it is called the "Mass. Ave." bridge, and ends at the Massachusetts Institute of Technology campus on the opposite bank.[12]

* * * * * *

In the beginning, the rock under Boston was part of Africa. The earth would churn and churn again, and a volcano popped up in sleepy Dedham. (A story told to show how parochial Boston was has one Brahmin asking another how he went to California. "By the Dedham road.") Then it began to warm, and two million years ago the sheet of ice covering New England began to melt. Still, some eleven thousand years ago Boston harbor was dry land. Then, about six thousand years ago came the melt-water that carved rivers like the Charles, which helped fill Boston Harbor with water—just in time for the Pilgrims and Planters searching beyond Cape Cod for land they could settle.

It is now the 1620s. Every good-weather month brought newcomers from England. Sail on the horizon would mean news from home, fresh supplies, and new people, but also the need to house and feed them through the winter. Settlements filled beyond the capacity of meager Cape land to support them. The need to colonize was imperative. A real harbor was a necessity for commerce. It must be deep, well-protected from the elements (and safe from England's foes), and it should accommodate other kinds of shipping, by providing docks and wharfs for the coastal cruisers and river craft that worked locally transporting people to jobs and goods to market.[13]

Trawling along Cape Cod Bay, the Pilgrims considered what is now Dorchester at the mouth of the Neponset River. The flood plain was inviting, but the river was sluggish and silted the estuary. They pressed on.

They considered the peninsula that became Charlestown. With water on three sides, it would provide necessary anchorage. It lacked springs for drinking water. We have seen, in the "Bully Hig" chapter, how some hundred people traveling from England to Salem in 1629 in the "Higginson Fleet," named for Henry Lee Higginson's first immigrant ancestor, settled Charlestown.

Boston merited a look. There was the welcoming embrace of the big outer harbor dotted with useful islands, and the inner harbor was not

only deep but sheltered. Above the water rose two considerable hills. Fresh water gushed from two big springs. To the north, round Copp's Hill (its final name) rose straight and sharp. To the southwest was the three-humped Tramount, Trimountain from whence "Tremont" as a place name. (Some Bostonians pronounce it Tree-munt but more say Treh-munt.) All around this craggy spur were sizable coves, too, so a variety of maritime activity soon ringed the new settlement, and Boston grew and grew.

What the settlers learned by exploration on foot, maps would clarify. The first detailed map was published by William Wood, an Englishman, in 1634. "Boston," originally "Shawmut," was yet another peninsula. Shaped like a big-lobed, lopsided leaf, it floated in water, a stem or "neck" connecting to the mainland. Off to the northwest flowed the Charles River. Before curling around Beacon Hill, it debouched into the shallow Back Bay. Wood's is the first description of Back Bay. Into it flowed two minor rivers, the Stony and the Muddy. In the midst of the bay was a great oyster bank, later called Gravelly Point, still later the site of Symphony Hall. Curving southeast of the hills was a passage that led to the South Bay. The future Charlestown (and Bunker Hill and Breeds Hill) was the peninsula bordered by the Charles and the Mystic River flowing from the north.

For some years the only way out of Boston was by a strip of land called Boston Neck, now Washington Street. Passable at low tide, but nearly flooded at high; on occasion, horses waded to their bellies. The very element that furthered commerce and trade was the problem: "Water, water everywhere, a river here, another there."

This was all right for a first settlement, for what you could call a beginner city. In 1630, the elder John Winthrop chose Boston for the primary settlement of the Massachusetts Bay Colony, the "city set on a hill" (from Matthew 5:14) that adorns so many speeches about Boston and America. In 1635, Boston Latin School opened, Harvard College in 1636, the first of their kind in America, and Henry Lee Higginson attended both. The first public library in America opened in 1653. Residents of the Agassiz would watch the construction of the great Boston Public Library (1887) in Copley Square in the 1880s, and one of the Agassiz residents was a trustee.

Winthrop knew Boston must find more buildable land than it could achieve by nibbling away hill top soil to fill in the wet places below, the ponds and marshes and estuaries. And so the first major projects began with the attack on Trimountain, by shaving down its three peaks: Mount Vernon, Beacon (highest and first called Sentry for the lookout), and Cotton. This was good land, with big houses and pastures. Emerson was not wrong to call them farms. A sort of urban renewal began in 1790. Mount Vernon was the first under the chop, 60 feet off the top,

the Hancock pasture and the Copley estate bought for sub-division for the mansions of the Mount Vernon Proprietors. Carts on wooden tracks carried the dirt down to fill shallow flats on the Charles River. We will see later what an elegant piece of engineering this "gravity railroad" was, even meriting the claim as America's first railroad. Mount Vernon dirt became the filled land that became Charles Street. The hill called Sentry and then Beacon went in 1795, landfill for a civic need: the Commonwealth needed a shelf on which to site Bullfinch's new State House. Much later, in 1835, Cotton Hill was the next to go. Ox carts dragged more than one hundred thousand cubic yards of gravel to fill the old Mill Pond, site of colonial gristmills, and Pemberton Square was laid out, giving the city another fashionable neighborhood.

Shovels and horse carts did the work on Beacon Hill, as shown in the serene drawings of J. R. Smith, his ink and pale watercolor washes done in 1811-1812. When the new process of chromolithography made art widely available and affordable, J. H. Bufford, in 1858, used Smith's on-site drawings for his prints.

By the time of the Back Bay landfill, the camera was the recording instrument. One astonishing photograph, shot from the tower of the Brattle Square Church on Commonwealth Avenue at Clarendon Street, looks west at a tide of promise. It is summer 1877. Six newly completed row houses, their steep steps like panting tongues, rise east of Dartmouth Street. The Commonwealth Avenue Mall has been planted with young trees, the many saplings in wooden braces, which will grow into the famed double allée of green shade (where much later the author will plant trees for her birthdays). There are street lamps. The mall is fenced, the broad center path smooth and curbed, and those smudges the camera has caught may be people walking. But there is no sign of construction workers on Commonwealth. The Panic of 1873 lingers.

To the north are the roofs along the flat (or Back Bay) part of Beacon Street, the houses built in the mid-1850s. Then comes the middle street, Marlborough, those houses dating from the early 1860s. Mrs. Howe's at Number 17 was built in 1865, a good while before Higginson, in 1881, confides to friends in her parlor that he will found the Boston Symphony Orchestra.

In the 1877 photo are signs that Dartmouth Street is filling in. There's a mass of solid and imposing row houses at the corner of Marlborough. By plan, each Back Bay corner was allocated to a big building, usually a mansion (often entered on its side street). Facing onto Commonwealth but entered at 306 Dartmouth is "our" block's big house, bookending the Agassiz. Dated 1872, an important presence with mansard roof and stacked bay windows, and still standing, its grand interiors intact despite

years as a variety of offices—from publishing (David Godine in the basement laundry rooms) to venture capital (upstairs in gilded paneling and stained glass).[14] In the 1960s such corner-plot mansions were in danger of being razed and having high-rises built on them. There was a public outcry: leave the Back Bay alone. The battle was won in 1966 when the three major residential streets of the Back Bay were designated an historic district and made subject to the Architectural Commission's strict rules banning changes to exteriors.

On Commonwealth, next to the mansion, the camera records a couple of row houses (dated 1873 and 1874), tall and ragged because of varying heights. The streetscape of the mature Back Bay will look like shelves of books, each spine, each facade, different from the next house. Then nothing, the photo not even hinting at excavation work for cellars.

Finally, we see the Hotel Agassiz, the width of three house lots, alone on its Exeter Street corner, its building permit issued in 1872. It looks as isolated as would the year-younger Dakota on New York's Central Park West. Alas, the camera does not show much of the Agassiz except its vast blank parti-wall that faces east. No sign of the row house, originally numbered 185 Commonwealth. A vacant lot on the 1874 Hopkins map, but a completed house in the 1883 Bromley map, when it was attached to the Agassiz for the Higginson residence. So it seems the Higginsons lived in one of the Agassiz's "French flats" for a decade. And the Agassiz continued in grand isolation for another five years or so. Until the last house lot was filled in, about 1883, this block was a building site. Oh, to be a fly on the wall to hear about living conditions in dirt and dust and noise of new construction. Almost without exception the Agassiz residents went elsewhere for the summer, and we will visit the "gentleman farmers" among them.

One who was stuck in the city, by choice, was Silas Lapham, the paint manufacturer who was the hero of the William Dean Howells novel of 1885 that chronicles his rise. Nothing but a "water side" Beacon Street house would do to mark Lapham's success in business and desire to place his two daughters in Boston society. Howells was himself a Back Bay resident, and from what he must have seen being built we can take as true the smells and sounds in his account of the construction of Lapham's house. The whole took almost a year.

"The work was not begun till the frost was thoroughly out of the ground, which that year was not before the end of April." Lapham told the architect "they might as well take their time to it; if they got the walls up and the thing closed in before the snow flew, they could be working at it all winter." But first they had to deal with the site, which was watery. "It was found necessary to dig for the [basement] kitchen; at that point

the original salt marsh lay near the surface, and before they began to put in pile for the foundation they had to pump. The neighbourhood smelt like the hold of a ship after a three years' voyage. People who had cast their fortunes with the New Land," as the Back Bay was called, "went by professing not to notice it; people who still 'hung on to the Hill' put their handkerchiefs to their noses, and told each other the terrible old stories of the material used in filling up the Back Bay."[15]

Every day in summer, Lapham would drive his wife Persis out in the buggy to watch the progress. Nothing gave him "so much satisfaction in the whole construction of the house as the pile-driving." When this began, early in the summer, he would stop the mare in front of the lot, and watch "the operation with even keener interest than the little loafing Irish boys who superintended it in force. It pleased him to hear the portable engine chuckle out a hundred thin whiffs of steam in carrying the big iron weight to the top of the framework above the pile, then seem to hesitate, and cough once or twice in pressing the weight against the detaching apparatus. There was a moment in which the weight had the effect of poising before it fell; then it dropped with a mighty whack on the ironbound head of the pile, then drove it a foot into the earth."

Lapham, who knew something of manufacture, was entranced by construction. "By gracious," he would say, "there ain't anything like that in *this* world for *business,* Persis." She "suffered him to enjoy the sight twenty or thirty times before she said, 'Well, now drive on, Si.'"[16]

By mid summer, the house was above ground. The "walls were up, and the studding had already given skeleton shape to the interior. The floors were roughly boarded over, and the stairways were in place, with provisional treads rudely laid. They had not begun to lath and plaster yet, but the clean, fresh smell of the mortar in the walls mingling with the pungent fragrance of the pine shavings neutralized the Venetian odour that drew in over the water" of the Charles River. Boston's natural air conditioning was in play: "the heat of the morning had all been washed out of the atmosphere by a tide of east wind setting in at noon, and the thrilling, delicious cool of a Boston summer afternoon bathed every nerve."[17]

* * * * * *

It's time now in this narrative to drain the old Back Bay to build the new. Horses, of which there were thousands on New England farms, could not do all the work. For one thing, even on well-surfaced roads, one horse could pull only two tons at very slow speeds. One horse on a canal towpath could pull 50 tons in a shallow-draft barge, but the Charles

River, subject to tide and current, was no placid canal.[18] So while hundreds of cart horses would be involved in the preparation of the project, the bulk of the work was done by heavy yet intricate machinery, much of it already used to build the nation's railroads.[19] The engineering brains for the project were two small-town Yankees, born in northern New England. One would not survive the strain. The other went on to bigger ventures. The technology was reliable. The financing, the land swaps, and the need to mortgage equipment were issues along the way, but it all worked out.

Until 2006 the "how" of the vast project had to be gleaned from two classics devoted more to architecture and real estate than engineering. The book with the broader canvas was *Boston: A Topographical History* (1963) by Walter Muir Whitehill, which drew on maps, drawings, and photographs, many from the collections of the Boston Athenaeum, of which he was librarian and director. Bainbridge Bunting's already-mentioned *Houses of Boston's Back Bay: An Architectural History, 1840-1917* (1967) had a narrower focus, but is no less invaluable for its analysis of building styles. We turn to his street-by-street lists to find out who built where and when, who designed each house, and, sometimes, who first lived at each address.

But we owe the "how" of landfill to two members of the Northeastern University faculty, William A. Newman, professor emeritus of geology, and Wilfred E. Holton, associate professor of sociology and anthropology, for their *Boston's Back Bay: The Story of America's Greatest Nineteenth-Century Landfill Project* (2006).

This is a wonderful nuts-and-bolts account in a little less than 300 pages. It's splendidly illustrated, and the captions a model of kind, whether for drawings, photos, maps, charts, and diagrams. (In a 1821 map, distance is reckoned by furlongs, a measurement that only exists today in horseracing.) It's deftly written, a thrilling narrative of adventure, enterprise, politics, Yankee ingenuity, determination, luck, surprises, and some lucky geology. Who knew that Dedham's volcanic ash when mixed with clay was good fill for the Back Bay? Or that suburban gravel lay just about anywhere for the taking? Or that fish weirs constructed in the tidal Back Bay more than 4,000 years ago, and in use for some 1,200 years, would, by their design, prefigure a solution to constructing buildings on marshland. Or that locomotives at the time of the landfill did not always have brakes.

The heavy lifting was done by machinery, draft horses not up to the entire task, and by the start of work in 1858, a great variety of equipment was in common use and available, like the steam engines which clawed fill into side-dumping gravel cars, which locomotives pulled to each site. In a nice book-design touch, a steam shovel heads each chapter.

Boston's Back Bay is as much a sociology text as it is a celebration of engineering. An authorial mantra becomes almost a tic, repeated in many a chapter that the landfill—in the guise of relieving crowded living conditions and dealing with pollution—really only benefited a single class, the "last hurrah" of the Puritan elite, that the purpose of filling the Back Bay was to provide nice houses for capitalists within walking distance of work so they would not flee to the suburbs. The very style of houses would exclude, except as day laborers, the growing population of Irish Catholics. Much of that can be inferred from Whitehill—and Bunting is frank.

Although Newman and Holton make it seem so, exclusion was certainly not exclusive to Boston. Every city has its snob neighborhoods, and they are not limited to the wealthy. They can be as small as a parish, as large as an ethnic migration, or self-selected, "like liking like": the towns of Hull and Squantum, south of Boston, were "the Irish Riviera."[20] As Newman and Holton rightly point out, Protestant America had its own political party.[21] On the surface, it looked benign, good government rooting out bad. But no "sunshine laws" applied. "Organized through secret lodges of Protestant men in cities and towns," the American Party "attacked the ineffectiveness of existing parties and the corruption of politicians, and it claimed to champion the interests of common citizens—meaning native-born Americans, excluding American Indians." Fuel, of course, for the Democratic Party—and the Know-Nothings quickly faded. But the seed had been sewn.

"The American Party's power in Massachusetts coincided exactly with the planning of the Back Bay landfill project: the final plan of the State Commission was approved in 1856. The anti-immigration ideology of this political party seems to have influenced the strong efforts of the commission on the Back Bay and the state legislature to attract wealthy Protestant families to the new Back Bay neighborhood," Newman and Holton write, and they include a map showing the fifteen cultural or religious institutions for which land was reserved in 1895. A whole block was given to the Massachusetts Institute of Technology and the Museum of Science (long since moved). "Placing prominent institutions in the new neighborhood was an important way to attract wealthy families to the Back Bay and give the area a positive image." By 1900, the churches were not only all Protestant but the fashionable sects, and the only Catholic church was tucked well off the Back Bay street grid, among the stables and outbuildings.

To 21st-century eyes, the heavy equipment used to fill the Back Bay looks quaint, almost toy-like. One can imagine hobbyists and model-train enthusiasts consulting the articulated detail in the old photos to make scale models. By 1856, the locomotive was a fixture in American transportation, engines varying according to task. The "bicycle" with big and little wheels like the penny-farthing looks perky, like the Little Engine That Could. Locomotives made in England would interbreed with American stock, and these iron horses got the job done pulling fill from the suburbs to Boston. By great good fortune, the steam shovel—a Yankee invention in the 1830s—was now in common use for excavation. Once the Needham hills were identified as the best available gravel, a long track was laid on which the steam shovel ran. The shovel claw would carve a long horizontal trench into the hill to undermine the stability of the gravel. Up above, workmen with poles poked and poked till the gravel cascaded in a landslide. The shovel then filled the line of waiting gravel cars and engine, and off the fill chuffed 14 miles to the Back Bay.[22] Every day, at the height of the landfill, 14 locomotives drew 225 gravel cars on 25 miles of track.[23]

The Back Bay landfill was under the direction of two remarkable men, George Goss and Norman Carmine Munson. Both were railroad contractors when that was a growing industry, as new lines were built and old lines straightened, and engines and equipment evolved. Both were Yankees born in small towns on the opposite sides of northern New England, Goss in 1826 in Danville, Maine, a village south of Auburn, at the modern junction of the Maine Central and Canadian National railroads, and Munson in 1820 on a farm in Hinesburg, Vemont, just south of Burlington. They do not seem to have had formal technical training except in the small town way of learning on the job. It was itinerant work, taking them on ventures along the Hudson River in New York down to Philadelphia and as far south as Baltimore[24]. How they met is unknown, but perhaps laying track on rail lines in Worcester County. Goss was the conservative one, the brake on Munson's propulsion. Goss broke down on the Back Bay job and disappeared in March 1860. Munson lived to fight another day, always the deal maker, the man who could find a bank to loan him money or mortgage his equipment, and speculators to buy his house lots in the Back Bay, for as part of the deal with public and private investors he was paid "in kind," in side deals. He worked steadily from 1859 to 1873, and, at times, prospered greatly, worth some three million dollars. Like so many others in this story, the Panic of 1873 (and land speculation that went wrong) did him in. He went bankrupt by 1879, yet he soldiered on, reorganizing the Massachusetts Central Railroad. Yet another bank failure took that away. He died of heart failure in his office on 16 May 1885, the Back Bay landfill almost complete.[25]

There was still the smelly, tidal Charles River to make sweet and safe. It remained tidal to Watertown till dammed in 1910 to make the Charles River Basin. With raw sewage clotting the water, swimming was banned and tetanus shots advised for rowers and sailors, the choppy water often capsizing small boats. Efforts to clean the water of pollution began to work. On 7 August 1996, Governor William Weld dove in the Charles to prove progress had been made. Swimming is now allowed—if not encouraged. There had been rowing and sculling on the river since at least 1851, when the Union Boat Club was founded. Some hundred years later, in 1965, the Head of the Charles was founded. Held annually in October, it is the world's largest two-day rowing regatta. Crowds line the river from Cambridge to Boston. One choice vantage for a day's outing is the Esplanade, with its paths, lagoons and ornamental bridges, picnic areas, and tot lots.

Known first as the Boston Embankment, the Esplanade was—and still is—the Back Bay's other park. Constructed between 1907 and 1910, it runs along the river from Berkeley Street west to Charlesgate. A Boston Brahmin named Charles Jackson Storrow (1864-1926) had worked to dam the river. With the Charles now a basin, of stilly if smelly waters, a great walkway was constructed along the north side of Beacon Street. Those fine houses—Silas Lapham aspired to the "water side of Beacon"—now had a park as fine as the leafy Commonwealth Avenue Mall. It was a huge success: people of all stripes strolled in good weather or walked briskly to work downtown, enjoying the moist air of water-girt Boston. That pleased Storrow. Unlike his social peers in Boston, he was not a nativist, or anti-Catholic. So popular a promenade the Esplanade became that, in 1928, the legislature named a commission to consider augmenting it with parkland, playgrounds, even beaches and swimming in wood-rimmed tanks. Storrow's widow, Helen Storrow, gave a million dollars to promote rowing in the greater Boston schools, in his memory.[26] The Esplanade itself was widened (more landfill) using muck from the river. And that spelled its doom.

The villain in the piece was, of course, the horseless carriage. Storrow had been the third president of General Motors. By 1944, even with a war on, the automobile was now a way of life. To ease Boston's traffic, the Esplanade was sliced into a bypass around the city. It bears the name the James J. Storrow Memorial Drive.[27]

5
Hotel Agassiz

"'Hotel Higginson,' let me return the compliment."
Alexander Agassiz to Henry Lee Higginson in 1877

Sometime early in 1874 the Hotel Agassiz was ready for occupancy. So excellent a place of habitation it was that, on the final building inspection, dated 29 December 1873, a city official rated it A and added an exclamation mark. As we have seen, things would and did go wrong with the plumbing and heating in its first years.

Then there was the matter of unpaid bills, one involving the architect. The correspondence makes painful reading. We know, as the architects did not, that Henry Lee Higginson was, as a businessman, all for the big idea but not very good on following through on details, and the Agassiz of which he was an owner was no exception.

The chief architect, Frank W. Weston, could stand it no longer. On 18 January 1876, well after the Agassiz was fully tenanted, he wrote a testy four-page letter to Higginson to complain he was still owed money for overseeing construction going back to 1873. "I feel it is totally impossible for us to settle this matter by correspondence ... Will you therefore oblige me by appointing a time for an interview here," which he underlined three times. "For that purpose I will keep myself disengaged any afternoon ... you may appoint."

The firm based their fees on the estimated building cost of $165,000 plus new work not in the original plans. By custom, these fees were two-fifths percent on unfinished work they had designed and five percent on work they had not designed. There were fees, too, for superintending work on the building. An itemized bill no longer exists, but, say, a total of $6,600 for the project.

| Inspector's Report | No. 5. |

DEPARTMENT
FOR THE
SURVEY AND INSPECTION OF BUILDINGS.

Boston, *Dec 29* 18*73*.

To the
INSPECTOR OF BUILDINGS.

Sir: I herewith submit my final report on the *Brick & Stone* building erected under permit No. *244* of the year 187*3*.
No. of buildings, *1* No. in block, *X* No. separate, *1*
Location, *Commonwealth av Cor Exeter St* Ward *6*
Owner's name *Agassiz & Others*
Architect's " *Shifton & Rand*
Builder's " *Weston & Sheppard*
Purpose, *Family Hotel*
No. of families in each, *4* ; No. of stores, *1*
Size of lot, No. of feet front, *84* ; No. of feet rear, *84* ; No. of feet deep, *124½* ;
Size of building, No. feet front, *70* ; No. of feet rear *74* ; No. of feet deep, *104½* ;
No. of stories in height, *5* ; No. of feet in height from sidewalk to highest point, *82* ;
Size of ell, ✓ feet long; ✓ feet wide; ✓ feet high.
Style of roof, *M.F.R.* Material of roofing *Slate & Cop* Means of access to roof *Scuttle*
Foundation laid on *Piles* Thickness of foundation, *18-28*
Material of foundation, *Block Stone* Laid with *Cement Mortar*
Cellar concreted or paved, *Concreted* How drained, *Sewer*

BRICK BUILDINGS.

Thickness of external walls, 1st story, *20-18* ; 2d, *12* ; 3d, *12* ; 4th, *12* ; 5th, *12*
 " partitions 1st story, *12* ; 2d, *8* ; 3d, *8* ; 4th, *8* ; 5th, *8*
Walls tied to floors, *Yes* Walls carried through roof, *Yes*
Material of front, *Brick with Freestone trimmings*
Material of Cornice, Lanterns and Scuttles, *Wood covered with Metal*
Size of headers and trimmers, *4-12 6-12* Bolted, tenoned or raised,
Girders, iron or wood, *Iron* Size, *4-10*
Girders, how supported, *By wall*
Size of floor timbers, *2-12 3-12*
Distance from centres, *12-14*

WOODEN BUILDINGS.

No. of Brick Walls in wooden buildings, and thickness,
Walls carried through roof,
Size of Posts, and Girts, Properly framed,

GENERAL.

Chimneys plastered, *Yes* How heated, *Steam*
No. of hoistways, *two* How protected, *Doors*
Fire-escape, *no* Unsafe in case of fire *no*
Conform to law, *Yes* Ever complained of, *No* Violation removed,
Nature of Complaint, ✓
Cost of each building without the land, *$200,000* General condition, *good A1*

SPECIAL.
(Wooden buildings within limits.)

Height from wharf or ground to peak or highest point,
Material of roof covering, Material of external covering,
Conform to the conditions of the permit,

W. Lemmon
Assistant Inspector.

N. B. — Assistant Inspectors will fill out, on the other side of the blank, any details which may be useful for future reference, and which are not called for in the above report.

Lest Higginson forget, Weston set forth the history: "The preliminary plans & Designs—a Memo for Specification, Details etc as were then needed—for a private Hotel, at cor[ner] of Exeter and Commonwealth Avenue, were prepared by Weston & Rand, Archts, under a private arrangement with Mr. F. H. Jackson—and at an accepted rate of remuneration." Was architect Francis Henry Jackson (1842-1873) the Higginson mole? "The services of W&R were mainly performed in their office—but Mr. R did during the duration of above arrangement assist very frequently in superintending the progress of the work. With the contracts—and with amounts of and arrangements for payments to contractors W&R had nothing whatsoever to do."

Jackson had died unexpectedly on 5 July 1873, and his work "both in superintending and in office devolved upon W&R" went without remuneration. Alexander Agassiz, partner with the Higginsons, Henry, and his widowed father George, in the Agassiz, visited the firm and tried to settle matters. Weston was not satisfied. His letter bristles with elegant fractions, such as the two-fifths of five percent owed. Also the "full five percent on the 'Extras." And "those extras we even then, feared would be large ... Our Diary is very clear on the point.—We entered with enthusiasm upon our duties."

Miscalculations abounded. There was, as might be expected, a bank account into which fees went. When Jackson withdrew the almost $6,100 he was owed, Weston & Rand found themselves in the hole: "instead of our Clients owing us some Two or Three Hundred dollars [we] were nearly Five Hundred dollars overdrawn."

Higginson seems to have ignored his pleas, and, to add injury to insult, had gone off to Europe.

"I honestly believe my claim agst. you to be legally as well as morally valid," Weston wrote on 19 February 1876. "I am—at present—too poor—and you are too rich—for me to fight you."

By 26 February 1876, the firm had dissolved, when Weston wrote again to Henry Higginson: "Mr. George Higginson owes us $35 as per A/c rend[ered]—If you insist on holding that amount to my credit, I am not in any position to resist.—If not, a cheque"—Weston was English—"would be very acceptable."

Again, nothing. Still no satisfaction. On 11 March 1876, Weston wrote a two-sentence note: "I would not be justice to myself to let our matter rest. I have therefore made up my mind to obtain & be guided by legal advice." On 11 March 1876, he asks his architectural drawings be returned. On 22 December 1876, he writes he has received some but not all, and, moreover has been sent two that do not belong to him.

The original architectural drawings by Weston & Rand have been lost. Something of the internal layout—bearing walls and flues—can be inferred from later plans, such as a 1916 renovation of the third floor, and, after 1972, the floor plans given to each new owner. For, among its other claims to history, the Hotel Agassiz would, a century later, become that new way of American living: the condominium.

* * * * * *

That exclamation mark saluted the original Agassiz for the last word in creature comforts and the sober style expected in Boston. Alexander Agassiz would jokingly call it "Château 191," for its street number, and other wags dubbed it "Château Hig,"[1] for Henry, who, after all, had named it for his wife's family—and for Agassiz who had made Higginson his first fortune. The first real château-apartment building in America was the year-younger Dakota on New York's Central Park West with flambeaux to light the carriage entrance into the courtyard.

While it lacked the theatrics of New York, the Hotel Agassiz was not without its amenities. It was lit by gas. Fueled by coal, steam boilers heated the water, and the staff included two "firemen" to see to that. Each apartment had speaking tubes for communication, and bell hangings to summon servants. From the innermost lobby the grand staircase reached up to skylights, and because it was made of cast iron, it was its own fire escape, and no fire stairs would ever disfigure the exterior. There were two elevators, and a "boy" to run them. The passenger carried residents up six floors, albeit slowly, and the freight took deliveries up from the basement. No one needed to climb stairs. This was a boon to old people—and to servants thus spared staircases to clean. The Agassiz's windows were tall and varied. As the building faced south onto Commonwealth Avenue, the big front rooms were sunny, and bay windows along Exeter Street brought in light and air. Nature was near to hand, for the Agassiz looked out on a double allée of trees on the Commonwealth Avenue Mall. Its center path was busy with baby prams and children and dogs, some from the Agassiz. Mere blocks away in Copley Square, the life of the mind and spirit beckoned with museums, churches, a library, and two institutions of higher education.

All this cost a good deal of money to build and equip, and the bills for the Agassiz were large and many. Then, too, as the financial Panic of 1872 grew into a five-year recession, architects and the building trades were among the first to lose work, and Weston's fears for his livelihood were real.

What determined Henry Higginson to go ahead with the Agassiz can't be known, nor how he and his partners were fixed for money. Surely the steady return in dividends from the copper mines they owned was a cushion. The Higginsons were partners in an established investment bank; their credit was presumably good. There was also the incentive to be part of the Back Bay, a new neighborhood for the elite. The Higginsons were already that, assured by birth and standing in the financial world. If they built, people would come.

From construction bills and invoices it is evident that work on the Agassiz began some six months before the Higginsons and Agassiz signed the deed to the property and the mortgage that secured it. Not until 17 March 1873 did they formally buy, from the Commonwealth of Massachusetts, their building lot of 10,458 square feet at the northeast corner of Commonwealth at Exeter, paying $52,146.83.[2] The deed set the usual restrictions on the design for any Back Bay building. It must be at least three stories high, and, "in any event," must not be used "for a stable or mechanical, mercantile or manufacturing purposes." There were rules about basements and the common alleyway behind each building. The facades must conform to the look desired for the Back Bay. In the case of Commonwealth Avenue, every building must be set back twenty feet from the roadway. Facades must not bulge out unduly. Trapazoid windows were limited to seven-tenths of the whole front of the building, and projections, such as porticos, doorsteps, balustrades, roof cornices, bay windows and circular front octagon windows, or orioles, must not extend out more than five feet. To the state fell the responsibility of building thoroughfares, paving and curbing streets, fitting them with gutters and water sewers. Owners could, "for the time being," have the right to cultivate trees in their sidewalk, "leaving a distance not less than ten feet between the front lines of the Lots and such trees."

Also on 17 March 1873, the owners and their wives—Ida Agassiz Higginson and Anna Russell Agassiz—received a five-year mortgage, for $120,000, to help finance the building. The rate was seven percent half-yearly. The lender required the building be insured against fire for not less than $80,000. Held by the Massachusetts Hospital Life Insurance Company, the mortgage was discharged in February 1888.[3] Like the deed, the mortgage was handwritten, pages and pages of clerical rickrack script. The lender would become Boston sui generis to a fault, and Russell B. Adams, Jr. in *The Boston Money Tree* has four enthralling pages on how a means of raising money for Massachusetts General Hospital became "a Species of Savings Bank for the rich and middle class of Society" and would lead to the deadening hand of the "spendthrift trust."[4]

Also handwritten were the bills for construction, preserved with Higginson's letters at the Harvard Business School's Baker Library. The penmanship on this paperwork was as individual as the writer and his education, some given to showy capital letters, others merely purposeful, but taken as a whole, they give the whole enterprise of building the Agassiz the intimacy of craft and the hand-made, and his own writing makes Weston's anguish palpable as his dips his pen and sharpens his resolve.

How the Higginsons and Agassiz decided on Weston & Rand as the architects is not known. Their choice would raise eyebrows on several counts. For what made the firm unusual, even scandalous in the profession, was that it built the buildings it designed, for Frank Weston was also Weston & Sheppard, a construction company. The Boston Society of Architects considered mixing design and construction "unethical" and would snub, for membership, men like Fred Pope who designed, built and owned great stretches of row houses on Marlborough Street. Weston & Rand, moreover, had never designed or built in the Back Bay, and Rand's largest building, the Worcester Insane Asylum (1870), later called Worcester State Hospital, was hardly residential.

On 29 June 1872, Weston, wearing his Sheppard hard hat, submitted an estimate of $75,700 to build the Agassiz; the breakdown of those figures have been lost. On 1 July 1872, Morton & Chesley submitted to Francis Jackson, their un-itemized estimate for Carpenter work, including [wall] paper dado, painting, stairs, bells, skylights, and gas pipes for $59,900.03. On 17 July 1872, they sent an amended estimate of $48,628, and they seem to have won the building subcontract. Did they pad the latter to reflect the former? As late as 25 January 1875, their bills were being challenged, and Weston wrote Higginson offering to bring Morton to Higginson's office to "ascertain how much of his A/c he can prove."

Something of the chronology of construction, along with construction material, comes from dates on the bills and invoices.

Although the building permit was not formally issued till December 1872, stockpiling bricks and stone began in late autumn. On 12 November 1872, Morton & Chesley submitted their bill for $10,810 for 418,000 of common brick and 5,000 of face [brick], 300 feet of running granite, 750 superfacial feet of freestone. On 23 November 1872 they billed $4,000 for unspecified material and labor. On 5 December 1872, they billed $4,190 for even more bricks: 87,500 common, 3,500 face, 1,150 superfacial freestone. On 31 December 1872, they billed $6,294 for the wooden innards of the Agassiz: 200 sqro [running feet] of floors laid at

Application for Permit to Build.

[BRICK AND STONE.]

Boston, August 7— 1872

To the
 INSPECTOR OF BUILDINGS.

The undersigned hereby applies for a permit to build according to the following specification:—

1. State how many buildings to be erected, _One_
2. Material, _Brick and Stone_
3. What is the Owner's name? _Alexander Agassiz and others_
4. " " Architect's " _Weston & Rand_
5. " " Builder's " _Weston & Sheppard_
6. " " location? _Commonwealth avenue — corner of Exeter St._
7. " " nearest street?
8. " " purpose of building? ~~Dwelling House~~ _Family Hotel_
9. If a dwelling, for how many families? _Six_
10. Is there a store in lower story? _No_
11. Will the building be erected on made or filled land? _Yes_
12. Size of lot, No. of feet front, _84_; No. of feet rear, _84_; No. of feet deep, _124½_
13. Size of building, No. of feet front, _70_; No. of feet rear, _74_; No. of feet deep, _104½_
 No. of stories in height _5_; No. of feet in height from sidewalk to highest point, _82_
14. No. of feet in height from top of foundation to highest part of wall, _89_
15. Will foundation be laid on earth, rock, timber, or piles? _Piles_
16. Whether external or party walls, _Both_ If party walls, give thickness, _16 in. to 2d flr 12 in above_
17. What will be the materials of front? _Brick & Stone_ If of stone, what kind? _Freestone dressings_
18. Will the roof be flat, pitch, or mansard? _All_
19. What will be the material of roofing? _Slate and Gravel composition_
20. Are there any hoistways? _Yes, two, propelled by Hydraulic motors_
21. How is the building heated? _By Cloggston's steam apparatus & the usual fireplaces_
22. Will a fire escape be provided? _The main staircase is to be of iron, enclosed by brick walls, with iron faced doors at each landing_

If the Building is to be occupied for a Tenement or Lodging House, or Family Hotel, give the following particulars:—

23. State how many families are to occupy each floor, _One_ and the whole number in the house, _Six_
24. What is the height of cellar? _9 ft. and 11 ft. in unfinished portions_
25. What will be the heights of ceiling on 1st story? _11_ feet; 2d story, _11_ feet; 3d story, _10½_ feet; 4th story, _10½_ feet; 5th story, _11_ feet.
26. Is the cellar to be occupied for a dwelling? _No — except two rooms for Janitor_
27. Is the front street 20 feet wide? _Yes_
28. Are there privies or water-closets? _Waterclosets_ How many? _21_
 Where located? _Three on each floor_
29. How is the building to be ventilated? _Flues in walls, roof ventilators and otherwise_
30. If there is a building already erected on the front or rear of the lot, give the size, _—_ and number of stories,
31. State how many fire escapes are to be provided, _An iron staircase as above_ and what kind,

[Sign here.] _Weston & Rand_

$15 or $3,000; 200 sqro wall and ceiling framing at $3, or $600; 70 sqro of partition at $6, or $420, 169 window frames at $6 or $1,014, 40,000 timber at $24 for $960, and 15,000 floorboards and framing at $20 for $300.

All quiet in January.

On 13 February 1873, Weston & Sheppard billed $6,670 for 222,500 common bricks at 20 cents for $4,450, 35,000 face bricks at 40 cents for $1,420, and freestone for $800. The firm had been paid $24,000 on 5 December 1872, and another $6,670 on 13 February 1873, or $30,670 to date. Was there then a delay because of weather? The winter of 1872 was the snowiest on record—till Boston was buried for days by some 102 inches in March 2015. Work must have resumed by 5 March 1873, when Morton & Chesley billed $10,437 for labor and materials furnishings "including the previous estimate."

Just when the foundation was laid is not known. The pertinent bill, either misdated or post-dated 20 June 1873, was for $51,115, with a notation that the builder has already received a total of $38,000. One item leaps out, $2,625 for "piles," the number alas not given. It's the need for wooden pilings that made Back Bay construction unique to Boston. Like all else built on filled land, the Agassiz rested on piles sunk into the ground water below. All was secure as long as the wood stayed wet, the water excluding the oxygen, which would rot it; to this day, the Back Bay fears drought will lower the water table. Maine contributed the pilings, whole forests felled, the spars of spruce trees supporting the new Boston; one estimate for eighteen blocks in the Back Bay ranged from 175,000 to 204,000 tree trunks.[5]

How many trees shored up the Agassiz? Perhaps nearly a thousand. The apartment building was the width of three row houses, and deeper than most. A useful comparison is the piling plan for the pair of row houses built in 1852 at 90 and 91 Beacon Street. That site required 540. Pilings averaged about 30 feet in length. They were driven in long double lines under the outside foundation walls and in single lines under internal bearing walls. Those for the Beacon Street houses were topped with a granite capping stone upon which the brick foundation walls were constructed.[6]

The same method of construction for the Agassiz can be confirmed by the rest of the bill. The granite already on site, the foundation needed more rough stone for $5,850, Hammond stone for $2,000, free stone for $12,000, iron work for $2,000, brick work ranges for $21,250, plastering for $3,740, and drains and concrete for $1,550.

On 23 March 1873, Weston & Sheppard began billing for the Agassiz exterior, 158,500 common bricks for $3,170, doubtless for the rear of the

building, and 19,000 face bricks for $780 for a total of $38,470. Then on 6 May 1873, they asked $14,540 for material and labor for the carpenter's contract.

Word of the Agassiz project spread by early summer 1872, and other contractors began submitting estimates. They make wonderful reading for the detail of 19th-century living. Thus, on 29 June 1872, J. W. Greenleaf asked $70,592 for all carpenter work, plumbing, painting, gas-fitting, bell-hanging and speaking tubes, iron skylights and building back stairs. On 1 July 1872, Gaines & Murray bid $70,000 for the same work, and on 2 July 1872, Jonas Fitch & Co., $74,873, ditto. As we have seen, Morton & Chesley had beat them out with what may have been an unrealistically low estimate. On 12 July 1872, James W. Bell asked $5,500 but only for furnishing and installing glass.

More work was subcontracted. On 3 January 1873, Boston Corrugated Iron Co., of 8 Pemberton Square, sent its estimate of $1,842 for unspecified galvanized iron work. Another unnamed company, on 9 January 1873, proposed doing the two skylights at the "new Apartment House Bdg" for $2,032 and broke down the various elements from "self-locking apparatus" to panes of glass with their sizes indicated. By 28 June 1873, all was well enough along for Morton & Chesley to submit its bill of $22,159 for "finished work and labor." Among the costs, floors for $8,085, framing for $4,680, roof for $2,200, skylights for $60, windows framed for $1,014, gas piping for $1,000, and stair carriages, the inclined wooden beam that supports the treads, for $350.

The conduit for pay was George F. Fuller. Describing himself on invoices as "superintendent," he made out the bills for the subcontractors and sent them to Weston & Rand's Francis Jackson for approval and payment. Thus on 31 May 1873, I. S. Clogston & Company was paid $2,000 for the steam "heating apparatus" and a further $1,500 on 27 June 1873. Thus on 21 May 1873, $300 was paid to Boston Galvanized Iron for labor and material. On 31 May and 16 June 1873, $700 more was paid to Boston Corrugated Iron. On 29 May, $1,000 was paid to Hayes Brothers on account of the skylights.

And so like most buildings, the Agassiz went up, brick by brick, bill by bill; and the cost would more than double Weston & Rand's first estimate of $165,000. Just the figures given above come to $324,944.

Who were Weston & Rand? Their office was at 17 Pemberton Square, a now-lost elegant enclave of architect-designed brick bow-front buildings. Alexander Agassiz would visit the office more than once to look at plans and assure about payment. If other architects considered the firm unethical for building as well as designing, that Weston & Rand also functioned as contractor may have appealed to the practical side of the Higginsons, for,

in the largely vacant Back Bay of the 1870s, there was little construction history as guide. "Unethical" may have meant double dipping, the firm benefitting financially from functions usually divided. Perhaps there was simple snobbism as well. Weston and Rand did not have the pedigree of gentlemen architects. Few architectural schools existed; the well heeled, like Charles Follen McKim (1847-1909), made for Paris and the École des Beaux-Arts. Others, such as William Rutherford Mead (1846-1928) and Stanford White (1953-1906), learned by working in an established practitioner's office.

That was the case of Frank W. Weston, born 13 July 1843 in Oxford Terrace, on England's River Tyne. Away from the office, he was also a prominent part of the Boston bicycle craze of the 1880s, chronicled in the chapter "Outdoors," and, after his death in 1900, the disposition of his ashes would concern cyclists. Upon his arrival in Boston, on 1 June 1866 he worked briefly for the Illinois-born architect William Ralph Emerson, then moved to Portland, Maine, which was in need of rebuilding after the Fourth of July fire of 1866. Back in Boston, Weston would work in the current styles, Queen Anne with clock tower for the town hall in Essex, on Boston's North Shore, and the New England Telephone & Telegraph Company's exchange building in Lynn. He was adept also in the Shingle style for houses, building one for himself and his wife on Savin Hill, in the Dorchester section of Boston. Weston & Rand could also build large. With Rand as the lead designer, their Worcester Insane Asylum of 1870 at Worcester looks more prison than refuge, nightmarish stretches of rough cast stone. Its clock tower, exceptionally threatening, is a reminder the pocket watch was for the few and the wrist watch yet to be invented.

Weston's partner, George Dutton Rand, was a country boy born in 1833 at Coventry, Vermont, and was a journalist in St. Johnsbury, editing *The Caldonian*, before settling on architecture, training in Senaca Rand's office in Hartford. Also adept in Queen Anne, Rand, when the partnership was dissolved, would go to Florida to design four buildings, including the gymnasium, at Rollins College, established in 1885 by New England Congregationalists to bring a liberal arts education to a state that had been the first to join the Confederacy. Rand would design Winchester's town hall, a brick pile that says government, as well as the town's own "Longwood" of Shingle houses. They line Rangeley Place, an early residential park dating from 1875, serene in their own little world of deep lawns and shade trees, and a tennis court or two. Tellingly, they are but a short walk from the railroad that would take the businessmen into Boston.[7]

How to organize and delegate space within the confines of an apartment building was the work of the architect. Weston & Rand had little to go on.

The very nomenclature of the Agassiz was misleading. It was not a hotel in the conventional American sense.[8]

Nor had the example of the *mâison particulaire*, the grand but intimate rooms of a city mansion, reached Boston. Henry Higginson and Alexander Agassiz had seen, if not visited, those houses in the European capitals of their youth. One example was the Louvre. Before it was a mammoth museum, it was a huge palace, and favorites at the Bourbon court might be granted apartments. One was the artist Jean-Honoré Fragonard whose suite of eight rooms on three floors included a wine cellar.[9] More modest in siting were the dozens of Paris residences, some hidden from public view. Often called *hôtels,* they were palatial city palaces bearing the name of the aristocratic (or rich) family who built it—or was given it by a grateful king. Nothing much to look at from the street, but the rich living behind high walls was proclaimed by the ornate gateway that was the carriage entrance to the courtyard. The superb Hôtel de Matignon was a block deep; the fourteen windows of its *grande salon* looked out on its own garden. Opposite that, at 58 rue de Varenne, lived the novelist Edith Wharton, and very nicely too, even if she had only a small part of the Hôtel d'Auroy. She and her Boston husband Edward (Teddy) Wharton rented the apartment from the George Vanderbilts of New York, a prime example of Americans clinging together when abroad.[10] Private though these residences were, the owners often rented space on the ground floor to tradesmen. Such an arrangement allowed Marcel Proust to make his fictional Hôtel de Guermantes further the plot in *Remembrances of Things Past.* He houses the Narrator in an apartment there and has the young man feed his crush on the Duchess by watching for her to sweep in by carriage, or, better still, to spy on her slipping out alone through a little door for her morning walk. He will discover that a different sort of traffic visits the courtyard *atelier* of the tailor Jupien.

The Hotel Agassiz was yet different. Each family had a whole floor. People like the Higginsons wanted large reception rooms for entertaining as well as private spaces for family and servants. But while the layout was indeed spacious, the plan would be identical floor to floor. That made it an apartment house rather than a *hôtel particulaire*, which had a different ensemble of rooms for each floor.

It seems Weston & Rand's solution was to adapt the typical parlor floor of a large row house as the template, and expand and stack it. So if row house living was cramped and vertical, with space lost to the internal staircase, the Agassiz—thanks to the elevator—was ample and horizontal. As the actress Mrs. Pat Campbell said of another living arrangement, "Ah, the deep comfort of the double bed after the hurly-burly of the chaise-longue."

There was another benefit of using the parlor floor as template. In row houses, this floor had the highest ceilings, between twelve and fourteen feet, with the tallest windows. Not so the bedroom and attic floors with their lower ceilings and shorter windows. Apartment house living meant high ceilings throughout. This had enormous benefit later when the Agassiz's six apartments were broken into as many as fifteen. With high ceilings uniform, former bedrooms were large and grand enough to work as living rooms. And so the Agassiz sailed nicely into the Condo Age.

Placement of staircases have always determined much about interiors. In the conventional row house, there is little chance for economy of space. The stair hall, narrow though the switchback was, might take up a third of usable space even placed along the blind parti-wall. How this affected room layout can be seen at the 1859 Gibson House Museum at 137 Beacon Street. The light well was pressed into service, strung with clothesline to dry laundry in wet or winter weather. Now, of course, the Agassiz had, and has, a massive staircase. It is wide to begin with and its three turns enclose a square column of space, a great shaft of light, an announcement the Agassiz had its palatial side. The architects could do this because of the width of the building lot. The footprint, moreover, included an ell, the broader part cornering west at Exeter Street and north on the public alley. With that breadth and length, the space lost to the grand effect did not much matter. As in a row house, the architects placed the staircase—the tiny elevator abuts it—along the parti-wall, in this case, east, and laid out a sequence of rooms around this core. Looked at this plan another way, the Agassiz is half of a grand country house with its central Great Hall and rooms wrapped around that.

The staircase settled, the question was how to organize the human traffic, polite and servant. There were two models in Europe. In Vienna apartments, rooms were *en suite,* doorways connecting each, and the traffic passed room to room. Along this enfilade ran a hidden service corridor for servants. When England's brilliant Oliver Messel designed the sets for the Metropolitan Opera's 1959 production of Mozart's *Le nozze di Figaro,* the curtain went up on just such a service-corridor room. While Figaro measures space for their nuptial bed, Suzanna teases about its proximity to their masters, he the valet, she the maid, to the Count and Countess. Mozart works the call-bells into the music. Figaro sings: "If by chance, my lady should call you in the night '*ding-ding,*' in two steps you can be there ... '*dong, dong,*' in three bounds I can go serve him."

In the "French flats" of Paris, while some rooms might be *en suite,* a formal hall replaced the hidden corridor, and that was the model for the Agassiz. Guests (or the family) would arrive by grand staircase or elevator and present themselves at a grand pair of double doors. These opened on the hall, and one

walked across it to the reception rooms. To the left, the dining room. Directly ahead, the double parlor. To the right, on the corner of Exeter, perhaps a library or smoking room. The hall continued along Exeter to the bedrooms. Except for the wooden back stairs there was no service corridor.

With the Agassiz on the "sunny side" of Commonwealth, Weston & Rand could stack the six kitchens on the north, or public alley side of the building. Alleys had their own traffic: tradesmen trundled wares to the household, the ice wagons and fish carts dripping water, horses dropping "road apples," dogs enjoying the traffic, servants chatting or hanging out laundry. Two tall but sunless windows kept the kitchens light and cool (the author lived in a condo converted from such, 1977-1996). Access to tradesmen was via the back stairs or the freight elevator.

The centerpiece of the kitchen was the cast iron range, with ovens and a water heater. At the Agassiz these were set into the east parti-wall, the flue internal. Refrigeration took two forms. There was an ice chest for perishables, the iceman in his rubber apron hauling up blocks on the elevator. Set into the north wall was a cold closet for non-perishables. This was contrived from shelves built between the studs and the exterior sheeted in galvanized metal, the better to attract cold and shield from warmth; and the black-painted backs of these cold closets can still be seen from the alley (the author discovered one such in her old condo).

At the Agassiz, the link between kitchen and dining room was the windowless space, along the east parti-wall, of the butler's pantry with its shelves and cupboards, the transition between cooking food and serving it. Pantries in the Victorian Age merit a book of their own. This was a time of inventive kitchen gadgets, made by tinsmiths, such as the rotary eggbeater patented in 1856, and, when Fannie Farmer's scientific way of cooking prevailed in the 1880s, the measuring cup with its ounces marked on the side. The Victorian table was a world's fair for the variety of cutlery alone. Never were there so many specialty pieces: forks for every sort of pickle, fish knives with pearly handles, and a spoon for each soup, from broth to cream to chowder.

At the Agassiz, the dining room was stacked over the front door. While the commotion of foot traffic through the front door might be noisy, it would by custom and good manners cease at meal times.

Next to the dining room came the reception rooms, sunny by day and stretching west along Commonwealth Avenue to the corner of Exeter Street. The drawing room was a double parlor, which could be divided and made intimate by drawing together the pocket doors concealed in the walls. Each parlor had a fireplace, the flues internal. It may be that the further, more westerly, parlor with its side windows on Exeter doubled as a library. Then along Exeter, the bedrooms: the master (with, perhaps, a boudoir) and

the children's (one perhaps a playroom/schoolroom), most with internal fireplaces. These continue down to Exeter and along the alley (the author now living in these). Servants' rooms filled in the space along the alley to the kitchen. As described in the chapter on Higginson as landlord, the WCs were clustered behind airshafts and staircases. True, these cubicles were not the tiled throne rooms of today, bathrooms that aspire to water parks. But the facilities were for hygiene, not recreation.

How Higginson and others furnished their apartments will be told in the chapter called "Taste."

Modern technology did not arrive at the Agassiz till the last decade of the old century. In December 1898, Higginson complained about poor telephone service to the New England Telephone & Telegraph Company, in which he and Lee, Higginson & Company were early investors. The general manager, in two type-written pages, explained the delay, caused, in part, by Thanksgiving, and a storm, and by Mrs. Higginson objecting to wiring coming in at a window.

As for replacing the gas lighting, it was Albert L. Coolidge, an Agassiz tenant with his wife from 1883-1891, who, most gently, made the suggestion. On 24 July 1890, he wrote Higginson: "I asked my young man to call at your offices yesterday and ascertain whether you intended to wire your [row] house for Electric Lights, if so I would like to arrange to have my apartments wired and thought it would be a good opportunity to do so. It seems to me it would be very desirable in many respects to have Electric Lights in the house but I do not know how you might feel about it." Coolidge was a partner in Houghton, Coolidge & Company, a shoe manufacturer. On 30 July 1890: "You will excuse me for suggesting that if you desire to wire your house for Electric Lighting that it would be well to get competed [competing] estimates on the expense of wiring it as the variation will be great in the same quality of work. I take the liberty of making this suggestion as I have had quite an experience the past two years in putting in large plants. I think you will not regret it if you decide to wire the building as the risk of accident, fire or insurance will not be increased and the great comfort and improved atmosphere will be a great blessing."

* * * * * *

Despite its rocky beginning, the Agassiz was a success from the start. By 1877, the place was fully tenanted, and full of children. The Fairchilds, parents already of two daughters and two sons, would have three more boys, and at least three dogs. The Bartletts had a baby girl and the Higginsons a baby boy. It was such a desirable residence that many of the first occupants grew old with it: some children succeeded their parents as

tenants and one spinster lived there for 62 years. In that respect it was the family home.

The location helped. Much of familiar Boston had burned in 1872. Here was a new neighborhood promising and delivering benefits not available in other parts of the city, and within walking distance. The Back Bay, moreover, was, and still is, flat, unlike Beacon Hill with its steep and challenging sidewalks. With the north side open to the high skies above the Charles River, it was light struck and airy. To be sure, its architecture was different, "Victorian" excesses rather than the prim "Georgian" of early Boston, yet familiar in landscape, and so it was a Beacon Hill on the flat, a continuation of streets such as Brimmer, Charles, and Pinckney. Men could walk to work downtown. Henry Higginson was one, sometimes in the company of his Agassiz tenant, Charles Fairchild, a fellow partner in Lee, Higginson & Company, investment bankers. Families had the green lungs of the Public Garden and historic Boston Common as parks and playgrounds for their children. In a later chapter, we will see the Fairchild children watching for baby squirrels, running their dogs, playing Hare and Hounds. There would be churches on many a street corner. Higginson's son Alex would be married at Trinity in Copley Square with his father's Boston Symphony Orchestra playing the Wedding March.

In the early 1880s, the Back Bay was still pretty empty. But not silent: the thud of pile drivers, the sharp scrape of horse drays delivering building materials, the tattoo of hammers. The streets had been graded and house lots dug. These became a winter paradise for children who could skate on vacant lots and sled down excavated dirt. A vacant house lot was the refuge of one lad, whose family already looms large in this book. One morning in 1887, Alex Higginson argued to himself he was "a misunderstood boy, and that I had best leave home." He was eleven.

This runaway was well organized, well capitalized, and well mannered. "I took all the money I possessed—about a dollar and a quarter—and went to the nearest bakeshop, where I bought myself a loaf of bread. At another general store nearby I bought a knife and a pot of jam, and with these provisions I proceeded to a vacant lot on Commonwealth Avenue, about a hundred yards from my father's house," Alex recalled. The boy architect: "I built myself a hut of several boxes that I found lying about." Lunch followed, "after which I went to work to finish my quarters, in which I intended to reside, I suppose, for the rest of my life."

Well, of course, when he had not reached home by seven, his mother was "in a state of excitement," and his father went out in the darkening Back Bay to look for him. "A faithless cousin" named Peggy Perkins turned him in. There was not the parental "hiding" that Alex felt he richly deserved. Instead, the surprise of a new pony his father had intended to show him

that afternoon. "I dissolved in tears ... I don't think I was ever so ashamed of myself in all my life, and I did not run away again."[11]

By 1875, there were enough children in the Back Bay to warrant opening a public school. On Newbury Street at the corner of Exeter, the Prince offered grades one through eight; now a condominium, it was one of the first buildings in Boston converted for alternative use. One particular schoolboy with connections to Higginson was Arthur Fiedler (1894-1979). Son of Emmanuel Fiedler, a Vienna-born violinist in the Boston Symphony, he would join the violin section in 1915 under conductor Karl Muck (and, starting in 1930, conduct the Boston Pops for 50 years). Was the young Fiedler one of the boys who lounged around the statues on the Commonwealth Avenue Mall and were shunned, as common and tough, by the likes of young Higginson, who, like the Fairchilds, went to private schools? They all, however, shared playgrounds, playing ball on the Common, skating in the Public Garden. The lagoon there was the waterway for the flotilla of Swan Boats, launched in 1887 by Robert Paget, whose family still operates them. Fiedler liked to tell how as a boy, he and a classmate fell through the lagoon ice. Fearful of a hiding at home, the boys found a friendly tailor shop to dry their clothes.[12]

Despite bank panics and city fires, many Boston merchants had prospered, and the Back Bay was ready for a bit of show. Contemporaneous with the Agassiz were the mansions that bookended most city blocks. They were huge, some solemn, others giddy little châteaux, and adaptable in the twentieth century. An Ames mansion would become offices of the American Casket Company, another Ames house, the French consulate. The residence of a Massachusetts governor, John Albion Andrew, is owned by fraternity brothers attending the Massachusetts Institute of Technology. For a time, the Château, built for Albert Burrage, was assisted living.

Such a grand new neighborhood should merit a great public space. Paris had any number of *plâces,* Italy its *piazzi,* and London, squares and parks. Those cities were a great deal larger. Little Back Bay would have to do with the scrap of land we know as Copley Square. Named eventually for the great American-born painter John Singleton Copley, and now marked by his statue, it was called Art Square until 1883. It was hardly a square at all, but pairs of unequal triangles, because, until 1966, Huntington Avenue sliced it in two. Yet it was a marketable place for the sacred and the profane. Its buildings, moreover, were an encyclopedia of old world architecture. "New" Old South Church, Congregational, was the first

to arrive, in 1873, a gaudy eyeful in Venetian Gothic. Equally colorful, Trinity Church opened in 1877, the parish having fled downtown in the Fire of 1872. Romanesque Revival, brown and orange, with turreted towers, checkerboarding on the exterior, it was red and green and gold inside, and the whole picture occasioned the witticism that Boston's opera house was as plain as a Unitarian church, but its leading Episcopal church was operatic.

Copley's south side was museum row. The nature history museum would become, many years later, the Museum of Science, rising on the Charles River dam site. Copley Square can claim the world's first museum built purposely for art, this in 1876; it would move in 1911 out to Huntington Avenue, near the opera house, and a scant mile west of Symphony Hall, which opened in 1900. The museums were a natural context for the Boston Art Club to build in 1882 next to Old South Church.

On Copley's north side, the Hotel Cluny, banking on the Agassiz's success as an apartment house, welcomed its first tenants in 1876. The Houghtons would move from the Cluny to the Agassiz in 1886.

First on the new square, however, was the mammoth exhibition hall built for the World's Peace Jubilee and International Music Festival of 1872, marking the end of the Franco-Prussian War. The din of construction silenced the opening prayers by Trinity's Phillips Brooks, and the 100,000 seats were seldom filled. Among the performers were Fiske University's Jubilee Singers, marking the first time black singers had performed at so public an event.

Anchoring the west side in 1895 was the great French Renaissance façade of the new Boston Public Library; an Agassiz tenant would be a trustee and, later, president. It joined two other institutions, which, since 1887, had catered to the physical life. On Huntington Avenue, S. S. Pierce opened its fancy grocery store, providing Back Bay kitchens with foreign treats. On the Boylston Street side of the library, the Boston Athletic Association's clubhouse offered indoor swimming and track, gymnastics, and storage, for that new rage, the bicycle. The building is long gone, demolished for the 1972 Post Modern addition to the Boston Public Library, but the finish line for the Boston Marathon, founded in 1897 by the BAA, remains out front (along with the horror of the 2013 bombing of the race).

Copley Square was an informal campus for higher education. After several other locations, Harvard Medical School opened there in 1883. We have met its sometime dean, Dr. Oliver Wendell Holmes, who coined the word "anesthesia" and defined certain Bostonians as Brahmins. As Harvard College was to the humanities, the Massachusetts Institute of Technology was to engineering. Before rowing its charter in a gondola

across the Charles River to its new Cambridge campus in 1916, MIT held classes on Boylston Street.

※ ※ ※ ※ ※ ※

For the first ten years of their marriage, Henry and Ida Agassiz Higginson called themselves "tent-dwellers." There was the log cabin in Ohio when he looked for oil and the cotton plantation in Georgia, but nothing permanent. Back home in Boston, their first child Cécile was born in 1870 in the city's first apartment house, the brand new five-story Hotel Hamilton (now razed) on Clarendon Street where they would live till the Agassiz was finished.

But some three years later Higginson was floating a plan to add more room to his apartment, probably for servants. Rather like Figaro and Suzanna, Agassiz servants lived on the same floor as the family, rather than relegated to attic bedrooms, as in row houses. A co-owner of the building, his brother-in-law Alexander Agassiz urged caution. There was little real chance for expansion given the Agassiz's corner site and the restriction against building onto the public alley. Higginson suggested building a six-story ell up the back of the building, which would add rooms to all six apartments. Doable, Agassiz wrote in October 1877. Then his warning: would the addition overburden the heating system? "We don't want to add to our housekeeping cares."

The answer lay right next door. As happened on a date unknown, Henry's father George had bought the row house abutting the Agassiz's east side. The Higginsons now moved there. Finally they had a real house of their own. Yet they were still part of the Agassiz, for the Higginsons used that front door and that lobby as their own. Only by careful study from the street is this hybrid of row house mated to apartment building apparent. The two buildings combined totaled 13,570 square feet.[13] By removing the row house steps and front door, the Higginsons gained space usually given to vestibule and side parlor. Now, running from Commonwealth Avenue straight back to the alley, some 70 feet, Higginson could have a music room for recitals and chamber ensembles.

It's worth remembering that Henry Lee Higginson was a patron of music in the old aristocratic way of Europe. He was the Esterhazy of the New World. If Haydn were a Boston composer he would have curried favor at the Hotel Agassiz. In other American cities, music lovers would band together to organize the concerts that grew into a resident symphonic ensemble. In 1881 Higginson made his own orchestra. He hired the conductors. He paid the bills. In 1900 he built Symphony Hall. And he and Ida entertained many a great name in music when they came

to Boston to perform with his orchestra or at the opera. They would come for Sunday lunch on their days off.

"Sometimes they enchanted us by sitting down at the piano and playing—though it was an unwritten rule that they were never asked to do so," Alex recalled in his memoir.[14] The Higginsons spoke French and German, international languages of the music world. Guests included the Polish De Reszke brothers, tenor Jean and basso Edward; the French bass Pol Plaçon; the "Australian Nightingale" soprano Nellie Melba; the German soprano Lili Lehmann who had starred in the first "Ring" cycle (1876) at Bayreuth, and her husband, the Wagnerian tenor Paul Kalisch. Among the pianists was Ignacy Jan Paderewski, who became Poland's prime minister in 1919, the year Higginson died. A music room also meant concerts by the homegrown talent.

* * * * * *

Château Higginson, in idea if not style, soon had imitators. The layout of the even grander Hotel Cluny, now demolished but built in 1876 in Copley Square, gives an idea of the amplitude possible in a very deep lot: each suite had two real bathrooms (with tub, basin, and toilet) tucked behind the sweeping central staircase, and 15 clothes closets. There was a smoking room off the library.[15] Apartment houses would appear in every block of Back Bay streets. In 1890, Agassiz tenants watched the Abbotsford rise across Commonwealth.

Among the Boston architects giving serious thought to apartment house design was Ralph Adams Cram (1863-1942). Born in New Hampshire, he apprenticed in the Boston firm of Rotch & Tilden, architects of many a Back Bay row house, then went to Rome to study classical architecture. There, a Christmas Eve mass in 1887 confirmed his religious leanings toward Anglo-Catholicism. While remembered for his Gothic Revival buildings, he also ventured into Art Deco. But it was to Tudor England that Cram looked to for Richmond Court, the 1898 apartment house he designed at 1213 Beacon Street, Brookline, just west of Temple Ohabei Shalom. If the Agassiz was buttoned into its corner lot, Cram could spread his building on perhaps eight house lots. His model was the 16th-century English manor, with the long sides swelled by square, windowed pavilions. The architectural historian Dougas Shand Tucci, in his book *Built in Boston: City and Suburb 1800-1950*, calls it "probably the first apartment house in the northeastern United States massed and detailed like a great Tudor manor about a courtyard open to the street."[16] The floor plan shows ten apartments a floor, five mirroring five, each "suite" with nine rooms, and the principal rooms—parlor, dining, library—giving on the garden

courtyard, and still gated by wrought iron with a lantern over the central path. This side of Beacon Street faces north, and Cram brought in light by banking wide (four-window) bays up the four stories. The roofline is plain. Not for Cram the "Tudoresque" with crenellations, or the phony battlements seen elsewhere.

* * * * * *

If the Agassiz was what worldly people called "French flats," its exterior was staid, so unlike the Vendome, kitty-cornered on Commonwealth at Dartmouth Street, which had opened in 1871. It was truly a hotel, a commercial establishment with rooms and suites let by the day or week, and a dining room. Persons known to be thespians stayed there. Those very thespians, as we shall see, dined at the Agassiz. The Vendome was white, in a streetscape resolutely brick or brownstone. The façade was opulent, the mansard roof bosomy, with every kind of eyebrow over the windows, and walls incised with the sort of floral arabesques that nuns used to embroider on corset covers and lingerie for wedding trousseaux. On the top floor, there was a glass-walled winter garden, as shown in an early postcard, before first fire. In short, a building that mothers warned daughters about.

In contrast, the Agassiz almost blushes to be seen. Yes, there's a mansard roof, but straight-sided, straight-laced, in grey slate. The windows show a pleasing variety: bays, bowed, paired slits, and all tall, gleaming in large plate-glass panes. Yes, there's a Gothic window, but only one, and that framed in a sharp gable that cancels the shout to heaven of such windows. On either side of the front door, bay windows rise, as pavilions, the entire six stories. Other pavilion roofs might puff into cupolas, or spike into German Emperor helmets. The Agassiz's pavilions sit low, though one cupola sports a weathervane. Taken as a whole, the Agassiz is academic brick in style. And chary of decoration, except along Exeter Street. The brickwork was all within the repertory of the mason: some toothy dentiling, a few falling-domino plaques, a few headless pilasters, a row of diamonds enclosing crosses, and narrow bands of black brick. It is entirely free of the theatrics of the popular "Queen Anne" style, with all those turrets and porches and windows popping out, whether crammed onto a narrow city row house or sprawling across a suburban manse. There would be a beaut built across Exeter Street from the Agassiz. Its Flemish gable announces the front door. Terracotta vies with brick: scalloping caps windows and friezes break out in botanicals, and the whole is a cheery red with orange accents. There is a tiny porch on the Commonwealth side of the house. Architects always ponder what style will fit. Should they try

to match the neighbors, defy them? The Hotel Vendôme seems to have infected the row houses right next to it as though sanctioning accesses in decoration and bundlings of architectural elements. The houses next to the Agassiz are as restrained as it. Henry Lee Higginson, the man who commissioned the Agassiz, liked most things "severe."

As successful as the Agassiz was, there was a newish worry. Was the market softening for Back Bay living? Like other commodities, real estate was subject to the winds of fashion. New inventions crowded in to change people's ways of life. Much of this book is about the cultural and economic fissures in Higginson's long life. By the time he died in 1919 the automobile was replacing the beloved horses of his youth and middle years, and by his wife Ida's death in 1935 the streets were virtually free of "road apples." Houses once only piped for gas were now wired for electricity. The photograph moved and we went to the pictures. The old Back Bay way of living would not survive the Depression and World War II, but Higginson would be glad, as an investor, to know that life is coming back to the city from a century-long exile in the suburbs. The Agassiz, which housed six families, one to a floor, is a fifteen-unit condominium.

Also as an investor, Higginson knew how demands change. He would be astonished at the transient life of this century. Millennials flock to the city, live and play in glass boxes near work. Then comes "love, marriage, and the baby carriage" and out to the suburbs they troop with an SUV (and child safety seats) parked in the drive of their Cape Cod, ranch house, split level, garrison, shingled Queen Anne, bracketed Tuscan, Greek revival, stockbroker Georgian, neo-colonial, "American comfortable," bungalow, Bauhaus glass, mid-century modern, Tech-Built, McMansion. Empty nesters used to move to residential hotels, which housed the "newly wed and nearly dead," as the pleasantry had it. Now the latter flock to the new wrinkle, the retirement village, always with something rustic in the name: Brook, field, woods, stream, meadow, hill. Like commercial hotels, apartment buildings had citified names, historical or pretentious. The Back Bay streets had their own satirical pecking order: Beacon for the old rich, Marlborough for the old poor, Commonwealth for the new rich, Newbury for new poor.

The lure of the suburbs was on Alexander Agassiz's worried mind as early as 1877. "Are not people"—meaning likely tenants—"going to Longwood, and I would make all reasonable enquires," he advised Higginson. The new threat was what lay on the city's far reaches, the park-like suburbs that stretched along rail lines, well established when the Back Bay was still a tidal basin. Was the city becoming obsolete? Was the Back Bay—the neighborhood built on filled land so the business elite

could walk to work—doomed from the first shovel turn in the 1850s? The Higginsons and Agassiz could congratulate themselves on betting people would live in apartments. Could they be lured elsewhere? Ralph Adams Cram's Richmond Court was mere steps from the trolley to Boston.

Agassiz's spectre was "Longwood." Today its hundreds of acres lie buried under the medical complex north and west of the Fens, with five teaching hospitals affiliated with Harvard Medical School. Back then, it was a leafy suburb as fashionable as brick-and-brownstone Back Bay, with only a short train ride downtown. Something of its rural origins lingered until the 1920s, when cows grazed near Boston Children's Hospital, their milk assuring sick children did not drink bottled milk, which still could be contaminated.[17] The original developer behind Longwood was one of their own. David Sears II lived in grand style on Beacon Street. In 1882, his white granite pile giving onto Boston Common would become the Somerset Club (and Higginson a member).

In the 1820s, Sears had spotted an opportunity only a few miles west of the Common. What had been old farmland was now, finally and reliably, connected to Boston by a road—now Beacon Street—built over the Mill Dam, a structure that had tried to make something useful from the still tidal Charles River. Sears amassed 500 acres, called it Longwood for Napoleon's estate on St. Helena, and began building houses. A development of a new kind, Longwood was one of the first planned neighborhoods in America. Sears planted 14,000 trees and laid out streets and squares. He dictated the architectural style. He built for his friends, and his friends would live as he did, in the sort of picturesque English "cottage"—gothic revival here, Greek revival there, or some of both—that architect Andrew Jackson Downing had adapted for American towns. These were seasonal houses, for the summer and clement weekends. With blazing fireplaces, Christmas was possible. This "Longwood" was no threat to the fully winterized Agassiz.

But in 1850, Sears sold 200 acres to the cotton textile magnate, Amos Lawrence, and Lawrence created the "Longwood" that made Agassiz fear for his namesake hotel in the Back Bay.

Still rural, the development strictly controlled, but the houses were now built for year-round occupation, and many could be rented. Why live in Back Bay and walk to work when one could live and play in the country and ride the train into town? An early defector from the Agassiz was Theodore Lyman, one of the original tenants in 1874 who, in 1883, moved back to Singletree, part estate, part working farm that his family owned in Brookline. He had studied under Louis Agassiz, and in the 1860s, was a curator of his zoological collections. When the young Alexander Agassiz

returned from his own scientific researches to take up Natural History and go in with his father, Lyman paid his salary.

Creating their own version of Longwood would prove irresistible to other landed gentry living on the edges of big cities. Several predate the Brookline development: Llewellyn Park, West Orange, New Jersey, 1853; Lake Forest, Illinois, 1856; Berkeley, California, 1866; Oak Bluffs, Massachusetts, 1866; and Riverside, Illinois, 1868.[18] In a nice coincidence, one such entrepreneur was Higginson's nephew, George, Jr., who bought 60 acres near Chicago in 1904, and, a gentleman-farmer like his father in the Berkshires, kept cows. In 1920, he sold off large parts of Meadow Farm, and the Windy City got a suburb called Winnetka with big houses on large lawns.[19]

6

The Fairchilds at Large

"the intruding race"

To the novelist Robert Louis Stevenson, the Boston financier Charles Fairchild was "simply one of the most engaging men in the world." Mrs. Fairchild, Elizabeth but called Lily, was "very intense and very handsome." Of the five Fairchild sons, the third most appealed: "Blair, *aet.* ten, a great joy and amusement in his solemn adoring attitude to the author of *Treasure Island*," Stevenson wrote in 1887.[1]

Earlier that year, as a present for Lily, Charles had commissioned a portrait of Stevenson from a future Fairchild friend and houseguest, the painter John Singer Sargent. It hung in Boston, at the Hotel Agassiz where the Fairchilds had lived since 1876, one of the first families to move into the new apartment building.

All looked rosy for the Fairchilds, and would remain so for the next two decades. Their landlord and neighbor in the Agassiz was Henry Lee Higginson, and Charles was a partner, and valued salesman, in his firm, Lee, Higginson & Company, investment bankers. When Sargent came to stay with the Fairchilds, they invited Higginson and his wife Ida for dinner. The ladies talked of books. The bankers slipped off to smoke. Having a son of their own, the Higginsons were friendly to the Fairchild children, taking the youngest boy to see his first play.

In those days, for people farther afield, friendships were often formed by letter and were certainly maintained by letter, the telephone not in general use. And so it was with the Fairchilds and Stevenson. It began when Lily, having enjoyed *Treasure Island*—one can imagine reading it to her young sons—wrote Stevenson a cautionary letter: "Beware the publisher who makes you rush from your first great success to write a lesser

book merely to make them money." Or so the story has come down in the family.[2]

That letter and Stevenson's long, enthusiastic reply have been lost. For their flavor, we will substitute their likenesses as Sargent painted them. No more melting portrait exists than his of Lily. It too was painted in 1887, when she was about 42. She has dark hair and dark eyes. She looks about to speak, but a gentle frown, as of a profound listener, creases her brow. Around her neck is some sort of lace, the details of which Sargent has softened to white froth: she was not the sort of woman who wanted every loop, every knot of heirloom lace documented. Sargent's Stevenson sits smoking, his left hand on his knee with the slender fingers splayed to show off his rings. "Mr. Sargent came last night to do the portrait," Stevenson's wife Fanny wrote on 22 April 1887. "It begins well, and one hand that is finished expresses almost all of Louis. God grant the head may follow suit."[3] The setting has a touch of theater. A wicker armchair embraces Stevenson, the orange of the varnish licking as flames at his dark angular figure. He has the face of a pirate's parrot and had, he liked to say, that bird's salty vocabulary. A week later, a friend saw the portrait in Sargent's London studio and, writing to the Stevensons, called it "wonderfully true," adding "isn't it a pity it should go off to America to this stranger lady."[4]

At this point in 1887, Charles Fairchild was still the patron, not yet a friend, and the Stevensons referred to him as "the millionaire." That June they invited him to lunch. It was an epic disaster as to food, with Fanny Stevenson moaning the fish had been eaten by the cat, the cream soup salted to brine, and the leg of lamb only the size of a kitten. Fairchild departed in style: "the millionaire had a special train sent down to take him back to London," Fanny wrote.[5]

Later that year, the same millionaire sent a carriage to meet the Stevensons at dockside in New York and convey them to a hotel they could ill afford. But all was mended, and friendship forged, in the sun and sea breezes off Rhode Island waters at the Fairchild summer house at Newport. Both Stevensons had fallen ill during the Atlantic crossing on a cargo ship freighted with combustibles (hay and matches, a hundred horses, twenty monkeys for an American zoo), and the novelist spent weeks recuperating in a Fairchild guest room. He writes his thanks in the guise of "the character of Indigent Invalid, Exact More Attention." He demands "an interview with that literate Blair," and confesses he fell in love with Lily's mother.[6]

Surely they must meet again, and so plans are laid, invitations exchanged.

For reason of Stevenson's health, he and Fanny and her son Lloyd Osbourne move to Saranac, a New York State mountain retreat later noted as cure for tuberculosis. Accommodations are spare. "Here comes

the begging part," Stevenson writes to Charles Fairchild.[7] "We cannot get any fruit here; can you manage to send me some grapes." But "our wilderness ... is a very nice wilderness." And "the venison (when you can get it) is really tiptop—it is worth the journey." And so in mid-November, the Fairchilds set off from Boston with oldest son Charley. Stevenson is blithe about travel: "You get to Plattsburgh, how you can; nobody here knows. Thence the Chateaugay R. R. takes you a variable distance. If you have influence"—this to a millionaire capable of hiring a train—"it will bring you within six miles of here; then that you must arrange for yourselves by hole-and-cornering." A sleigh is one possibility.

Lily has come down with a cold, and Fanny is also under the weather, and only the two men dine together. Two days later, Lily waves farewell to Stevenson behind his closed window. The Fairchilds do leave Charley in Saranac for a week's shooting with two guides, and Lloyd accompanies Charley to Boston. "The Port Admiral," meaning Lloyd, "is at Boston mingling with millionaires," Stevenson writes to England. There are worries about health, filthy weather, and business scrapes. His lamentation: "I am but a weed on Lethe wharf," borrowing from *Hamlet*.[8]

Only the stepson will visit 191 Commonwealth. Then comes the last exile, for reasons of the novelist's health. In January 1890, the Stevensons and Lloyd fetch up in Samoa, where he will end his days in December 1894.[9] The journey by various ships was long, "Six months on tinned meats ... I think we would have wept at sight of an onion," he writes to Lily. The rest of their friendship will depend on the vagaries of the mail.

Letters do get through. As he writes in longhand he hears the "ping!" of Lloyd's typewriter, a sound of modern communication. "I am now an old, but healthy skeleton," Stevenson tells Lily, and he delights in the passing scene. Their washerwoman trains a chorus to sing Samoan hymns. "She is a good, healthy, comely, strapping young wench, full of energy and seriousness ... it almost looks as if she were chaste." And, sure enough, there were whispers, gossip, which, impishly, he begs Lily not to spread.

Lily's letters to him are lost. Based on his replies, they discussed books and plays. He admires Scott, awaits an edition of Flaubert's letters, finds Howard Pyle's *Aladdin* "capital fun." He spoofs the new fashion for the "problem plays" by Ibsen and Shaw, the psychological insights of which were drawing young people away from theater spectacle. When Lily unburdens herself on the New Youth, Stevenson is both reassuring and impatient of whining: "But let us remember the high practical timidity of youth," he tells her. " ... And so when you see all those little Ibsens, who seem at once so dry and so excitable, and faint in swathes over a play (I suppose—for a wager) that would seem to me merely tedious, smile behind your hand, and remember the little dears are all in a Blue Funk."[10]

Then as now, some literary figures verged on celebrity. Imagine the thrill of opening a letter to read that Stevenson expected an "invasion of Kiplings" and was at a loss how to provide beds for the Kipling ladies who would not sleep outdoors, native fashion. (In the event, they skipped Samoa.) The widowed Henry Adams did visit. He proved an indifferent postman, and a letter entrusted to his care never reached the Fairchilds. In it, Stevenson asked Lily to give hospitality to a Samoan native, who "is not only my friend but my Chieftain, for I was adopted as a brother by one of his clan."[11]

It comes, perhaps not as a shock but surely a sadness, to learn that Charles Fairchild's friendship with Stevenson was considered a liability in the world of finance. A partner in Lee, Higginson & Company—J. P. Morgan called it his "Boston bank"—Fairchild was involved with the Higginsons and others in investments in two of the century's great inventions, the telephone and electric lighting, with holdings in the company we know as AT&T, and the General Electric and Westinghouse companies. As a traveling salesman he was often in London, New York, and Chicago to woo investors to join the firm's ventures. As we have seen, Higginson would hold Fairchild's worldly friendships against him, damning him as "a great friend of Robert Louis Stevenson."

If Robert Louis Balfour Stevenson (1850-1894) tainted his Boston standing, what of the other free spirits that the Fairchilds counted as friends? They really did know a great many bold face names. We shall resort to genteel Italics for the most noted.

During their long friendship, *John Singer Sargent* painted seven pictures of the Fairchild family.[12] While their house guest at the Hotel Agassiz, he played Wagner on the piano, exclaiming how fine it was, after all the troubled music of "Götterdämmerung," to come on "those grand cosmic chords," as Lucia Fairchild told her diary. The most famous English thespians of the time, *Henry Irving* and *Ellen Terry*, came to dinner at the Agassiz, and a Fairchild son was a super in a Shakespeare play they brought to Boston. Through Terry, a Fairchild daughter met *George Bernard Shaw* and made him read his plays to her. *Henry James* expressed pleasure at the looks of the Fairchild women. *Bertrand Russell* thought the elder daughter the most graceful woman he knew. Thanks to *William Dean Howells*, the Fairchilds corresponded with or dined or took tea with *Mark Twain*.[13] Introducing them to Twain was a favor returned: the Fairchilds had built a house on their country estate for Howells, whose novel *The Rise of Silas Lapham* defined the rise of the Back Bay as a stylish neighborhood. It is nice to know that Lily Fairchild helped Stevenson and Howells mend a breach in their friendship.

And although a bit of a stretch, but to make a link to a 20th-century classic, the Fairchild daughter who knew Shaw was a kindergarten teacher

in a house that became the grand residence of *Edwin O'Connor*, whose novels chronicled the Irish Catholic world the Back Bay was built to exclude, and who himself lived at the Agassiz. "My lot used to work for your lot," he liked telling a Proper Boston lady.[14]

* * * * * *

Our first domestic glimpse of the Fairchilds comes from a not disinterested source, Elinor Mead Howells, wife of that very author and *The Atlantic Monthly* editor. They were being mobbed in Cambridge and the social life interfered with his writing. Thus there was appeal in retreating to a country hill, just beyond Cambridge, on land which belonged to the Fairchilds. By 16 October 1877, Elinor has settled on an architect for the Queen Anne shingle they will call Redtop, and writes her brother, architect William Rutherford Mead, about arrangements she has made with Charles Follen McKim, who's the McKim of McKim, Mead & Bigelow (Stanford White joined in 1879); she must have been as lively a client as she was a talker.

"We think now we will build on Mr. Fairchild's land," she writes to her brother, "but we can't afford to pay as much as we may not be able to sell [the Cambridge house] for some time & will have to pay Mr. Fairchild ten percent rent … " Charles Fairchild was then a partner in S. D. Warren & Company, paper makers in Maine with offices in Boston.[15]

And to Aurelia Howells, her husband's younger sister, a further excuse: "Every *soul* in Cambridge, nearly, leaves in Summer… Mr. Fairchild, brother of Gov. Fairchild of Wisconsin & our consul at Liverpool, a very rich young man owns a magnificent place just three miles out from here (on the Fitchburg railroad), on the top of a very high hill—from which Boston is overlooked & the adjoining town, and one sees way to the sea. He only goes out there Summers—living in a flat in Boston in the Winter. Well, he knowing our fix, has offered us land at a merely nominal price, and is building a lovely little house [designed by McKim] on it, (pretty near his house but distinct enough for us to be quite independent,) which we are about to move in to next Summer, paying low interest on it (about 300) until this house is sold, and then buying it. It is so near Cambridge that we can be here in ten minutes on the cars."[16]

To her brother: "You have never seen a finer view that from Mr. F's place. His wife was Lily Nelson of Medford. Mr. McKim may know of her—a beauty & a reformer. Taught down south."[17]

Belmont will figure very little in this book for it is the Agassiz and the Back Bay that concerns us. But Elinor Howells touches on aspects of daily life that will be the burden of this chapter. In her chatty way she also manages to "place" the Fairchilds socially without seeming to. She was

not without political guile: a cousin was the "President" she writes about, Rutherford Birchard Hayes (1822-1893). For their part, the Fairchilds will meet another President, Ulysses S. Grant, at tea when Charles's older brother, Lucius Fairchild, becomes American consul general in Paris.

That the Fairchilds moved easily in literary and artistic circles as patrons—and as practitioners—recommended them to Bostonians of the same bent, but may have estranged them from others. They were never garret-starving bohemian, yet never truly Brahmin. Solid citizens who were descended on both sides from public servants, secure in the rising upper-middle class, and yet, as chronicled in her letters, Lily frets about maintaining social standards. A friend of one of her Harvard sons is a "hayseed." One of her own sons values friends with money more than he should. A debutante's manners are vulgar. The family pets run with the wrong set: "Tug and Ravenger have found a dog that they follow around all the time, he seems to like them very much, also we call this dog the disreputable friend for he almost always is rather dirty, he is one of those little brown and white dogs," Lily's youngest son writes and we can hear her voice.

If not Brahmin, they had those same prejudices. In some respects they were the intruders, in others the intruded upon, as is explicit in Lily's letter about train travel. Nowhere was class division more apparent than on passenger trains. Train travel was the great leveler, unless in the private cars enjoyed by the great financiers, and Lily found it rather too democratic. Returning from New York City in March 1892, she assesses her fellow passengers seat-by-seat on her "perfectly dull secure journey home" to the Back Bay:

> Opposite me was a very badly brought up baby. I longed to give her mother an object lesson in [raising] infants. Just before me were two very distressing 'ladies' (of the intruding race by their features) who had the table put between them and then first played cards upon it (after lunching) then set up an array of bottles and powders and did their nails! On the other end of the car were a party of Italians with animals in baskets—3—whether dogs or monkeys I couldn't work out; they were caressed through the wicker but not let out. Behind me sat two young men who had been to Florida and described the Ponce de Leon with a mean admiration of its cost—and nothing else.[18]

Lily's letter is as vivid as a genre scene by Britain's William Powell Frith (1819-1909) whose vast canvases of crowds—at the races, the seaside, and Paddington train station—are an encyclopedia of English types and

classes on holiday. The difference is her superior reaction to class and race and origin in the close proximity of a passenger train. Had she lived into the late twentieth century, she would be dismissed as WASP: White, Anglo-Saxon Protestant. At the Agassiz she was fully at home, and of her time. She was no different from Francis Lee Higginson's Henry's brother, who wrote to him on 26 February 1875 complaining of the passenger list of the London-bound *Parthia*: "Nobody on board expect nuns and commercial travelers." What's more, the ship "is as slow & uncomfortable a machine as you ever saw—damn her."

Those "intruding" races were immigrants of an ethnicity far different from white Protestant Back Bay. Catholics arrived first, fleeing famine in the 1840s. Later in that decade, propelled by revolution, came Germans. Although they tended to settle in the Midwest and Texas, yet in Boston they managed to build their own place of worship, Holy Trinity (German) Church on Shawmut Avenue, in the South End in 1842; served by Jesuits until 1961, it was made into a high-end condo in 2015. By 1888, Irish maids and coachmen working in the Back Bay demanded a parish of their own, and St. Cecilia opened on Belvedere Street, well away from the established Protestant churches.

In the 1860s, the need for cheap labor to build transcontinental railroads brought "Coolies" from China to the West. They dug rail beds with shovels from the Ames Shovel Works, in North Easton, a town south west of Boston, making a fortune for that family. Boston's Chinatown dates from 1870 when Chinese, imported from San Francisco to the Massachusetts Berkshires to break a strike at the Sampson Shoe factory in North Adams, drifted east to Boston. In the 1880s, four million poor and starving Italians and Sicilians would start arriving in America. Shipping companies, very glad of this market, crammed them into the holds of their new steamers. Proper Bostonians knew Florence and Rome and Venice, of course. But to have these swarthy, dirty southerners settle in Boston required something be done. They must be made American. And so the "settlement house" was created. Part health clinic, part indoctrination school, and chiefly staffed by Protestants, settlement houses sought to break them of their old ways. Particularly abhorrent was the practice of Italian mothers chewing the food they would then feed their infants.[19]

From Eastern Europe came Poles and Hungarians. From the Levant, Greeks and Syrians. Russian Jews, fearing slaughter in the pogroms of the 1840s, left to find safety in Europe till they could sail to America.[20]

Any of those foreigners could have intruded on Lily Fairchild. By the end of the 19th century, immigrants and their children would account for three-quarters of the populations of Boston, New York, Buffalo, Cleveland, Chicago, and San Francisco. By then, "nativist" Americans had pressed

Congress for immigration quotas, literacy requirements for admission, and other firewalls.

In many ways, the population of the Agassiz replicated the boyhood neighborhood of Henry Lee Higginson. His was a remnant of colonial Boston. Its clustered houses formed "one of those cosey little courts which were favorite retreats for families on intimate terms with each other and a little aloof from the great world," Higginson wrote toward the end of his life. Whether rich or poor, they were all of English stock. "There were only enough foreigners to exercise benevolence on, not to intrude."[21]

* * * * * *

For most of the two decades (1876-1897) the Fairchilds lived at The Agassiz, the household consisted of the parents and their seven children, with a cook and four maids to look after them.[22] The two daughters and five sons were all born in Belmont, where the family spent half the year at Holiday House, their hilltop estate,[23] exchanging entertainments with the Howells family. Sally Fairchild, called Satty, arrived 17 June 1869, when Charles was 31 and Lily was 24. Lucia was born on 6 December 1870; Charles Nelson, called Charley, on 8 March 1872; John Cummings, called Jack, on 7 March 1874; Blair on 23 June 1877; Nelson, called Neil, on 22 September 1879; and Gordon on 31 January 1882, when the parents were 44 and 37. Lucia was the first to leave the nest. She would study art in New York City and marry a fellow painter, Henry Brown Fuller. It is from Lily's weekly letters to her that we can live life at the Agassiz for 1892-1897, and snoop on the Fairchild doings in Boston.

Blair was seventeen, a freshman at Harvard, when in January 1894 he had a moment of theatrical glory: he trod the boards with the great Henry Irving and his celebrated first lady, Ellen Terry. The play was *Henry VIII*, direct from London's Lyceum Theater, where Irving was actor-manager, doubling as producer, director, designer, costumer, and publicist. The 1892 production leaked money, realizing only 4,000 pounds on the 11,000 it cost. Both stars were painted in costumed splendor. Blonde Terry posed manacled in jewels and brocade as Queen Katherine, bought and paid for but, alas for her, Henry's investment did not produce a son. Irving played Henry but sat for his portrait as Cardinal Wolsey, his Boston role. He is royal in red silk—not that it will do him any good. The heavy folds of scarlet cloth perfectly mimic Irving's face: long nose, hollow cheeks, glowering eyes, with the mouth a barrier.[24] He who secured Henry's divorce from Katherine has now been fired, and Wolsey's dismissal speech is thought worthy of Shakespeare, though John Fletcher probably wrote the play.

With other Harvard boys as supernumeraries, Blair was in costume as one of the King's Guard. On cue, the cast cries "Here comes the Queen!" It was Ellen Terry wearing a king's ransom. As she spots Blair, she chucks him under the chin, and he hears her say: "You are favoured among ten thousand." (Not a line from the play, but perhaps improvised from "my beloved is white and ruddy, the chiefest among ten thousand" from The Song of Solomon.)

Oh, to have been at dinner at the Agassiz on that night in mid January 1894. It was a Sunday, when the theaters were closed, and the following Sunday night Irving and Terry would return the favor, inviting the Fairchilds to dine with them at the Hotel Vêndome (on Commonwealth Avenue, within sight of the Agassiz) where they were staying.

Oh, to have heard the Fairchilds put the guest list together! Did they simply choose admirers of Irving and Terry? The men included three business associates, past and present of Henry Lee Higginson, two of them Civil War vets. And sitting across from them, three literary lights, two of them women. Lily is so pleased with the evening that she draws Lucia the seating plan for dinner.

Henry Irving	LNF[Lily]
Mrs. Fields	Col. Livermore
Aldrich	Satty
Sarah Jewett	Mr. Agassiz
CF [Charles]	Ellen Terry

"Satty," then twenty-three and caught up in the social whirl of a post-debutante, was friends with "Edy," Edith Craig, Terry's natural daughter who had the run of the Fairchild apartment. To Satty's left, a very familiar name in this story, is Alexander Agassiz, whose development of those copper mines in the Upper Michigan peninsula had made the Higginsons and others very rich, and who, with Henry and his father George, built the Agassiz. To Satty's right, Col. Thomas Leonard Livermore, a Civil War hero who enlisted at seventeen and rallied New Hampshire volunteers at Antietam when he cried out "put on the war paint," and for twenty years was first vice president of Agassiz's Calumet & Hecla Mining Company.

There was nothing about the menu, but Lily's letters mention food only when comic. It was enough that Henry Irving was put next to Annie Fields (1834-1915), and Sarah Orne Jewett (1849-1909) was kitty-corner from Ellen Terry. An established novelist, sickly as a child in her native Maine, Jewett was noted for quiet stories that depended less on plot than local color. When she was nineteen, her first important story was published in *The Atlantic Monthly*, of which James Fields was editor. After he died in

1881, the widowed Annie and maiden Sarah set up housekeeping, and had by 1894 what was known as a "Boston marriage."

Thomas Bailey Aldrich would sit next to Lily the following Sunday. A wit among wits when he edited *New York Illustrated News*, a rival to *Harper's Weekly*, he came to Boston to edit another weekly, *Every Saturday*, published by Annie's husband at Tichnor & Fields, and then succeeded William Dean Howells as editor of *The Atlantic Monthly* (1881-1890). A poet judged better at light and lyric verse than the narrative or dramatic, he was the juvenile hero of his own novel, *The Diary of a Bad Boy* (1870). Important, literary critics would say, as the first realistic depiction of childhood in American fiction, and it would lead to Mark Twain's *The Adventures of Tom Sawyer* (1876). He was a natural to be at both parties; and Lily wrote Lucia on 24 January about the sequel: "We had a most delightful time at the Irving dinner—though it was too long & we had frightful things to eat. The cooks had conspired to make every dish an edifice, and Mr. Aldrich who was my neighbor on one side (Jefferson [Thomas Jefferson Coolidge] on the other) was killingly funny as he sometimes is. But the table was too big for general conversation."

But that is to anticipate, and the Fairchilds and their dinner guests will now rise from the table and go into the parlor. Here, as was the custom, people invited just for an evening reception would assemble. There would be conversation and light refreshments, and perhaps entertainment. Agassiz is now joined by his two sisters, Ida, who had married Henry Lee Higginson and lived at the Agassiz, and Pauline, who married Quincy Adams Shaw, whom we will meet later in connection with the Fairchild children's schooling. And there were five or six others. Lily wrote Lucia that the Searses "were quite wild with excitement" to be in the Presence, and Satty thought the very rich "Mr. Sears might drop a few million coupons about." These are the bicycling Searses. They are known to have ridden 22 miles a morning. "They are crazy about riding," Lily writes.

And what of Irving and Terry? Did they declaim? Was it enough for the guests to gaze upon them (and prattle the next day)? Did anyone doubt they were the greatest? The Boston reviews were not kind. Reviews in London savaged Irving.

His acting style had become subject to satire, and in 1892, two years before the Fairchild dinner, it inspired a killing scene in *The Diary of a Nobody* by the Grossmith brothers, veteran theatricals. George was the comic singer who created the patter-song roles in Gilbert & Sullivan, and his brother Weedon wrote plays. The diarist is Mr. Pooter, whose son has invited an amateur actor, Mr. Burwin-Fosselton of the Holloway Comedians, for supper.

He "not only looked rather like Mr. Irving but seemed to imagine he *was* the celebrated actor ... he began doing the Irving business all through supper. He sank so low down in his chair that his chin was almost a level with the table, and twice he kicked Carrie under the table, upset his wine, and flashed a knife uncomfortably near Gower's face."[25]

While the fictional Charles Pooter suffered the counterfeit Irving kicking his wife and menacing his best friend, Charles Fairchild could look down his table and see the genuine article thrilling Boston's literary ladies and money men.

"We had a very good time," Lily continues, "& it cheered up your poor papa a good deal. He keeps up his spirits *wonderfully*." The worry, kept in the family, was financial, and his days in Boston were numbered.

Who were Charles and Lily Nelson Fairchild that they moved easily in the cultural establishment of the late nineteenth century? It's not known how they met or decided to marry. They came from old New England stock, both families early arrivals in America from England, and the Nelsons could boast collateral descent from a Signer of the Declaration of Independence, Josiah Bartlett of New Hampshire. Nelson and Fairchild men had Harvard in common—and advancement through party politics. But the Nelsons were, in contrast to the Fairchilds, the sort of old Yankee family that never moved very far from the apple tree. Not for them the wagon train that took one Fairchild to the Gold Rush and onward and upward.

The Nelson way upward was through the law, though of course party politics is always a factor. Lily was the only surviving child of Judge Albert Hobart Nelson (1812-1858) who had married Elizabeth Phinney of Lexington in 1840. A Harvard graduate, the college in 1832 and the law school in 1837, he was in private practice for a while. When and why he decided to move on is now unknown. His route, however, is public record. As is still common today, he headed for the bench via a stint as prosecutor, becoming District Attorney for Massachusetts and the eastern district, in effect the greater part of the state. Then a detour, to the state legislature, where he served a term or two as senator from his rural district. Then right into the State House, when elected by his district to the executive or Governor's Council. This body, a creation in colonial times and still in existence, confirms gubernatorial appointments, including judges who are nominated by the governor to the state courts.

The elections of 1854 were to change Massachusetts politics when the American Party, the "Know-Nothings" who opposed anything foreign and

Catholic, swept into office, taking all state-wide positions. Thus Henry J. Gardner became governor, and, as we have seen, Gardner appointed the commission on the Back Bay that created a neighborhood tailored to a Yankee elite. A libel on the judiciary defines a judge as a lawyer who knew a governor. And it was Gardner who put Nelson on the bench. Nominated chief judge of the Superior Court for Suffolk County, the trial court for Boston, Nelson served from 1855 till elevated to chief justice of the Supreme Judicial Court, the state's appellate court. He resigned in January 1858 and died that June at the McLean Asylum for the Insane. The obituaries preferred to dwell on his attainments at the law.

Lily Nelson (1845-1924) was thirteen when her father died. Her mother Elizabeth did not remarry, and appears in Lily's letters as the "faithful Gam," grandmother of the seven Fairchild children, who charmed Robert Louis Stevenson. Lily marries Charles Fairchild in 1868, now 30 and living back East, having tempered in politics and business in the Midwest; and she 23, a published poet. Of her upbringing and education, nothing is known. It must have been thorough as to deportment and enriched by reading.

As we have seen, Elinor Howells described Lily as a reformer who taught down South. It may be she was in the first wave of Northerners to take up the plight of newly freed black slaves and see to the education of their children. Alas, she has left no letters about her first sojourn from home. Teaching in the South gave her something in common with Henry and Ida Higginson, neighbors for those two decades at the Agassiz, who, as we have seen, had started a little school to teach reading and writing to the former slaves who worked on their cotton plantation in Georgia.[26]

The future Mrs. Charles Fairchild was a poet, later to be published in such beacons of literature as *Scribner's* and *Harper's*. Her first works she signed as Lily Nelson. All her life she kept the issue of *The Radical*, which printed "At Last" in the July 1868 issue. A monthly magazine, it was devoted to "Natural Religion and Intellectual Liberty," by which was meant "beliefs outside the bounds of orthodox Unitarianism." Her poem "Barnacle" finds God in Nature, and other verses find God in beauty.[27]

But of course, the conventions of polite society decreed that married women must disappear behind their husband's names. In another chapter we will meet the composer Mrs. H. H. A. Beach.

Lily obeyed—in her own way. She became A. C. Price. Or "A Caprice." And it may be that "A. Ward" was her, too. The verse is tidy in meter and rhyme, heartfelt, and melancholic. She kept a tally of submissions and rejections (very few) but no indication she was paid. "The Lost Guide," her memorial to Charles Eliot Norton (1827-1908) in the February 1909 *Scribner's*, began "I knew a pine that topped an ancient hill,/A mark

and beacon to the country-side," saluting him as critic, early translator of Dante and Harvard's first professor of art history. Only once did she sign herself as Elisabeth Fairchild, which was not quite her birth name of Elizabeth. That was in *Scribner's* January 1911, the year after Charles died, and the occasion was a memorial poem to Julia Ward Howe (1819-1910), the abolitionist and feminist who wrote the thunder we sing for "The Battle Hymn of the Republic."

> The lips are touched with silence that so long
> Were golden-tipped with song;
> The lovely hands that ne'er before sought rest
> Are quiet on her breast ...
>
> Bid her farewell, as fits a warrior
> When the good fight is o'er;
> No primrose way was the long path she trod;—
> But she has walked with God.

From this view of Julia Ward Howe, we would not know she had a whole second act to her life after the death of her controlling husband. She had been a belle in New York City and something of a singer, before marrying an exemplar of Cold Roast Boston, Samuel Gridley Howe. After he died, she whizzed around America speaking in aid of women's issues. But widowhood revived the belle in her when she moved to fashionable Boston, to 241 Beacon Street. Among her guests was Oscar Wilde, who, touring America in 1882, spoke at Harvard and dined at the St. Botolph Club. She treasured his company, less that of his valet, Davenport. "It was one thing to entertain the Aesthete, another to put up with the gentleman's gentleman," she wrote. Entertaining Wilde to a meal, she made a pastry confection and fashioned, in yellow angelica, the Sunflower he liked to carry to *épater les bourgeoise*.[28]

Lily's letters to just-married Lucia reveal no inner life at all. The "caprice" poems all date from well after the Fairchild family's removal to New York City when Lily and Charles were becoming empty nesters, as we would say. We will meet their hectic life of social Boston in another chapter.

The Fairchild children got their good looks from both parents. Too bad that Sargent did not paint Charles (1838-1910) for the formal portrait photographs are stiff and prosy. We see only the dark hair and broad brow. He was "clubbable," among the earliest members of the St. Botolph, founded in 1880 so that gentlemen could meet artists; and the more playful Tavern (1884), whose drag musicals derived from Harvard's Hasty

Pudding Theatricals. As we shall see, the same Thomas Jefferson Coolidge who'd sat with Lily at the Irving-Terry dinner took the Fairchild children on a memorable winter outing in his tally ho.

Charles Fairchild could count on two associations to recommend him to Henry Lee Higginson, his landlord, neighbor and business partner: Harvard and the Civil War. A transplant from the Midwest, Charles was only partly Harvard; a transfer from the University of Wisconsin, he graduated with the Class of 1858, but he did fight in the Civil War. His brother, Lucius Fairchild, was even more the hero, and Charles got Sargent to paint him, a portrait actually done at 191 Commonwealth Avenue in 1887. Below the chestful of bright medals is grotesque blackness representing the lower left arm that Lucius lost near Gettysburg. This was the "Empty Sleeve" of sentimental Civil War ballads (and title of the warts-and-all biography by Sam Ross). The always-quotable Lucius did not think much of the Sargent: "A lot of badges running off with a bald-headed man," he wrote to his wife.

Like Higginson, Lucius Fairchild believed the Civil War was fought to preserve the Union rather than to free slaves. Lucius sought office in the Grand Army of the Republic, a patriotic organization for Union veterans, and when he became commander-in-chief of a swelling membership, certain newspapers "heard the whispering of a Western breeze bearing the name of Fairchild" as the Republican choice for president. Then Grover Cleveland, as President, directed the Secretary of War to return all captured Confederate battle flags to the Southern states. Blazing with anger that Cleveland would reward what he regarded as treason, Lucius Fairchild cried out: "May God palsy the hand that wrote the order! May God palsy the brain that conceived it! And may God palsy the tongue that dictated it!"[29]

His only federal office would be as part of the diplomatic corps in the 1870s. Residence abroad would certainly benefit the family of his younger brother, Charles Fairchild. Friendships with Sargent and Stevenson date from those years.

One indicator of social class is the speed with which the top people make it up the ladder. Higginson men got a running start in the 17th century, prominent in Salem (as we have seen) and capitalizing on that in Boston. The Fairchilds took generations longer, and traveled farther afield to accomplish what they did, and it's worth a detour to follow their detour from well-settled New England to the possibilities in a rougher America.

The Fairchilds were as old a family as any in Boston society. Thomas (1610-1670) was the first to arrive from England in 1639, settling in Connecticut, at Stratford, part of the New Haven Colony that stretched along the Long Island Sound toward New York. They would be part of

the New England diaspora, families eager for new opportunities, and, via New York State and Ohio, the Fairchilds find their way (by lake steamer) to the Wisconsin Territory, where Charles and Lucius's father, Jairus Cassius Fairchild (1801-1896), would become the first mayor of Madison in 1856.

In the larger towns and cities, Latin was still taught, oration prized, the occasional touring company brought Shakespeare to the local opera house, and people read their Bible. All or none of this may account for given names; there was also among Protestants a built-in genealogy, with surnames becoming first names. Thus, Blair comes to the Agassiz because it was the family name of Jairus's wife Sally, and will become the middle name of Lucia's son Charles, and her son Blair's first name. Simple family affection would account for three generations of Sarah and Sallie/Sally and "Satty."[30] Lucia must have been named for her father's older brother, Lucius.

Every Boston family had its self-made men, and the Fairchilds had theirs. A weathervane in politics, Lucius Fairchild as a young Democrat approved his father calling Lincoln "Greasy Abe" and was no stranger to the N-word. In 1848, he had left home riding a fat black Chipaewa pony to join a wagon train and pan for gold. Six years later, given up for dead, the Prodigal returns, flush and handsome, a ladies man, having made his pile not in mining but, more sensibly, selling miners much needed provisions. More reliable than prospecting, "mining the miners" made many a small fortune.

The modern reader can be forgiven thinking everyone owned a railroad in those days. Once structural steel was available for bridges, rail lines jumped streams and canyons and spread across America. Built by cheap labor, they got raw material to mills and finished goods to stores; they carried children to school and milk to market, and hayseeds to the big city. But railroads were no sure thing. Bostonians, like Charles Francis Adams, had the deep pockets to finance transcontinental systems. Mayor Fairchild had only a piggybank railroad and the Panic of 1857 finished that. He would lose his and his sons' investments in a coal and ice business, a sawmill, and a cranberry bog.

Lucius was not the first or last to see the Democratic Party as a cash cow. In 1859, he won election as the county clerk of courts, and immediately appointed young Charles as his assistant. The brothers did so well collecting fees and taxes for the county that they parlayed their cut into a dry goods store. But the Democrats were also broke, and Lucius moved on, joining the Republicans. For services to the Party, he expected and got appointments to lucrative consular posts—Paris, with few but social duties, paid better than Liverpool, which was hard work being a port—

but insisted he was never so greedy as to "ride a free horse to death." His last public service was a sorry affair concerning grazing land when he, as commissioner, favored cattlemen over the Cherokee whom he damned as "Blanket Indians" backwards because tribal, a "dirty filthy people." None of this was nice, but all of it was part of 19th-century America, and Lucius Fairchild was the adored older brother of Charles of Boston. Bred in the Midwest, educated at Harvard, and proven in war, Charles went home to work for Lucius in the first of his three terms as Wisconsin governor. (It is not for this tale, but Lucius's biography is well worth reading for the collision of free enterprise and government regulation.)

Thus, when Charles went back East and married Lily, he had the gritty practical experience of running things and knowing how to sniff out investments. Although he joins Lee, Higginson, on 1 September 1880, he first comes into our view in the 1870s when he moves into the Agassiz and becomes a partner in S. D. Warren & Company, papermakers in Westbrook, Maine. Among the cotton rags that went into the smelly maw that became paper were old mummy wrappings from Egypt. Old Sam, the founding Warren, believed Christianity was good for business (he housed mill hands in a model village) and applied the Golden Rule also to family; that eight Warrens were in management appalled Charles Fairchild, who had profited from political nepotism but did not see it necessarily benefiting private enterprise.

His years at Warren can't have been easy. Book publishers were natural customers of paper makers, and Fairchild backed the wrong side in a publishing war. Historian Martin Green describes a corporate culture within the Warren company that bordered on the puritanical. Old Sam was allied with the Houghton of Houghton Mifflin, who distrusted England (for even thinking of backing the Confederacy) and held that only Americans should write children's books as they would be free of English class divides. Charles Fairchild was allied with cosmopolitan men like the publisher James Fields: "genial, Anglophile, name-droppers, and party-goers."[31]

To which can be added the association with John Singer Sargent. It was certainly a friendship but also a business arrangement, with Charles Fairchild commissioning a portrait or two and later acting as the painter's financial adviser in America. To have Sargent banging out Wagner on your piano must have counted for something. But, as we will see, it was not enough to overcome what Higginson would call a want of "prudence."

7
Father and Son

"You can choose and I couldn't."
Henry Lee Higginson to Alexander Henry Higginson

They always had horses to talk about. Horses, and an actress or two. That went some way to repair the hard feelings that Alexander Higginson (1876-1958) harbored into late middle age about his father's neglect of him as a boy. Henry Lee Higginson (1834-1919) would come home, partner in a leading investment banking firm, exhausted from shaking the money tree all day, with nothing left for small Alex. Or so Alex thought. Then, in 1881, his father fulfilled his dream of creating a symphony orchestra for Boston, on the model he had known in Europe. If it wasn't business that got in Alex's way, it was music, his father worrying over the entwined problems of art and money posed by the orchestra—and talking it out with his mother. He was so tired he could hardly talk to the boy who so eagerly waited for his company.

"He was generosity itself to me and gave me pretty much everything I wanted, boats, ponies, and in later years, horses and hounds, to say nothing of the chance to shoot and fish and indulge my taste in ornithology," Alex would write in his memoir, *An Old Sportsman's Memories* (1951). "But I was robbed of that companionship in my youth which I think is a son's due, and I would gladly have given up all those benefits for *one trip with him*. Alas, such a chance never came—he was always too busy."[1]

There was in fact one family trip together, to Europe in 1883 when Alex was seven and Henry felt obliged to scour the continent for musicians for his new orchestra.[2] Then, too, a return to the Europe of her girlhood might revive his wife, Ida, who was ailing. In Vienna Alex saw the emperor, Franz Josef, by then king of Hungary, in the majesty of the Dual Monarchy with

glittering soldiers and fine horses on parade. He was dazzled at Christmas with the shops all illuminated and pantomime at the opera. He saw Venice and Paris, or as much as a boy could take in. He found ponies to ride, but was homesick for his own, and the life of a real boy. And, worse, his father left the family abroad for three months to go home to tend to business.[3]

"I grew to hate the Orchestra and everything connected with it," Alex wrote, adding "particularly when, as I grew up, I was not allowed to share in the burdens and problems which arose concerning its maintenance." Yet, there were moments. For Alex's eighth birthday, the orchestra's first conductor Georg Henschel (1850-1934) wrote the "Santa Claus March" for him. The second conductor was Wilhelm Gericke (1845-1925). To Alex he was a "stiff but kindly soul," to his father the "drill master" who set the orchestra on its way to world renown. Next came Arthur Nikisch (1855-1922), brilliant and erratic with mustaches flying. One Sunday night, he sat down at the Higginson piano and played Hungarian music. Asking them to find a newspaper, he put it on the strings to make it sound like the hammered zither called the *cimbalom*, and showed how Hungarians improvised on a theme.[4]

And when Alex, still at Harvard, married his first wife, Rosamond Tudor, at Trinity Church, Copley Square, in 1889, the Boston Symphony played the Wedding March. The marriage fell apart after four years, and to his great sorrow, Alex could only see his son, Henry Lee Higginson II, born 5 July 1899, at "stated periods."[5]

What Alex persisted in calling "an ever-widening breach" between him and his father was finally healed when his father faced a crisis in 1915, four years before his death.[6] Careless with his personal finances, at 81 he faced ruin. Perhaps eager to be free of an old man, his fellow partners in Lee, Higginson & Company forced him to sell his holdings and asked he leave investment banking. Alex's feisty second wife, the former Jeanne Calducci, her blood up, stormed the State Street offices. On a table in the main reception room were two telephone directories. These she lofted and slammed down. Clerks and errand boys came running.

"I want to see Jim Storrow," she demanded, "and George Lee, and Hallowell, and the rest of Father's rotten partners who have tried to squeeze him." Lee got on the phone to Alex. "Your wife's in here. She's very much excited. She called me and Jim Storrow a couple of 'pot-bellied office-boys.'" Alex: "That's just about what you are."

And if they didn't take the old man back, she told them she would march right over to the *Boston American*, a Hearst tabloid not friendly to the Yankee establishment. "I'm going to ask for the city editor, and I'm going to tell him exactly what you've done, and we'll see how long this firm stays in State Street."

When she got home, she looked radiantly happy. "Get your hair done?" Alex teased. She was "a strikingly pretty girl, with flashing black eyes that bespoke her Italian parentage," he would write of the great encounter. No time for hair, she said. "I went to see Father at the office. Did he telephone you?"

Indeed he had. And told his son: "Jeanne is a rather wonderful little girl. She saved the whole situation."[7]

The telling of this has the speed of screwball movies. Alex's third, and last, wife would be a stage actress (who, like Alex, rode to hounds). When her career at the Old Vic in London blossomed, it threatened his as an English country squire with his own pack of hounds. There were Scenes, a temporary Estrangement, but the curtain rang down Happily.[8] Alex's social life was, in the telling, a bit of drawing room comedy, a bit of cabaret.

* * * * * *

Fine books have been written about the Boston Symphony Orchestra's founding. Because of its wonderful detail, we will defer to Mark Antony DeWolfe Howe, a BSO trustee, for his history, which was first published in 1914, then expanded in 1931 to mark the orchestra's 50th season. The beginnings were ambitious. There were twenty concerts that first season in the Boston Music Hall, from the middle of October 1881 to the middle of March. Subscriptions, based on seat location, were $10 or $5. Single tickets were 75 cents or 25. Every week there would be an open rehearsal, with no reserved seats, for a quarter.[9]

With 50 concerts for revenue, the box office would bring in $50,000, leaving an annual deficit in the same amount for Higginson to cover. So he envisioned a principal of one million dollars, and two million would be even better. He wanted a real symphony orchestra, not chamber. Wind instruments, about twenty. A dozen each of first and second violins, ten violas, eight each of cellos and basses, for a total of 70. (The modern BSO numbers about 104.) Men would be paid $1,500 a season. (The starting salary today is over $100,000.) The conductor would get $5,000. (More than a million today.) Two concertmasters would get $3,000 each. (In the 1950s, when the BSO board was Harvard-centric, they valued the worth of the concertmaster at $25,000, or what a full professor got.)[10]

Some conductors and composers pleased better than others. "Exit in case of Brahms" was followed years later by people walking out on Stravinsky. Howe's history would take the story up to the triumphs of its music director, the legendary Serge Koussevitzky. When it was found necessary to replace Koussevitzky, Howe's namesake son would be sent on the

quiet in 1948 to vet his successor, Charles Munch, then guest conducting in San Francisco.[11] Another Howe figures in the BSO chronology. It was not at the Agassiz, where Higginson lived, that he founded the orchestra, but quietly in the parlor of Mrs. George D. Howe at 17 Marlborough Street. "She knows and loves music well, and ... has been most cordial and efficient in the whole matter," Higginson wrote in the plan to create his orchestra.[12] He also called her one of his best advisors "outside of my own household." And so it was at her house in March 1881 that Higginson offered Henschel the job as founding conductor. There were other maestri in Boston: Carl Zerrahn, Bernard Listemann, and Louis Maas, but the concerts occasionally given by Theodore Thomas, the father of symphony orchestras in America, were the standard against which all else was measured.

Then, on 3 March 1881, in its final orchestra concert of the season, the Harvard Musical Association, introduced Henschel to Boston, and the audience went wild. They particularly liked how, instead of mounting the conductor's platform, he stood among the musicians, rightly seeming to be one with them. Higginson wasted no time. A few days after the concert, he asked Henschel to meet him at Mrs. Howe's. A day or so later, Henschel told Higginson what he would like to be paid. Higginson sent the contract by telegram to Washington where Henschel had just married his soprano, Lillian Bailey.

There were, of course, no players for the BSO's new maestro to conduct. Henschel would recall Higginson's necessary tact. "In order not to make *'böses Blut'*—as Higginson, who was an excellent German scholar, put it; i.e. to say, in order not to give offense at first, Mr. Higginson advised me to engage for the first season only the available local players."[13] The first concert was given in the Boston Music Hall, on the evening of Saturday, 22 October 1881.

This tale has the charm of folk legend, the grandeur of saga, Higginson as garage nerd willing his enterprise into life, telegraphing instead of texting. It would not be possible today without lawyers, unions, and agents, and a fundraiser or two. But Higginson would foot the bills. And go broke doing it.

In 1881, Alex Higginson was then five, and perhaps too young to have taken much in. Where the new enthusiasm, consuming passion, and first worries of his father would begin to tell on time with the son came in the years of building the orchestra, finding conductors, and hiring players (many from Europe), hence the 1883 trip to audition musicians. In Vienna he planned to huddle with "dear chum" Julius Epstein, a pianist who had advised Higginson every step of the way, and must now advise him on Henschel's replacement. That Higginson had to cut his quest

short for his other life as a businessman tells much about the precarious world of finance and investment banking. But the orchestra was his, his creation. And doubtless the greatest possible balm for his own failure as a musician. He had had hopes as a pianist. In 1858, manic practicing six hours a day in Vienna lamed and disabled an arm, and the doctor advised it would be permanent. "Thus a young man ruins himself," he wrote to his father, "I came home [from the doctor] and swore like a pirate for a day; then coming to my senses I decided to sing away, study composition, etc., hard, magnetize, and await the result." To make ends meet, he would give English lessons. But the Germans charged only 25 or 50 cents, which he could not afford to do.[14] Turning perforce to composition, a less physical form of music making, he wrote songs. There was a market for song. Schubert wrote some 600, many well within the ability of the amateur soprano accompanied at the home upright. Glee clubs sang "good music," so did barbershop quartets. Higginson in 1909: "I, too, wished to write music, studied two or three years in earnest and very hard, and wrote a few songs good enough for the fire in the grate."[15]

The first Higginson fortune had been made in copper from the northern Michigan mines at Calumet and Hecla. Now the market for copper was softening, and for the first time in its history, Calumet had passed paying a dividend. In January 1884, Higginson suggested his father sell some of his 2,300 shares, far more than Henry had retained, and cash in. There was also the low tariff to fear because it would flood America with cheap goods from Europe. "It may be sooner or later, but come it will," Higginson wrote to his father. The tariff "will bother cotton and woolen goods and iron at least, and so it will bother our railroad" which carried goods to market. For that matter, all markets were in a bad state. "Everyone is selling right and left. It is simply cussed," Higginson wrote to his wife Ida.

There would be financial ups and downs till Higginson's death in 1919.

But there were good times too, when Higginson was flush, and when he could afford to indulge Alex. As we have seen, Higginson's father George had indulged him, sending him on a four-year *wanderyahr* to study music in Europe. Realizing his talents were slender, young Henry returned to Boston and a life in business that he more suffered than enjoyed. He would indulge his only son.

※ ※ ※ ※ ※ ※

The two men had another bond. When not involved with riding and driving horses, they went often to the theater together. They had an eye for actresses. Alex was even something of a stage-door Johnny. One night in

1898 he went to a debutante dance for the Miss Beebe who lived at 199 Commonwealth Avenue (now the St. Botolph Club). Among the guests, to his delight, was the "tall, slight girl" he had seen first in a play called *The Bauble Shop* starring Maude Adams and John Drew, and, earlier that week, in *Rosemary* with Drew.

"Hullo, Higginson," said Drew, as Alex Higginson recreated the evening in his memoir, "It's so nice to see you again. I've just brought my niece Ethel here with me. You remember her, don't you? Do be nice to her; she knows nobody here." Ethel was Ethel Barrymore. She loved good classical music. His father had founded an orchestra. "I was thrilled beyond words when she consented to come to the concert with me on her final Friday afternoon ... and though classical music was a bit over my head, it mattered little to me if I could sit by her side while she enjoyed it." At the deb dance, with Ethel on his arm, Alex thought himself the "most envied man at the party."[16]

Both Higginsons had feelings for Eleonora Duse (1858-1924) as did much of the theater world. George Bernard Shaw thought her superior to her stage rival, Sarah Bernhardt. The tactful Ellen Terry said it was good the world had both. In 1896, President and Mrs. Grover Cleveland went to every Duse performance in Washington, and the First Lady honored her with the first White House tea given to an actress. In New York, tickets to see Duse cost from $10 to $20. A Boston deb Marian Lawrence saw her in a double bill. In *Cavalleria Rusticana,* she "looked the picture of despair and so pale and ill one would not think she could live an hour but in the second play ("La Locandiera") she was the most gay and bewitching coquette. One would think her the most healthy and happy young woman and yet in a day or two she had broken all engagements owing to illness. She really is an invalid and has to use a cane to walk."[17]

How the Higginsons met Duse is not recorded. Alex's *frisson* was the excitement of star-struck youth. Henry's *tendresse* was doubtless flutter which he could mask as devoted servant, for he also advised on her business affairs. She was the victim of bad theatrical management, he thought. He wrote consoling her in French, and, as we will see in a later chapter, outlined in a long, office-typed letter, to a Boston impresario, Charles A. Ellis, how Ellis could profit from giving Duse a season in Boston.

Alex: "One day, my mother told me that she (Duse) had expressed a desire to visit an American's 'student's' room, and suggested that we might bring her to our quarters at Wadsworth House." A much earlier occupant of the study that Alex shared with a roommate was General George Washington, in Cambridge in 1775 to take charge of the Continental Army. Duse "had tea with us, and expressed herself as delighted—in very broken English—and sent each of us a signed photograph, very much as

royalty might have done. Mine is on the wall of my study [in England] as I write."[18]

In 1917, when America finally joined the European forces mired since 1914 in the Great War, a Higginson in-law, stationed at Fort Devens, asked for entertainment for the troops. Alex knocked at every stage door in Boston, and lined up the leading stars, who took a train an hour out to Ayer Junction on their Sunday off. He asked his father to be master of ceremonies. (This was type-casting, for Higginson was the beloved president of The Tavern Club, that merry band of thespians.) The performers included Irene Bordoni (1885-1953), later famous for singing Cole Porter's "Let's Misbehave." This "little French actress" Alex remembered as "one of the most attractive bit of femininity I have ever known." She was reluctant at first to give up her day of rest. "'*Ah, non, Monsieur, c'est impossible*—no, I cannot come, I am too tired.'" But, said Alex, " 'this is for the soldiers who are about to go to your country—to France'" She saw his point: "*Les soldats* who go to *La Belle France*." At Devens she put on a little khaki suit. "'Mon Colonel, give me your 'at,'" she demanded of Major Barlow, who, an actor himself, belonged to the Lambs Club in New York. The saucy Bordoni parked his felt service hat on the side of her head. She made the band strike up "Over There." This was the song composed to get Americans to enlist. She sang it in French. Alex thought the audience would go mad. "'Now *you* sing it for *me*.'" Pandemonium. She snatched the band leader's baton and voices roared out the battle hymn that would make Yankee soldier boys famous.[19]

So there was that side of Alex, flirting with actresses and the world his oyster.

And what of Alex's mother Ida? Now at Harvard, Sargent's pencil portrait was done in 1917 when she was almost 80. It's a strong face, but not a welcoming one, the eyes narrowed, and the mouth, if not pursed, headed that way. Higginson said he liked the severe in most things, including women. She was unfortunate in the millinery fashions of the time. A passport photo shows her grim faced and big jawed under an exploding cabbage of a hat. Her stepmother had no doubt seen to her polishing to enter polite society, to run a household. There were three, one in the city, two in the country. The 1880 U.S. census records four Irish-born female servants for Boston alone, and in his memoir, Alex recalls lovingly the boatmen and stable help of his youth. Ida had her motherly side, delighting him with stories about growing up in Germany. He does not fail to record her disapproval of country sport as his life's calling. She was, after all, the daughter of a famous scientist and told him he should find his life in science, as had her brother. "Although my uncle, Alexander Agassiz, was a very distinguished scientist, I was a little frightened of him."[20] His

namesake did try—for a bit. And, while Ida rode with her husband when they lived on their cotton plantation, she had no real understanding, no love of horses, and hated to watch her son ride in steeplechases. She spoke German and French, and could hold her own in conversation, and as we shall see, told Sargent that Henry James's characters had no vitality.

Her son admired what his parents had made of marriage. Their "early days tried them out, as it were, under every sort of condition, and welded them together. My father was a very quick-tempered man, but never in all the days I lived at home did I hear a single cross word spoken."[21]

Ida's days in Europe had come to an abrupt end. Motherless at twelve, a city girl who was translated to countryish Cambridge where her Swiss father Louis Agassiz founded Harvard's department of natural history, she was lucky in her stepmother, the lively patrician Elizabeth Cabot Cary, in age more a young aunt or older sister. Her own little family was intact: older brother Alexander Agassiz, who used his geology studies to make the Higginson fortune in copper, and her pretty younger sister Pauline, who would also marry well and introduce Boston to the kindergarten, a German invention. The given names of Ida's children come from her side of the marriage: Cécile for her mother who had died when she was four, and Alexander after her brother. And while there are hints of less than robust health, she lived to be almost 96, bright and cheery at 94 when Alex last saw her for what turned out to be the last time. This was in September 1933, and he would sail the next day for England, where he now made his home, kept his hounds, and hunted his foxes. They dined together at the Agassiz. A few days before, they had listened on the radio to a ranting speech by Hitler who had been named Chancellor on 30 January 1933. "She understood it even better than I did." Dinner over, and the fond farewells, she hurried after him to ask if he had everything he wanted. Yes, yes, he assured her. But impatient, she kept on, whispering: "*A tu assez d'argent?*" As Alex was to recall in his memoir, that question was "that dear old lady's last kind thought for her spendthrift son, whose habits she knew so well."[22]

By any personal measure both Higginsons followed their own line of country. Old Alex recalls his younger self: "I was a very obstinate little boy and took a violent dislike to most things I was asked to do, on principle—a characteristic which I am afraid I have retained all my life."[23] By any financial measure, father and son spent freely and gladly on their chosen pursuits. For years, Henry picked up the annual deficit of his Boston Symphony, something like $30,000 a year. So, if anything, Ida's husband was more the spendthrift than her son. There were two estates to maintain. The gentlemen's farm at Manchester was as much home as Boston. The rustic lodge at Rock Harbor on Vermont's Lake Champlain

was for the fall foliage, and another Higginson delight: chopping wood. A day well spent was eight hours of reducing trees to logs for the fire, with Alex often wielding an ax. There were horses, trotters and hackneys, and a stud groom and stable hands to pay. On the other hand, yachts held no appeal—he did not like the water. While tycoons might own their own railroad car, Higginson rented when need be. He liked to live well, and live generously. For Ida, he imported 200 English rose plants to plant at Sunset Hill, their Manchester estate. He bought her a Steinway piano. He bought art. He liked shopping, lavished the best on their residences. That the butter was spread pretty thin may account for his reputation as a late pay. Had his personal papers not included a letter from a New York doctor hoping to settle a year-old bill, we might not have known Ida was treated for psoriasis, a skin condition that can also punish torso, palms, and soles.

If there was one single example of Alex's spendthrift, money-wise as well as emotional, it was the very large box of ashes that puzzled a customs inspector in England. Alex had shipped all his furniture to England. Looking for contraband that would be dutiable, the inspector asked what could be packed in those ashes. Nothing, said Alex. They are "simply the wood ashes taken from the fireplaces of my old home across the water ... I always like to bring the ashes from one house to another, when I move." The inspector: "Do you mean to say that you have gone to the expense of shipping a thousand pounds of ashes—just plain wood ashes—across 3,000 miles of ocean, for sentimental reasons only?" Alex: "I do. I have always done it, and it may be that someday, if I move back across the ocean again, those ashes will come with me."[24]

Now while the sporting gent is one of the gilded figures of the Gilded Age, Alex was not necessarily a playboy, and his life was not as frivolous as we might think. There is no denying a fine horse cost ten-fold what he paid a man to look after it. Agriculture—the landscape of his life—had benefitted generally from the scientific turn begun in the late 18th century. Farmers who could afford it began breeding animals with proven pedigree to improve their livestock. Every gentlemen farmer of the Higginson generations bred for quality, Henry importing a hackney stallion and brood mares to improve carriage driving, and Alex was not alone calling his own efforts his hobby. Take just the phenomenon of the thoroughbred horse which transformed the native English stock. At the turn of the 17th century, three aristocrats each imported an Arab stallion, known forever more by its new owner's name: the Byerly Turk, the Darley Arabian, and the Godolphin Barb. When bred to the coarse English mares, and that offspring rebred and interbred, there soon appeared a purebred, the speedy thoroughbred, beating the local talent on the turf. Thoroughbred racing began in America on Long Island in 1665.

The same idea of breeding for desirable traits, when applied to farm animals, produced pedigreed cows, each breed developed for, say, butterfat content (Jersey) or meat (Angus). As versatile as Al Capp's Shmoo, a hen called the "American chicken" was as rich in breast meat as prolific in eggs.[25]

Dogs, too, came under scrutiny. Those that raced in the British Isles, lurchers and greyhounds, were registered to keep contests honest. When dog aficionados began to prize beauty of breed over function, kennel clubs were formed, America's in 1877. Alex had a foot in both. At the estate in Lincoln given to him by his father, he bred Ayrshire cattle, Scotland's red and white milk cow. Dogs were a common interest with his wife Jeanne. She bred and showed wire-hair fox terriers, and her West Highland white terriers were among the first in America.[26] From acquiring fox hounds so he could have his own hunt in Lincoln, he would breed them in Britain for a hunt he took over at Cattistock in West Dorset. He became a noted judge at hound shows, including Britain's Peterborough, which set the standard for Best Unentered Hound, bitch as well as doghound, or those not yet put in a pack for a season of hunting, or Best Young Entry, a hound in its first season. The fine points were, by tradition, discussed at length during the hospitality of the Puppy Show luncheon with its speeches and awards.

Alex saw himself coming at the tail end of the Golden Age of Sport, by which is inferred the amateur with deep pockets, not the paid professional. His racing days behind him, he was a historian of fox hunting in America and Canada, compiled hound stud books for England and America, and judged hound shows. He also kept diaries, and these are the source for his 1951 autobiography. It begins with the delight of a grey rocking horse for his second birthday, decorated with daisies and primroses stuck, by fond parents, in its bridle, and ends when he resigned as Master of Fox Hounds in England, sold his pack and contemplated "going to ground," like the wily fox who hides to live another day. The 300 pages are specialty reading, fascinating for his life in the cream of the horse world but dull for the chronicle of the plays he saw. The stage career of his much younger third wife, actress Mary DeWolf Newcombe, tested their marriage. But it is not every callow youth who was asked his opinion of Shaw's *Man and Superman* by an equally callow youth, a 30-year-old actor who wanted to put it on in America. Not notwithstanding the brilliant dialogue, Alex opined it *read* better than it would *play*, and advised cutting an act. It was a hit in America, but not till 1905.[27]

Like most established pursuits, fox hunting has its own lingo, its own music. Here is one of Alex's accounts of a day in the field. Listen to the verbs. Remarking that the wise Master breeds and hunts hounds that suit his country, he finds beauty has little to do with performance, that

his Virginia host's odd-looking and long-eared hounds gave good sport. There was a spot of snow in the air, but the scent of the fox lay well. "We found our first fox in a broomsedge field where he had been hunting for mice, and hounds getting away close behind him, were off almost before we knew it, and streaming over the lovely country ahead." Alex hardly had time to jam his velvet cap over his head before the first fence on his borrowed steeplechaser. The huntsman, a club staffer, "rode easily at the tail of his flying pack," and the Masters ranged left and right. "Hounds were running well together, heads up and sterns down, just flying ... and swung into a little wooded hill. The Master slipped over a low wall and [in a few minutes] we were again in the open, with hounds still going on, at top pace and still screaming at him." The next 25 minutes were effortless, "the big timber fences seemed to come to one, as we raced along ... In spite of a little flurry of snow, the going underfoot was almost perfect." Then came "a very welcome check, and hounds were at fault for a bit in a wheat field, but presently hit off the line again and ran on for another twenty minutes, finally losing their fox along the bank of a little brook, where he probably got to ground, although they did not mark him." This was in the 1920s, and Alex had another 30 years to ride.[28]

Now, of course, all this cost money. He had a small inheritance from his Higginson grandfather, but that went for a racing yacht. He lived somewhat off the stock of the R. J. Reynolds Chocolate Company of which he was vice president. But it all started with his father, and a confrontation scene that could have come from a Victorian novel—Trollope comes to mind (he rode to hounds four days a week)—or a morality play about the Prodigal Son.[29]

It was 1901, and Alex was 25, married and the father of Henry Lee Higginson II. He had designed and raced yachts. He had applied himself to ornithology, dragging his brand-new wife to the west to track the zones of birds for the Bureau of Biological Survey, information that had a bearing on agriculture.[30] A year of ornithology was enough. Back home with Rosamond, he bought an old farm in Lincoln, converting a chicken coop into a kennel. He hunted with the best packs, and was developing his own hounds.

"Sonny," quoth his father, "you're getting older and I don't see that you're getting anywhere. You've got a boy and a home, and you ought to think about what you intend to do with your life. You're luckier than I was—at least you're luckier in some ways—for you can choose and I couldn't. I had to earn my own bread-and-butter or starve; and although, as you know, business in the sense in which the word is commonly used, did not attract me—for I wished to study music—I had to adopt the course I did." Then, well aware of the family dynamic, Henry tells his son: "You

thought—or to be more truthful, your mother thought for you—that you wanted to become a naturalist." If not the work in geology that absorbed his scary Agassiz uncle, she could countenance the study of ornithology in beautiful country. "Time has shown that that is not what you are fitted for."

Then: "You are not lazy, and I know you are not vicious"—a lovely Victorian word concerning morals—"though you are terribly extravagant."

Then the comedy of a would-be CV: "The career of a newspaper reporter—you remember you once suggested acting as Yachting Editor of *The Globe*—is not worthwhile. I think you see that for yourself."

What then should Alex do? His father could see only two courses. One was business. Perhaps join him at Lee, Higginson & Company and learn investment banking. "I suppose I could give you a start; but I don't want you here, because it would bring us into a relation, which would, I am sure, end unhappily for us both." Perhaps start at another firm. "Begin at the bottom, clean ink-wells"—few typewriters existed—"and run errands; and someday you'd probably be taken into this firm, and earn a good deal more than I can give you. Do you like the idea?"

Alex shook his head. "No, I didn't think you would, and I'm not sure that I blame you. You would have to give up your yachting, and your hunting and all the pleasant things the country life brings."

Then, the good news. "The other course is one that I wouldn't have allowed you to follow a few years ago, before you were married, and before I had seen that you *worked at your sport*. You can live on your place at Lincoln; I'll build you a better house there someday"—and he did[31]—"and you can live the life of a country gentleman."

The breed was in need of refreshment. There are not many country gentlemen in America, said his father. "The boys you know are either in offices or else they are good-for-nothing loafers. But you don't drink, you don't gamble, and you don't keep a mistress; and I can't see why you won't be better off leading the kind of life you like than any other way."

He asked Alex to sleep on it, reminding him that business would pay better. "You're all I've got, and I'll leave you all I can. I may lose it all," Henry smiled, "but I don't expect to." The next day, Alex said he had decided on "liberty."

His father reached for the cigarette box on his desk. He lit up, and smoked for long minutes in silence. "All right," he said. "I'm not sure that you are not right. *I couldn't choose.*" Curtain down.[32]

Henry was as good as his word. He built Alex a house fit for an estate, and barns and stables as well. Sometime about 1913, Alex was driving back to Lincoln with his boy after a theater matinee when he noticed a

glow in the sky. "Sonny, that's our place; either the house or the stables," and urged the chauffeur to hurry. It was the stables, loose-boxes organized around a court yard, which he had designed after the English style. There was every equine comfort, the horses in knee-deep straw, with hay on demand from racks. In those box stalls, horses were not tied up and so were without halters. Some did get out (the fire alarm was sounded well in time), but there was no way to secure them, and, as horses will, several ran back into the blaze. Balford and Sir Wooster and the White Pony, "All gone, sir," said Daniels, the stud groom, tears running down his face. "We got some of them out, but they ran back in." Of his 26 horses, few survived. Alex's butler John named them: Black Pine, St. Patrick and The Ace of Clubs.

"My father telephoned that night," Alex would write. "He had read of the calamity, which had been reported in the late editions of the evening papers, and the next morning, he came out from Boston." About the catastrophe he "was kindness itself," and gave his son *carte blanche* to buy new hunters and build a better stable on the site of the old.[33]

The boy who had gone to the matinee, then witnessed the carnage, was Henry Lee Higginson II. He died on 16 October 1981, in Ponte Vedra, Florida, at 81, almost a hundred years to the day of the first performance of his namesake grandfather's Boston Symphony on 22 October 1881. In an obituary in *The Boston Globe* on 23 October 1981, there is mention of Navy service in World War II but none of education. In one of Alex's Harvard Class Reports, he says his son could not pass the exam to get into the college but thinks he will turn out all right. Further: "My boy doesn't have the heart for horses," so no hunting, "but he's very interested livestock breeding." *The Globe* obit describes him as a dairy farmer, and poet laureate of Ponte Vedra, a member of the American Poetry Association (not the American Poetry Society). A daughter, Cecile Higginson Murray, has served as a Boston Symphony Orchestra overseer. The second Henry was buried in Mount Auburn Cemetery, Cambridge, as was his grandfather in 1919, the first Henry going to the grave with undergraduates lining the route after the simple service in Harvard's Appleton Chapel with the Boston Symphony playing Handel's Largo.

Alex was in on the death. He had dined with his parents, the last time all three were together. His father, though a bit tired after a day at the office (he was within four days of 85), was happy and cheery. But the next morning he phoned Alex to say he had spent a restless night and sent for the doctor. An immediate operation was advised, or as his father put it, a "slight operation." "I thought you'd like to know, Sonny. Don't worry; it doesn't amount to anything." Alex drove in from Lincoln, and took his father to the hospital. "I remember well his firm step and soldierly erect

carriage as he passed up the hospital steps—to his death—for he never survived the operation and died a few hours later.[34]

Ida Agassiz Higginson, 97 when she died on 6 May 1935, was buried at Mount Auburn, the funeral service taking place there on 9 May. Four years earlier she had sat on the stage at Symphony Hall, a guest of honor, when Serge Koussevitzky, the Boston Symphony's most noted maestro after Henry Higginson's death, conducted a six-day festival for the 250th anniversary of J. S. Bach's birth.

Alex Higginson died 12 November 1958, aged 82, in England at home at his estate, Stinsford House, Dorchester, West Dorset. He and his actress wife Mary had stayed in Britain during World War II. No sooner had she trained and qualified as a Red Cross nurse than she was recruited to found a theater company to entertain British troops, and got friends in America to pay for it. Queen Mary, as patron, attended a production at the Badminton village hall.[35] Alex had served in the Great War as captain in the U.S. Remount Service, procuring Army horses. Now, too old for military service, he helped form farm laborers into a unit of the Local Defense Volunteers in Britain. Hunting continued, as did hound breeding, though catch-as-catch can with the war on. On 2 April 1946, his 70th birthday, Alex had his last day out with the South Dorset Hounds as active Master in the hunting field.[36] *The Boston Globe* obituary of 15 November 1958 lists his clubs, four associated with field and turf and the Lambs Club of New York, associated with thespians and their followers. About his place of burial, the *Globe* is silent. Because he remained an American citizen while living abroad, a death report was required by the U.S. Department of State. Alex Higginson went to ground, as he would say, in Stinford Churchyard. Those fireplace ashes brought from America were never repatriated.

8
Horses

> Of bang-tail fillies and hide-bound colts
>
> After an interval of some minutes, in which both men spent looking around the dash-board from opposite sides to watch the stride of the horse, Bartley said with a light sigh, "I had a colt once down in Maine that stepped just like that mare ... Kentucky?" he queried of her breed. "No, sir. I don't ride behind anything but Vermont, never did. Touch of Morgan, of course; but you can't have much Morgan in a horse if you want speed. Hambletonian mostly," replied Lapham. "You let me come for you 'most any afternoon, now, and take you out over the Milldam, and speed this mare a little. I'd like to show you what this mare can do. Yes, I would."
>
> *The Rise of Silas Lapham* (1885) by William Dean Howells

As a horseman, and fancier of trotters, Henry Lee Higginson would have known this scene with its camaraderie, its insider talk of breeds, its little boasts. He himself had raced friends on the Mill Dam. How much else he had in common with Lapham is doubtful. For the fictional Latham is the personification of the self-made Bostonian, a paint manufacturer who longed to move from the fading South End not just to Higginson's Back Bay but to a mansion on the swell "waterside of Beacon Street." Higginson of course knew the novelist, and, as we have seen, Howells was well connected to an Agassiz family, the Fairchilds. In the 1880s of the novel, we are also in the heyday of the world of the horse. Howells plunges us right into those fast pleasures. Slang escalates. Lapham's "speed this mare a little" will become our "floor it!" Higginson kept off buying

an automobile, never drove one himself, yet invented the license plate. The horseless carriage would never be the same as taking the reins, of sharing the joy of men leaning off the sides of a buggy to watch the piston legs of a trotting horse.

* * * * * *

To look ahead a bit: Oliver Wendell Holmes (1809-1894), the self-styled Autocrat of the Breakfast Table, thought it "worth mentioning" in 1891 that a "new wonder" had joined the "new miracles" of 1882, the telephone and electric illumination. The "electric motor," he declared, was to be the "common carrier." This from one of the best writers on the horse in American life. And so, a few years later came the inevitable sales pitch to Higginson, Holmes's younger contemporary and Back Bay neighbor. On 18 June 1898, on the letterhead of the Pope Manufacturing Company in Boston's South End, a salesman wrote to Higginson urging on him the transportation of the future. "Our president has suggested that you might enjoy a ride in our Columbia Motor Carriage, and we shall be glad of the opportunity to take you for a spin in our horseless carriage at a time when it will meet your convenience." As with car dealers now, the salesman knew to be agreeable. "If you could give us a short notice, telephone us (Tremont 603) or drop a line the day before, we would be glad to send our man with the motor carriage to meet you at any part of the city." R. L. Winkley signed himself "Very respectfully yours."[1]

It would be some decades before this Pope mobile and others like it put Dobbin out to pasture. Like much of America, and Boston, and indeed the world, the Back Bay was horse country almost to Higginson's death (in 1919). The first American railroads were being laid out about the time of his birth (in 1834), the "stage coach" bodies of the first cars giving way to the long box that will become the bullet train. But for purely local transportation, it was the horse, whether ridden or driven. Wars were still fought by horse. On farms horses pulled the plow and got the hay in. Where there was no waterpower for mills, they traced endless circles to grind corn on stone. The Massachusetts state police rode horses, patrolling from Cape Cod to the Berkshires, and today's motorcycle uniform retains the black boots of the mounted unit. Out west, ranch horses herded cattle to market. They were also the fireman of the Great Plains. In 1899, G. F. Woodman of Gladstone, North Dakota, advertised his "Approved Prarie Fire Extinguisher," a steel chain mat covered with asbestos blanket. In the advertisement sent to Higginson, two cowboys drag it between them by ropes attached to their saddle horns. Let us not fail to mention the impact of horse upon the senses. There were the smells, fetid urine but the sweet

breath; the sounds of whinnies and the rattle of equipment; muzzles velvety to the touch; the pleasing (or piteous) sights to the eye. Many countries ate horse; in France, a gilded horse head marked the *boucherie chevaline* of the butcher who sold it. But it was taboo to eat in England and America, though the Harvard Faculty Club served horsemeat for more than 100 years, taking it off the menu in 1985.

Without the horse the Back Bay would have remained water. Although engine-drawn mechanical equipment was employed to excavate and fill the land, work horses did the grunt work, carrying gravel and dirt in carts and pulling graders to shape land. Horse manure even had a function: when boilers on steam locomotives sprang leaks, the engine's fireman would shovel it in, the fibrous material of partially-digested straw sealing the breaks.[2] There were something like 6,000 horses in Boston in the 1800s, many pulling the trams that served as public transit, and that required several thousand men to tend them. In those days, the Haymarket was just that, not the quaint name for a subway stop. Horse traffic raised dust along the first Back Bay thoroughfare, Beacon Street, which, perched on the old Mill Dam, took Bostonians out to the countryside of the future suburbs, Brookline and the Newtons, and beyond. By the time the Hotel Agassiz opened its doors about 1873, every sort of wheeled transport—smart private carriages, sober public cabs, the sturdy wagons and carts of tradesmen, the city's horse trams—traveled the grid of Back Bay streets. Ours is a silent age, the low hiss of tires scarcely registering. Then, streets were noisy with horse, the ring of metals, horseshoe on cobblestone, the creak of carriage springs to absorb shock, the chatter of coachmen to their team. By 1891, some form of "rapid transit" was envisioned by Boston's major and alderman, and Higginson agreed to serve on a committee to promote it from the city to the suburbs. In the country, however, hilly roads were still graded to provide "thank-you ma'ams," or leveled stretches to rest the horse between climbs.

It was an age when livery stables needed no odometer to tell how far a rented horse had been "used."[3]

Let us not forget the horse as companion in sport. Higginson, who sat a horse well and loved to take the reins, will serve in this chapter as representative of those who took their leisure in the company of horses and pleasure in the friendship of horsemen—and matching wits with horse traders.

Return with us to the yesteryear of stable talk, horse tack, breeding (who "leaped," who didn't "catch") and horse dealing, even intrusions of religion and politics. And song: When Stephen Foster wrote about the "bang-tailed filly," everyone knew that her tail was kept long but banged, or trimmed even just below the hocks. There was the brassy music of the

road, as we shall see. Horse people will want to read every word about shoeing and lameness and colic, will nod knowingly that Latham's "hidebound colt" will never fatten. Other readers may sidle along the thank-you ma'ams, preferring to hear less of nags and more of horse owners. So let us imagine all the possible reactions of Henry Higginson when confronted with the death of Adonis. He'd bought the gelding from Sir Roderick Cameron, a bargain which did not long survive the train trip from New York to Boston. Cameron, the Canadian-born shipping company magnate and noted breeder of thoroughbreds at his stud on New York's Staten Island, had paid $400 for Adonis, and Higginson got him for $250 from a Cameron groom. The particulars of the horse's demise are given in this letter of 20 September 1887 from Cameron's son, Duncan Elwell Cameron, acting for his father who was away in London.

"The horse left New York all right and arrived in Boston in the same condition," Duncan wrote, quoting his father's groom, Thomas Jenkins, who accompanied Adonis. They were met at the train by Higginson's coachman and together took the horse to a livery stable close to the railway station. Jenkins did not like the stable, nor did Adonis: "the horse while there would not feed." So Jenkins rode him to a second stable. There, Adonis developed a chill and touch of colic. It was now evening. Jenkins telephoned for a veterinarian who took two hours to arrive. The next morning Adonis seemed better and at 11, Jenkins left for New York, believing "the horse would get over it in two or three days." (As horses do.)

Adonis "having left New York in perfect health," young Cameron does "not feel authorized to refund the money as the horse was sold to you in New York, or rather at my stable." Then a stinging PS: Jenkins "further says that if yr coachman had remained and taken care of the horse instead of leaving him sick to strangers, he believes the horse would not have died."

Across the settled agricultural world, the horse was a part of the language, whether expressed by simile or metaphor, and in English it lingers on in "working like a horse" or "eating like a horse." For the unobtainable: "If wishes were horses then beggars would ride." We still speak of "horse power" for automobiles, though more rarely of the "iron horse," for locomotives, and more rarely still of "getting about on Shank's Mare" ("Shank's pony" in Britain) for the horse-less who had to walk.

The common soldier shanked it, as did a Higginson friend and investment client, the future Supreme Court justice Oliver Wendell Holmes, Jr. (1841-

1935), when he was a private in the Civil War. When promoted to captain, however, he had to learn to ride. The mounted leader was a symbol of command, but there was a practical reason as well. A man stationed five or six feet above ground had a clearer view of their surroundings than the foot soldiers below. Years later, with the war (and horses) still within living memory, Holmes's contemporaries would understand his likening a bad situation to the army's poor opinion of cavalry saddles. None was satisfactory: "one strained the man—another galled the horse."[4]

We owe a lot to the horse for models for horseless transport. People admired its powerful beauty, its music. The war horse in the Bible [Job 39:25] "sayeth among the trumpets Ha Ha." But as Matisse said about getting milk from cows, one had to put up with the "inconvenience, the mud and the flies."[5] And so we tinkered to produce a horse without the horse. The bicycle was itself a sort of equine steed, first called a dandy horse, from the French dandies of the 1790s, who propelled themselves from a saddle by walking their feet on the ground, or shanking it, if you will. This was also called *vélosopede*, which the French still shorten to *vélo*. Just as the first trains were stage coaches, the motor was also horseless, a carriage whose body would look eerily like a buggy till the early 20th century, and was doubtless as mind-boggling as the robot car introduced in 2014. "But where are the reins?" becomes "where's the steering wheel?"

And when autos came to the end of their useful life, and were scrapped, no pall hung over their demise. Even for the most beautiful (the aforesaid Adonis) and talented of the equine kingdom there was no horse heaven. The dead urban nag was only so much garbage and by the hundreds was burned on islands in Boston's inner harbor. The smoke and stench from smoldering carcasses was a fact of travel for adult passengers on the various shipping lines, something to be borne, but a thing of horror for youngsters. It was forever in the memory of two young brothers, Wolcott and Buckminster Fuller, of Milton, who, about 1904, would board a boat at the Boston Steamship Line dock at five in the afternoon and wake up before dawn in Maine to spend the summer on the family's island in Penobscot Bay. The boys knew the clear air of Boston's outer harbor lay ahead, but first they had to pass the city prison on Deer Island, barely visible in the smoke of burning horses. If they could scarcely breathe, they shuddered thinking what it must be like for the inmates.[6]

The Columbia automobile offered to Higginson was the venture of a fellow Civil War officer, Colonel Albert Augustus Pope, whose Pope Manufacturing Company had its own building on Columbus Avenue in Boston's South End. We will meet him at greater length in the chapter titled "Outdoors." America's first bicycle tycoon, who capitalized on—nay, monopolized—the country's craze for cycling in the last two decades

of the 19th century, Pope was now moving up from two-wheelers (three if you count the popular tricycle) to the four of the horseless carriage. He would make one fortune on the dandy horse and lose another on the horseless carriage. And why should one shank at all? Why ambulate when seats on a "moving sidewalk" would carry you thither and yon? That was the promise of The Multiple Speed and Traction Co. of Chicago inviting investors, Higginson "and other Americans interested in solving the problems of Rapid Transit," to come to the Casino Pier of the World's Columbian Exposition "and examine our road on the spot." In his three-page letter of 5 August 1893, consulting engineer Max E. Schmidt says, "hundreds of thousands of all ages and both sexes have already been carried without accident or delay" on the mile-long road. The contraption was noiseless, cheaper than an Elevated train to build, and passengers would pay two or three cents a ride. "These low fares can be maintained and pay dividends on the investment."

In the mid-1890s, however, other Bostonians had more faith in horse power itself, and saw the need for scientific care of horses. Interest in "model stables"—and "model dairies" for cows—led to debate of the best flooring in stalls, given the fragile nature of horse anatomy. Wood was kinder on the joints, as was earth, but cement could be hosed down, thus promoting sanitation. And there was the holistic approach, ways of treating the whole horse; one advocate was Francis H. Appleton, who hoped to interest Higginson in supporting a veterinary hospital. Harvard Class of 1869 and sickly, Appleton thought country air would restore his health, and when Harvard opened an agricultural department in 1871, he enrolled in its Bussey Institute to learn the scientific basis for farming, which he then put to use on his estate in Peabody. A century would pass before any of the six New England states would have even a veterinary school. In 1978, enterprising Tufts University, whose own medical school was among the country's oldest, saw a market for the treatment of the small animals of the pet world, and went on to found a department for large animals as well. This opened in 1982 in the stables of what had been a state hospital in Grafton, Massachusetts.

By then, the horse was largely a recreation, or the creature of nostalgia, in the "discovery" of heritage breeds to work boutique farms, and Grafton had treated many a noted race horse. Appleton's veterinary hospital was intended to serve all in agriculture and sport. His letters of 19 and 23 November 1895 are of interest for what today would be called a public-private venture. He had already got through the Massachusetts legislature the bill "creating Veterinarian Commissioned Officers in our State troops," then horse units, and the New York State Veterinary Association "not long since" asked Appleton how he did it. For the care of all horses and,

one supposes, cattle and farm animals as well, a veterinary hospital was the next step. Appleton's (and Higginson's) "friends of Harvard," would push it, and the state would pay the bills. Appleton saw the propriety of that. "I feel that, to secure the <u>establishment</u> of a Veterinary Hospital … it would be perfectly proper for the friends [of Harvard] and future users of it to petition the Legislature for money to <u>establish</u> it; and the animal owners and others, who felt its benefits, to support it." Appleton confided that they'd "better ask" for $10,000 than $5,000 to $10,000 for a three-to-five year appropriation. This money "for assisting so desirable a foundation at Boston, both from a sanitary and a veterinary standpoint, seems to me most proper." Appleton wanted it housed at Harvard-friendly Massachusetts General Hospital. He was savvy about fund-raising, and, here we see his understanding of Harvard's dictum, "every tub on its own bottom." Thus "friends" and users but not college "authority," or its officers, should work for passage and pass the hat if needed. Should the Legislature not see it Appleton's way, "a second young Veterinary Hospital would not receive state money & Harvard alone would be free to prove the value of the Hospital … Later other cities might desire to copy it." … "The M.D.'s, and veterinarians, both concede the need of it."

It is one of life's ironies that just as a force in our life seems perfected there is no further use for it. Thrilling as horseflesh as they are, the Budweiser Clydesdales—hunks of horsedom with their white stripes and feathery white feet—work more on TV pitching beer than as dray horses of old delivering the local brew. (That's appropriate too: the first of Anheuser Busch's eight-horse hitches was introduced on 7 April 1933 to cheer the repeal of Prohibition. From St. Louis, August A. Busch sent a team and wagon east by train, even delivering a case of beer to President Franklin Delano Roosevelt in the White House.) But there they were, Appleton and Higginson, in 1895, organizing the future healthcare for a beast that would soon be displaced by mechanical horse power. Within Higginson's lifetime the perfect war horse would be bred. Patriotic Americans lent or gave their stallions—thoroughbred, standardbred, Morgan—to the Army Remount to service local mares, glory years described by Phil Livingston and Ed Roberts in *War Horse: Mounting the Cavalry with America's Finest Horses*. But until the Army entered the breeding business in 1911, the cavalry rode what it could find cheap. Good horses were crucial. Commanders, like England's Wellington in the Napoleonic Wars and Grant in the American Civil War, rode great distances, and fast, behind the line of battle. Wellington's fifteen chargers "had scarcely any flesh on their bones—so much were his horses used."[7] Grant's great horse, Cincinnati, stood a towering 17.2 hands, and like his four other mounts, was expected to carry the rough-riding general down gullies and over water and fences.[8]

The result of the Remount Service was indeed an improved cavalry. But useless against machine-gun nests in war.

✳ ✳ ✳ ✳ ✳ ✳

Very few letters to Higginson are annotated with his response. He answered a good deal of mail himself, by hand, and he dictated replies to his secretary. From the content of other letters to Higginson during these decades, his heart lay with horses. "He disliked motor-cars, fought against them for years," his biographer Bliss Perry wrote, "and then one day, happening to ride in a big car that caught his fancy, he proceeded to buy two of them!"[9]

Little is known about Higginson's own stable of saddle horses, and if he kept any in Boston to ride. (His son Alexander recalls his father had a stable on upper Newbury Street.) He was still riding in 1897, aged 63, when on 23 April a friend named C. F. Morse writes the teasing letter of one Civil War comrade to another. Morse will come east from Kansas City to ride in a parade with Higginson and others. "I still keep my 'riding legs' with me so you need not be so particular about the 'very gentle' horse if he is well mannered and has a proper respect for people outside the ranks. You do not say whether you will button yourself up in your old uniform coat but I assume that you are … If you think Jim Francis needs any additional spurring I will write to him and 'order' him out."

Higginson's riding was hacking for pleasure. The North Shore of his Manchester estate was open country. "My dear Henry," wrote E. F. Bowditch from Millwood Farm, in Framingham, on 31 May 1888: "My man reports that he left 'Gloucester' all night at Saugus Stables [midway to Manchester] and I hope he will get to you in good condition. Nat [unidentified] told me you were going to have him ridden down, so I had him led by the side of another horse and he went very quietly indeed. I wish you many pleasant rides on him."

In May 1899 he pays a New York City dealer $950 for Garland, a chestnut saddle horse, and $600 for an unnamed bay mare. That Garland could also be driven was in his favor, and the dealer, in the way of dealers, was sure all would work out even though "Garland has not had a harness on him in over a year." The advice: "Hook him with a plain snaffle [bit]—martingale [to keep his head down]—breast collar & go ahead. May seem a little awkward first off but you can trust him. The mare has always been driven with the same sort of rigging with the addition of a check [rein]".

Riding for pleasure was popular and Boston well situated for excursions on horseback. For the city equestrian, male or female, there were livery stables with hacks for hire, riding schools and riding clubs, and horse

shows for polite society to show off rider and mount, driver and rig. The New Riding Club, built in 1891 to Williard T. Sears's design at 52 Hemenway Street, offered an indoor riding ring for lessons and exercising. (In 1934, the ring became courts for the Badminton and Tennis Club, of which the Agassiz's Robert Manning, editor of *The Atlantic Monthly*, 1966-1980, was a member.) But a block away from the riding club were the bridle paths in the Fenway, and the elm-girt Fens on the Back Bay's western edge was a gateway to the countryside around Boston. This sylvan expanse along the Muddy Brook was part of the Emerald Necklace of parks, designed by Frederick Law Olmsted, more famed for New York's Central Park. Although Olmsted much preferred Bostonians to walk in silent appreciation of Nature he was obliged to provide bridle paths and carriage ways.[10] The use was heavy: a census of Boston's parks taken between 1 and 7 p.m. on 28 October 1894, recorded 86 saddle horses, and 3,479 carriages alone on the Fens and Riverway, including 1,208 carriages in a single hour.[11] A rider who benefitted was the Agassiz's young Alice Towne, whom we will meet when Higginson sells her a saddle horse.

When in Boston, Higginson often walked to work. In Manchester, he commuted by train. On summer mornings, to get a drive in, he would take the reins and head the horses for the eight o'clock train to Boston. Recalls his son Alex: As "he was very fond of driving, he often left the house half an hour before the train was due at our local station and drove down the Shore Road behind one of his trotters—the groom meanwhile boarding the train at West Manchester and remaining on board till it reached Montserrat or Beverly, some eight or ten miles down the line. Then he would get out and take the horse, while the 'old man' would board the train and go on to Boston. I used to go with him, driving back with the groom, and as the years wore on, I was presently allowed to 'let him out' when I came to a straight piece of road, although I was not supposed to do so."[12]

For getting around country and town, Higginson was thus in the market for the family horse, and the roadster. For sport, he cherished trotting horses.

And for one brief year, in the early 1890s, his passion was for the showy hackney driving horse. He sent a man to England to buy the best, intending to breed the best from the best, and, as a prospect, he bought a young bay stallion called Enthorpe Performer, foaled in 1889. He built a model stable for his future stud. In September 1891, the horses arrived. Higginson was as "excited as a boy over them," his son Alex said, recalling "the night they came down by special train from Boston and were unloaded at Manchester."[13] For a man who demanded Symphony Hall be a "plain" building and whose own residence, the Agassiz, was as plain as they come,

the flashy hackney may seem an odd choice. In 1891, he was 57, perhaps mindful of Time's winged chariot.

A carriage breed, the hackney was all high-stepping action and it gave carriage driving an engine for elegance. It was not necessarily the fastest driving horse: the hackney gait was a churning trot rather than the long stride of roadsters and the standard bred, or *vroom vroom* versus *click click*. But hackneys hitched to a smart rig made driving a sport for the gentleman amateur, and, with a groom or "tiger" in attendance, a stylish recreation for ladies driving themselves. Although fortune would favor Higginson through investments, he was not born to great wealth. Nor was he in the chips as a young man. But he worked hard, traveling often in the early 1870s to New York on business for Lee, Higginson & Company, and would write to his wife Ida: "I've turned a penny for you, and hope one of these days to see you driving your own wagon."[14]

The showy hackney was nothing to the shining thunder of the coach and four-in-hand. The children of the Agassiz's Fairchild family were treated, the day after Christmas in 1896, to a more comical excursion to Brookline in Thomas Jefferson Coolidge's rig. And what fun it was, Jack Fairchild wrote his sister Lucia. "This afternoon Jeffy Coolidge took all us boys & girls out in a Tally Ho to [T]he Country Club when we had afternoon tea! And all the way over whenever we passed a particularly swell carriage Jeffy would toot on a very small baby's tin horn for we had not regular coaching horn." The real thing was four matched horses, harnesses glittering, owner on the box, grooms in livery, and a cargo of ladies with parasols and gents in toppers, and, from the long golden coaching horn, the sweet carrying honk that was as much a boast of deep pockets as a warning to get out of the way. That the horses should match in color and breed has produced some novel hitches, a send-up of orthodox hackneys and other carriage-breds. The most striking was the zebra team which the British zoologist Lionel Rothschild drove about 1910. As careful examination of the photo reveals, one (the lead nearside animal) is a ringer, hidden by the three-striped kind. But then zebras, unlike horses, are notoriously difficult to train. It was much easier for Walter Eayers to train four old polo ponies, matching chestnuts with roached manes, which he showed at the Four-in-Hand meet at The Mount, Edith Wharton's estate in Lenox, Massachusetts, in October 2008.[15]

Only a year later, in 1892, Higginson would dispose of his hackneys. He told his son little about the whys: "I know he himself was very much disappointed at having to give it up." Perhaps it was age: "Father was a sportsman at heart—but he was always too busy to indulge himself that way in his early years, and I think in later life, when he had the time to do it, he had lost to a great degree the desire."[16]

Let us hope the horses gave him pleasure. They were not easily sold. Enthorpe was still his in 1893, still a contender for highest hackney honors, and perhaps Higginson gave him his last hurrah at New York's Madison Square Garden horse show, the great annual display of bloodlines, equine and social. For on 23 October, the acting secretary of the National Horse Show Association of America writes that should Enthorpe win a first prize in his classes, he will be eligible for the Challenge Cup as a post entry. "Yours truly," James T. Hyde, who encloses a "bill for entrance fees, stalls and boxes."

As would happen with the motor car, what one buys dear, one sells cheap, and horse dealers were known to cry poor, insist they were stuck with more inventory than they could move, but willing, always, to do a fella a favor and dicker. Thus, on 24 August 1893, the shrewd H. G. and R. Cheney of the Manchester Hackney Stud in Connecticut move in to help Higginson out:

"Dear Sir: We have heard, indirectly, that you contemplate disposing of your hackneys. Business and the business-outlook are so poor that we do not feel justified in making any kind of an offer to you, but should you decide to dispose of your stallion at a low figure, we should be glad to know it, and might find some way of taking him off your hands.

"We already own one of the best hackney stallions in this country—Dr. Parker—so are not in need of a horse for stud purposes. It is only our interest in hackney breeding and a desire so see 'Enthorpe Performer' safe into 'hackney' hands, where he may have a future, that induces us to write." The fear here, one guesses, is inferior mares might be bred to him, cheapening the blood line. Lest that happen, Robert Cheney was a founder, and president, of the American Hackney Horse Society in 1891, its goal to register "high class" full and half breds "together with the prices secured."

Higginson's reply was quick, and on 29 August, the Cheneys make an offer, but not before tightening the screw. They spied out the most likely buyer for the Higginson hackneys, their "cousin" who had taken the "Dexter place" in Beverly for the summer. This was most likely a name known to Higginson, but not divulged in the letter. "Owing to tight money matters we were unable to convince him." Unfortunate, indeed. But the Cheneys see a way out. "Rather than see this matter drop, we will ourselves, make you the only offer that seems interesting to us, and which we gather from your letter you desire us to do. We will give you our joint note for $5,000 at 5.7 [percent] for one year, from Sept 1, 1893, and take the horse 'Enthorpe Performer' and mare 'Princess Royal,' subject to our veterinary's Examination. This is all we are able to do, as the addition of more stock than we now have —i.e. 26 head—necessitates new stables,

and more grooms, which we do not care to go in for this year." "High action" at the trot is often likened to the sewing machine, and, for what it's worth, the next owner of Enthorpe Performer was the president of the Singer Sewing Machine Company, Frederick G. Bourne.

※ ※ ※ ※ ※ ※

Higginson's ownership of harness horses went way back. He chose trotters over the slightly speedier pacers, and as a young man he loved nothing better than to race on the old Mill Dam with such friends as Greely Curtis, a cavalry major, and John Shepard.[17] Here is Silas Lapham enjoying just such a splurge of speed—to the envy and admiration of the throng. It is winter, and he is taking his wife for a drive.

> The sleighs and cutters were thickening around them. On the Milldam it became difficult to restrict the mare to the long, slow trot into which he let her break. The beautiful landscape widened to the right and left of them, with the sunset redder and redder, over the low, irregular hills before them. They crossed the Milldam into Longwood; and here, from the crest of the first upland, stretched two endless lines, in which thousands of cutters came and went. Some of the drivers were already speeding their horses, and those shot to and fro on inner lanes, between the slowly moving vehicles on either side of the road. Here and there, a burly mounted policeman, bulging over the pommel of his M'Clellan saddle, jolted by, silently gesturing and directing the course, and keeping it all under the eye of the law … "I'm going to let her out," Lapham said to his wife, and he lifted and then dropped the reins lightly on the mare's back. She understood the signal, and, as an admirer said, "she laid down to her work." Nothing in the immutable iron of Lapham's face betrayed his sense of triumph as the mare left everything behind her on the road. Mrs. Lapham, if she felt fear, was too busy holding her flying wraps about her, and shielding her face from the scud of ice from the mare's heels, except for the rush of her feet, the mare was as silent as the people behind her; the muscles of her back and thighs worked more and more swiftly, like some mechanism responding to an alien force, and she shot to the end of the course, grazing a hundred encountered and rival sleighs in her passage, but unmolested by the policemen, who probably saw that the mare and [Lapham] knew what they were about, and, at any rate, were not the sort of men to interfere with trotting like that.[18]

Scenes like that were common, Currier & Ives prints on the hoof. In the second half of the 19th century, Boston boasted at least three driving clubs

and racing associations: the Readville Race Course, South End Driving Park, and the River Side Riding Park in Allston (this was later Beacon Park). The last vestiges of these disappeared in 2015. In 1865, Beacon Park issued a lithograph of the speedy roan horse, Capt. McGowan, trotting full out to set the world's record for 20 miles in one hour, actually 58 minutes and 25 seconds, pulling a high-wheeled sulky.[19] The low-slung modern sulky was well established by 1928, when the *Boston Herald* photographed C. F. Adams (an owner of the Boston Braves baseball club, founding owner of the Boston Bruins hockey team, and president of First National Stores, a grocery chain) urging his trotter Silk Aubrey after the "rabbit" driven by trainer Walter Gibbons. (This Charles F. Adams was not the same Charles Francis Adams who, by 1917, had bought into ownership of the Agassiz.)

Friends and breeders from all over wrote about trotting horses Higginson might buy. Just as Higginson's business letters bristled with numbers so, too, his dealings with breeders: in place of the stock price, the best timing at the mile to the fraction of a minute. Breeding was as variable as profit. It began with the bloodline.

"I understand you own Frank Ellis 229 ¼ by [the stallion] Hermes," writes L. C. Underhill, manager of *New York Sportsman*, on 16 March 1889, in the hope that Higginson will allow the horse "to trot this year and get a fast record. Hermes is at my home this year and I have great faith in him as a sire of speed." Underhill and others had watched Frank Ellis "the year he campaigned and know he could trot close to 220 ... if campaigned. Would it not greatly increase the value of your horse and also add much to your pleasure in driving him?"

The American standardbred was English by its foundation sire, Messenger, a thoroughbred foaled in 1780, and imported in 1788. The first races were under saddle through fields. The American line descends from his great grandson, Hambletonian, foaled in 1849, and the "standard bred" breed name means just that, able to trot or pace a mile, at a "standard," then set at two minutes 30 seconds. The one lament about the great trotter Greyhound (1932-1965) was that as a gelding he could not reproduce his kind. Fast and consistent, he clocked an astonishing two-minute miles 25 times, and his record for the mile, 1.55 ¼ stood from 1938 to 1969. The gate of the pacing horse is slightly faster than the trotter. Of all harness horses racing in 2014, a pacer, He's Watching, set the world record of 1.46 for the mile.

How a horse is shod, and the condition of the feet, are factors in speed as well as health, as we learn from a 21 May 1884 letter from Nicholas Baker, a coal and wood dealer with his own wharf at Wickford, Rhode Island. Higginson had sold him a bay trotting mare which Baker hoped to

breed to 2.23 ¼ stallion but needed to know her pedigree. Also: "how she trotted with or without weights," that is, weighted shoes. But she still has those "cornes" in her feet. The hopeful Baker: "She will trot very well just after she has been shod and the cornes cut down."

Much was expected of Woodmansee, foaled 1884. From his dam he allegedly inherited the gait and speed of the Wilkes line, and from his sire the speed and fighting qualities of the Blackwoods. With the fast rapid gait of old George Wilkes, he wears only a 10-ounce shoe forward and a five-ounce behind. "He will be allowed to serve a limited number of approved mares," the 1890 prospectus informed Higginson. Breeding by and for pedigree started in earnest in America in the 19th century, with stud books kept not only for horses but cattle and sheep (with the 20th century came rules about artificial insemination), and several Agassiz families went in for breeding purebreds on their country estates. So social snobbery has its parallel in the animal world, and brings to mind the very first anecdote that Cleveland Amory tells in his 1947 classic, *The Proper Bostonians*. It seems a Chicago banking house was thinking of hiring a young man from Boston's Lee, Higginson & Company. Just the ticket for you, said his old Boston boss. His father was a Cabot, his mother a Lowell, and way back, he was pure Saltonstall, Appleton, and Peabody, and the list could go on. Silence from Chicago. Then a rejection. Not quite the man we are looking for. "We were not contemplating using him for breeding purposes."

There were of course artificial aids that helped performance. One was shoeing. It was a science as well as an art, and much could be blamed on it, such as lameness. Here is a horse dealer, A. A. Allen, worriedly writing on 15 October 1888, just as the Higginsons are about to arrive at Rock Harbor, their country place at Westport on the New York side of Lake Champlain. For their month in residence enjoying the autumn colors, Higginson had paid a thousand dollars for four driving horses, and one was lame. As sellers do, the seller insisted she arrived sound, something Allen doubts: "I said to him if that mare was all wright as you say she was what did you have her fore feet shod with those heavy shoes and the other mare with the light and he said he had the heavy shoes put on the nigh [near, or left side of a driving pair] mare because she did not lift her fore feet as high as the other." Stuck with deception, Allen temporizes: "The mare is not very stiff when she has been driven a half mile or so she does not show it … or that only a practice eye would detect it," and of course she had arrived, warmed up, at Higginson's place. She had her value: "A good kind single driver." Allen had another thought: "I would have a stall fixed for her on the ground when she stood longer than overnight," dirt being easier on feet than wood or concrete.

Breeding was not always easy, nor did bloodlines guarantee return, especially when the market was off. This, from H. C. McDowell of Lexington, Kentucky, on 30 July 1893, ranges from a problem not uncommon with fillies (some prefer motherhood to racing) to divisive national politics. "Your filly has developed so little speed that it is hardly worthwhile to handle her much longer. I have therefore turned her out in pasture. The time was when a filly as beautifully gifted as this one would have been driven a season or two, but natural speed is now too common. Although unusually hard to break, she now drives pleasantly, and as she is handsome and stylish and can trot a 3:20 gait, she should make a fair roadster." McDowell may himself sell his "youngsters," for a reason that Higginson—a financier who vigorously opposed Free Silver—would understand: "I am not hopeful of improvement with the proclivity to free trade and soft money in the ascendant."

And this from John A. Doolittle of New Haven, Connecticut, on 17 January 1890:

"Dear Sir: I understand you own the mare Parana 2.19 ½ and that you have been trying to breed her but have not succeeded very well. As I own a Wilkes stallion and have had first class luck 'catching' some mares that have been repeatedly bred to other horses but have failed to catch, I am writing to you to know if you will sell this mare to me." She will have the best of care, Doolittle promises. "And if you should like a colt from her and I get more than one, we could arrange so that you could have one." Among the references that Doolittle supplies is Hon. C. M. Pound of Hartford, breeder of speedy Clipstone 2.14.

Stud fees varied widely, again determined by the market as well as by blood and the ability of horses (and mares) to "throw" their own desirable characteristics to their progeny. The American marvel was "Figure," better known by the name of his owner, Justin Morgan (1761-1798). An itinerant singing teacher and composer of hymns and fuguing tunes, Morgan lived off the horse's modest stud fees as he rode town to Vermont town. He also hired the horse out, and for 30 years, the little bay stallion, pony-sized at a bit over 14 hands with short close-coupled back and the little ears of an Arabian, was a work horse, pulling plows, skidding logs and drawing buggies, and his get would become the ideal light horse. He had a showy but ground-devouring trot, and was a good ride, spirited but gentle: President James Monroe rode Figure in a muster-day parade. Oliver Wendell Holmes boasted that of his six mares, one was the "prettiest little 'Morgin' that ever stepped."

Higginson's own breeding stallion, Max, was of more modest calling, probably used as a roadster for driving around Lake Champlain. We learn the going rate for Max's services from A. A. Allen of Westport, who writes on 9 March 1889 to ask Higginson what should be charged that season. Allen advises a "single leap" for five dollars. "Stalians are thicker than grass hoppers here. I find that all of those that charge $10.00 tomorrow [come down to] 6-7 & 8 as they can make a bargain. Max is fat as a cub & feels as nice as a horse can and is very pleasant to drive on the road for a stalian and as nice a style as can be found anywhere."

But breeding a mare to Mr. Balch's Boston stallion, Wedgewood, would cost Higginson one hundred dollars, we learn from the arranger of that mating, the founder of L. C. Chase & Co., manufacturers of carriage robes and horse clothing, whose factory at 129 Washington Street, Boston, adorns the letterhead. It was due and payable only when the mare, Naantite, had a live, viable foal, or what is still known today as able to "stand and suck."

* * * * * *

Trying out a suitable driving or riding horse was one favor one gentleman could do for another. E. C. Chase, a partner with Higginson's nephew in Chase & Higginson, which brokered railroad shares in New York, was always on the outlook for driving horses. Thus from New York's Staten Island one Sunday in 1875, he sits down to report on likely candidates. His family is off in Philadelphia. He has trouble writing: "D--- the pen." He is lonely for company, and hopes Higginson will visit when next in New York.

"Dear Henry. I have not been to church. I have been trying a horse for you. The one I tried is not the one you wrote about. I go by 7 am boat tomorrow to try that one.

"The horse I drove today is a good one and what you desire, except, perhaps, the tail which is rather short. He is a fine driver, shys at <u>nothing</u>, carries his head finely without check [rein]. The horse you wrote about I have not seen, evidently. Your description says 15.2 [hands] high 975 lbs—which I think is wrong on your part. 16.2 and 1075 would certainly be better & that applies to the horse I have driven today & the one I shall see & drive tomorrow. If the latter fills the bill I will have Leotard V.S. [veterinary surgeon] look him over ($5.) also a friend & then <u>report</u> to you. I feel the great responsibility, I assure you—I never experienced more (or a worse pen) in my life."

He closes: "Good bye, Yrs. EEC". Then: "P.S. Perhaps I should have said that I never go to church. Mrs. C is a Romanist. I am a Unitarian"—

as was Higginson, who thought it the most tolerant of religions. "We can't ever seem to hit upon a compromise."

From Chase's report we can know of competing fashions in the look of driving horses. Boston snobs used to distinguish between the "short-tailed Forbeses and the long-tailed Forbeses." The first was social shorthand for the part of the family that liked a graphic smartness, the second favoring the natural look—or horses as art and horses as horse. That the tail of Sunday's horse was short is open to interpretation. Was the hair merely sparse? Or was the tail "docked"? That is, the final vertebrae was not necessarily amputated but the hair cut short at the bone-end so it formed a bush that stood up in the air and looked dashing. A stylish look, standard on hackneys, but considered cruel because a tail-less horse had nothing to swish flies with. Farmers and teamsters docked for safety reasons, as long tails were known to clamp over the reins, and a photo of the 1890s shows docked tails on Boston's tram horses. Clover Adams's saddle horse looks docked.[20]

That Sunday's horse went well without a check rein was in its favor. The check (or bearing rein) ran up the forehead, between the ears and down to the harness proper; it was a sort of leather ratchet. With fashion insisting the horse hold its head high and out, if nature did not furnish this look, the check-rein forced it. True, the check would prevent a horse from seizing the bit and bolting. Measured against that safety factor was real cruelty. As horses breathe only through their nostrils, too elevated a head blocked their air. And a head fixed high meant the horse could not extend its neck, which was necessary when pulling heavy loads on the flat as well as uphill.

Four years later, E. E. Chase is still vetting driving horses for Higginson, and has one F. T. Rand report on what he also saw that May 1879: "He is about 16-1 hands, weighs about 1100, is very well built. Has a good back—short; good-looking legs—very well proportioned. Looks as though he could work & stand it. Apparently a good strong family horse & will answer your purpose. Black offers to drive him under the Elevated Road—says he is a free driver—either single or double," meaning would drive alone or paired with another horse. "[Black] paid $300 for him six months ago & now asks $400. Mr. C thinks & is told that this is a full price for such a horse at present."

By Higginson's prime of life, railroads had put the stage coach out of business, except in rural areas. That was all to the good. Picturesque as sporting prints make the famous English stages seem, the bright paint on the coaches, cocked ears of the horses, and bustle on the streets, one cannot but shudder at the hard life it concealed, post horses pushed to physical limit galloping from stage to stage; and it makes painful reading in English novels, such as the sporting tales by Robert Smith Surtees

(1805-1864) in which a hunting horse, once pride of the field, might end its days lashed to a coach with three others to gallop till it dropped. Nor did Dickens prettify. In *A Tale of Two Cities* (with the mare that shies at everything) the dark and stormy side of the London-to-Calais route prefigures the challenges to come, and the social comedy of *Martin Chuzzlewit* only magnifies the labor of the post horses taking the Pecksniffs from Salisbury to London. Nor was the drunk driving in *Chuzzlewit* a fiction.

To say a horse is only as good as his driver is to state the obvious. They were and are fragile creatures. Letters to Higginson regret unexpected and unexplained lameness, or chills when ill housed in a livery stable, with of course the tendency to blame a groom or stable owner. In a "Dear Henry" letter dated 1 January 1886, W. G. Saltonstall owns up to the driver of his sleigh causing a Higginson horse to spook and kick apart its sleigh—even though another horse had caused the whole shindy by spooking the Saltonstall horse; and would $30.75 repair Henry's sleigh? Coachmen, even those in private service, were universally believed to drive drunk, perhaps encouraged by cold, wet weather on the box. They were far from the majestic figures in the sporting prints. On 20 October 1884, James E. Wood writes from home at 39 Allen Street, Boston, seeking employment with Higginson in the city:

> Sir: I heard that you have not got a coachman and if you have not I am in want of a place and I know the city well and can make myself usefull and I have good habits and I am a good driver and I have worked for Mr Francis Bartlett the last summer and references Mr Bartlett will give you if you are in need of a coachman. I will work for reasonable wages for the winter and I am willing to do other work besides driving if I am wanted to do it, and [around] Horses and Carriages and Harness I am as good a man as in the city to take care of them. Please let me know if you want a man and if you do hear of anybody wanting a man you would please let me know I would be ever so much Obliged to you.

Employment of sober men and non-smokers was necessary for safety. A fear of all horsemen was fire that destroyed livestock as well as barns and stables. "Model" stables might well be constructed of stone, warm in winter, cool in summer, and thought to prevent fire. The prudent horseman stored hay in a separate barn. Even so, the interiors in which horses lived had every sort of flammable material from the wooden stalls to hay for fodder and straw for bedding. Hay itself was combustible, "working" if damp and compacted into a gas, hence the need to air hay lofts, and the handsome cupola on the roof of barns and stables was as practical as

it was a pleasure to the eye. Ben Franklin's lightning rod helped protect against electric storms. But human behavior being as variable as the human condition, most fires had a human cause: the drunken stable hand or coachman who kicked over a lantern, carelessness with the wood-burning, pot-bellied stove in tack or feed room, and of course smoking. Now is not the place to tell of Higginson's country estate and farm in Manchester. But an undated letter fragment, received between 1872 and 1886, paints a picture of stable life as seen by a snitch who did not sign his name:

> Col. Higinson the people of West Manchester think you ought to get a smokink Insurance on your stable as since that smoking Machine of Bartolls has come to your stable it looks as if it was made a smoke house and a Loafing place as those to used to loaf with him at the Dr. stable has followed him to yours and are often seen going to and from yours with pipes in their mouths if you should send a man to watch your place you might find out something that would be of importance to you as there is no doubt that one was burned by the carless use of pipes or matches.

Whatever the cause, stable fires took an awful toll, as we have seen when Alex Higginson lost more than 20 horses at his Lincoln estate.

* * * * * *

Fine horses were (and are) costly to buy and costly to house and maintain. To "keep a carriage" in Boston defined one by purse as well as class. That the horse was a plaything exposed its owner to bitter taunt, such as the biting sarcasm behind the joke that even the rich man cries poor because "polo pony food has gone up again."

There was another divide, and it was the geography of the leisured classes. While most of Boston's 6,000 horses earned their hay as day laborers in the city, the sporting horse was rural in habitat and bred for country pursuits. Feeding in green pastures, tended by skilled servants, he was no common nag. A studbook recorded his parentage. He was trained to a high order. He was loved for his beauty, admired for his accomplishments, and was thus a reflection on his owner. A tour of your host's stables was not easily to be declined. Like E. E. Chase, one might skip church but not a horse fancier's recital of equine begats. People who didn't like horses called them the "dumb blondes" of the animal kingdom. Men were there who surely thought more of their horses than their spouses, though we won't go so far as to call the cosseted beast the "trophy wife" or "arm candy."

To take the geographical point further, the sporting horse sprang from a culture that valued the English landed gentry and copied their pastimes. So it was that horse racing soon took hold in Colonial America, for what man does not want to believe his horse can't run faster than the other fellow's. There was even a political excuse nicely disguised as the animal husbandry wing of agriculture. The flat fields of Hempstead, on New York's Long Island, stretched from the Connecticut Sound to the Atlantic, a land grant that if not settled by the English would be forfeit to the New York Dutch. Where a man farms so might he race, and so it came to pass that in 1665 they were off and running on a course named for Newmarket in England.

By Higginson's day, horse sports were well established in the old agricultural towns that circled Boston. County fairs built grandstands the better to see the trotters and pacers, many owner driven. In theory anyone could ride to hounds, and it behooved organizers to cultivate the farmers over whose fields they hunted Brother Fox. But again, it was a rich man's sport, with kenneling hounds an added cost. Higginson's son Alex was a noted master of fox hounds, keeping his own pack in Britain till the start of the second world war.

For those who wanted the thrill of jumping without the bother of hounds (and Brother Fox), steeplechasing was the answer. In England, it once was just that, racing over walls, fencing, gates, and brooks from one village steeple to another, and it was only sporting to wager a bet on the outcome. In Brookline, The Country Club indulged "jump jocks"— gentlemen riders, it goes without saying—with steeplechasing over its own fields until the obsession for golf demanded the race course be sacrificed to expand the links. The team sport for the horsey set was the ancient game of polo, not really "hockey on horses," as some would have it, which started in Persia, and which ladies played in ancient China. The English learned it when running India, and, when stationed there, the young Winston Churchill played on the kind of small wiry native horses that Rudyard Kipling memorialized in "The Maltese Cat," his 1895 short story of a championship match "told by" the polo team captain's grey who directs the play of the other ponies. Harvard fielded a polo team in the 1890s, the Agassiz's Neil Fairchild a member of the club. After World War II, surplus cavalry horses, including a plug called V-Mail, were brought home to the Berkshires by Zenas Crane Colt to revive the Pittsfield Riding and Polo Association; and in the 1950s he promoted college polo, three players to a side, mounting teams from Harvard, Yale, and Cornell. (The author was official timer for Pittsfield polo games 1949-1953.)

* * * * * *

Women of course drove,[21] and at least three equestriennes had connections to the Agassiz. Henry Adams's wife, Clover Adams, who'd hoped to live there, rode sidesaddle the day long and sat for her photograph in 1869 on her horse. Also riding sidesaddle, and fast over jumps, Mrs. I. Tucker Burr Jr., the former Evelyn Thayer, was the first woman named Master for two hunts, the Dedham Harriers in 1923, and the Norfolk Hunt, serving from 1933 to 1940, when she quit after a spill that broke her neck. She also founded a children's hunt. Her son Tucker Burr III, who would become a large animal vet in Walpole, New Hampshire, remembers dog hairs everywhere in the house as hounds recuperated on the sofas, and the distain of his father who preferred golf, cocktails, and music.[22]

But it is the young Alice N. Towne who had the most intimate connection with Higginson and horses. It did not start well. She was 19 when she and her widowed mother, another Alice, then 46, moved into the Agassiz in 1878. We have met young Alice in the chapter "Landlord Higginson" when she writes to him about smelly toilets. Diplomatic then, she is now—in two letters—as full of guile as a hardened horse dealer.

She will address him as "My dear Mr. Higginson" and she will send "love to Mrs. Higginson and baby Alex," having even offered to find a children's nurse for them.

"Your most kind and pleasant note has just been brought to me, and to begin with let me assure you that I do not believe we will ever quarrel, and certainly not about this creature"—the horse, Dandy—"for if I buy him it will be on my own responsibility. I like all you tell me about him and my only fear is that he will do nothing but trot. Still he could probably be trained to canter, which is a necessity for me. I like to change the gait because I ride alone much of the time and I am weary of the violent exercise entailed by trotting." Even on sidesaddle, riders posted to the trot, that is, rose and sat, but, like riders astride, sat to the canter or gallop. "I will gladly try him at once. If you had time and did not object to it, I should be glad to go out on the road with him, if you could take me. I could tell more by doing that than by riding twenty times in a ring, but I should be afraid to go with only a groom, and I have no one else I can ask.

"There are two other questions I should like to ask. 1st whether you would want me to take the horse over at once—2nd whether if I should get him and use him for the summer you would object to my disposing of him in the fall in an utterly heartless manner. Of course if he was just what I wanted nothing would induce me to do this but I belong to a family which thinks it rather dreadful ever to sell an animal of any kind, and so I

mention this for fear you may have like scruples. As to taking him at once. If you are not able to use him, of course I do not want to leave him in your hands, but otherwise I should prefer not, taking him for two months or so, as I have no one to ride with here, and find it very dull to ride round and round the ring when the spring sunshine looks so tempting out of doors," she writes on 9 March 1878. "Please be very frank with me about this, and if you want to get rid of him at once, do not hesitate to say so. Also about the trial, which I shall be glad to make as soon as possible, please tell me at once if you had rather not be troubled to take me out. I should go on my own responsibility, but if it could make you uneasy I would rather give it up and do my best in the ring."

There is a happy ending to the tale. She writes on 30 March:

I have now given Dandy a long and fair trial of more than two weeks, and continue to like him in every way. He has also been ridden by Col. Waring, who liked him and asked me to tell you that if you had any more such horses at that price he knows of people in Newport who would be glad to take them off your hands!

As to the scar to which you called my attention Col. Waring thinks there will never be any trouble from that leg, at least it is unlikely. Just at present the horse has a slight cough, but as he was not troubled in that way when I first rode him, I suppose it is only a temporary cold, from which he will soon recover. ["Stable cough" was endemic.]

I enclose a check for $125 and hope you are not cheating yourself by selling him at such a low price. I will see that his blanket and surcingle are returned to you. I am very grateful to you for solving a difficult problem, and am sure that I shall have many a good ride on Dandy this summer.

Alice will marry Roland Crocker Lincoln, a relation of longtime Agassiz resident Solomon Lincoln, and they will live at the Agassiz in 1884 and 1885, the first years of their marriage.

In due time, the "baby Alex" to whom Alice and her mother send love, will be old enough for his first pony. The Fairchild boys, whose family we have met, ride their "western ponies," as their Yankee mother called them, probably pintos or paints, on the Newport beaches. In June 1885, when Alex was six, his uncle George Higginson obliges with a pony. Rare among Higginsons for never having "seen Europe," George lived a country life at the other end of the state, in Lenox at Ma-Kee-Nac Farm, which, passing down in the family, eventually became the northwest corner of Tanglewood, the summer home of Henry Lee Higginson's Boston Symphony Orchestra. George writes on 25 May 1886 that brother Henry has failed, for almost a year, to pay for the transport of Alex's pony

and traps, probably by train, from Pittsfield to Boston. (Henry Higginson was a late-payer all his life, and his correspondence is dotted with notes "reminding" him of what was owing for club dues, benefactions, art works, family business transactions, and medical treatment in New York for his wife.) The exact amount is $15.40 for which $14.10 was the express charge, 30 cents for one telegram, and $1, another charge. The letter is also interesting for George's inquiry about Henry's horse called Smuggler. "Do you mean to keep him as you bought him or have him altered?" That is, gelded. Today that is the practice for riding horses, but in Higginson's day, unless gelded because sickly or unruly, the male was a whole horse.

Alex took to horses, and Henry rejoiced in that in him. "About 1900 I began to take an active interest in horses, and he was always ready to help me in any and every way in connection with them," Alex told his father's biographer.[23] His parents attended the steeplechases he rode in, though it made his mother "rather nervous." In 1911 and 1912, when presiding steward at The Country Club races in Brookline, Alex had it in his power to invite his father to watch from the judges' stand. Up climbed Henry, and often, and cast a keen eye on the horses as they went by for their warm-up gallops. One was a handsome grey.

"Who's that?" asked Henry.

"Winner of the Grand National Steeplechase in New York a few weeks before," said Alex. "Why don't you buy him?"

It was a very expensive horse. They went down to the paddock to watch the official saddling. The grey, as it happened, was owned by Tompkins, who also trained Alex's horses. Henry had a word with Tompkins.

"I want that horse of yours for Alex, and I want him now. What's his price?'" He was told the price. "All right,'" said Henry. "he runs in our name and interest then."

"And it happened so quickly," Alex recalled, "that I hadn't time even to draw a long breath, and he would hardly let me thank him, though you may be sure I tried very hard to do so. If that horse had won that day, the story would have been complete; but luck was against us and he was beaten by a nose, though he won many a good race for me after that."

There was another side to horses and Higginson as surrogate father. Charles Seabury was treasurer of the Calumet and Hecla copper mining companies, source of Higginson's first wealth, and indulged his son Frank in horse sports. Higginson wrote to reprove the boy, and in an undated letter from Newport on 26 August, Frank replies:

> Your kind letter of the 24th is before me & while I feel mortified at the evil that required it—the evil was not without good—as although I have

felt at times that Racing & C.C. [Country Club] was taking too much of my time, yet I had not the will to throw it off—My father too has noticed it, but in his desire & goodness that I should enjoy life in all that was in his power he could not help his judgement against his love and it needed you who have done so much for me and mine to help both he and me.

I am extravagant & it is the hardest thing in my nature that I have to fight, but I will conquer it little by little & I will commence this day.

I owe to you almost as much as to a father & to live and act your wishes cannot be but pleasant to me.

I am here visiting Mr. Norman for the purpose of riding in the 'Hunts' (there are three more) & it might be awkward to leave but of course if you desire or even wish it I will gladly do so at once.

I will sell all my horses as soon as I return, keeping one for exercise only.

I feel happier & better this moment to think you could give the thought & time for that letter & I will always remember it.

Frank Seabury would live at the Agassi in 1898, the first year of his marriage.

* * * * * *

This chapter began with the motor car beginning to muscle in on the horse. We will end with a twist. We have seen how, in various ways, the horse was man's transport for work and pleasure. How did man transport the horse? How did man move great quantities of horses long distances? Whether of Spanish or Dutch or English stock, the first horses in America crossed the Atlantic in the belly of sailing ships. On land, there were ferries that carried them across streams, even across the Thames at London. If we are to believe *Mrs. Brown,* the 1997 movie about the widowed Queen Victoria (Judi Dench) and John Brown (Billy Connolly) as her much-favored Highland gillie, her favorite Highland riding pony traveled in a horse-drawn cart hundreds of miles from Balmoral, her castle in in Scotland, to her castle at Windsor, for Brown was sure that the outside of a horse would cure her inner sadness, her morbid mourning of Prince Albert.

As they herded cattle, so cowboys herded horses, moving them in loose formation and slowly, for by nature the horse is a grazing animal, as all riders know when their horse or pony simply drops its head to eat. The military had to be quick and efficient at moving pack animals and officers' mounts. It would not do merely to lead one riderless horse alongside one groom, as we have seen when Higginson's friend conveyed a horse

some 30 miles. "Ride one, lead one," as the practice is known. "Ride one, lead three" makes for high drama in Frederic Remington's 1890 painting "Dismounted: The Fourth Troopers Moving the Led Horses" as some dozen snorting chargers gallop toward us.[24] A fictional battle—Remington painted it in his studio from photographs and props—nonetheless it records how the military got horses quickly away from the shooting. Soldiers would count off in fours, three dismounting to fight, and the fourth leading their horses to safety. The cavalry was as efficient with large numbers: As many as 50 army mounts could be exercised by a mere five riders when the horses were hitched in pairs to a floating picket.

Who does not thrill at General George Washington tossing on the icy Delaware on Christmas night 1776, though historians think painter Emanuel Gottlieb Leutze was wrong to include his white charger tossing in another row boat because the horses would have crossed by ferry, and were doubtless muzzled lest they cry "Ha Ha" and warn the British. The Civil War general Ulysses S. Grant's brilliant use of the railroad to transport troops and horses helped the North to victory. Rolling by rail to battle, and unloaded fewer than 10 miles from action, meant that Grant's "trains of mules and horse-drawn wagons never operated more than a single day's march … therefore [consuming] none of their own loads [of provender] on the march and were no more fatigued by their work than drayhorses on a city delivery round," writes military historian John Keegan in *The Mask of Command*.[25] The train manufacturer, George Pullman, was quick to follow for civilian use, the iron horse pulling the horse Pullman named after him. Freight cars were adapted with stalls set across the middle. As in stables and barns, the windows were horse level, not only to provide light and ventilation, but as the horse is a curious and sociable animal, a way to look out. Until the circus folded in 2017, horses travelled the U.S. in the silvery railroad cars of Ringling Brothers, Barnum & Bailey.

Rail service allowed the transportation of race horses between tracks. Also thanks to rail, there were sporting junkets of great invention. Loath to end the hunting season in December, in 1899 the Norfolk Hunt simply loaded horses and hounds onto an express train at Medfield Junction and by lunchtime were on Cape Cod, where for four or five days they continued the chase on the beaches at Chatham.[26] The Norfolk was a drag hunt, hounds following a scent laid down by the mounted "drag boy" to mimic fox, and so was easily translated to new country, the sand beaches replacing a hundred miles of country of bridle paths with some two hundred jumps.[27] The Cape Cod seasons lasted till the outbreak of war in 1917.

But for transportation by existing roads, the invention of the horse box or van would have to wait till the horseless carriage mated with

the farm cart. Richard Saltonstall tried just that. He was one of the farming Saltonstalls, over whose family estates in Dover and Sherborn, the Norfolk hunted, and his brother, Leverett Saltonstall, later governor of Massachusetts, 1939-1945, and U.S. senator, 1945-1967, would occasionally ride as whipper-in to the Master. (We have met a cousin, John L. Saltonstall, who, newly married to Gladys D. Rice, would transform the whole third floor at the Agassiz.) In a 1930 photograph, Leverett's tall silk hunting hat exactly extends the long Saltonstall face.[28] He was "a Harvard accent with a South Boston face," Boston's most quotable mayor, James Michael Curley, quipped; and a canny politician himself, Saltonstall always marched in "Southy's" St. Patrick's Day parade, "Irish," as a wag said, "on his chauffeur's side." Like other members of the Norfolk, Richard longed for a way to transport his horses that did not involve shanking them, from Sherborn (where he farmed) to hunt in Groton—ride one, lead one—with an overnight's stabling to boot, and so he contrived a sort of van.[29] It was hitched to a friend's LaSalle sporting coupe. To make it legal on the roads, helpful Governor Saltonstall got the state Registry of Motor Vehicles to give it a special license. All looked good to go. Alas, the contraption would not back up. It was too heavy to go up the slightest incline. The van itself had no brakes. And so the sporty LaSalle was refurbished as a horseless carriage.

9
Entertainments

"He overdid it beautifully."
Max Beerbom on Henry Irving

During his long life, Henry Lee Higginson was celebrated as founder, in 1881, of the Boston Symphony Orchestra. Less well known is his occasional fling as impresario, a role which combined the *tendresse* for actresses he shared with his son as well as a sharp eye for management. This all came together in 1896, when the great Italian actress Eleonora Duse, down on her luck, appealed to him to book her in Boston. In a six-page, typewritten letter to orchestra manager Charles A. Ellis (1855-1934), Higginson lays out the terms of her engagement, and in so doing sheds light on the theater practices of the day.

As we have seen, Shakespeare staged by the scenery-chewing Sir Henry Irving still had a vogue, but the so-called "problem" plays were the coming thing. Duse (1858-1924), and her rival, "The Divine Sarah" Bernhardt (1844-1923), rightly held the boards for their character acting, and both were famed for their voices. Bernhardt specialized in tragediennes: Tosca, Phèdre, Violetta. It did not hurt the box office that wondrous tales were told of her life. True, she slept in a coffin. True, she had a wooden leg, her right having been lost to gangrene when, as Tosca, she was badly cut in the parapet leap that ends the play. She crossed gender lines, as the first woman to wear a pantsuit, the first to play Hamlet (four hours in French prose), and, for good measure, the title role in *Judas,* which was promptly banned in New York and Boston. She made Hollywood movies. She left her theater company in the sure hands of her son.

Duse was none of that. The younger actress first came to notice in Italian productions of Bernhardt's old roles. In poor health and need of

money, she would die of pneumonia in a Pittsburgh hotel on one of her comeback tours. Thousands of New Yorkers watched her cortège travel from a Lexington Avenue church to the pier where a ship would take her coffin to Naples. If Bernhardt was called "most famous actress the world has ever known," it was Duse who touched the soul. Charlie Chaplin said she was the "greatest artiste I have ever seen." Her technique, he wrote, was "so marvelously finished and complete that it ceases to be technique." As she herself put it: "The one happiness is to shut one's door upon a little room, with a table before one, and to create; to create life in that isolation from life." To Chaplin she brought to the stage a "heart that has been taught the lessons of human sympathy, and the incisive analytical brain of the psychologist."[1]

When Higginson met her, she had gone nearly broke from poor management, and her managers, Mssrs. Rosenfeld, were suing for their share of the box office. With the proper contract, Higginson assured Ellis, she could carry a five-month season in Boston. "It is my impression," wrote Higginson on 6 May 1896, "she has done better [at the box office] than Irving or Sara Bernhardt."

Duse was also "safe" for society to take up. "I do not use paint. I make myself up morally," she said of acting. And perhaps of life, for we have seen how the Higginsons encouraged their son Alex to invite her to tea in his Harvard rooms. Theater people were often on tour, and without fixed address. Ellis was himself in Europe on orchestra business, and should he have to track Duse down in Paris or London, Higginson advised asking this princess or that countess her whereabouts. Or the poet and novelist, Laurance Alma-Tedema (1865-1940), the socialist daughter of the painter. Or famed soprano Nelly Melba. One who certainly would know was the lawyer (and future baronet) Sir George Lewis (1833-1911), who had represented Duse in the past. To be invited to Lady Lewis's parties was to mingle with the cream of society and the arts: painters, actors, musicians, writers, politicians, and lawyers, for she insisted that establishment and bohemia embrace. More to Higginson's point, Lewis was a sharp lawyer, as expert in criminal cases as civil, and had the largest practice in financial cases in London. Captioned "an astute lawyer," Spy's caricature in a 1876 issue *Vanity Fair* makes much of his Jewish nose. Higginson recommended Ellis use Lewis to draw the agreement with Duse. "The advantage of a contract made by a lawyer is that it is clearly and carefully made." For his first meeting with Duse, who spoke no English, Ellis must "take a reliable and competent person with you to talk French. I should not take an artist, but somebody whose business it is not to talk and who will hold his tongue."

What might Boston expect to see Duse perform in? "She is to provide three or four plays besides her present repertory, and one of them is to be

a Shakesperian play." Much depended on her "finding a satisfactory actor to play with her."

She would perform three or four times a week. While she will not bring her own scenery (too bulky to travel) she would furnish her own troupe with clothes, by which was meant costumes. Whatever scenery was on hand would do. "She does not undertake to have any great layout in that respect, nor is it necessary." If Irving depended on spectacle, Duse did not, and audiences of the time, more than today, colluded with the actors, singers, playwrights and composers by using their imagination to conjure a scene.

Now to the bottom line: Duse told Higginson she got $1,000 a "representation," or performance. Ellis was to bear certain costs, transportation to and from London, and within America. Duse and her troupe would pay their hotel bills. She would get a percentage of the gate, and Ellis would pay for advertising. If Ellis took in $120,000 for 50 shows, and paid her a total of $66,000 and laid out $30,000 in expenses, he would get a satisfactory $24,000, Higginson thought. Duse had chronic lung problems. Should she want "from time to time a little rest, she was to have it," he wrote. Whether she should be docked for not performing was up to Ellis. "But you may find it easier to make no change in the [agreed] terms."

Higginson himself found Duse "not suspicious," meaning trusting, but "very bright indeed and very keen. She is generous and will treat you as you treat her, but she is working for her living and she likes to have what she can get fairly." One caveat, which Higginson added in his own hand: "She is impatient." There is evidence of that in Sargent's 1893 portrait. It looks unfinished for she walked out after 55 minutes.

Boston was a theater town. As Duse could count on drawing a crowd, Ellis booked her into the Tremont Theater, which was also the show place for the royalty of the London stage, Henry Irving and Ellen Terry. We have met them being entertained by, and entertaining, the Fairchilds in January 1894, when they appeared at the Tremont in *Henry the Eighth*, which was not necessarily by Shakespeare. But it was spectacle, and filled the eye, and commanded the ear, and it was live, as was all public entertainment back then. Theater was democratic, catering to all social groups, drawing folk from the Agassiz as well as the working class. Boston still has a notable reputation as a "theater town," with vigorous resident professional companies, and many a thespian has trained at local universities and conservatories. Until the late 20th century economic realities killed "the road," Broadway-bound shows tried out in Boston, fine-tuning hits such as *Oklahoma!* and *Who's Afraid of Virginia Woolf?* (whose author Edward Albee had been adopted by the founding family of the Keith-Albee vaudeville chain).

Playgoing in Boston dates back to Colonial times and by the 20th century the city could count 50 theaters, most clustered between Tremont and Washington Streets. Part of the fun was defying the old Puritan morality and its lingering censorship. If "Banned in Boston" delayed production here, it guaranteed sold-out houses elsewhere. Live theater, in some minds, was the slippery slope to less innocent entertainments. In 1895 came the debut of silent films as well as the technology that would produce the first radio broadcast (from coastal Massachusetts on Christmas Eve 1906). Television, cable, the Internet and social media were blips on the horizon. 1967 was an "effing good year" for movies, *Ulysses* the first to say the "F word" out loud.

Theater in the late 19th century offered something for every taste and pocketbook. For their amusements in 1894, Bostonians got dressed and left the house. They flocked to the theater and the concert hall. Variety shows and vaudeville were heavy on comic sketches, light music, animal acts and trained birds, tap dance routines, and sing-alongs. A "museum" was two things, both full of curiosities, one vulgar, one high minded. Copley Square, a few blocks from the Agassiz, had the latter, museums of fine art and natural history.

For the other "museum" you had to go downtown. This was entertainment for the credulous, evenings of exclamation marks and drumrolls, the quick fall of the curtain, the blackout forever preserving the secrets behind jaw-dropping tricks of mind and body. There were jugglers and contortionists, sword swallowers and fire eaters, knife throwers and spoon benders, magicians and mind-readers. Cowboy Will Rogers threw in aw-shucks philosophy as he spun his lariat. This mix of marvels lingered well into late night television. Actor Ed Ames guested on The Johnny Carson Show, throwing tomahawks at a cardboard cowboy. When he came close to slicing the crotch, Carson winced: "Welcome to Frontier Bris."

Theaters, of course, closed on Sunday and Holy Week. Which is not to say there was not drama in places of worship. If for theological reasons, Protestant churches resisted the color and ritual of the Catholic Mass, they were not without their own theater. The Puritans had brought Bible preaching to America. Mated with oratory, there was high drama in the pulpit at the two Sunday services. Maiden hearts, beating to great thoughts expressed in great words, went morning and evening. Sermons were subjects of conversation, and reported in the newspapers. The Episcopal bishop William Lawrence lived on Commonwealth Avenue, and walked across the Public Garden and the Common to his cathedral, at 138 Tremont Street, a stone's throw from the Tremont Theater at No.176. His consecration, in 1893, crowded Copley Square's Trinity Church with 250

1 Americans had always lived in single-family houses, but Henry Lee Higginson gambled that well-traveled Bostonians of his ilk might take to the apartment-style "French-flats" he had known in Europe, and so he built the Hotel Agassiz in 1872. It was an immediate success. While living there, he founded the Boston Symphony Orchestra in 1881. This portrait hangs in the Symphony Hall lobby. It's a 1953 copy, by Pietro Pezzati, of the 1903 original by John Singer Sargent, commissioned by grateful students for the Harvard Freshman Union, which Higginson gave so that boys of all social classes could dine together. Sargent posed him with his Civil War cape. Saber scars crease his right cheek. *Courtesy of the Boston Symphony Orchestra. Photo by Robert Torres.*

2 The waters of the old tidal Back Bay, as shown in this 1844 print, illustrate Boston's dilemma. On the one hand, trains brought some 30,000 people a day to work, adding to the economy. To the far left, the Boston & Worcester Railroad; in the foreground, the Boston & Providence line. But because the trains ran on trestles, those very railroad structures impeded flow of the tidal water that would have run mills to make Boston a manufacturing city. *Courtesy of the Bostonian Society.*

3 This is Boston on 13 October 1860. The first aerial photo taken in the United States, it was shot by James Russell Black from a balloon 1,200 feet up. This view of the mercantile district, with the inner harbor busy with ships, makes the point that, with water on three sides, old Boston had no room for expansion, hence the need to fill the Back Bay for a new neighborhood.

4 The first public building in Copley Square, the 14,000-seat Boston Coliseum, would be renamed Jubilee Hall to house the World's Peace Jubilee and International Music Festival to mark the end of the Franco-Prussian War. Among the events, the first public appearance of the Jubilee Singers from all-black Fiske College. This 1869 photo of the construction shows Back Bay landfill not yet at street level. *Courtesy of the Bostonian Society.*

Above: 5 Perhaps shot from the tower of the First Baptist Church (H. H. Richardson, 1871) on the corner of Clarendon Street, this is the first known photo of the Hotel Agassiz. It opened about 1873 on the corner of Commonwealth Avenue at Exeter Street. The first important apartment building in America, it would house six families, one to a floor. Looming in near-vacant Back Bay, its 10,485 square feet would increase to 13,570 when Agassiz creator Henry Lee Higginson later attached his row house to it. *Courtesy of Historic New England.*

Below: 6 Commonwealth Avenue was a construction site well into the 1880s. Once each cross-street corner was secured by a large building—a church, or the Hotel Agassiz, or a mansion—then row housing commenced to fill the block. This photo, shot probably from the roof of the Vendome, a commercial hotel at the corner of Dartmouth Street, looks east toward the tower of the First Baptist Church with the State House dome beyond. Fencing bulging into the Vendome side of Commonwealth indicates excavation. Across the tree-lined mall, the stark parti-wall of a row house awaits a new neighbor. Scaffolding marks a building in progress. *Courtesy of Historic New England.*

7 Elizabeth (Lily) Fairchild's letters to her married daughter Lucia sketch Boston's artistic and social life. A published poet, mother of seven, she was painted by John Singer Sargent in 1887-1888, during his first working tour of America, when he also painted Isabella Stewart Gardner. He became a fast friend of the Fairchilds, and, when he was their house guest at the Agassiz, Lucia, then an art student, would write about him in her 1890-1891 diaries. *Oil on canvas, 19 9/16 in. x 18 1/4 in., Bowdoin College Museum of Art, Brunswick, Maine, Museum Purchase, George Otis Hamlin Fund and Friends of the College Fund, 1985.40*

8 The Fairchilds' friendship with Robert Louis Stevenson began when Charles Fairchild commissioned John Singer Sargent to do this portrait in 1887 as a gift for his wife, Lily, a fan of *Treasure Island*. Letters and visits were exchanged till Stevenson's death in Samoa in 1894. When the Fairchilds fell on hard times, Sargent helped sell this picture to Robert Taft in 1910. *Oil on canvas, 20 1/16 in. x 24 5/16 in. Bequest of Charles Phelps and Anna Sinton Taft. Courtesy of the Taft Museum of Art, Cincinnati, Ohio. Photographed by Tony Walsh.*

9 The genre-photographer Baldwin Coolidge shows Elizabeth (Lily) Fairchild sewing at the Agassiz in a room that defines the American Aesthetic style for its emphasis on homey artisanal and high art. There's a hooked rug on the floor, pottery on the mantel, an embroidered fire screen, reproductions of Old Masters on the walls, and, among the books, surely the Shakespeare plays that her children gave her for her birthdays. Is her fur-trimmed robe another anniversary present? *Courtesy of Historic New England.*

10 Coolidge posed the Fairchild daughters reading and writing in their Agassiz bedroom. Also a sitting room, it was amply furnished with an oriental carpet and an embroidery cover on a side table. The elder Sally, called Satty, sits at a "Winthrop" desk, named after the one used by John Winthrop, first governor of the Massachusetts Bay Colony. The pictures on the walls were likely by artists the family knew, for Lucia would become a painter in the 1890s. *Courtesy of Historic New England.*

11 The phrase "carriage trade" was just that: posh people whose top-hatted coachman and smart pair of horses drove them shop to shop. This view along Boylston Street near Boston Common shows a famous "carriage trade" store, L. P. Hollander. Started in 1848 by dressmaker Maria Theresa Baldwin (Mrs. Hollander), it would import the latest Paris and London fashions. Its great success led the company to open its first branch, in New York City in 1890, and shops at resorts soon followed. *Courtesy of The Boston Globe.*

Above left: 12 Members of the New Riding Club on Hemenway Street could trot around The Fenway for a short outing or head to the country for an excursion. Women rode sidesaddle, the men used long stirrups.

Above right: 13 A uniformed officer dates this photo to the First World War. His companion assured the popularity of the 1923 book, *Riding Astride for Girls*, which argued that astride was healthier for rider and horse. Sitting on a sidesaddle might cause twisted spines and chafe the mount. Riding like men, moreover, would not harm "internal organs," or threaten fertility—just what The New Woman wanted to hear. *Courtesy of The Boston Courant.*

Below: 14 The level streets of Boston's new neighborhood brought public transportation in the form of the horse tram. With carriage wheels sliding on iron rails, pairs of horses, working four-hour shifts, could draw cars carrying 30 passengers at six to eight miles an hour. By 1880, horse trams in major American cities transported 18 million people a year over 6,000 miles of track. In Boston, with some 6,000 horses to care for, immigrant Irish found work as drivers and stable hands. But as soon as Boston was electrified in the 1890s, the tram horse was put out to pasture. Shown here, the last trip of the Back Bay horse tram which ran along Marlborough Street to its central stop on the Copley Square side of Old South Church. *Photograph by unidentified photographer, n.d. Collection of the Massachusetts Historical Society.*

Above: 15 The Roman god Mercury was the inspiration for this entry in the annual Boston Bicycle Parade. With his winged helmet and sandals as symbols of speed, he was a natural deity for cyclists. In 1914, AT&T chose him to advertise the telephone and telegraph. As the god also of commerce, Mercury was the messenger boy well into the 21st century, even delivering pizza by bike. *Courtesy of Historic New England.*

Below: 16 The best seats for the bicycle parade were in the reviewing stand at the Hotel Vendome on Commonwealth Avenue. Judges conferred in their box to pick the best entries and award prizes. The bicycle craze was good for business: hotels and inns invited cyclists to stay and eat and drink, and *The Boston Herald*, the city's leading morning paper, sponsored the parade to promote circulation. *Courtesy of Historic New England.*

Left: 17 Dr. & Mrs. Henry Harris Aubrey Beach often visited the Agassiz, taking tea with the Fairchilds. As a medical man, he had advised landlord Henry Lee Higginson on the apartment house's foul toilets. Mrs. Beach, the former Amy Marcy Cheney, was a formidable pianist and composer, but polite society decreed she concertize under her married name. She wrote every kind of grand romantic music from symphonic and choral to songs and chamber music.

Below: 18 In 1881, the Boston Symphony was not the only orchestra in town. Marietta Sherman Raymond led the Beacon Orchestral Club, a women's orchestra. Dressed in white silk and golden cord, they played at weddings and social events, even touring to summer resorts. She also taught piano and violin, and was photographed in her Dartmouth Street studio by Baldwin Coolidge in 1903. Music teachers and their students were a loyal part of the BSO audience, patrons especially of the cheap "rush" seats available the day of the concert. *Courtesy of Historic New England.*

19 **Text:** Perhaps the earliest interior photo taken at the Agassiz, it shows the four oldest Fairchild children about 1877: Jack, Lucia, Charley, and Sally, called Satty. While the family dogs had the run of the apartment, this room was home to song birds in a cage and a squirrel running its wheel. With windows giving west over Exeter Street, afternoon light streamed in, and sunsets blazed. On the back of the photo, their mother Lily wrote: "The nursery – without its curtains. It is really a beautiful room, but this is a horrid picture of it." *Courtesy of Lucia's granddaughter Lucia Fuller Miller (no relation to the author).*

20 Charles Fairchild was one of the earliest residents of the Agassiz. Like Henry Lee Higginson, his landlord and partner in the investment banking house, Lee, Higginson & Company, he had gone to Harvard and fought in the Civil War. Although he was good at drumming up investors, conservative Boston thought he was too "bohemian" in his friendships with actors, writers, and artists to be "sound" in business. *Courtesy of Lucia Fuller Miller.*

21 Of the five Fairchild sons, the two eldest followed their father into the business world. This trio went in other directions. The oldest of the three, Blair was a composer and would commission Stravinsky's violin concerto. Nelson, called Neil, was frail as a boy and ended his days in China in the diplomatic corps. The youngest, Gordon, became a history teacher. *Courtesy of Lucia Fuller Miller.*

22 A politician, Lucius Fairchild was the son of the first mayor of Madison, Wisconsin, and the older brother of Charles Fairchild, and later served as American consul general in England and Paris. John Singer Sargent painted him in 1878 at the Agassiz. Lucius did not think much of the portrait: "A lot of medals running off with a bald-headed man." He had lost his left arm in the Civil War, and the pose would echo "The Empty Sleeve," the song about patriotic sacrifice. *Courtesy of The Wisconsin Historical Society.*

23 Gordon Fairchild was the youngest of Lily and Charles Fairchild's seven children. John Singer Sargent painted him twice, this little-known study in 1887, and a more formal picture in 1890, which posed him curled in a wicker chair with his guinea pig. Boyhood letters to his married sister Lucia describe pets and games, the books he was trying to read, and the plays he saw. *Courtesy of Richard F. Jones, Kansas City, Missouri.*

24 Sally Fairchild, called Satty, was painted three times by John Singer Sargent, who called her his favorite model. Two of the pictures were more impressionist figures than this formal portrait done in 1887. Her mother's letters chronicle her years as a "bud," or debutante. College was out of the question for a girl or her social class, but she was one of the first kindergarten teachers in Boston. Friendship with a daughter of actress Ellen Terry led her to London where George Bernard Shaw read his plays to her. *Courtesy of the Iris and B. Gerald Cantor Center for Visual Arts at Stanford University, Stanford, California.*

25 The Hotel Agassiz was a massive building, running some 70 feet from Commonwealth Avenue back along the Exeter Street side, shown here, to the public alley that ran parallel to Commonwealth. The brick work is slightly more decorative than the formal front, and the variety of windows give it a livelier look. When the Agassiz opened about 1873, this was the private side of the building, each family having six or seven bedrooms for themselves and servants. It is now a condo, with two or three owners a floor. *Photograph by Peter Vanderwarker.*

clergy and theological students. To his daughter Marian, the most colorful cleric was a Greek, the Archbishop of Zante. "He was in purple velvet robes with high black crepe headdress and the black crepe hung down behind him and trailed on the ground. This headdress and his cloak were held on to him by beautiful jeweled clasps. He made an address in English and a benediction in Greek."[2] And by one of life's little coincidences, a noted Boston theater, the Charles Playhouse, was first a place of worship, and would serve three denominations.[3]

Shakespeare—spurious and not—was just one of the attractions that January week in 1894. Much of the talent on the boards was exotic, as far as you could get from Boston, and perhaps actually from Foreign Climes, from the far north to down under, from the Ould Sod to the Nile and the Rhine, or advertised that way. Pure escapism, something for every fancy, every budget, and *The Boston Globe* sampled the fun. The Eskimo troupe with its "adorable hazel-eyed" baby girl whose "complexion tended toward the swarthy" would be succeeded at Austin & Stone's museum by Australian boomerang throwers and Tasmanian warriors. At the Howard, the burlesque was *Nanon: Or the Belle of Beacon Hill*, and accompanying the 40 pretty girls was a chorus of whistling marines. *A Night in Egypt* concluded the bill at the Palace; earlier that evening, the duo playing German brewers was "decidedly funny." For Boston's burgeoning Irish population there was the four-act comedy drama, *The Rambler from Clare* with the squire, a cruel landlord, to hiss. *Charley's Aunt* would be held over at the Columbia, the drag comedy "uproariously funny from beginning to end." Joseph Jefferson was Rip Van Winkle at the Boston. Thomas W. Keene would pounce on Henry Irving's territory, offering *The Merchant of Venice, Hamlet,* both *King Richards*, and *Othello,* all certifiably the Bard's.

Irving and Terry returned to Boston in March, and for one performance, reprised their greatest hits for "Harvard night at the Tremont." The auditorium was a sea of red, everybody wearing Harvard crimson. Terry got red roses, Irving a gold medal. Laughter welled when he told the audience he would have worn the medal "but I dropped the pin." "To name the undergraduates" in the audience "would be to list all the prominent men in college," gushed the *Globe*. One was Agassizan Jack Fairchild, president of the class of 1896. Terry did light comedy, *Nance Oldfield,* and Irving was the mad Polish Jew who, at the curtain of *The Bells,* confesses to murder. At the end the audience sang "Fair Harvard."

Irving's star was dimming. He and Terry cannot have been happy about the reviews for *Henry the Eighth*, if the *Globe's* pan, on 9 January 1894, is representative. Most of the play was by John Fletcher, though Shakespeare probably wrote the speech in which Cardinal Woolsey ponders the king's favor that brought him down. The unnamed critic praised the scenery and costumes, "rich and costly, and so correct historically that they will serve, with the architecture of buildings and furnishings, as valuable aids in learning of old England in and out of doors." But there was a tepid reaction from the public. Instead of applauding for the usual six curtain calls, the audience fled the Tremont Theater. "The prevailing dullness of the play was no doubt largely responsible for the slight interest manifested in the acting of Miss Terry and Mr. Irving … He was inclined to make too prominent the Mephisphelean traits of the cardinal's character," and he mumbled: "His reading of the familiar speech 'a long farewell to all my greatness' was often indistinct." Nor did Terry thrill the *Globe's* critic. She was "tender, sweet and womanly," and the way she spoke her lines gave pleasure, but "you could not feel the least sympathy for Queen Katherine and her death did not seem of special consequence. Needless to state the gowns worn by Miss Terry were exquisite."

Terry was about to turn 48. To Graham Robertson who painted her, "she shone with no shallow sparkle or glitter, but with a steady radiance that filled the room and had the peculiar quality of making everybody else invisible." Virginia Woolf laid in the soundtrack: Terry's voice was like someone drawing "a bow over a ripe, richly seasoned cello."[4]

Irving would be knighted the following year, the first actor so honored. On 30 March 1885, at the height of his career, he had lectured at Harvard on "The Art of Acting." He based his on a "double consciousness" of emotion and craft. "The actor who combines the electric force of a strong personality with a mastery of the resources of his art must have a greater power over his audiences than the passionless actor who gives a most artistic simulation of the emotions he never experiences."

But in 1894 his time was nearly over, his theatrics failing to draw as canny London rivals played to the new demographics. If playgoers began to see Irving's spectacle as "foe to beauty," critic and wit "The Incomparable Max" Beerbohm still defended him: "He overdid it beautifully." But a younger, more educated public wanted intellectual content, and flocked to the "problem plays" of Henrik Ibsen and George Bernard Shaw with their ensemble acting, realistic settings, and contemporary themes of class issues and inner life. (Not surprisingly, Duse embodied Ibsen's conflicted women.) When Shaw lured Terry to act in his plays, Irving could not carry on alone. Critics began to savage the stage presence that had once riveted the eye. Yes, he was "magnetic" and "intense." But, look again:

"an eccentric walk, legs too thin, a dragging leg, shoulders too high, body clumsy." And worse: his voice is without music, "he does not know how to speak his own language."

The week of *Henry the Eighth,* the Fairchilds, loyal friends, gave Irving and Terry a dinner party, and, as we have seen, the favor was returned. The eldest Fairchild daughter was a friend of Terry's daughter, who would introduce her to Shaw, who would read his plays to her. Terry had spotted the Fairchild son who was a super in "Henry" and chucked his chin.

That same January, the youngest Fairchild also went to the theater. Gordon, almost 12, had his first inkling that plays don't show everything you might like to see the actors do on stage. "Last night we went to see the play that the Higginsons gave, *The Men of Iron,*" he wrote to his sister Lucia, on 14 January 1894. This was a dramatization of the 1891 novel by author-illustrator Howard Pyle (1853-1911), who was part of the Brandywine artists' colony in Pennsylvania that included the Wyeths, but, more important for children—his best audience—he invented the garb that pirates wear in books, and still do in the movies. Gordon thought the play "fine." The time is 1408, the king is Henry IV, and the young hero, Myles, is a squire-in-training. The grown-up Myles, now a knight, throws down his gauntlet, initiating trial by combat, and, as he is the model of chivalry, this almost costs him his life. There was one disappointment: "The fight Miles had wasn't on the stage but the people tell what is happening." Young Gordon would find that playwrights from the ancient Greeks to Shakespeare used the same dodge.

Like Duse, if the ornaments of the stage were presentable socially, they were received in polite society. In the 1890s, Boston cheered the virtuoso pianist Ignacy Jan Paderewski (1860-1941) at the Music Hall. In the audience was Bishop Lawrence's school girl daughter, Marian (1875-1974). "There is something so fascinating about him," she wrote in her diary. "He is so foreign-looking and so indifferent-seeming to what people think of him." As a fighter for Polish independence from Prussia, he would be a delegate to the Paris Peace Conference in 1919. He was welcome company off stage. Marian: "They say he plays a wonderful game of billiards at the Tavern Club."[5]

Alex Higginson and his friends were no snobs when it came to entertainment. Not much of a student, Alex confessed in his memoir he "played" through Harvard, and the set he ran with "played together," as he put it. Summers on Boston's North Shore were a riot of parties. A hired bus took the "clan" to Salem to see Buffalo Bill's "Wild West" show. When someone forgot the tickets, Alex's cousin, Peggy Perkins, said all would be well: her father knew Colonel Cody.

"I can see him now, with his long white hair streaming in the wind, as he handed the reins to his groom and jumped down from the high mail phaeton as lightly as a boy of twenty," Alex wrote. He spotted Peggy, "and swinging off his *sombero*, he made her a low bow." Cody swept them to the best box seats, as their ticketed friends could not but notice. The show seemed presented for the clan. In any event, it was spectacle. "What a fine picture [Cody] made, when, his entire company having gathered at the opening of the show, he rode before them on his chestnut horse, and making a low bow to the assembled audience, said: 'Ladies and gentlemen, I have the honour to present to you a Congress of the Rough Riders of the World.'"[6] Buffalo Bill's flamboyant phrase was borrowed by Colonel Theodore Roosevelt, who, on his horse Texas, led the famous infantry charge up Cuba's San Juan Hill in 1898.

And if you couldn't get into Buffalo Bill, Boston offered its share of public spectacle. There were solemn parades commemorating the Civil War. These were not limited to holidays but might honor a distinguished visitor with suitable pageantry. Hundreds lined snowy streets on 6 March 1902, when Prince Henry of Prussia (1862-1929) visited town. For one day, he was visible all over the Back Bay and Harvard. He arrived by train from Niagara Falls, drove to the State House to call on the patrician Governor William Murray Crane, then to the Boston Public Library to call on Irish-born Mayor Patrick Collins, then to call on Mrs. Jack Gardner at her Fenway palace. Next, photographed by *The Boston Globe*, he is escorted by mounted lancers over the Charles River to Harvard where he gave several items to the Germanic Museum for its collection, and received an honorary LL.D. degree from President Charles William Eliot. Speeches followed at the Harvard Union, the two-year-old benefaction of Henry Lee Higginson, who was doubtless in attendance. He went back across the river for the City of Boston's dinner at the Hotel Somerset before he caught the train at two in the morning for Albany. A grandson of Queen Victoria, son of the liberal but short-lived Emperor Frederick of Germany, he was the ignored younger brother of the bellicose Kaiser William, whose actions in Europe would result in other, sadder parades.

Classical music was not unknown in Boston. Theodore Thomas (1835-1905), a German-born violinist, is accorded America's first maestro and, after the Civil War, would bring his touring orchestra to Boston.

But what did set Boston apart from most other American cities was its resident symphony orchestra, and those concerts—most tickets sold by subscription—governed many a musical and social calendar. Other books

have told the history of the Boston Symphony Orchestra which Henry Lee Higginson founded and which gave its first concert on 22 October 1881 in the now-razed Boston Music Hall on Winter Street. Built in 1852 with a $100,000 gift from the Harvard Musical Association so the city could have a concert hall, it was also the birthplace of the New England Conservatory of Music which opened in 1867 in seven rooms above the concert hall, after Eben Tourjée (1834-1891) had persuaded Boston civic leaders to back a school to train musicians.

Also in 1881, the Beacon Orchestral Club was founded, an all-women ensemble conducted by Marietta Sherman Raymond, who taught piano and violin in her studio at 116 Dartmouth Street. For concerts they dressed in white silk trimmed with braided gold cord. They played for the Women's Charity Club and as far away as the Lowell Opera House and the Hotel Balmoral near Saratoga, New York. Popular also at society weddings and receptions, but not engaged for the wedding of Alexander Higginson to Rosamond Tudor, his father having hired the Boston Symphony.

Another offering at the Music Hall was the Handel & Haydn Society, founded in 1815 to sing oratorios, and remains vigorous, under Harry Christophers, as the oldest continuous performing arts group in America. Choral singing flourished in Boston, from church choirs and college glee clubs to massive ensembles to thunder Handel's *Messiah*.

As we have seen, Higginson saw his orchestra as recompense for the failed musician he knew himself to be after four years abroad studying piano, voice, and composition in Germany and Vienna. He was also ambitious for Boston. His travels in Europe confirmed in him the belief that great cities were known by their orchestras, and their opera houses, for his letters home are a diary of the singers, good and bad, he heard, and of the operas which were new to him, at 18 years old. And if the repertory was not the new music of the day, it was the contemporary, for Verdi and Bellini were still active writing opera. In a letter home from Munich on 5 October 1852, he writes of hearing *Nabucodonoso*, as Verdi's *Nabucco* was called at its Italian premiere in 1842, and perhaps still was a decade later. "Less noisy than Verdi's are." Then two weeks later: "Heard *Nebuchadnezzar* again ... Liked it better than before, but perceived Verdi's faults more. He tries the voice too much, is noisy, is very fine in the choruses, but is not a very pleasing composer." Two nights later, he heard his first *Fidelio*. "Beautiful exquisite opera, so full of feeling, so quiet, so expressive: and Fidelio's part is exquisite." He thought it measured up to his then-favorites, Mozart's *Don Giovanni* (1787) and Bellini's *I Puritani* (1835). Of *Fidelio*, he wrote: "A most beautiful opera, so calm, and yet so full of feeling."[7] Beethoven was the only composer whose name Higginson allowed to appear in Symphony Hall in an age when concert halls were

lettered with the names of the greats, and the Boston Public Library's façade was similarly littered. Only Beethoven is enshrined in the great gilded cartouche above the stage.

Opera would come and go in Boston. "The Symphony," as the BSO is still called, yet flourishes. On the one hand, Millennials can download its recordings of Mahler symphonies. On the other, management worries, as managers do worldwide, that they will not show up at concert time, for they are the ones who must replace the greying subscribers. Far fewer people take music lessons today, unless it's to twang guitars and bawl into microphones. They know only digital sound, not the acoustic of unamplified performance. It was not this way two generations ago, when Boston's piano teachers, voice teachers, string teachers, and their students filled the cheap "rush seats" sold at concert time. They heard the great performers; they learned the classics and the latest music (in the old days, some by Brahms) and, as they heard the canon repeated over many seasons, they had an inventory of performances on which to judge music. It was in their ear.

The audience for the Friday afternoons was female, as women were not yet working. Among those at the very first Friday afternoon, then called rehearsals (for the Saturday night concerts), was Clover Adams. She paid 25 cents for her seat. The rehearsal "was *fine*," she wrote to her father, "mind you go in now and then."[8] The Fridays were of course social as well as musical. In some years, hearts of the Friday ladies were also at Fenway Park: the irrepressible Isabella Stewart Gardner wore a bandeau lettered "Go You Sox." Like many another social ritual, the Fridays were a community in themselves. Ladies had their "Symphony friend," the woman she sat next to for 30 years and exchanged intimate histories of family, yet neither addressed the other by her first name.

Odd then, that classical music figures little in people's letters of those times. Perhaps concert going was like church, more to be internalized, hard to put down on paper; and it did lack spectacle.

Consider just the effect of stage lighting. In 1881, the Boston Symphony played while illuminated by fringed gas chandeliers we would think quaint. The content of what people actually saw in a theater followed from the kind of light that lit it. For Mozart's operas, the audience sat in the same candlelit brilliance as the singers on stage. The plots of most of his operas are domestic, taking place indoors, whether a boudoir or harem or temple, and if outdoors, a Seville street, a Grecian shore, within an architectural confine. Then, in the early 19th century, came two ways of lighting the stage that would snuff out candles. It would change not only how we saw stage action but what we saw on stage. One was called limelight and still exists in the expression, "in the limelight." Flame

directed at a cylinder of lime or calcium made it give off an intense light. Placed in the wings, the cylinders could be shoved forward to brighten the stage, and pulled back to dim it. In 1837, London's Covent Garden was the first theater to use limelight. Gas light was earlier, installed in London's Lyceum in 1804. More flexible than limelight, because it was tubed into and around the theater, its gas jets could be placed anywhere illumination was needed. By the 1850s, gas lit all American and European theaters. Those audiences saw the stage through the lovely glow of footlights.

Better still, gas could be dimmed way down. The audience now sat in darkness. The stage, too, was dark. A dark stage was the natural habitat of the supernatural. Ballet was transformed. Wilis who danced (fleetingly) on their toes in spectral gloom replaced the old candle-bright court dances of royalty and Louis XIV in his red heels. Ballet—but less so, opera—battened on tales of haunted nuns, demented gypsies, swans who lured, lurking demons and devils, and looming bats and werewolves. Meyerbeer's *Robert le diable* (1831) had it both ways: limelight lit the undead nuns who roil out of the grave and gaslight lit the regular folks. The new lighting made moonlight possible. Weber used it in for the Wolf Glen spell in *Der Freischütz* (1821) and the dancing spirits in *Oberon* (1826). In Verdi's *Falstaff* (1893) midnight is the wooing hour and men disguised as witches and elves beat the fat knight to his senses. With gas light there could be storms. The din of the old, shaken-metal "thunder sheet" now cued bolts of lightning right on stage. Playwrights and librettists took notice. Characters braved filthy weather in Wagner's *The Flying Dutchman* (1843), Meyerbeer's *Dinorah* (1859), Verdi's *La Forza del destino* (1862). Verdi's *Otello* (1887) opened with a colossal sea storm. It was heard in some of the loudest music ever written. Lighting shivered the stage.

Lots of this could go wrong. Many a movie, many a play, delighted in staging chaos, from the Marx Brothers to Michael Frayn's *Noises Off* (1982), now a staple of amateur theater. The hazards of touring grand opera invited Lily Fairchild's gleeful pen. Opera companies regularly visited Boston, the Met for a week every spring till 1986. In April 1894, the Fairchilds heard the touring German Opera do Wagner, Walter Damrosch conducting *Die Walküre* and *Götterdämmerung*. "I was asked to be a patronne so I went to both," Lily Fairchild writes. She had company, daughter and son sharing her other tickets: "Satty chose the 'G---' & that left Blair the 'W---', and of course he went the second day on a standby tickets and was completely exhausted, and <u>Materna</u> sang Brünnhilde superbly." Boston was hearing a legend. Famed for her bright lyric power, the Austrian soprano Amalie Materna (1844-1916) had sung in the first

complete *"Ring"* cycle at Bayreuth in 1876, where Wagner himself saw to every detail.

Touring, however, might require improvisation. Lily continues: "But the setting was poor enough, especially the last act, which ought to be so fine and impressive was <u>totally bare</u>! And poor Brünnhilde had no funeral pyre, no Rhein in the background, no crowd of attendants. She was quite alone on the stage with a drop scene representing a wheat field at her back! Damrosch begged our pardon for this: the chorus, he told us, and some of the properties were, on account of the raging storm, 'becalmed at New London'—which pleased the audience almost as much as if everything had been complete." (That same coastal storm kept varsity rower Jack Fairchild and the Harvard crew off river practice for eight days, and, in the spring ritual, his boat lost to Yale.)

Wagner dispatched, in the next paragraph Lily turns to another ritual, the opening of Harvard's annual Hasty Pudding show. *Charley's Aunt* at the Columbia was not the only drag show in town, for Harvard, like collegians elsewhere, relished boys playing girls (as did theatricals at the Tavern Club and the St. Botolph Club). Opera did drag, too. Mezzo-sopranos were treasured in "trouser roles," among them, Mozart's Cherubino in *Le nozze di Figaro* (1786) and Octavian in Strauss's *Der Rozenkavalier* (1911). Today's countertenors wishing to sing these roles miss the point. There was a vocal color the composers wanted, and the audience liked seeing comely legs. Mordant Lily on the Hasty Pudding: "Said as usual to be the best for years!" The music was by Ned Hill who was also the lovely heroine "about whom everybody is raging. Jack says he is really <u>not</u> a good looking boy but in a blonde wig, ravishing."

Boston debutantes played boys in the annual Vincent Club show for charity. As she was tall, Marian Lawrence was always asked to do a man's role. As "Mamma and Papa do not allow me to do that I am always an usher, wearing lavender dimity dress and white apron and cap." As it does today, the 1895 show raised money for what would become the gynecological/obstetrics department at the Massachusetts General Hospital. As it does today, it featured a show-stopping, precision-marching drill, which Marian thought "wonderfully done." The play was very good, the dances pretty, the audience enthusiastic. "After the last performance Gertrude Whitwell gave a supper party at her house which got pretty gay. Of course, there were only girls there and Mrs. Gibson, Ethel's mother, but there was much dancing of the Café Chantant style and health drinking and one or two of the girls *smoked* though I would not mention this outside the club."[9]

Children acted, too. On Christmas 1895, Marian saw girl cousins perform "Young Lochinvar," from *Marmion* (1808), Sir Walter Scott's

epic poem about Scotland. The famous couplet—"O Young Lochinvar is come out of the west/Through all the wide Border his steed was the best"—would require a gee-gee for the lovers to ride off on. There can't be many households so grandly equipped in stagehands to make this happen. "Hope was Y. L. who eloped with Hetty on the big rocking horse. This was most realistically accomplished by Uncle Augustus, unseen behind the parlor door, and the butler, unseen out in the hall, each with a rope attached to the horse pulling it across the parlor so that it appeared to be galloping wildly."[10]

Theater and classical music extended into the family parlor in another, more intimate way—reading aloud and playing the piano. Letters, books, and magazine and newspaper articles all might be vocalized in the family circle, and Lily Fairchild's weekly chronicles to her married daughter are little playlets in their dashed-off dialogue. People passed around letters to read aloud. By the time of the Victorians, novels were masterpieces of narration. Pages of galloping prose took readers and their listeners all over the world, and into every sort of life. But this was not true to life. Speech was orderly (no one speaks that way), and attempts at regional speech were painful. Edith Wharton tried to do Yankee in *Ethan Frome* (1911). Comic speech fared better: the contrived vernacular, the crude stereotype, only added to the fun. P. G. Wodehouse (1881-1975) gave us Bertie and Jeeves, addled toff and wise butler. Many a novel could be adapted for the stage (Wodehouse's made it onto television), but not all novelists made it as playwrights. Henry James was one who bombed.

In Brahmin Boston, *The Atlantic Monthly* was required reading; a 20th-century editor named Robert Manning (1919-2012) would live at the Agassiz when it went condo about 1973. A "republic of words," the magazine was a broad tent for literature but morally strict, the conscience of America, given to public service, intellectual honesty, and democracy. Poets and short story writers aspired to publication in *The Atlantic*. Its readership extended abroad, and that was reciprocal, *Atlantic* subscribers also taking Britain's many literary and intellectual "papers," as they called magazines. A fixture of *The Atlantic* was Oliver Wendell Holmes. His comic poem "The Wonderful One Hoss Shay" (1858), illustrated by Howard Pyle, was a folksy recitation piece with a last-stanza lesson on the false economics of building for a hundred years. As an essayist, Holmes was a ventriloquist of the written word. He called himself "the autocrat of the breakfast-table," and as that character he gives the illusion he is talking right to you. Or through you. If today he's an acquired taste, of almost antiquarian interest for what was on Victorian minds and what guided their manners and morals, he often was quite funny. He slid into the first essay: "As I was just going to say, when I was interrupted, that one of the

many ways of classifying minds is under the heads of arithmetical and algebraical intellects." Not the easiest of introductions. But along the way, subsumed into the narrative, are cameos from such talkative characters as the landlady, the divinity student, the poet, the old gentleman, and the courtesan Ninon de l'Enclos, "who said she was so easily excited that her soup intoxicated her." He remembered the first bicycles on which he saw Harvard boys astride, the pedal locomotive as he called velocipedes, "on which they used to waddle along like many ducks, their feet pushing against the ground, and looking as if they were perched on portable treadmills." As for exercise, walking was a puny second to riding a horse. "I have the additional pleasure of governing another's will, and my muscles extend to the tips of the animal's ears and to his four hoofs."[11] He loved horseracing. He names the great horses he saw run in England. "Stubb's old mezzotint of Eclipse hangs over my desk." But there's a moral coming our way: "Horse-*racing* is not a republican institution; horse-*trotting* is." Only the rich can afford to keep race horses, and, besides, "I say racing-horses are essentially gambling implements, as much as roulette tables. Now, I am not preaching at this moment," he assures us, "I may read you one of my sermons some other morning."

Holmes was all dialogue, all voice, rambling, *parlando,* to use the Italian for giving the impression of talking. The "Autocrat" begged to be read aloud, and it was. Reading aloud had a human function in daily life: like radio and television, it filled the gaps when there might not be much else to say. It was companionable, it was safe, it invited conversation. The grand narrative style, the sheer story-telling power of the Victorian novel,[12] filled hours. Those deadening rivals of speech on the printed page—the droning individual's internal monologue and the skatty self's stream of consciousness—were yet to come. Parents read to children, lovers read to beloved, and old people read to another.

Where people read depended on household lighting. If it was still a single chandelier, tallow or gas, over a parlor table, the reader sat there and read to a circle, who might do handiwork as they listened. When rooms were more generally lit, by wall sconces and free-standing lamps, people drifted away able to be private, and read or worked on their own.

Dickens was splendid to read aloud. He was a theater man, his characters a world's stage, the novels written to act out. "He do the police in different voices" was the challenge and the best reader relished changing sound and accent from Mr. Pickwick to vicious Bill Sikes and the snobby Pecksmith sisters. Henry James was impossible to read aloud. It took the breath control and phrasing of a singer to get through his long surfing sentences, his internal *parlando,* and pity the poor stenographer to whom he dictated the later novels.

One evening at the Agassiz, when John Singer Sargent was staying with the Fairchilds, conversation turned to writers. As we will see, that he did not prize Dickens brought a sigh of relief. Hawthorne he liked but thought *The Scarlett Letter* was "morbid." He defended Henry James. The others agreed with Ida Higginson, that his characters had no vitality. Her husband liked the author himself: "Harry James ... is a good chap and agreeable,"[13] he wrote from London in 1884.

What else was the Agassiz reading? As we will see, Gordon Fairchild struggled to get through Sir Walter Scott's *Rob Roy*. His post-debutante sister Satty curled up on the sofa with the latest by novelist F. Marion Crawford (1854-1909). He was the society figure who was the reason why the Gardners never showed Sargent's portrait of her. As a popular writer, Francis Crawford, called Frank, would sprawl genres. His novels were dramatized for the stage. His own play, *Francesco da Rimini*, was produced in Paris by his friend Sarah Bernhardt. His 1909 novel, *The White Sister* was a 1915 silent movie, and filmed twice more. What was Satty reading in 1894? If *The Novel: What It Is* (1894), then she would learn that its "intention is to amuse and please, and certainly not to teach and preach."

In this day of devices delivering instant communication, we forget that even reading could once require a bit of labor. Some books and many novels came with their leaves uncut. As still today, texts were printed on a single large paper sheet and then folded as "signatures" and bound. Often left untrimmed, the edges had to be cut open to read. The properly equipped home library had pen knives for the purpose. Woe to the reader who claimed to have finished the latest novel only to be exposed when someone noticed the leaves uncut.

While the Higginsons entertained the piano virtuosi who came to Boston to play with his orchestra, those "bohemian" Fairchilds listened rapt to Sargent banging out Wagner. The make of the Fairchild piano is lost to history, but Higginson had bought a Steinway in New York for his wife, perhaps a "German" from Hamburg, rather than an American-made sold on Boston's Piano Row at Steinert & Son. More than today, piano lessons—and music lessons in general—were part of middle class life. Young women often taught piano before and during marriage, and piano teachers were stalwart subscribers to the Boston Symphony, sitting in the cheaper second balcony seats (where the sound is better). Piano manufacture was a part of Boston's economy, from 1823 when Jonas Chickering opened what would become the largest brand in the country till surpassed by Steinway in the 1860s. The Chickering factory still stands at 791 Tremont Street, but long converted to studios for artists and musicians. Steinert Hall on Piano Row, with its basement stage 35

feet below 162 below Boylston Street where virtuosi would try out the instrument they wanted to play in concert, has gone, in part because of fire laws, in part from the declining market for home pianos.[14] Chickering and Henry Steinway (or Steinweg when he first came to America) met in spectacular fashion at the 1850 concert introducing the custom-made grand that Chickering had made for the "Swedish Nightingale," Jenny Lind's American tour which began in Boston. In New York the concert was delayed while Steinway stormed the stage to inspect the innards of his rival's piano, Chickering having patented the one-piece, cast-iron plate to support the greater string tension of larger grand pianos. Chickerings, father and son, also made smaller pianos for home parlors. In a toast at the Harvard Musical Association, Jonas's son Frank was saluted: "Chickering, like his pianos, grand, upright and square."

10

Outdoors

Of the curve ball and "steeds of steel"

It is a topic for debate whether the design of America's first real apartment building counted much in the professional life of its architect. His other life is another matter. In the 21st century, his fame is manifest in the racks of rental bicycles all over Boston and environs. The English-born architect Frank W. Weston (1843-1911) is considered the "father of American bicycling."[1] One of 13 founders of the Boston Bicycle Club in 1878, he imported "machines," published a magazine about them, and organized races for them, including the first 100-mile event for tricycles. The bicycle "craze" was like none other for its mobility, both physical and social. It was democracy on wheels. Women were among the earliest cyclists, and had their own magazine, *The Wheelwoman*. On its cover was a woman of color.[2]

In one way, Weston had the last laugh on Henry Lee Higginson, who commissioned the Hotel Agassiz from his firm. As we have seen, there was a spat over bills. As we will see, Higginson came to have a low opinion of cyclists. So there is a certain irony that in 2014, on Commonwealth Avenue, where Weston's Agassiz still stands at the corner of Exeter, City of Boston workmen painted dedicated lanes for the bicycles that have pushed aside modern automobile traffic, as the motor-car, the horseless carriage, had pushed aside the horse.

Cycling was disturbing because it shook the old order. Of all of the 19th-century's new recreations, it was egalitarian. It embraced all, challenged property rights, and changed manners and clothing. A bicycle was soon within the means of all, as little as $5 when a workman earned $500 a year, and—as around the world—would become the daily

transportation of America's laborers. It was the only recreation to have an effect on modern traffic patterns. And it brought all classes out of their houses into the outdoors. The same could not be said for competing recreations of the 19th century. In a literal sense, tennis and golf were games only for the landed gentry. Often sited on country estates, they required earth to be moved and grass established for courts and links. Biking took to existing roads, even to railway lines. Moreover, biking was flexible. Biking was for the rider seeking solitude. Biking was for courting. Biking was for the camaraderie of groups. As we will see, this camaraderie closed, most movingly, the chapter on Weston's own life.

In the timeline of recreation, the earth-bound but cheeky bicycle was the middle ground between horse and auto. Higginson was passionate about horses, less so about cars. Cyclists did not easily mix with either. There was friction. There were accidents, fatalities. Horse people feared cyclists would spook horses. Cyclists resented horse manure. Car drivers were spooked by speeding cyclists coming out of nowhere, and fumed they were seemingly unanswerable to traffic laws. Bicycling would become all about speed. The Boston Bicycle Club was about friendly rivalry, the ingenuity of tinkering with spare parts, fresh air, sore muscles, manly sweat (but ladies "glowed"), and freedom.

Is there a century like the 19th for sheer invention? It was the age of mechanical ingenuity. The tinkerer was king, the inventor emperor. Until there were systems developed for industry and transportation it can be argued there was no sport—recreational or organized—as we know it. We telegraphed and telephoned, and the word was made deed. We took photographs, and the deed was made record. We rode in elevators, and elevators made cities. We drove cars, "caught the train," and we got places to do things. Transportation opened America up, making cities of towns, and uniting them by easy travel. When life was scattered, lived on remote farms or down river valleys, you would be hard pressed to assemble 11 players for football or nine for baseball. Time changed too. One of the great bi-products of industrialization was recreation for the masses. Life was marginally easier, and time freed up for leisure. There was just enough money for little pleasures. Education brought literacy, at least to the level of the lending library, the penny dreadful, and popular magazines. Theater thrived. If you did not have to hack a living from the land, nature was actually quite attractive. The great outdoors beckoned, and what had been strategies for survival became playing at survival.

All sports derive from those most ancient escape strategies: we run, box, throw, swim, and, when horses allowed themselves to be domesticated, we could ride and drive. For kings and princes and their courts, sport was rehearsal for war. Reasoning that she might need to raise a militia

of archers from her subjects, England's first Queen Elizabeth encouraged archery practice on village greens on a Sunday. Doubtless, rural people fished and hunted (or poached) small game but more for food than recreation. With leisure to spare, royal courts staged events that verged on the theatrical. Hundreds of men and horses swept fields and forests in pursuit of game. For the solitary hunter, a falcon was a prized possession. In imitation of the warrior, court ladies pulled bows and shot at targets. In the name of chivalry, and to woo a lady, fiercely armored men mounted war horses and galloped spears at one another. Jousting could put a dent in the budget.

That exercise was good for the health, physical and mental, was long known. It is said the ever-quotable Dr. Benjamin Rush, a signer of the Declaration of Independence, advised John Adams that the outside of the horse was good for the insides of the man. (Perhaps as a joke: the saddle-weary Adams regularly rode from Massachusetts to New York and Philadelphia for constitutional conventions.) And to many, Nature was akin to religion, the greatest example of God's work, and, in America, the likes of Henry David Thoreau and Ralph Waldo Emerson were his apostles. In England, the Lake Poets. And Shakespeare in pastoral mode: "And this our life, exempt from public haunt, finds tongues in trees, books in the running brooks, sermons in stones, and good in everything."[3] It was but a step to commune with nature while walking, hiking, fishing, canoeing and sailing, and cycling.

Mankind had always taken to water, and so ocean-bound Boston and lake-dotted New England did likewise. The Atlantic coast was bright with the sails of every sort of craft. Unlike many other rich men, Henry Higginson did not crave a yacht, though his son Alex did, and raced them. Lakes and ponds drew canoes, some with swains playing the banjo to their girls. Nearer to the Agassiz, the Charles River was the race course for Harvard crews. It was not the sparkling Charles basin we know today, but, until dammed in 1908, a tidal estuary with smelly mud flats and the water thick with sewage and waste from the tanneries where the Massachusetts Institute of Technology stands today. Jack Fairchild rowed; his family grieved when his Harvard boat lost to Yale.

The cycling craze also hit Boston society. There were boasts. We have heard Lily Fairchild exclaim that the Saltonstalls thought nothing of riding out to Framingham and back, some 20 miles, and "the bicycling Searses" were known to have ridden 22 miles a morning. It was not long before Bostonians took to cycling on their trips abroad. What we would call "destination travel," it combined physical prowess with culture, something for mind, body, and soul. The same Searses invited the Fairchilds on a bicycle tour of English cathedrals. Other friends promoted Spain. It was

cheap, or cheap for some, about $100 dollars for the summer; yet, as we have seen, Lily Fairchild had to decline the invitation (Newport was near and dearer).

The Sears name, however, belongs to tennis. And tiny Nahant, a scrap of land, a near-island across the harbor from Boston, was, if not its cradle, certainly the nursery of American tennis. The village was already a summer resort, having hived off from Lynn when the Temperance movement made that town dry. Among the luminaries to summer in Nahant was poet Henry Wadsworth Longfellow, and geologist Louis Agassiz (who set up a laboratory in his wife's house). The Townes, tenants of Henry Higginson at the Agassiz, went there. Ida Higginson recuperated there with baby Alex. It was an art colony as well.[4] In the 20th century, it was home to Boston Mafia, such as a North End gangster, Gennaro Anguilo (1919-2009), who had worked his way up to Mob leader.

In 1874, on what had been pasture in the 1630s, on grass shaved to lawn, two cousins played the first-known game of tennis in America on their uncle's yard in Nahant. James Dwight (1862-1917), born on Bastille Day in Paris, had, in the way of his family, travelled abroad, and in England seen something called lawn tennis, and had the fixings—net, racquets, and rules—shipped home. He and his cousin, Frederick Richard Sears, Jr. (1855-1939) gave it a go. They organized a round robin, each playing against friends. Racquets, rather than tennis scoring, were used, and Dwight beat Sears 15-15, 15-7, and 15-13. That was that, till they taught the game to yet another cousin, a Harvard student like them, named Richard Dudley Sears (1861-1943), but called Dick. He and Dwight would become the Mssrs. Tennis of America. Henry Higginson of course knew both families. But, as we have seen, he was particularly fearful of Dick's grandfather David Sears. Sears was developing property—Longwood, his country place in Brookline—by carving it into mini-country estates. The houses were winterized, and within walking distance of a trolley line that would take men of business downtown to work. This was the same market that Higginson craved as tenants for the Agassiz.

The tennis that Dwight and the Searses played bears little resemblance to the earliest game. That derives from the lowly game of handball, dating back to the 12th century. When the player's glove became a racquet and the net introduced, the modern game of tennis was born and it was played outside on grass. Staged indoors, court or royal tennis was rightly called the sport of kings, played by those 16th-century rivals, François Premier and Henry VIII. As Dick Sears told the tale, his introduction to tennis was on a rainy afternoon in Nahant in August 1874. He took to it at once. They played and played and played, in rubber boots and mackintoshes, till he and Dwight had each won a set.

In old photographs, Dick Sears and James Dwight wear cleats tied over their shoes, lest the smooth leather soles slip on grass. The net droops behind them. Their racquets have the straight bottom of a paddle. Dick Sears looks oddly professorial, with mustache and pince-nez. The rest of him is the sporting gent. His pants are natural linen, his shirt white, his necktie as boldly striped as his jacket and cricket cap. There's a link to cricket, because the first lawn tennis court was installed in 1878 at the Longwood Cricket Club, built on a corner of David Sears's Brookline estate. Dwight would bike over from Harvard for afternoon games. While Dick Sears was still in college, he began his extraordinary record, winning his first U.S. Championship in 1881, and then another for the next six years, retiring (injured) in 1888. He lost only three sets of the 24 played. Not till 1921 was his streak broken, and then by the great Bill Tilden. Sears was equally competitive at doubles. He and Dwight were champions in 1882-1884, and again in 1886-1887, and he with Joseph Clark in 1885.

Girls and women took to tennis. One was Marian Lawrence Peabody. In her memoir, she recalls being much better at tennis than at golf, which was to be next new country club craze. Dress for tennis was as formal as for men: women wore the long-skirted costume familiar from the "Gibson Girl" illustrations. She found it "perfectly comfortable and not such a handicap as people think, because it was quite full." But a floppy white chiffon hat "partly accounted for my *bad* playing." She saw the game evolve. With her cousin Hasket Derby she won Maine's mixed-doubles championship. She was tall and played at net. "Up to then no girls had tried it but it was the latest way to play ... and I was more often asked to make a fourth with the men than the other girls." Her sister was a good player at back court, and served underhand, as "all that was expected of girls." Girls had to be "steady and quick or they were a handicap instead of a help. Many tournaments were handicapped in this way: best man got worst girl and vice versa. They were not the most popular tournaments."[5]

Because of the sheer space needed for the game, the new craze for golf would change the American landscape even more than tennis had. Like tennis, it would introduce "leisure wear" as a way of dressing. From rowing we got crew shirts, and rugby, polo, hockey, and golf contributed their distinctive attire. It was Mary Queen of Scots (1542-1587) who coined the word "caddie," a diminutive for the cadets who carried her clubs, and the famous course at St. Andrews was established during her reign. The game became so popular that in 1457 James II of Scotland banned "gowf" (and "futball') as distractions from archery practice for his army. Mankind has always bashed something at something. About 960 the Chinese started hitting feather-stuffed balls with clubs they made from tree branches. While Scotland claims to have invented modern golf (with

holes the ball must drop into), the earliest form was Dutch, players using a stick called a *kolf* to send a ball or stone the farthest in the fewest strokes. When the Dutch settled New York, they introduced their *kolf* to America, near Albany in 1650, playing in fields, or on ice in the winter. Golf clubs sprang up all over the country: Charleston, South Carolina, in 1876, and California in 1879 at San Francisco. The same year saw the founding of the Massachusetts course at the Vesper Country Club in Tyngsboro.

Girls and women took to golf as they had to tennis. In her memoir, Marian Lawrence Peabody recalls that when she started golf, it had overtaken tennis, and she remembers the little course at Stockbridge with the swiftly flowing Housatonic overhung with willows. On her first day she put 11 balls in the drink. And, of course, a Sears was one of the early women's golf champions. A cousin of tennis champ Dick Sears, Evelyn Georgianna Sears (1875-1966) won both the U.S. tennis and golf titles in 1908. The greatest Sears amazon was Eleonora Randolph Sears (1881-1968). She held titles in tennis and squash. She boxed. She owned and raced horses, and rode show jumpers over tall fences. One of the first women to drive a car and fly a plane, she was also a long-distance walker, strolling from Boston to Providence in time for lunch, and, for that, was written up by A. J. Liebling in *The New Yorker*. When she tried to play polo with men, she was banned by the Burlingame Club in California as un-ladylike, and her wearing of trousers in public raised eyebrows.[6]

Golf would shove aside other sports requiring open land. When The Country Club, the modifier distinguishing it from clubs in the city, rose on Brookline farmland in 1882, its open fields were a natural for horse sports such as steeplechasing; and one of the most devoted riders was the Agassiz's Alex Higginson. But when golf caught on, the club installed a little course over the racing surface in 1893. With the golf craze, the golf bore, and humorists began to notice. That golfers talked of nothing but their scores invited the attention of Franklin Pierce Adams, known as F. P. A., whose column, The Conning Tower, spotted life's absurdities for readers of the *New York Tribune*. He invented a golf competition. He envisioned the shaving mirror as the golf course, the razor the club. "How many strokes does it take you to go around your face?" he asked. Letters overwhelmed space to print the boasts.

Team sports in America were largely amateur, and largely played outdoors. Basketball was the first inside game. The hoop with net seen in every park and driveway began as little more than a soccer ball tossed into a peach basket, and was invented in Springfield, Massachusetts, in 1891 by James Naismith (1861-1939), a Canadian-born physician looking for a physical activity that would be interesting to play, easy to learn, and could be played in a gym in the winter. It was just what his

fellow teachers at the International Training School of the Young Men's Christian Association (now Springfield College) were looking for. And it was a success from the start: In the first game, the boys beat their teachers, including Naismith. The YMCA, or "Y," had been founded in London in 1844 as a safe haven for young men seeking city work. It had a strong religious, even proselytizing foundation, which, mated with the Muscular Christianity movement, believed athletics contributed to a healthy body, mind, and spirit, making for better men (and women with the YWCA) by taking their minds off sin. In big cities, Y's were sports clubs with gyms, swimming pools, and the indoor running track at the Boston Y, a block from Symphony Hall, has attracted Boston Symphony players.

Team sport carried with it a sermon: Manly vigor when applied to cooperative effort and love for rule made the better man. Sport built character. Harvard's Charles William Eliot (1834-1926) did not agree. President from 1869 to 1909, he tried to abolish football in 1905, calling the game "a fight whose strategy and ethics are those of war." Only two years earlier, Harvard stadium had opened on The Soldier's Field, the land given by Henry Lee Higginson in 1890 in memory of classmates who fell in the Civil War. The design, by Lewis Jerome Johnson, Harvard professor of civil engineering, was a construction marvel, the first use of reinforced concrete to make a vertical structure. So on one hand, Eliot could be proud of the stadium, for he was the Harvard president who worked to transform a provincial college into a university headed toward preeminence in science and technology. (He had hoped to do it on the cheap by acquiring the Massachusetts Institute of Technology.) But he was also mindful how violent college football had become. In 1905 alone, 18 died and 159 were injured. Eliot deplored sport in which the weaker are the legitimate prey of the stronger. He had no use for baseball, basketball, or hockey. Only tennis and rowing were "clean sports," he told the *New York Times* on 28 November 1909, the month of the annual Harvard-Yale game. He was no fonder of the national pastime, as baseball would come to be known. "Well, this year, I'm told the team did well because the pitcher had a fine curve ball. I understand that a curve ball is thrown with a deliberate attempt to deceive. Surely, this is not an ability we should want to foster at Harvard."

Other team sports, such as ice hockey, cannot be said to have a moral basis beyond player loyalty and a will to win. To Canada belongs the honor for ice hockey, played there on frozen canals and ponds in the nineteenth century with the traditional puck. Variations in America included "ice polo" played with a ball. "Pond hockey" would go indoors, when a skateable surface was refrigerated at the Glaciarium in London in 1876.

So, team sports were more recreations for schoolboys and college students. Professional football begins only in 1920. Baseball can be said to have Massachusetts roots. The earliest known reference comes in 1791, when the Berkshire town of Pittsfield passed a bylaw against "base ball" breaking precious glass windows. The first modern baseball team was the New York Knickerbockers, organized in 1845 for upper-class sporting men. The Boston Red Stockings first played in 1871. The "Curse of the Bambino" began in 1919 when the Red Sox traded slugger Babe Ruth to the New York Yankees, and the team never again won a World Series till 2004. Baseball remains the one American team sport in which the player scores, not the ball or a man carrying the ball. In that, it's like a board game, the throw of dice advancing the token. It was cricket, a game not unlike baseball (nothing like, the Brits say), which brought tennis to Boston. The first Red Sox manager, the English-born Harry Wright (1835-1895), played cricket at Longwood as well as center field for the Boston Red Stockings 1871-1874.[7]

Before there was baseball at the Polo Grounds in New York, there was polo. Yet another sport called the Sport of Kings, it was as ancient as any, first reported in Persia in the sixth century BCE and spread through Asia (there was a Chinese ladies team) to India (in 1833), and India to Britain to America. The name may derive from "pulu," the Banti word for ball. Rules varied as to number of players as did styles of play, from fast and vicious to slow and mechanical, and number and length of periods (chukkers). The ball was usually willow wood painted white for visibility, and mallets, called sticks, were made of cane for camber. James Gordon Bennett claimed to have brought polo to America when he organized the first game on 6 May 1876 at a riding academy in New York City. But Texas many have beat Bennett to the goal posts. Dennison, near Dallas, already had a polo club, and a retired British army officer played it on his ranch in Boerne, near Austin. Massachusetts came a decade later. In 1888, on mowed pasture in Hamilton, members of the Myopia Hunt Club first practiced "stick and ball" and that fall challenged players from Dedham. Harvard boys played polo. In fact, taking a grandmotherly interest in the sport was the founder of what would become Radcliffe College, Elizabeth Cary Agassiz. Young Rodolphe (Dolph) Agassiz had gone to England to play on the American team in 1903. They had won their first match on 4 May. "Dolph's playing is noticed as good and it is said that the team as a whole played well together." Then came the rains. "Too bad, for all those postponements have had an effect on our ponies—and their riders have not had a fair chance."[8]

And until the Great Depression, the game thrived, thousands attending matches on Long Island. The Cole Porter musical, *Red, Hot and Blue*,

brought polo to Broadway in October 1936. Ethel Merman and Bob Hope introduced "It's Delovely," and Jimmy Durante got laughs playing the sentimental jailbird who is captain of the polo team at his penitentiary. And when horses were not available, or for the merry hell of it, there was auto polo, golf cart polo, baby buggy polo, bicycle and motorcycle polo, elephant and camel and yak polo, canoe polo, hobby-horse polo, and now Segway polo. These forms of locomotion are a back-handed tribute to the game. Anyone can hit a ball. To do it from a thousand pounds of plunging, swerving, galloping horse—not just alongside but back-handed, and fancy stuff like a forehand under the neck—is the challenge. Is there another game that invites fans onto the field at half-time to repair damage to the surface? Stamping down the divots carved by those 32 horseshoes is tradition.

Early Back Bay Boston was the Age of the Horse, and equines have had a chapter to themselves. For some children, riding lessons were a part of growing up. The Agassiz's Alex Higginson got his first pony, a Shetland, when he was six, and, when he was eleven, a smart roan cob which stood about 14.2 hands, or nearly the size of a small horse. These he kept in his father's stable on upper Newbury Street. Only blocks away, and handy for park-like rides in the Fenway, was the New Riding School on Hemenway Street. Marian Lawrence went there for lessons.[9]

"Mr. Busigny was the instructor, and we were told he had been a French cavalry officer. This was easy to believe. On his beautiful horse, he looked like a fine equestrian statue which should have been in a city square. He was an expert at schooling horses and fascinating to watch. The trouble with Mr. Busigny was that he made his pupils cry." That put Marian on her guard, and all went well for months. "But one day toward the end of the year when I always lose my pep anyway, he kept us trotting around and around the ring. We rode sidesaddle, of course, and were taught to rise to the trot. We went on for so long and I got so exhausted that finally I pulled out to rest. Immediately he called out, 'What is zee trouble, Miss Lawrence?' I said, 'I have a pain in my side.' This he found so funny that he bowed back and forth on his horse in laughter and said, 'Trot some more and you will get over your pain.' After that he lost his charm for me."

Alex Higginson, too, suffered from the riding teacher's tongue. The young H. L. de Bussigny, born in 1840, had served the ill-fated Maximilian, Napoleon III's puppet emperor of Mexico, whom rebels executed in 1864. Bussigny wrote *Hand-book for Horsewomen* (1884), for the sidesaddle set. His class of 12 boys met three times a week in the winter. If his language was at times "picturesque and rough," he "had a heart of gold," Alex writes. When he did not like the way a boy rode, "he would stop the whole class; single out the culprit and shout at him, much in the same tone

of voice in which he would have ordered a cavalry charge: 'Monsieur Alex, you look like a cat in a thunderstorm,' and then turning to the others, say: 'Mes enfants, look at 'im and nevaire, nevaire ride zat way." Alex's only criticism: Bussigny was a "most excellent teacher of 'Park riding'" but "hardly efficient" as a an instructor of cross-country pursuit, such as steeplechasing or fox hunting.[10]

In 1790, Thomas Berwick published his classic of the natural world, *A General History of Quadrupeds*, illustrated with several hundred of his own wood engravings of animals from Adive to Zorilla. Reissued in 1885, and again in 2009, it began with an entry dear to the hearts of the horse-loving Higginsons. "The various excellencies of this noble animal, the grandeur of his stature, the elegance and proportion of his parts, the beautiful smoothness of his skin, the variety and gracefulness of his motions, and, above all, his utility, entitle him to a precedence in the history of the brute creation." Berwick's name was pronounced Buick, as in the motor car. "The horse," he continued, "in his domestic state, is generous, docile, spirited, yet obedient; adapted to the various purposes of pleasure and convenience, he is equally serviceable in the draught, the field, or the race."

Still true today, but that the horse is an artifact is also true, ridden for recreation and sport, and, nowadays, plowing on boutique farms to sew heritage corn for the locavore market. By the turn of the century, machines on wheels were increasingly the new horsepower, and, when they grew wings, the new Pegasus. A man with a feel for both was Amos Ives Root.

"While I like horses in a certain way, I do not enjoy caring for them," he wrote in 1904. "I do not like the smell of the stables. I do not like to be obliged to clean a horse every morning, and I do not like to hitch one up in winter." And so as an early motorist, he drove an Oldsmobile Runabout, which cost a mere $350, or less than a horse and carriage. "It takes time to hitch up a horse; but the auto is ready to start off in an instant." This from Root's column in his own publication, *Gleanings in Bee Culture*. By profession, he was part of agrarian Ohio, making and marketing supplies for the beekeeping necessary for production of honey and for pollination of plants and trees. But he loved any kind of machine, and when word reached him of Wilbur and Orville Wright's experiments with flying, he got in the Olds and drove 400 miles to see for himself. The Wrights considered Root's accounts in *Gleanings* the most accurate reports of their early manned and powered flights.[11] In 1912, Boston looked to the skies when the newly-founded Harvard Aeronautical Society demonstrated a glider and a bi-plane built by some of its 250 members.

The hymnist of the horse, Berwick wrote when the temperate world was agricultural. It costs little to feed horses. Vegetarians by nature, they do

well on a diet of cereals (oats, corn, bran) and grasses. But they are costly to maintain, dollars to pennies for the bicycle. The "wheel" was affordable for all. It did not require special housing. It was not difficult to repair. The rather simple parts were used in the Wright Brothers' airplanes. Bicycles got the laborer to his job.

Best of all, for a population whose work week had shrunk, allowing a good part of the weekend for leisure, cycling was the recreation that was the horse without the mess. You could go places. The roads were free. It was even good for you. And you did not have to buy special clothes. A long wide skirt for women, trouser clips for men, and up on the pedals you got. It can be argued that today's Americans will only take up a new activity if they can dress up for it. Where would yoga be without yoga pants? Yoga pants go the office, as costume becomes street wear. Today's cyclists wear gleaming skin-tight polyester that would pop the eyes of the men who rode in thick knickers and knee stockings.

By 1880, the bicycle craze hit Boston, as richly chronicled in 2014 by Lorenz J. Finison, a founding member of Cycling Through History. The Boston Bicycle Club was the first in America and its members helped found the League of American Wheelmen. Cycling magazines appeared; among other topics, *The Wheelwoman* advised on dress. Newspapers had bicycle editors. Biking had something for everyone, for the solitary rider and for the sociable, though the early clubs were seldom co-ed, and were exclusive in other ways. Finison found Irish-appearing names are missing from club rosters. There would be clubs organized around ethnic and religious affiliations. Poets formed a club. The cover of Finison's book spotlights the bi-racial Kitty Knox, a rare cyclist of color. She would scandalize by wearing bloomers. "If she has a garment which women can wear on the wheel comfortably and gracefully, she ought to be hailed as a benefactor by all haters of the unaesthetic," opined *The New York Herald-Tribune* in 1895.

Never mind the men, said Minna Caroline Smith, a student of English and history at the Harvard Annex, the future Radcliffe College, we women will go off on our own. "I intend to demonstrate what women can do on wheels without masculine help," she promised when organizing a "a ladies' tricycling tour to Cape Ann," from Malden to Gloucester, in the fall of 1885. It came off, though women insisted their husbands come along, and the husbands insisted on riding two wheelers. They had their picture taken on Salem Common. The tall-wheeled tricycle, for lady alone, oddly mimics the one-horse shay (from the French *chaise*). The rotary quadricycle held two people: the gent rode behind the lady and pumped while she steered. Pretty soon she pumped for herself.

The roads, bad as they were, lumpy from cart and buggy wheels and strewn with stones, beckoned cyclists. What really was the point of

a bike if you couldn't go somewhere? In 1878, Wheel Around the Hub was America's first two-day cycling tour. "Around the Hub" was literal, the route through towns ringing Boston on 11-12 September. Most men rode halfway up Blue Hill and hiked to the top. One, on a 56-inch wheel, pumped all the way up. The group photograph taken in Hyde Park shows more than 20 men posed with their tall-wheeled penny-farthings, hand on the saddle to keep them upright.[12] These bikes were a challenge to get on, get going—and stop. To mount, the rider had to clamber on, and hope to engage the moving pedals to continue forward. He sat perched on the very large high front wheel, with the little wheel in back. Thanks to the centrifugal force of the big wheel, the bike was stable. Woe to the rider who hit a rock and took a "header." He fell higher and harder than from today's bikes, and without a helmet. There was not much in the way of braking: only if the rider applied strength on the pedals would the wheel slow so he could hop down from the saddle.

The first to bring one of these monsters to Boston was Alfred Dupont Chandler of Brookline. He had seen "English wheels" of various kinds at the 1876 Philadelphia Exposition (for the American centennial) and had one shipped to Boston. Another enthusiast was Colonel Albert Augustus Pope (1843-1909), an auto and bicycle manufacturer, whose name would come to be reviled by cyclists. A salesman for his Pope Manufacturing Company tried unsuccessfully in 1898 to sell Henry Lee Higginson a Pope-mobile, as we have seen in the chapter "Horses." He was the first car maker to use mass production. In 1900 his plants at Hartford, Connecticut, produced more autos than any other factory in the world. Yet he would die broke, in part because of the 1907 financial panic.

But it was with bicycles that Pope made his first fortune. He would manufacture a quarter million bikes a year. He too had fallen for cycles at the 1876 Philadelphia Exposition. Importing penny-farthings from abroad, he took out U.S. patents on these European models. More money was to be made, when, in the 1890s, he established a monopoly, a bicycle trust by which he controlled the major American patents. Bike makers paid him $10 a cycle. His own brand was the Columbia, which cyclists called the "monopoly machine."

As cycling grew, and its clubs became organizations, there would be politics fought and moral questions asked (betting at bike races) and lobbyists lining up. For most cyclists, it remained a social event. Bicycle jaunts were jolly affairs. Pope sent a wagon out with a feast to feed those first Hub riders. It was good business, too, for resort hotels and country inns. They welcomed cyclists to fill bedrooms and ballrooms. Carts took luggage on ahead. Strong drink was not unknown. There were dances, and singing. Cyclists staged minstrel shows. Camaraderie encouraged joshing

nicknames. It was ritual for a bugler to sound "Boots and Saddles." The gentle strains of the cello were heard at a picnic.

Anniversaries were observed. For its 40th in 1910, the Boston Cycle Club took to their steeds of steel and planted a tree at the Fairbanks House, in Dedham, built between 1637 and 1641 and the oldest surviving timber-framed house in North America. The next year, another grand old man of cycling died, Frank W. Weston, perhaps lesser known as the architect who had designed the Agassiz in 1872. He and his wife lived on Savin Hill, Dorchester, in a Shingle-style house he had built. When he died in 1911, he left instructions his ashes be mingled with his wife's. That never happened, and in 1937 his were discovered unclaimed at an undertakers. Out to Dedham rode the Boston Cycle Club to scatter him under the anniversary tree.[13]

It surprised no one that cycling could lead to intimacy. In 1892, it got its song. An Englishman named Harry Dacre, who'd brought his wheel here, wrote a ditty about a courting couple: "Daisy, Daisy, give me your answer do/ I'm half crazy all for the love of you." And off they go, on "A Bicycle Built for Two." Strum the tune on the mandolin, and people immediately sang along. The rhyme scheme lent itself to parody.

They say you never forget how to ride a bike. Learning how took instruction. There were cycling schools to teach riders. One, in Boston's South End, still stands. The handsome round brick Cyclorama, tubby with turrets (gone today) and then noted for the largest dome in the country (after the nation's Capitol), was built in 1884 so people could stroll and study a mural, 400 feet long and 50 high, of the battle of Gettysburg. In 1889, the cyclorama was Custer's Last Stand. Sarah Caldwell's Opera Company of Boston staged Verdi's *Luisa Miller* there in February 1978, when the leaky roof wet the audience. But for cycling, the great round floor unimpeded by structural columns was ideal for lessons. That space, over the years, would attract roller skating, riding (horses and carousel), boxing (John L. Sullivan fought in 1894), and, inevitably, a parking garage in 1899. Plays are now staged there. For decades, the Ellis Antiques Show was an autumn fixture.

With men like Chandler taking the lead, Back Bay Boston also cycled. It was good for the health, as Chandler could attest. Hilly jaunts around Boston on a "steel and rubber steed" in the 1870s restored him to full vigor, his muscles as steel and digestion in perfect working order.[14] The clubs, if not snobbish, were organized along the affinities of race and religion. Irish, Jewish, African American, women only, and at least one club member went into the bicycle business. But road races were a civic event, the judges' stand grandly placed before the grand Hotel Vendome on Commonwealth Avenue. Cyclists loved a parade. On 30 May 1895,

several hundred members of the American League of Wheelmen (and women) posed on the steps of the newly-built Boston Public Library in Copley Square on the occasion of their ride through the Back Bay.[15] Cyclists could play around, too, dressing as Mercury aloft a pageant bike.

The bicycle was not without problems. They scared horses (so did cars). Their riders did not like to be told what they could and could not do. They forced the repeal of the law requiring bicycle lights. No, said the cyclists. Lanterns would scare oncoming horses, create a glare and blind other riders, and were too weak to light the roadway. Governor William Murray Crane, from rural Dalton, signed the repeal in 1900. On the same day, he signed the law requiring railroads to carry cycles as "free baggage." Railroads were angry they had to carry them at all. The Fitchburg line argued the bike was not baggage but "a rocking horse for older people."[16]

Sober-sides felt the free-wheeling nature of the cyclist endangered the entrenched interests of other transportation. Higginson, who took the train from his country place at Manchester to Boston, was concerned with safety, and probably, public behavior. On 8 July 1898, he wrote to the president of the Boston & Maine Railroad, and the next day Lucius Tuttle replied. "The suggestions you made cover two of the most troublesome questions we have to deal with. Bicycle riders take the risk of riding between our rails throughout the whole system, and although our employees are instructed to prevent this, the evil continues unabated. Riding a bicycle or even walking upon railroad premises is technically a trespass under the law, but the possibility of getting convictions is extremely remote." As for passengers climbing over train gates, another concern of Higginson, Tuttle could only throw up his hands. "I reached the conclusion many years ago that in certain matters there is a little too much freedom in this country."

Cyclists would trump property. All through suburbia, the old rail beds are now tarred over for bicycle paths. The "rails to trails" movement has strong Massachusetts roots. Among the first advocates were Joan T. Kanswisher and Barbara Burwell of Woods Hole, who, in 1977, founded the 11-mile Shining Seas Bikeway. Named for the lyrics to "America the Beautiful" (1893) by Falmouth-native Katharine Lee Bates, the trail was laid out on the roadbed of the bankrupt Penn Central. Inspired by his mother, David Burwell (1948-2017) was co-founder in 1986 of the Rails-to-Trails Conservancy. Laurance Rockefeller put up $75,000 to get it rolling. The conservancy, often in conjunction with the National Park Services, operates in all 50 states and the District of Columbia. More than 2,000 trails run over 22,000 miles of rail corridors with 8,000 miles in the planning stage.[17] The longest and most diverse of trails is the John Wayne

Pioneer Trail, stretching 253 miles in Washington State. Dating from 1980, when the state acquired the failed Milwaukee Road, its founder, horseman Chic Hollenbeck, decreed it be open for riding and driving horses as well as biking and cross-country skiing. He named it for actor and horseman John Wayne (1907-1979). The Duke's roles as cowboys and cavalry men and loners in 83 Westerns helped form the central core of the Republic's creation myth. What goes around comes around, especially on wheels: the Iron Horse railroad gave way to the Horseless Carriage auto, and the horse to the dandy horse velocipede which became the bicycle.

11

Taste

Of staircases and satyrs

The Henry Lee Higginson who professed to like "the severe" in most things seems not to have lived that way at home. He followed the fashions of the times. If taste called for Old Masters on the walls, he had an important Madonna by Rogier van der Weyden (1400-1464). Oils of sturdy French hunting hound s by the *plein-aire* Barbizon, painter Constant Troyon (1810-1865), came and went. In the art of his own time, he was cool to the shimmer of the French Impressionists. As we will see, none other than Henry Adams negotiated with Auguste Rodin for the bronzes he wanted to buy. He seems not to have bought a Renoir nude when offered. Elsewhere, his fancy was global. His wallpapers were Japanese, his carpets Indian, his china German (Dresden) or English (Minton). His carriage horses were English hackneys. He drank Spanish sherry. He had studied music abroad: the Boston Symphony Orchestra he founded was more European than American. He lived in what were called "French flats." His wife was Swiss. The pajamas he had made in New York were also foreign in origin, nightwear brought back to England from India or China.

That said, is this of any wonder? From the vantage of the 21st century, it derives from the merchant taste of the China Trade that enriched Boston households in the 18th—but brought smartly up to date. The same "oriental" carpets, but in place of ancestor portraits, usually gloomy, the delights of nature in landscape. The nude, if she were academic and chaste. In place of plain walls, or scenic papers, the busily-dense geometric. And above all, the effect of living in a city. The grandeur of 18th-century Salem was set in greenery, the big houses massed around the grassy Common, the countryside a short walk (or drive) away, and those interiors tending

toward sylvan pastels. The Higginson of the Agassiz looked out on city brick and brownstone. The Back Bay, moreover, was built to house the city's business elite. Rich interiors were in a way a barometer of the market. Effects of the bank Panic of 1873 were still worrying much of the industrialized world in 1878, and so it was not necessarily cheeky that a Boston dealer in floorings, having told Higginson where to shop for carpets in London and Paris, should conclude his letter, "I hope you find your stocks higher on your return."[1] If Higginson was out shopping, wealth might trickle down.

* * * * * *

Let us now pause to consider the taste of a man on his way up. His name is Silas Lapham and he is no less real for being a fiction of novelist William Dean Howells in 1885. We have met Lapham as a fancier of trotting horses, as was Higginson. While living comfortably in domestic bliss in Boston's South End, he has made a fortune in the manufacture of paint. What should he waste his money on? "The Laphams had not thought of spending their superfluity on servants who could be rung for." They kept two Nova Scotia "girls" and a "darkey" to look after the furnace.[2] The two daughters go to the local grammar school. A chance encounter on vacation brings the female Laphams into contact with their betters on Beacon Hill. Not unmindful that the Miss Laphams—pretty but brainless Irene, plain and bright Penelope—are of marriageable age, their mother fears they live in the "wrong neighborhood" to find husbands. For reasons more to do with his own success than his daughters' futures, Lapham has already contemplated a move out of the faded South End to the smart Back Bay of his merchant peers. "Well," said the Colonel, who like Higginson had served in the Civil War, "there ain't a prettier lot on the Back Bay than mine. It's on the water side of Beacon, and it's 28 feet wide and 150 deep. Let's build on it." They do, but *The Rise of Silas Lapham* ends in a fire set accidentally by Lapham himself, and the house of their dreams burns to the ground.

While the fire pungently realizes the novelist's moral to his story, the scenery of the South End and the Back Bay—architectural, social—can be taken as real life. For one thing, Howells was married to the former Elinor Mead, whose brother was the Mead in the celebrated architectural firm of McKim, Mead & White. He designed Red Top, the country retreat the Howells built on land given them by an Agassiz family, the Fairchilds. For another, the Howells lived not only on the "water side" of Beacon, at number 302, but near Dr. Oliver Wendell Holmes at 296 Beacon, he the Autocrat of the Breakfast Table who defined the Boston Brahmin for a curious world.

All grist for the mill, as Howells wrote to great friend and fellow novelist Henry James on 22 August 1884. "Drolly enough, I am writing a story in which the chief personage builds a house 'on the water side of Beacon,' and I shall be able to use all my experience, down to the quick."[3]

Little got past Elinor Howells's satiric eye and pen. She knew to the minute when the self-made could become acceptable in Boston society. Her daughter, on the same debutante track as the Fairchild girls, had learned to dance at Papanti's classes, but novelist Howells rightly notes the Lapham daughters did not go to the private lessons. Elinor Howells, who would move house almost 50 times in married life (a list of the couple's addresses, compiled by Elif S. Armbruster, Ph.D, not dated, is available on the Internet), knew that how one furnished one's rooms was half of "belonging," of fitting in. "They are going to have a library in their Beacon Street house," (104) a Lapham suitor tells his patrician father, meaning it more kindly than, at the other end of Massachusetts, Edith Wharton with her crushing remark about *arriviste* neighbors in Lenox who "they tell me they intend to have books in their library."[4]

Howells was an outsider, born in small-town Ohio in 1837, with only a grammar school education, but acceptable in Boston society for editing *The Atlantic Monthly* from 1871 to 1881. He was by no means sparing of his Boston Brahmin readership. He makes Lapham find the patrician father of one of his daughter's swains "offensively aristocratic" for his tall, thin, slight stoop, white mustache.[5] That worthy, in return, "quivered in resentment" of Lapham's "vulgar, braggart, uncouth nature." Part of the reason was tribal. "He recognized his own allegiance to the exclusiveness to which he was born and bred, as a man perceives his duty to his country when her rights are invaded."[6]

The hardly fictional Henry Cabot Lodge was of the same mind. Like Higginson, he was a direct descendent of the Rev. Francis Higginson, who settled in Salem in 1629, and so came from the same line of China Trade merchants. As United States senator, he fought mightily for the League of Nations, and failed, and like Higginson, opposed Free Silver, and lost. As he saw Boston in the year of his birth, 1850, and his boyhood: "The town still had personality, lineaments which could be recognized, and had not yet lost its identity in the featureless, characterless masses inseparable from a great city. I do not say that this was an advantage; I simply note it as a fact ... Boston had a meaning and a personality ... It may have been narrow, austere, at times even harsh, this personality, but it was there, and it was strong, manly, and aggressive. It would still have been possible to rally the people in 1850, as they were once rallied against the British soldiers on a certain cold March evening with the cry of "Town born, turn out."[7]

Of the self-made Lapham, Howells causes one character to muse, "But money has its limitations" and another character to agree: "Yes, there is a point when taste has to begin."[8]

What the interiors of the rowhouses and apartments in Boston's Back Bay looked like in the generations between 1870 and 1920 can only be guessed at. As urban archeologists of a sort, we can snoop through letters, public documents and utility bills, and invoices from merchants. Napoleon called the English a nation of shopkeepers; their letters to Higginson bristle with pride in product. And we can study the occasional scene in novels for vignettes and the telling detail. Here is Howells on the style of the Laphams's South End house.[9]

They had both sitting room and drawing room, and the later was done in "the parti-coloured paint which the Colonel hoped to repeat in his new house: the trim of the doors and windows were in light green and the panels in salmon; the walls were a plain tint of French grey paper, divided by gilt mouldings into broad panels, with a wide stripe of red velvet paper running up the corners; the chandelier was of massive imitation bronze; the mirror over the mantel rested on a fringed mantel-cover of green reps, and heavy curtains of that stuff hung from gilt lambrequin frames at the window; the carpet was of a small pattern of crude green, which, at the time Mrs. Lapham bought it, covered half the new floors in Boston." The Beacon Street architect will have different ideas for his new client.

The choice of art was not Higginson's. In the paneled spaces were "stone-coloured" landscapes, meaning hand-tinted prints, "representing the mountains and cānons of the West, which the Colonel and his wife had visited on one of the early official railroad excursions." Travel abroad was never for them: not for them the timeline of the Beacon Hill matron who says she's like "people who have been home from Europe three years; she's past the most poignant stage of regret, and hasn't reached the second, when they feel they *must* go again."[10]

How the Laphams placed their statuary is one of Howells's great gifts in describing social life of the times. Much is made in the novel of the custom of sitting in windows, both to observe the passing scene, and to be seen, and pretty Irene looks forward to her perch over Beacon Street, on display through the sheet glass now common. As do her parents: "I don't think our girls would look very bad behind one of those big panes," said the Colonel. "No," said his wife dreamily.[11] If this smacks of country living, for the Laphams were small-town Vermonters, it serves also to remind how recently, mere decades ago, that people had left that old rural sociability for the hard confines of the city. Howells also knows the importance of what else windows displayed to passersby. In their long South End

windows the Laphams placed statues, "kneeling figures which turned their backs on the company within-doors, and represented allegories of Faith and Prayer for people without." As for patriotism, at a Beacon Hill dinner party to vet his family, Colonel Lapham allows how he faced Rebel fire so intense that "about one in five of us got out safe." When a guest exclaimed cowardice on the field of battle was the exception, that no Union soldier fled from fire, Lapham dismissed that: "the woods were full of them." Whether his other major piece of statuary was a political statement (as we would say) or fashion can be debated, but not its innocence of art: it was a "white marble group of several figures, expressing an Italian conception of Lincoln Freeing the Slaves—a Latin negro and his wife, with our Eagle flapping his wings in approval, at Lincoln's feet."[12]

Howells more than makes up for the scarcity of photographs of interiors, and the snobbish pen of Edith Wharton is another. There was a vogue for rooms done in a historical "period." "I call this my Louis Quinze room," said a proud Lenox cottager of her chosen Period décor. "But why?" said Wharton, inspecting the bungled attempt through her lorgnette. And of another cottager, "Period—they say they are going to have Period, but of what!"[13] Would that we had more glimpses of interiors from the camera of Clover Adams.

Teaching herself photography in the 1880s with her "new machine," an affair of mahogany and brass, and her own dark room to develop glass plates, she recorded the shutter speed and lens used for every picture, and was satisfied with few. Domestic interiors creep in around the edges of her camera portraits of great men (her husband Henry Adams, historian George Bancroft, statesman John Hay) writing in their libraries. A twinkling H. H. Richardson holds a straight edge, symbol of the architect he was, and over his bookcases are the drawings and prints he collected. Clover called his massy dark style of architecture "Neo-Agnostic,"[14] and one wishes she had poked her nose around the Agassiz. As for the summer house at Beverly she and Henry built, her photo catches the anecdotal style of the well-travelled taste: bamboo and wicker, Chippendale, oriental carpet. Flemish candle sconces, and Morris wallpaper were all more comfortable than stylish.[15] Chair legs, moreover, have been shortened: neither Adams was tall. Clover was not above the cute pet picture, staging a tea party for her three Skye terriers.[16] But in general, the Boston reluctance to show off "show" was foreign to New York or Newport. The Back Bay did have its mansions, and occasionally those interiors were photographed but they could be excused as architectural studies. And so we are lucky to have four photos by Baldwin Coolidge of the Fairchild family's apartment at the Agassiz. Comfortable, solid, intimate, with none of the Big Bow Wow of the mansion style. In the children's nursery a squirrel runs in its

cage. Lily Fairchild sews at her boudoir fireplace, the setting a primer of the Arts and Crafts movement.

* * * * * *

To understand the taste of Boston's Back Bay, it is best to start with geography. As they say, all real estate is local. And there was something to be said for living on the "sunny side" of a street, or the "water side" of Beacon, which was also the sunny. The huge benefit was light. As we have seen, the Back Bay was laid out as a grid, the land level, no hills to shadow sunlight, no pockets of perennial shade as on Beacon Hill. The long, major streets, like Commonwealth Avenue, ran east to west, sunrise to sunset. On three of these long residential streets, the odd-numbered addresses faced south. Houses on corners got the most light, three exposures. The major reception rooms thus had sunny rooms. Kitchens and pantries, and minor bedrooms, were on the back.

The exception to all this was, as usual, Beacon Street. It was the oldest in the Back Bay, the Mill Dam whose road was Beacon Hill's link to the mainland, and the first street along which houses were built. Here, the even-numbered were on the "sunny side." And while the rear rooms faced north, they did so over the immediate vista of the Charles River. It was tidal then, and smelly from sewage and from tanneries where the Massachusetts Institute of Technology is today. But, then again, most of the Back Bay escaped to summer places, or summer resorts, and sunny airy rooms for the year's longest, hottest days. Howells has Lapham sum it up: "When people talk to me about the Hill, I can understand them. It's snug, and it's old fashioned, and it's where they have always lived. But when they talk about Commonwealth Avenue, I don't know what they mean. It don't hold a candle to the water side of Beacon. You've got just as much wind over there, and you've got just as much dust, and all the view you've got is the view across the street."[17]

When electricity came to the Back Bay in 1886, architects could add rear ells to rowhouses and light those interiors artificially.[18] In the earlier decades, however, if it were not for skylights and light wells, most row houses would be dark indeed. On each long side, they shared a parti-wall, or firewall, with their neighbors. The only windows were front and back, and protruding windows, bows or bays often banked, or glassy oriels, were much employed to invite the sun to cut interior gloom. Contriving light goes back to the beginning of domestic life. Farmers hoped for sunny days for their crops. For themselves, up with the sun, in bed soon after it went down. Even in the simplest domestic interiors there was a desire for light, even if firelight, even by candle. And so, like households in the

centuries before there was a Boston, there was a slight of hand, smoke and mirrors, to approximate light, to borrow it, to fool the eye and warm the spirit. For, early on, whether consciously or not, we experimented with reflecting surfaces to multiply light. To throw light into the room, the wall sconce which held the candle was mirrored. Hanging from ceilings, chandeliers leafed out, radiant in crystal, flame flickering from the eddies of candle-heat and glancing off glass. Silver and gilt thread woven into the wall tapestries of palaces smoldered. Louis XIV was France's Sun King, *le roi du soleil*, and when the real sun had to set, the great Hall of Mirrors at Versailles blazed, the silvered glass upping the amp of the hundred-candle chandeliers, as he paraded on his red heels in near daylight. What movie palace of the 1930s could resist Versailles mirrors for its grand foyer? "Best seats in the mezzanine," cried ushers. Up we climbed, to find another usher with flashlight stabbing at our row. There we sat. It was dim, and as flickering as a church, popcorn as incense, the shaft of light from the movie projector the one true way as, by the hundreds and thousands, we worshipped Hollywood.

Private housing was all this in miniature. We can be sure that the glow from gas lighting in early Back Bay interiors bounced off the French-polished wood of furniture, the gilt of frames and varnish on oil paintings, the sheen of china and gleam of silver, the warmth of copper and the banked fire of bronze, the wax on parquet floors, the smile of tiling. Velvet and plush would damp down light, curtain netting filter it, silky damasks enhance. The photo-realism of mirrors gave us snapshots of ourselves. There we are, our vertical likenesses in the tall pier glass installed between tall windows. There we are, head and shoulders, in the trio of horizontal mirrors that lined mantel shelves or buffets, like devotional paintings above a chapel altar. As good as an oil painting was the important mirror over the fireplace, framed in choice wood or gilded, perhaps in the noisy gilt and red lacquer of Chinese Chippendale with its temple roofs and birds and little bells. Plain or fancy, mirrors never lie, and the mirror showed Bostonians among their treasured possessions, kings and queens in their own castles, Versailles in brownstone and brick.

It would be French Empire that Silas Lapham's architect sold him on. Lapham wondered to Mrs. Lapham what the "Ongpeer style" could be.[19] She, for her part, had only insisted on having "double tubs" to suds and rinse laundry. Lapham of course had nosed around Beacon Street with a master builder who had put up a great many houses on the speculation he could sell them ready-made, and Bainbridge Bunting's book on the houses of the Back Bay names many builders. (He could find no architect listed for the houses of Howells or Holmes, indicating builder-designed.) But before the architect seized the day, Lapham's idea was "a brown-stone

front, four stories high, and a French roof, and, above that, a hydraulic 'air-chamber' with which to circulate heating. On the street level of the house, a reception-room facing out on the street and a dining room in the back. The parlors were to be on the second floor, and finished in black walnut or party-colored paint. The chambers were to be on the three floors above, front and rear, with side rooms over the front door. Black walnut was to be used everywhere except in the attic, which was to be painted and grained to look like black walnut. The whole was to be high-studded, and there were to be handsome cornices and elaborate centre-pieces throughout, except, again, in the attic."[20]

What Lapham got, no, what Mrs. Lapham got, was lighter in color, grander spaces, a white marble mantelpiece in the Empire style, and, the "brief but intense intimacy ... which the sympathetic architect holds with his clients" which makes them think he is designing no other house but theirs. A bit like poker, he knew when to raise, when to fold. "I know," said the architect, "there has been a great craze for black walnut. But it's an ugly wood, and for a drawing room there's nothing like white paint."[21]

But the major change, and more interesting than the cosmetics of paint, was the staircase. The (unnamed) architect has cornered Mr. and Mrs. Howells:

"He was skillful, as nearly all architects are, in playing upon that simple instrument Man. He began to touch Colonel Lapham's stops." Sketching a floor plan on a scrap of paper, he continued: "'Put your little reception-room here beside the door, and get the whole width of your house frontage for a square hall, and an easy low-tread staircase running up three sides of it. I'm sure Mrs. Latham would find it much pleasanter ... That gets you rid of those of those long, straight, ugly staircases—until that moment Lapham had thought a long, straight staircase the chief ornament of a house—and gives you an effect of amplitude and space.' 'That's so!' said Mrs. Lapham. Her husband merely made a noise in his throat."[22]

So it was that Henry Lee Higginson, flush with copper money and soon to found the Boston Symphony Orchestra (in 1881), was in the market for suitable furnishings for the Agassiz to convey his standing to the discerning eye. He had caused the apartment house to be built and lived there from about 1874 till his death in 1919, first in a flat, then in a row house attached to the building and entered through the Agassiz lobby. When in London in 1878, he shopped for a mirror, and much else, Indian carpets, antique table knives and forks by the dozens. He went armed with a letter from N. Willis Bumstead of J. F. Bumstead & Company, whose

shop at 148 Tremont Street, Boston, was a leading purveyor in "wood carpet and inlaid flooring, and paper hanging." For Bostonians inclined toward the English Arts and Crafts—"American Aesthetic"—look in home décor, this was the place to start. On 1 April 1878, Bumstead writes to recommend four London shops for "Eastern" carpets, a "Mr. Liberty" at a Regent Street shop for "Algerine hangings," and a Bond Street shop for "swell things in the way of fire place fire dogs." In Paris he recommends two shops for "Oriental rugs and tapestries." Bumstead also shopped abroad for inventory: "I hope you will enjoy your trip and find all your stocks higher on your return. It is barely possible you may see me over there." The "Mr. Liberty" he recommends is likely a connection of the famous Liberty of London, whose all-over floral patterns in the flat Japanese way gave color and cheer to high-minded Arts and Crafts interiors.

Higginson found a mirror he liked. It arrived in Boston in early October 1878. It was preceded by a letter from the maker, B. Verity & Sons, "designers and manufacturers of lamps, candelabra, &c., only address 31 & 32 King St. Covent Garden W.C." The shop was mightily embarrassed that the order, placed in May when Higginson was staying at the Brunswick Hotel in Bloomsbury, had taken so long. "We apologize for having kept you so long waiting for this, but most unfortunately, our man to whom this work was given was taken ill almost immediately the matter was placed in his hands and was laid up for some weeks, the matter was therefore delayed to our regret."

Having groveled enough, they signed themselves, "We are, dear Sir, yours faithfully, B. Verity & Sons." A proud P.S. assures Higginson "We are doing a great deal of this high class work, being the only people in London who undertake it."

What did Higginson get for his 28 pounds? The mirror was large, the glass itself measuring 19 inches wide by 21 inches tall. The style is not revealed. He had apparently liked one in the shop and told them to enlarge it. "By making it to the [glass] size you proposed ... we shall rather improve it, than otherwise, as we think that at present, perhaps if anything, the size of the frame is rather heavy in comparison to the mirror." That sentence served to confirm his belief in his own taste.

What else followed Higginson home from England? On 9 November 1878, he is billed $29.79 to deliver a "cask" or barrel of Minton to 191 Commonwealth Avenue. Whether porcelain or china is not specified, but Minton was often gilt-edged with delicate patterns that gave light and luxury to dining tables. On 26 March 1879, a London vintner, A. W. Binglay of 156 Piccadilly, writes to alert Higginson of the Manzanilla *fino* sherry he is shipping by Cunard steamer to Boston. It will arrive in bulk,

three dozen each, in quarter casks, standard and butts, and "It is fit to drink immediately [as soon as] it is bottled."

Henry Higginson's wife Ida was not part of that 1878 shopping spree. She had stayed in Boston with their two-year-old son Alex, who was ailing. They had lost little Cécile cruelly to sewer fever. Henry seems to have liked shopping. He was neither a collector, who amasses, or a connoisseur, who winnows, but got satisfaction in a deal. Letters home to her father from the honeymooning Clover Adams in 1873 mention Higginson in Europe on a junket with male friends. In Paris she takes him shopping for French furniture for the Agassiz.[23] As a grand old man he would tell banking youngsters about the thrill of the chase. For every failure—making magnetic iron out of ore, say—there was the possibility of making money out of the new-fangled batteries, and he had highest hopes for "a process of making alcohol from chips." Investing in the telephone was "'trumps'— and think of the blessing to the world!"[24] And this in 1918, a year before his death: "I have never cared about money for its own sake, have had the good luck to get considerable, and have spent it as well as I could. It isn't bread and butter we want as much as it is pleasant, friendly relations with our fellow creatures; and if we did nothing for them, didn't hold out our hands to them, didn't foster real democratic spirit, not of excess but by real charity and kindness, I think we have missed our ends."[25] If he spent freely on his interiors, his was the old Boston taste, rich but not showy.

* * * * * *

The profession of interior decorator was still some years away. Your architect or builder determined spaces and surfaces, as Edith Wharton was to explain. Her first royalty check was not for a novel but for *The Decoration of Houses* (1897) which she wrote with Boston architect and aesthete Ogden Codman. A graduate of the Massachusetts Institute of Technology, he studied grand style at the Beaux-Arts in Paris. But until a decorator decided your tastes for you—that was not till the early 20th century and led by the furniture industry—the uncertain muddled along with what they had and the confident went shopping.

From letters we can guess at tastes. Very sure of hers was Marian (Clover) Hooper who, at 28, married Henry Adams, 34, in June 1872, and spent a year-long honeymoon in Europe broken by winter in Egypt. She loved ornate Dresden china and English table silver, and Higginson would order whole sets of each. And like the well-traveled Bostonian, she came home with her souvenirs of the foreign and exotic and romantic places she had seen. In this, she was truly Victorian. If they were English, Victorians

furnished home with the spoils of Empire, and the Anglo-loving Adamses and Higginson followed suit. As Americans and Bostonians, they well knew that trade followed the flag. Not a hundred years since, clipper ships went to China and brought back the "Oriental Lowestoft," the export porcelain that graced many a Beacon Hill table. In 1853, a few years before the Back Bay landfill began, an American naval officer, Commodore Matthew C. Perry, sailed into Tokyo's Edo Bay and presented President Millard Fillmore's request to commence trading to Japanese ministers. "Opening Japan to the west," as it was called, opened a whole new style of art to Europe and America. Without the Japanese woodblock prints, no Impressionism, no Monet or Mary Cassatt. It was different to western art, which prized realism and labored to produce the three-dimensions of the world around us on the two-dimension surfaces of canvas and paper. Old Master artists differed among themselves: Was it better to make shapes seem round by cross-hatched lines or by chiaroscuro shading? And here was a new aesthetic, the powerful graphic of Japanese prints to argue the earth was flat. There was no regard for perspective or shadow, along with irregular shapes and blasts of strong color. Cartoons, you might say, and Toulouse-Lautrec drew on the eye-popping drama of *ukiyo-e* prints for the theater posters that made his name.

In London, an enterprising merchant set up a kind of zoo with real live Japanese people producing Japanese handicrafts and playing Japanese music. This fell on the grateful ears of W. S. Gilbert. Desperate for a subject to woo Arthur Sullivan away from composing his dreary classical music, he contrived the libretto that became *The Mikado* (1885). (How this smash hit saved the fortunes of the D'Oyly Carte Opera Company is entertainingly told in the 1999 movie, *Topsy-Turvy*.) Japonism had already reached America. In New York, the First Japanese Manufacturing and Trading Company set up at 865 Broadway, and, from them in 1880, Higginson ordered 50 rolls of a Japanese-made wallpaper in one of the many "gourd" patterns. Fifty rolls would certainly cover a big room, especially one broken by tall windows giving on Commonwealth Avenue. The year before, he had looked at Japanese paper at R. E. Moore on New York's Madison Square, pattern not specified. A large room would require 240 sheets to paper, a small, 126; and it would be $110 for the lot.

There were many gourd patterns, riffs on the headless-snowman shape of the fruit of the calabash tree. (An irresistible name to comedian Jimmy Durante, who would sign off his radio show, "Goodnight Mrs. Calabash, wherever you are.") And while it is not known which pattern the Higginsons chose, most likely it was dense and rich and probably dark, and the eye would look past the gourds and fix on the paintings hung there. The paper was made in Japan. An agent from the New York shop

writes on 23 March 1880 that he will place the order himself when he reaches Japan "but, I am afraid, they cannot reach here until the middle of July."

Victorian taste was eclectic. They loved to pile pattern on pattern. The Japanese gourds perhaps picked up on the figured Indian carpets that Higginson had seen in London in 1878 at Vincent Robinson & Company, at 34 Wigmore Street, London. He had written to reserve two "antique lustre" carpets as well as the Indian. On 9 August 1878, the shop's F. W. Howard writes with the good news: none had yet been sold. The antique lustre, probably Persian, measured 7 by 5 feet, was a costly 65 pounds because it was of "a museum collection" quality. The larger Indian carpets were less, 58 pounds for the 14-foot square "cream" ground. The red ground carpet sounds large, 17'6" by 12'5". But the Indian carpet ("the color of the Nubian desert") that Clover Adams bought for her Marlborough Street dining room was even larger, 20' by 14'.

Higginson was in want of silverware. On 13 March 1879, a London dealer in antique silverware, Widdowson & Beale at 73 Strand, writes with more good news. Still unsold was the set Higginson had looked at, and just to be sure it was the same one, the shop enclosed a sketch (now lost) of the handles. The whole was "properly fitted in a case, and we consider them the most perfect service that has come into our possession for many years." The price was 95 pounds for six dozen table knives, four dozen table forks, two meat carvers and forks, two poultry ditto, 18 small knives, and 18 small forks.

There was something about putting on the dog that enchanted yet repelled Marcel Proust when he wrote of French aristocracy and the *gratin* in *Remembrances of Things Past*. The actual time of the novel is the late 19th century, about the time that Clover Adams and Higginson were buying Dresden china. What else might be seen on fashionable dinner tables? Proust has been likened to the Goncourt brothers, famous for recording French society and passing judgment in their diaries, and in a brilliant parody of what he calls one of their "unpublished journals," he sets the table of a certain Princess:

> We go into dinner, and then begins an extraordinary procession of dishes which are simply masterpieces of the art of the porcelain maker, concerning which the artistic small talk during an exquisite repast is most agreeably listened to by the flattered attention of the lover of fine China—Yung-Tsching plates with nasturtium-red borders, bluish, turgid petals of water-iris, the dawn streaking, with truly decorative effect, across a flight of kingfishers and cranes, a dawn having precisely the matutinal tones which I glance at every day, on awakening, in my

Boulevard Montmorency home—dishes of Dresden ware, more affected in the gracefulness of their design, with the drowsiness, the anemia of their violet-tinted roses, the deep purple markings of a tulip, the rococo effect of a pink or a forget-me-not—Sèvres dishes latticed with the fine network of their white flutings, with whorls of gold, or knotted with the graceful contrast of a golden ribbon against the creamy tone of the porcelain—and, finally, a whole set of silver plate entwined with the myrtles of Luciennes which the du Barry would recognize.[26]

Disgruntled letters from the earliest tenants at 191 Commonwealth Avenue are inadvertently revealing of taste. They write to Higginson, their landlord, to inventory what water leaks and soot-belching chimneys have ruined. And give dollar figures. Not all things work, toilets for one, but storm windows, far from modern, were common in the 1870s. New tenants, announcing their re-decorating plans, criticize the taste of the previous occupant. The taste for whitening ceilings accomplished two things: it introduced light and it erased chimney soot. As we've seen, invoices to Higginson record his taste in wallpapers, silverware, art, even that he wore the new wrinkle in sleep-wear, pajamas rather than night shirt. The chapter "Horses" tells of fashions in sport and transportation. Three chapters on the Fairchild family and the painter John Singer Sargent depict their social life in the Back Bay (and selected suburbs). A memoir by a Saltonstall bride takes a clean broom to the old days. Higginson was then a very old man (for the time). He looked in to see what she was doing and departed without saying a word.

* * * * * *

What did the Higginsons hang on their walls? The fictional Silas Lapham was well behind them, having "not yet reached the picture-buying stage of the rich man's development."[27] He made no pretense of knowing about art, only that he knew what he liked. He had the merchant's view of the marketplace. If he expected the Beacon Street house to end up costing $100,000, rather than the $40,000 he intended, he rationalized: "You can't have a nice house for nothing. It's just like ordering a picture of a painter. You pay him enough, and he can afford to paint you a first class picture; and if you don't, he can't." Lapham sold house paint by the gallon, so it follows artists charged by the inch. Oh to know the collector who, he says, "gave one of those French fellows sixty thousand dollars for a little seven-by-nine picture the other day."

Higginson was not above the marketplace. He bought and he sold, and he and Ida gave some pictures away. While other Bostonians were

snapping up Impressionists at great rate (and would give their Monets to Boston's Museum of Fine Arts), the Higginsons ventured no further than the Barbizon School's Millet and Daubigny. Their most important picture was done centuries earlier, the "Saint Luke Drawing the Virgin," painted about 1435-1453, by the greatest of Flemish masters, Rogier van der Weyden, which they gave to the MFA in 1893. He had bought it in 1889 when a Spanish duke sold off art from a royal collection. The Rogier, duly insured, was shipped from the American Art Galleries, on Madison Square South, New York City, in early June 1889. For reasons now unclear, it was to go to "General Loring," the Charles G. Loring II, who was the first president of the MFA, then on the south side of Copley Square. .

The provenance of the Rogier is right out of Verdi's opera, *Don Carlo* (1874). None other than Philip II acquired the painting from a Brussels cathedral, Spain having seized the Low Countries, and installed it at the Escorial, the palace of tombs he built for his ancestors. In the opera, when his liberal son, Carlo, demands freedom for the Netherlands, his father obeys the order of the Grand Inquisitor and has him killed.

Rogier's Virgin is one of the least "religious" of madonnas. Mary is without halo, though a lunette window suggests that, and the light that streams down on her head is an annunciation. In the tile work at her feet is the suggestion of a compass which, for the devout, would recall the prayers on Rogation Sunday addressed by the priest to the four cardinal points of the world. Rogier has carved figures of Adam and Eve into her simple throne to say Mary and Christ will redeem their sin, for of course the immediate vista is of an enclosed garden, symbol of her purity, Eden before the Fall. Her full attention is on nursing her baby. She is not the sorrowing mother of Christ crucified. His little hands and feet are those of a squirming baby not quite focused on her breast. The scene is domestic, the religious symbols confined to the furniture. One could say it was a Madonna for Unitarians, such as Henry Higginson was, or for the former Ida Agassiz, who was the granddaughter of a Swiss protestant pastor living in a Catholic part of Switzerland. Rogier's Virgin has, moreover, the broad highbrow, if not the square jaw, of Ida drawn by John Singer Sargent in 1917, and now at Harvard. Some art scholars think that Rogier gave his own face to Saint Luke. While hardly a "conversation piece," the sort of large oil painting beloved in the nineteenth century that showed a humorous scene (involving clergy) or sentimental event (departing soldier), it nevertheless offered the wisp of a story: a painter painting an artist at work drawing. And it was also architectural. It is the built world inside and out.

In the nineteenth century world of the Higginsons and Hotel Agassiz, domestic interiors were as architectural in spirit, and in fact, as the exterior

facades of buildings. Rogier's Virgin sits in architecture. The damask of her throne is geometric, as are the tiles. Rising to frame the river view beyond her garden are columns capped in appropriate classical order. They function like a window, the transition between the interior and nature. If we were to stray beyond the painting into a room, we would find fireplaces as tabernacles, pillars again in the classical orders from solemn Doric to exuberant Corinthian, supporting the mantelpiece.

Architectural elements defined space in the older, grander Boston dwellings, especially those on Beacon Hill that overlooked the Common. The Laphams are bid to dine at just such a house and Howells has them baffled at such classic refinements on the façade as the slender white fluted columns holding up the portico with its delicate cornice moldings. Inside they find only an ample staircase climbing in a graceful, easy curve. "The place looked bare" to Lapham eyes.[28]

In such houses, the internal columns, not necessarily load bearing, were as practical as they were swank. They broke up large rooms and, by piercing walls, brought in light. They may seem grandiose today, but, in the 19th century, columns spoke of engineering as well as elegance, the bones of prosperity, as suitable for bank buildings as for your drawing room. If not columns, then their flat friends, the pilasters, to shape up and enrich walls. The interiors of the (grand) houses discussed by Edith Wharton were all designed by architects. Higginson writing to architect Charles Follen McKim, who would design Symphony Hall (1900): "I always like the severe in architecture, music, men and women, books." In the Sargent drawing, Ida Higginson has as severe an architectural face as could be desired, almost Art Deco. Her jewelry was severe, if luminous, consisting of strung pearls, 96 worn as a necklace or 73 worn as a bracelet.[29] Yet the heavily-geometric Japanese gourd wallpaper that Henry Higginson ordered in 1880 was not unlike the damask and tile work surrounding Rogier's Virgin. It approved of dense pattern. It extended that richness as setting for the painting. Higginson had his Silas Lapham side.

But he made better choices in sculpture, thanks to Henry Adams as tastemaker. That Adams was Higginson's agent for bronzes and a marble figure by Auguste Rodin (1840-1917) adds romantic comedy to the transaction, along with the snobbism of the art patron. Adams was long a widower but chasing Elizabeth (Lizzie) Bancroft Sherman Cameron (1860-1944), who chose to stay married to her older, dull but safe husband, J. Donald Cameron (1833-1918), a United States senator who had been President Grant's Secretary of War.

Why was Higginson so attracted to Rodin's marble Minerva, for which he gave Adams a draft credit of one thousand dollars? "Henry has a sort of weakness for the Poet in arms; perhaps for the new Spring, and

generally Ida is beyond the age of Nymphs and Satryrs[30] ... Be gentle with her, while waiting till you too have passed sixty," Adams wrote "Mrs. Cameron" as he always addressed her, then 42.[31] Believing Rodin would respond better to the charms of Mrs. Cameron on money, Adams let her do the bargaining. It worked. "Between us all, it is arranged that you are to have your five little bronzes for our five thousand francs," Adams wrote on 29 November 1901.[32] One was the Minerva, "your poet." The others were chosen by Adams, those "selections with an eye on Boston and Cambridge." In addition to one of Rodin's famous *bourgeois de Calais,* "a little Vulcan fashioning a figure which he holds; the Alcestis group, dear to me for a certain grave depth of quiet feeling; a Sister with a baby brother; in short a little gallery to suit quiet classic tastes.[33] But the transaction fell apart, Rodin expecting twice the 5,000 francs. "He is not in the least dishonest; he is only a peasant of genius; grasping, distrustful of himself socially; susceptible to flattery, especially to that of beautiful or fashionable women." Hence Lizzie Cameron. But she soon fled with her husband to his ancestral Scotland. Letters in French fly back and forth.

Then on 10 July 1902, Rodin himself delivers the Alcestis to Adams. "Either he mistrusted me, or had some clumsy French notion of politeness, or wanted to show what a gentleman he is ... In he came, like a country peasant, and echoes my admiration of the bronze, 'superbe!' 'exquis!' &c,&c, catching himself up every now and then to say that of course he referred only to the *patine,* when it was quite evident he was admiring his own work, which he liked in its bronze dress."

There was more to come. Taking it out of his pocket, Rodin proposed substituting for the Burgher of Calais, a 1902 casting of the 1885 "L'Emprise" (The Ascendency) of two entwined lovers, "seven inches high, excessively Rodinesque and of course a bronze gem ... but about the most undressed pair he ever made, and the least calculated to please Ida, whatever interest it may have to the true Rodinian amateur."[34]

It all works out, for 13,000 francs, though the lovers stayed with Rodin.

Letters to Higginson from Boston and New York art galleries are a paper trail for his taste in painting. But maddening in their lack of detail. We often know more about horses offered to Higginson than about his art works. From a Doll & Richards letter of 10 April 1881, "if he wants to sell," he can expect $600 for the Troyon he'd bought the year before. He could expect $250 for a William Morris Hunt landscape with old tree and $300 for a "sunny" Hunt landscape, while John LaFarge's landscape with horse would fetch $150. On 29 February 1888, the New York office of Durand-Ruel, then at 298 Fifth Avenue, acknowledges Higginson's check for $3,700 for five pictures, none fully described. "I hope you will be pleased with your acquisitions, and that your pictures will grow more

on you every day. One of the pictures may have been a Renoir. "I shall be pleased if you decide to take the nude figure of Renoir. It is the finest example I ever had by that painter, and one that all connoisseurs have always admired."

The spring of 1893 saw Higginson deeply engaged with art galleries. As we have seen, it was also the year he started disposing of the hackney carriage horses he had imported in 1891 from England, a decision that mystified his horseman son, Alex.

On 30 May 1893, the Rogier goes to Boston's Museum of Fine Arts. The month before, the New York office of Durand-Ruel, famous as the Paris dealer for the Barbizon School and now the Impressionists, replied to Higginson's queries about several French paintings. Were they to be replacements for the Rogier? Two were by Delacroix, a leading, perhaps the leading, painter of the French Romantic school. A "Don Quichote" (but not identifying which of many scenes) would be $4,500. "Lion Hunt" (finished in 1825, but one of many he painted) would be $25,000.

The latter was new on the market. It "is considered by connoisseurs as the most important work of Delacroix," writes a Durand-Ruel agent on 7 April 1893 from 315 Fifth Avenue, corner of 32d Street. "It was sold by my father to Mr. Borie of Philadelphia in 1867 or 1868, and remained in that collection for over twenty years. We may perhaps take it back to Paris where it would surely find a ready sale."

Higginson had expressed interest in a "Bay of Naples" by Corot, a landscape painter who is a transition to the *plein-air* Barbizon painters. In the same letter: "I have had many enquiries about it during the last two weeks, but always answered that I was not free to dispose of it. However, the season is fast nearing to a close, and my brother and I expect to leave for Paris before the end of this month, and I wish you would decide about it at once; otherwise, we might be likely to lose the chances of disposing of it before the amateurs leave the city. I left it to you at a very low price, being desirous of concluding the business and can assure you that you would make no mistake by taking it for that amount."

From a Durand-Ruel telegram from New York dated 8 May 1893, we do know of two pictures of the Barbizon School that Higginson actually owned, but not their subjects: "Have chance sell your Millet also perhaps Daubigny can you ship." If it was "Into the Light," Millet's early (1849) black crayon of his mistress and later wife, Catherine Lemaire, the Higginsons kept it and Ida gave it in 1921, two years after Henry died, to the Boston's Museum of Fine Arts.

On 9 June 1893, Doll & Richards, the old-line Boston art galley, acting for Higginson, sells "At the Bath," by Jean-Jacques Henner (1829-1905) for $1,250, less their 10-percent commission, or $1,125. Henner was the

last of the Romantics. He loved painting red hair. Nudes were a specialty. His models were sometimes drawn from "the studio for the ladies," an atelier he and Carolus-Duran, Sargent's teacher, organized because women were not allowed as students at the École des Beaux-Arts. His nudes gleam in the gloaming, which would look well against Japanese gourd wallpaper. Even sprawling, they are chaste, wet dreams for over the mantel, and he was often copied. "Susannah at the Bath" combined nude with the religious subjects Henner also painted. The Higginson painting could be one of many.

How far Higginson's tastes or interests had changed comes in letters from a Philadelphia dealer concerning dog pictures by Constant Troyon (1810-1865). There are many of these, dramatic compositions of hunting hounds that art scholars trace to a 17th-century Dutch master, Frans Snyders, and painted during Troyon's annual visits to the Touraine to the kennels of a fellow artist, Léon-Félix Loysel. Higginson perhaps owned the one described for a 1996 sale of sporting art at Christie's as "*deux chiens couplés by une chaine, flairent une piste dans la plaine, au sortir d'un bois,*" for the inquiry of 7 May 1888 asks if he would like to sell "the two dogs in leash." Writes dealer George House: "From something I heard recently as to your taste running now into other matters, I have thought you might be willing to part with it." House would offer $8,250. Higginson accepts, but not before inquiring of Doll & Richards what he'd paid in 1880 (less than $600). House thanks Higginson on 19 May 1888, and begs his pardon for listening to art gallery gossip that he might sell the Troyon, and, further, for reasons murky now, begs that he not reveal the sale. The painting is very fine work, writes House, which "would be saleable at a much higher price, but for the subject, dogs. Strange to say, whilst this subject of the master is a most favored one, on the other side, it is in disfavor with our Collectors, who are like a flock of sheep, following a silly leader with no heads of their own."

12
Clover Adams

Then I got three-quarters of an hour of the Higginson rehearsal for twenty-five cents and it was *fine*; mind you go in now and then.
Clover Adams writing to her father on Sunday afternoon, 23 October 1881 while visiting New York City.[1]

The night before, Henry Lee Higginson's dream had come true when the Boston Symphony Orchestra gave its very first concert. As part of his grand design, the regular Saturday evening concerts were preceded by public rehearsals the previous afternoon, and so began Boston's great social and musical tradition, Friday at Symphony, with Clover Adams in that very first audience.

Clover Adams killed herself on 6 December 1885 by swallowing the cyanide potassium she used to develop her photographs. Her husband found her on the floor in their house in Washington, D.C. Their marriage, and her name, is never mentioned in *The Education of Henry Adams*.

That book, published in 1918 after his death, is one of the marvels of personal history. It is a narrative, Adams writing in the third person, and "Henry" a character in his own life. He lives through observation, his about others, the author about him. The public Henry Adams was a biographer of others as well as a historian. Some people thought he rather cruelly put Clover into his novels about Washington.

He was on the short side for a man, about five foot three, and held himself importantly erect, unlike small men who slope thinking that will fool others into thinking them taller. Important men ran in the family. There were the two presidents. John Adams, the second, produced John Quincy Adams, the sixth, who then produced Charles Francis Adams, who produced Henry. This first Charles Francis Adams also developed

American railroads, insuring the family had money, and was U.S. Minister to England, assuring social status. As the poet T. S. Eliot, as well connected to Boston as any—Milton Academy and Harvard, and kin of a Harvard president—put it: Henry Adams knew that "never in his life would he have to explain who he was."[2] Through his mother Abigail Brooks, Henry was related to Peter Chardon Brooks, Boston's first millionaire, and so he was born Henry Brooks Adams in 1838. He had very blue eyes, as did Clover, who was about an inch shorter. She was quick and athletic and loved to ride horses all day. One source says she called him Hal; perhaps for Shakespeare's Prince Hal?

It was best that Clover did not know how Hal first described her. Very close to the bone, as though he were the Adams of *The Education* in the making. He was 34. A month after their engagement in 1872, he writes in exquisitely chilling penmanship to an English friend[3] to introduce his fiancée:

Imprimis, and to begin with, the young woman calls herself Marian Hooper and belongs to a sort of clan, as all Bostonians do. Through her mother, who is not living, she is half Sturgis, and Russell Sturgis of the Barings [bankers] is a fourth cousin or thereabouts. Socially the match is supposed to be unexceptionable. One of my congratulatory letters to me further describes my 'fiancée' to me as 'a charming blue.' She is certainly not handsome; nor would she be quite called plain, I think. She is twenty-eight years old. She knows her own mind uncommon well. She does not talk *very* American. Her manners are quiet. She reads German—also Latin—also, I fear, a little Greek, but very little. She talks garrulously, but on the whole pretty sensibly. She is open to instruction. We shall improve her. She dresses badly. She decidedly has humor and will appreciate *our* wit. She has enough money to be quite independent. She rules me as only American women rule men, and I cower before her. Lord! how she would lash me if she read the above description of her.

Clover did love clothes. She writes in triumph of buying silk stockings in violet and blue and yellow and gray.[4] She wore pink, and pink slippers, to an evening party given by the Dean of Westminster Abbey. She and Henry could not find the deanery door. "I caracoled up the solemn cloisters, with dim lights setting on tombs ... till we saw from the astonished gaze of some pious midnight visitors that we were off the track. Henry compared me to the prima donna in *Robert le Diable*.[5] Tales like these, told later at their dinner table in Washington, would convulse Henry, and guests reported he would wave his napkin in glee. True, she did not care much for being fitted for clothes (nothing was ready-made in 1879) but knew

she must submit to fittings in Paris by the fashionable Charles Worth, the English-born dressmaker for *tout* London, Paris, and Boston. She writes home: "I have become bored with the idea of getting any new gowns, but Henry says 'People who study Greek must take pains with their dress.'"

Clover did have her bluestocking side. She had indeed studied Greek (her sister married their Greek teacher) at the ancestress of Radcliffe College, a day school for girls run by Mrs. Louis Agassiz in her Cambridge house on Quincy Street at the corner of Broadway. Louis Agassiz, then Harvard professor of zoology, would get faculty to teach anything from natural science to languages and history. A horse tram took the Hooper sisters from Back Bay Boston over the old Charles River to school. Clover went there six years till she was 18. Classmates included the daughter of Ralph Waldo Emerson, and, closer to home for this book, her lifelong friend, Ida Agassiz, future wife of Henry Lee Higginson. She had grown up with Henry Higginson, another "Hal," the Bully Hig we have met. And as we shall see, the young married Adamses hoped to move into the Agassiz. Apart from that friendship there are several other reasons for including her in this chronicle. Letters home to her father—this book is a book of letters—show her as representative of Boston women of her class and age. Her travels abroad were very like those of Agassiz residents. In fact, she and Henry meet one on the Nile. And while her comments on the art and music and literature are decidedly her own, sound as well as silly, they are of the times. To read her is to know the taste of the Back Bay and what we might expect had we been invited inside the Agassiz.

Modern biographers depict a Clover Adams quite different from the young woman, and new wife, appearing in the edition of her letters for the years 1865 to 1883. She is almost 29, which was late to be married for girls of her vintage, but happy in her choice of Henry Adams (and he in her). Her letters are alert to everything: funny, witty, and so sure of her taste and position that she's withering of lesser beings. She can capture a scene, whether in London society or in a snooty shop. "Oh, for the pen of Abigail Adams!"[6] a tribute to Henry Adams's letter-writing wife, but she is just as sharp. She is fond and affectionate to her family; most of the letters are to her widowed father. She scrawls her views edge to edge of her note paper. Her handwriting tilts forward. She loves the speed of the "stylographic pen" given her by an unnamed "bright civil engineer from Brooklyn" who sat at their table in first class on the *Gallia* to England.

"It holds two weeks' supply of ink and is indestructible." In contrast, Henry's hand is glacial, round and vertical and so perfectly formed by nib that it's unnerving. It could pass for the home computer font that mimics handwriting.

Then in 1884 came darkness, and madness, and suicide, which ran in the family, and confirmed the Adams' caution against marrying Hoopers: "Heavens!—No!—They're all as crazy as coots."[7] Clover's biographers tend to structure their narrative toward trying to find out why she killed herself. Family losses? Artistic disappointment? Henry? She did not long survive the death of her father, Dr. Robert William Hooper (in April 1885). He had been her only parent following the long decline of her mother, Ellen Sturgis Hooper, who died from consumption when she was five. She had a loving older sister, Ellen Hooper (wife of that Greek professor, Ephraim Whitman Gurney) and brother, Edward William (Ned) Hooper, and was a fond aunt to their children, but her father remained her best anchor.

She may have concluded her photography was not an art she could master. For one adept at photographing the truth of others, she was reluctant to face the camera. Only baby pictures show her features. At four she looks ready to take on the world. Hats shadow her adult face.

She may have felt that Henry was falling for Elizabeth (Lizzie) Cameron, who was, in fact, to become his *amoureuse-amitié* from Clover's death in 1885 to his own in 1918. Henry liked pretty women, and Lizzie was that, dangerously so, some thought, but she was not so taken with Henry that she would leave her indifferent but rich husband. By most accounts, she was a flirt and not engaged emotionally, and certainly not one "to go all the way," as a Boston contemporary wrote.

* * * * * *

Clover (and Henry) will appear in this book for the happy reason they longed to begin their married life in Boston living in the new "Higginson-Agassiz Apartments," as Clover wrote home to her father while on her year-long wedding trip. The first suggested lease was more than they could afford, and still build a summer place in Beverly, near her father and family. In a nice twist to this story, Clover's niece Louisa Chapin Hooper (1874-1975), who became Mrs. Ward Thoron, would live there on the fourth floor from 1960 till 1972. As we have seen, Henry helped Henry Lee Higginson negotiate purchase of Rodin bronzes. And Clover belongs in this book because she and Henry represent a highly cultivated taste of the times. Her letters tell what people of their sort did and wore and furnished their houses with, how they traveled in the horse age with its

carriage trips of 10 hours. She writes in very little detail on food, though she considers taking cooking classes in Paris. Left to themselves, their own breakfast was at noon, an intermission from Henry's writing. There was plain afternoon tea at five, when friends might drop in for conversation and stay for dinner, and dinner was at an hour determined by the country they were in.

"Now for business," Clover writes to her brother Ned from Lake Como on 12 October 1872. "We have been wondering why we heard nothing from Henry Higginson, for of course we could decide nothing until the rent was fixed. I am not surprised at the great cost of the building. It seemed to me in the spring they were getting in very deep." (Those rumors were right, as we have seen.)

"Henry is going to write to H. Hig. asking for particulars, saying merely we have heard rumors of the building having reached higher estimates and that we cannot afford to pay more than $3,500. The furnishing will be a heavy expense." (As we have seen, Higginson would set the rent at $2,500 but expect tenants to contribute to the property taxes.)

Henry would be paid $2,000 a year for giving three lecture courses at Harvard. He and Clover had private incomes, living off dividends which went up or down as the economy did. The financial Panic of 1872 dented many a trust fund—and launched a five-year recession. Boston burned in 1872, that famous fire followed by a smaller the next year. When the Dwight Mills burned, Clover lost $9,000. One of Henry's forbears was Boston's first millionaire Peter Chardon Brooks, and his own grandfather left an estate of $300,000. Clover's grandfather, William Sturgis, put his pile in trusts, and her father did not practice medicine because he did not have to work. But the greater the number of heirs the smaller the cut, and, while very comfortably off, Clover was not rich, and would eventually question dribbling away money on rent when they could use it to buy a house. (The building is now condominiums, which can be mortgaged like houses.) Her constant refrain: "How we do wish that apartment was cheaper."[8]

In the event, Henry and Clover rented a Back Bay house at 91 Marlborough Street, later buying it, building a large summer cottage in Beverly, then moving for the winter in Washington for the rest of their lives. With every seasonal move, capital to coast and back, they packed up and shipped their most prized possessions, the water colors and drawings collected during their life together.

Had the money been right, we would have known exactly, from her letters, how they would have furnished a flat at the Hotel Agassiz. From her letters we also hear something of her talk, her conversation, and its origins.

Clover and Henry loved to shop, to haggle, to commission. It was a great game she called "mousing." (For someone who kept dogs, she often depicted herself as a cat, a tabby.[9]) Knowing that her father wanted a tile stove for the chilly months at Beverly, Clover took up the quest. None she liked in London[10] so she would try Holland. None that suited in Berlin: "eight feet tall and dead white ... I think I have seen simple soapstone ones at home that were truly prettier than these German piles."[11] Visiting Voltaire's house at Ferney with its view of Mont Blanc, she is shown the parlor: "On one side ... his heart is preserved in a curious, gilded monument, and, opposite," she writes her sister, "a stove, blue and gold, sent him by Frederick the Great, which I should like to send Father for Beverly."[12]

Henry and Clover had been to Europe before they married, she with her father, he as private secretary to his father, Charles Francis Adams, when U.S. minister to London. On their wedding trip they were entertained grandly in England and France and Italy. Thanks to those friends they saw sights the ordinary tourist did not. They were in London for the Seasons of 1872, 1873, and 1879. Those summer months, June till mid-August, were, as usual, a flurry of social activity for the English upper classes as families presented daughters at Court so they could find husbands. There were balls and soirées, theatricals, the Royal Academy of Art show, dinners given and dinners returned. Henry and Clover partook, but warily, not sure of an English welcome, not wanting to seem to need it, and in their superior way letting it come to them. And it did. To footnote the people mentioned in his edition of Clover's letters, Ward Thoron needed only to raid the *Dictionary of National Biography* and *Burke's Peerage*. A Washington lawyer, Thoron was Clover's nephew by marriage and would do research for Henry.

Clover liked being out in society. "I might have liked to be presented at Court," she writes to her father in June 1873, [but] "by someone less vulgar and ridiculous than the Schencks, who are underbred, disagreeable people and laughed at by everyone. Old Schenck has lost thirty-thousand dollars in his bogus silver mine, which is some consolation at least."[13] But Major General Robert Cummings Schenck was the U.S. Minister at London 1871-1876, and a Congressman before that, and such a diplomatic post was in the gift of the President, then Ulysses S. Grant. "The king of 'Vulgaria,'" William Tecumseh Sherman called Grant to the vast amusement of Clover.[14]

It being the season, they went to the opera, but her letters never say what they heard or who sang. (So unlike Henry Lee Higginson's letters home at 18 when he discovered opera and went three nights a week and compared singers.) They went to museums and galleries, in part to shop.

"We saw the exhibition at the new Royal Academy in Piccadilly and were much disgusted with the low condition of English art," she writes. There was "a life-size portrait of by Whistler of his mother; the whole picture in black and gray, interesting, but affected it seemed to us."[15]

In London and on the Continent, dinner parties meant sitting next to the great names in politics, academia, and the arts. History was Henry's field. In Berlin at short notice, Clover "scrambled into a gown" to dine with Theodor Mommsen, whose three-volume *Roman History* she and Henry Lee Higginson's Swiss wife, Ida, had "plunged through" in German. "As I was the only lady, I went into dinner with the host and Mommsen sat on my right. He speaks English but not easily, French better, German like a mill wheel."

She met Browning several times, and the acquaintance did not improve. In 1873, he "tapped me familiarly on the arm and said 'I'm coming to see you,' in the tone of 'keep up your spirit.' He's not exciting and I don't hanker to see him again." In 1879, "utterly uninteresting." He was eclipsed at another party, an evening soirée at the Grosvenor Gallery. She gazed on "Mrs. Langtry in white, no flowers or jewels, and really handsome," the Jersey Lily who acted on stage and charmed the Prince of Wales. She met Whistler, or rather he was introduced to her: "Even more mad away from his paint pots than near them."

Mrs. Jack Gardner was also there. The story goes that when someone mentioned a Boston medical institution, the Charitable Eye and Ear, the New York-born Isabella feigned disbelief: "There is not a charitable eye or ear in Boston." Perfect company, then, for Clover, as they sat side by side for some 20 minutes waiting for their respective broughams, "and sympathized over the awful gowns. Down came an elderly female in black, followed by a jolly-looking very fat one, and the Britons fall back on either side and bend their sovereign-loving knees, because it's the Grand Duchess of Mecklenburg-something and her sister Mary of Teck. Mrs. Gardner and I smile pityingly on the Britons." (Twenty years later, a younger Mary of Teck married the man who became King George V.)

On a Monday morning (in 1879) Henry goes at 10 o'clock "for pipes and grog" to meet Herbert Spencer and Thomas Huxley, and the next afternoon at tea Clover has "chat with Anthony Trollope—a rosy-gilled John Bull."[16] Like everyone else, she and Henry read George Elliot. On the boat to Naples in 1873: "half the passengers are reading *Middlemarch*, we among them, and though it's dreary, I like it."[17]

Henry James had known Clover since she was a child (she called him Harry) and they quickly picked up in London, becoming near neighbors. He was often of their party in Paris in 1879, stopping by their apartment at 6:30 three times a week, going out to dine with them, then on to the

theater, and once to the *cirque*, after which they and the Gardners ate ices on the boulevard and didn't get home till midnight. In 1881, James sent her a copy of *The Portrait of a Lady*. "It's very nice," Clover wrote to her father from Washington, "and charming things in it, but I'm ageing fast" (she was 47) "and prefer what Sir Walter Scott called the 'big bow-wow style." Then borrowing a witticism once made of a Bostonian she knew: "It's not that [James] bites off more than he can chaw ... but he chaws more than he bites."[18]

The Portrait of a Lady (1881) is James's great canvas of America adrift in Europe. Upon inheriting an English fortune, a young American leaves her provincial acres for an adventitious marriage abroad, her only way out. Thwarted in love and then by marriage, she—in James's cunning hand—learns to use the ways of Americans seduced by Europe against them. The monstrous Madame Merle, who has "made a convenience" of his heroine, is sent packing back to the States (as Clover finds "the Britishers"[19] call America).

James has fun with American speech and accent. For the newly-engaged Henry Adams, one of Clover's charms was "she does not talk *very* American." His own accent was faintly English, perhaps from his days at the American Legation in London. For the 21st-century reader, one of the charms of hers and Henry Adams's letters is how Yankee they sound, and how their idiom—formal though it is—remains more American rather than British. An "Old Boston" accent could sound quite English, as a London-born music administrator for the Boston Symphony Orchestra in the 1980s, discovered among the old ladies at the Friday afternoon concerts.[20] No doubt Clover and Henry's "Yankee" is put on. As children in the 1840s, they knew rural America in the small towns where their families sometimes lived or had houses. And while their formal speech was of their class, class also meant slumming with slang. "Duds" for things. And a knowing use of irony: her sister and husband, he a teacher of Greek at Harvard, live in the "flesh pots of Cambridge." Or this: At Baden-Baden "we won four thalers at the roulette table and then lost it on principle."[21]

Clover had the prejudices of her time and class. She was anti-slavery at home but in a Nubian shop described a small black shop girl as a "little nig."[22] A Sunday in June 1873 they spent with the Goldsmids, "a very rich old Jew family who have a fine establishment in Regent's Park ... with much blue plush livery." It's a "stunning house," she wrote of another party there, "and an immense music room, the singers professionals, super at little tables in a great marquee tent built out from the dining room."[23]

"The English may keep up swell establishments at home, but they waste no pennies in travelling," she observes of fellow guests at an Amiens hotel

in 1879 that included Lady Goldsmid. "Our rooms are much nicer than theirs; a viscountess may live in a small bedroom and go without a sitting room, but not a Yankee.[24]

The year of hard travel in 1873-1874 was bound to affect the newlyweds. Henry James's invalid sister Alice thought Clover changed, marriage adding "a charm, a feminine softness which was decidedly wanting before." Henry James thought her "toned down" at the expense of her "ancient brilliance."[25] He'd called her "a Voltaire in petticoats." Clover's wit had a "touch of genius." She was "conversational, critical, ironical."[26] Circumstance trained her up to some of that. She will continue to write and to talk as the motherless girl she was, brought up among men, after her older sister's marriage running her widowed father's household, acting as his hostess, learning how to talk interestingly to adults and to men. If she has a place in James's *Portrait* it is of the New Woman, the young very American journalist, Henrietta Stackpole.

"Tuesday we had a charming dinner here," she writes her father a prescient letter on 11 July 1873, from a London house they were lent. Three guests were a surprise, brought by a friend. The Mrs. Drummond was a "stepdaughter of Lord Russell, made a runaway match with her penniless husband and they both write for the papers. She is a strong radical, like all her family, and very gentle and sweet." Another guest was George Trevelyan, a young man in Parliament for nine years, and "considered one of the most promising men in political life and good for a rise. There was much political cross-fire and it was very interesting to us."

Clover adds: "I like giving dinners in such a big society—one can get more variety of material than in Boston."[27] She was already on her way to Washington.

Clover and Henry spent their first winter, November 1872 to March 1873, on the Nile. It was jammed with other Americans cruising in their own *dahabiehs*, with English people doing the same—there were a total of 18 at Philae.

"Tell Colonel Peirson from us," Clover had written her father, "that we hope he will not give up on his plan of going up the Nile with us; that he will need a gun and plenty of ammunition. Henry says tell him he has twelve ball pin cartridges."[28] Or might have, had the London dealer shipped them in time.[29] Charles Lawrence Peirson (1834-1920) now disappears from Clover's letters, but not from this book. One of the earliest residents of the Agassiz, he lived there from 1877 until his death, a widower since 1910.

Clover and Henry's *dahabieh* was the *Iris*. By no means the largest, it had a dining room 12 feet square, three single cabins, a bathroom, and a double stateroom in the rear. On the roomy upper deck, a table and two sofas were well sheltered by awnings. The crew slept on the lower deck, "where all the cooking, washing, etc., is done," Clover wrote home. She and Henry breakfasted about nine, sat all day on deck reading or studying "or doing nothing at all, and get an hour's walk on the banks before sunset." When there was no wind to fill the sail, their crew poled the boat or towed from shore.[30] "One sails up the Nile, but one floats down, and although floating is a rather ignominious process it is quicker than sailing," Henry wrote a friend. "My boat was a poor sailer, but tremendous on floating."[31] Boarding at Alexandria they inched toward Philae.

When it came time to float back, Clover regretted "the pretty sails" were down on both boats when Henry photographed *Iris* and the *Lotus*, the *dahabieh* of Mr. and Mrs. Samuel Gray Ward. The company of the couple could not have been better tuned to Clover's needs and Henry's interests. Mrs. Ward had seen Clover's mother through her final illness. Ward had "bankerial and artistic tastes," as Henry described the American agent of the London bankers, Baring Brothers.[32] Patrons of the arts, as well: Ward and another Nile traveler, William T. Blodgett, were two of the incorporators of the new Metropolitan Museum of Art in 1870.

Henry had taken up photography some years before Clover did, and had the *Iris* equipped with a dark room. Sam Ward's eye was invaluable, admits Henry, in helping him select the viewpoint to shoot the colossus at Aboo Simbel (Henry's spelling). "I do not hesitate to say that my photograph is worth half a dozen of any I have yet met."[33] His shot of Philae's ruins was just as formal. Clover's camera sought the inner lives of people.

For every dull moment on the Nile there was compensation. Under a full moon, the desert sand of Nubia turned gold. And a sporting match: a rowing race for 30 miles between the crews of the *Iris* and the *Lotus*. Their crew sang and screamed, and when they beat the *Lotus*, Clover promised her men a sheep at Luxor for winning. The Nile was crowded with the good and the great, and they were not always Bostonians. "Some New York people" included the Roosevelts and a squeaky-voiced adolescent named Teddy. Word got back to Clover that Ralph Waldo Emerson "was not interested in Egyptian antiquities, which," she wrote home, "for a philosopher is quite shocking."[34]

Clover loved Egypt. Not perhaps the whirling dervishes: she felt "surrounded by maniacs." There would come a time on the Nile when yet another monument palled, overwhelmed. The Pyramids were better seen

from the boat. "I must confess I hate the process of seeing things which I am hopelessly ignorant of."

But with the Wards she could relax and enjoy an Egypt beyond her ken, in a trip to the temple at Goorna and the Memnonium at Thebes. "The weather is perfect—like June at home. We had a long row, then found our donkeys ... We lunched among the ruins of the Memnonium and wandered about, trying to imagine how it looked when we were three thousand years younger." The two colassi thrilled: "They look like monuments to patience, as if time would have no effect on them." At Abu Simbal Henry fussed about photographing. Now moved to Lake Nassar to save it from Nile floods, Abu Simbal was then "an immense dome-shaped mountain rising sheer from the river's edge with a temple cut into it." Looking up at those colassi, between 60 and 70 feet high, Clover found the "faces of several of them are quite perfect and the expression of power and sweetness is very striking."

Life along the river never disappointed. "It was much more beautiful than I expected." The crocodiles amused. Water wheels never fell silent as they irrigated. She saw "camels and oxen yoked together and drawing ploughs that can't have been patented later than the days of Pharaoh." They rode donkeys, sometimes for four hours in only 40 degree weather to see a temple.[35] The flowers were sweet smelling. If the villages were ugly, the greater part, seen at a respectful distance, look attractive, half hidden in a grove of palms." (Something well known to the European and American "Orientalist" painters, such as F. W. Bridgman (1847-1928), who focused on horses drinking at a stream, with the village in the background.)

Villages offered tempting things to buy. "The shops [at Siott] are very good and if it were not for the bother of getting it home we should get a good deal, but five thousand miles is no small distance to send breakable duds." She had her fun: "Whenever we venture into a village we are set with swarms of small beggars crying '*Backsheesh howadji*'; no baby seems too small to learn that. I find retaliation my only defense and hold out my hands piteously, echoing 'Backsheesh,' which generally convulses them and quenches them for a short time." (She would later joke that haggling in Italian improved her accent.)

They had stopped at Siott to let the crew buy corn, grind it, and bake bread, and as "it happened to be Christmas Day we had our boat dressed with palm branches in default of the orthodox hemlock." She photographs Henry enshrined in palm in the *Iris* cabin. Granted that the shutter speed of those cameras did not allow spontaneity, it does catch Henry to the life, mummified in dark suit (Nile winters were cool), hunched at a table, looking down, not having it his way. Yet she describes him as "utterly devoted and tender."[36] She learned to make Turkish coffee on the Nile,

and bought a little grinding machine so an American servant could master the grinding. For the moment, she does just that: "Now I feel I can retain Henry's affection as long as it lasts."[37]

The Nile trip has proved something: she writes she is no longer homesick.[38] Back in Europe, about to traverse an Alpine tunnel, they get out of their carriage. "We ate snow and made and fired snowballs, which was a great excitement after a winter of golden sand."[39]

And when the honeymoon was up, they sent home some 25 crates of watercolors and oriental carpets and china and linens and terracotta pots and dinner services and three silver teapots (which were wedding presents), along with her Paris gowns by Worth and his books, and presents for all. "We shall send all except our trunks by sailing packet to Boston," the frugal Clover wrote her father. "The cost is one-half the steamer's charge, and we do not wish to be kept in New York to pay duties."[40]

They themselves sailed in the *Cuba*, with Henry Lee Higginson among the passengers. His wife Ida was at home with their baby daughter Cécile, and he was returning from a toot with three other married men and his own evenings at the opera. He had often dined with Clover and Henry in London. Yet nothing in the letters leaks out about the apartment house he was building.

The Adamses would probably not like having their style in decoration described as high Victorian, for that would make them seem to follow rather than lead. They were early American patrons of Gottfried Bing, whose Paris shop offering Japanese and Asian goods to the French, and French to the Japanese, had opened in 1873. Clover writes in 1879 she has "succumbed to a small piece of Japanese silver, a matchbox, which I wear as a pendant from my chatelaine. Tiffany's are good, but this is better. It's so nice in traveling to have tapers [matches] under one's fingers." Hers was "a seed vessel of some kind, and the calyx opens on a hinge as cover."[41] Bing was later more famous for his Maison de l'art nouveau, which opened in 1895 and took the broom to "Victorian" whatever the country. Art nouveau was called *Jugendstil* in Germany, *Succession* in Austro-Hungary, *Modern* in Russia, *Stile Liberty* in Italy, *Modernisme* in Spain, and, at about the same time, Americans could shunt from gaudy Victorian to vanilla Colonial Revival. Whichever suburb of the Aesthetic movement, it celebrated the handmade, the artisanal over the manufactured, and there was a certain abandonment in dress, ladies going out without corsets. But, alas, by then Clover was dead. She was not without instruction in home decoration. Two years before she married she

had a copy of Charles L. Eastlake's *Hints on Household Taste in Furniture, Upholstery, and Other Details*,[42] which was the summation of Victorian taste.

Charles Locke Eastlake (1836-1906) went to Westminster School, in the embrace of the Abbey, and was articled to an architect, and on trips to Europe fell in love with the medieval and Gothic. Gothic was "spiritual," the pointed arches lifting the architecture heavenward. By the time of Eastlake, it was antique, ripe for the Gothic Revival that was the basis of heavy, high-minded Victorian design from the House of Parliament by A. W. N. Pugin (1812-1852) to home decoration. And Victorian—in its love of color and the exotic—was the ideal showcase for the knickknacks of the British Empire, those pots and brasses and tiles and rugs and curios that travelers shipped home.

Eastlake attacked clutter, edited those assaults on the eye, to lead his readers to a new simplicity in decoration, and was a forerunner of Aesthetic. He never practiced architecture, and, unlike William Morris, a rival in the decorative arts, he was not truly a craftsman. "(A drawing board designer," John Gloag calls him in his foreword to the 1968 Dover paperback of *Hints*.) Eastlake liked heavy furniture, preferably held together by pegs, and Gloag calls the chairs he did design "loutish." But he had a good eye for arrangement and fittings of rooms.

Eastlake was a good read, his opinion brightening every page, and Clover might even have read aloud his comic sketch of a lady shopping for carpets.[43] He would have applauded Clover and Henry's oriental carpets. He loves how the textiles of Persia, Turkey, and India are "absolutely careless" in working the design out. "You will probably find a border on the right in which the stripes are twice as broad as those on the left. There are exactly thirteen of those queer-looking angular flowers at this end of the room, over the way there are only twelve. At the north corner, that zigzag line ends in a little circle; at the south, in a square; at the east, in a clot; at the west there is nothing at all." English and French designers look with distain on the irregularity of Eastern work, says Eastlake. "In their eyes nothing can be quite beautiful of which the two opposite sides are not precisely alike."

The goal for Clover and Henry was a house of quiet for Henry's writing, and the welcoming of friends when he was not. Above all, it must encourage conversation, so it is likely that attention was paid to comfortable furniture. Comfortable for some, that is. Clover's most recent biographer Natalie Dykstra says that Clover shortened the legs of their chairs and sofas "to better fit their personal proportions." Justice Oliver Wendell Holmes Jr., a whole foot taller than Clover, plummeted down to sit. They did not buy furniture in Europe; Boston had plenty of

cabinetmakers. Clover knew a Boston shop that imported the wallpapers she liked in England.

Clover gives the address of their first home together as 91 Marlborough Street. The street number is misleading. It was the Marlborough end of a block of five contiguous brick houses built at 271-279 Clarendon Street about 1869 for speculation by George Wheatland, Jr. No architect is given; Wheatland would buy up house lots all over the Back Bay and build houses for sale or lease. These five on Clarendon Street rise five stories from full (or English) basement (for kitchen and laundry) to dormer bedrooms in a mansard roof. The dining room was on the entrance floor, above the kitchen, and the parlor with bay window on the second, and the whole defines plain domestic architecture. Not at all the "gimcracky," as Clover called the neighboring Fiske mansion on the corner of Commonwealth and Clarendon which she found affecting the Queen Anne style that was done better in London.[44] (Later razed for a dull apartment building.)

Clover and Henry's row house still stands, though now combined with its nearest sibling and entered at 273 Clarendon. Clover wanted a sunny house, and as it's on the Marlborough Street end of the block, it had south and west facing windows. A drawback to row houses was lack of light, as windows were only on street front and alley back, but skylights helped with ventilation.

The Adamses were not the first noted residents of No. 91. That honor goes to the Boston lawyer who lived there from 1870 till he moved to Europe to paint in 1872. He is forgotten now for his own pictures, but forever remembered as the father of "The Daughters of Edward Darley Boit" painted by John Singer Sargent in 1882 in the family's Paris apartment. Now in the Museum of Fine Arts, Boston, it is displayed with the pair of actual (and ugly) Chinese palace vases that Sargent edits and renders as lovely companions for the four young girls in their starched pinafores.

How we wish Clover had photographed her rooms! When she did photograph interiors, they were settings for her true subject, portraiture. We can peek around the edges but not see far into the rooms. As we will see, the photographs of the Fairchild apartment at Agassiz tell much about décor, but, as with Clover, their letters tell us more than a photo could.

Those 25 crates that Clover shipped home helped decorate Pitch Pine Hill, the country house that Clover and Henry built in Beverly to be near her father. It was not a showplace but substantial with plenty of guest rooms and accommodations for four servants. (People at the Agassiz had as many as five maids.) Did Clover invent the Infinity Pool? Her garden pond ends on the cliff to the water and it must have intruded skyscapes onto the lawn. Her photograph shows the house is a Dutch gable, so a

Colonial Revival of a sort. The four double dormers on each side of the roof make for sloping ceilings and odd little spaces. (Abigail Adams' birthplace, built in 1685 in Weymouth, Massachusetts, had four single dormers.) The porch may resemble a poop deck but for the eccentricity of tree branches holding up the veranda roof. Clover insisted houses be "well plumbed." A bathroom separated hers and Henry's bedrooms, and each had a dressing room. On a visit to the current owners, Natalie Dykstra found Pitch Pine Hill a blaze of color and design. Morris tiles still line fireplaces. The entry hall floor is laid with more tile showing medieval castles and knights and medallions. The dining room mantel displays Clover's collection of plates painted with four-leaf clovers.[45]

The contents of those 25 crates were also a brag on themselves as travelers, citizens of the world, superior to Boston stay-at-homes. Like Henry Lee Higginson, Henry Adams did not necessarily believe Boston was the center of the universe and hub of the solar system, as Doctor Oliver Wendell Holmes did not correct people who quoted him to that effect. And of course foreign travel was an endless topic of conversation in polite society, even providing useful information: who knew one could tour Pompeii in a sedan chair? "Mrs. Blodgett and I took *chaises-à-porteur* so that we needn't get tired, for it takes at least three hours to do Pompeii justice."[46]

There is something disarmingly practical to Clover putting on the dog. She has bought three carpets, two from Turkey and one from India, "the exact color of the Nubian desert," for their unseen abode in Boston. She writes out the measurements for her father. "So our house is nearly carpeted already," she crows, and if everything doesn't quit fit, she can "stain the floors or put red drugget to eke out corners."[47] The India carpet measured 20.6 feet by 15.3, which gives some idea of the size of Clover and Henry's first dining room.

Her letters home are full of detail about the china they bought. For everyday "a set (breakfast and dinner complete) of blue and white Danish china, pretty, cheap, and nice shapes." (This was a staple a hundred years later in Terence Conran's Habitat shops.) Linens and silver were second hand, by which Clover hoped to escape or reduce customs duties. Thanks to the many checks as wedding presents, she and Henry "shall have quite a spree" in Paris buying "a swell dinner set." She spent Uncle Sam Hooper's $500 on "a Dresden dinner service—gay and handsome—which the [dealer] swears he bought in Paris at private sale of Louis Napoleon's things with Eugénie's diamonds—we don't believe him, though; anyway it's uncommon pretty, and [we] are buying old silver forks, spoons, and Dutch coffee pot" with the $500 from Henry's parents. Eastlake would have deplored their choice of Dresden china.

Sometimes confused with Meissen, it is porcelain, and very decorative, German rococo, with cobalt blue for coffee cups and floral centers on white plates whose scalloped edges are often gold rimmed and sometimes pierced. On the back, the stamped letter D and a crown further enchanted the purchaser. But not Eastlake: "Your pinks and mauves, magentas, and other hues of the same kind, however charming they may appear in the eyes of a court-milliner, are ignoble and offensive to the taste of a real artist." He was just warming to his subject: "The fashion of gilding the edges of cups and plates, and *touching* up, as it were, the relieved ornament on lids and handles with streaks of gold, is a monstrous piece of vulgarity."

Dresden was all the rage, and would remain popular as a wedding present for Lucia Fairchild 20 years later. Clover was determined to go one better, to lead fashion on her return to Boston: The dinner set she envisions buying will be "probably of four or five different kinds, which is the go and more amusing than all alike."[48]

Pictures meant a great deal to them, and were often a present one to the other. "Henry had found and given me a charming little sketch in black and red crayon by Watteau—a girl lying asleep on a couch, bare feet, etc."[49] For their seventh wedding anniversary, he gave Clover a little portrait of Princess Charlotte by the 18th-century court painter Zoffany and she gave him a "a wee little early Turner watercolour, about five inches by three.[50] Pictures gave them a sense of hominess. Whenever they could stay a week or more in a hotel, they would furnish their rooms by hanging their newly framed acquisitions, and Clover would put plants on the balcony.[51] "Oh, the bliss of putting one's clothes in a bureau after nine months of hard traveling."[52]

They stuck to a budget when looking around galleries and auction houses. Something of a bargain was a William Blake, which Clover at first offered to buy for her brother Ned, one of Blake's earliest America admirers, and whose collection was later scattered. (Ned was to be another mad Hooper, confined at what was first called Asylum for the Insane, later called the McLean Hospital, where Clover would fear being taken herself.)

"Ask Ned," Clover writes home, "if he would like a watercolour by Blake of Nebuchadnezzar eating grass—about 18 by 9 inches—which [Francis Turner] Palgrave owns and is willing to let us have for ten pounds." The sale would please Mrs. Palgrave, née Cecil Greville Miles Gaskell. She was the sister of Henry's lifelong English correspondent and recipient of Henry's first impressions of Clover, and she hated the Blake. The money would be welcome: "they are not opulent," Clover writes. "We think it very striking though quite ghastly, but Ned's enthusy-musy for Blake may extend to this."[53]

Clover and Henry decided after all to keep the Blake. It joined their other watercolors at their first married home at 91 Marlborough Street. The dining room was papered in yellow and on the floor was the yellow India carpet to remind them of the golden sands of Nubia. They kept the curtains shut so sunlight would not bleach their two Turners, "The Valley of Martigny" and an India ink of an ancient ruin. Henry appropriated the Turner of the mad king Nebuchadnezzar for his library where he wrote Charles Eliot Norton, Harvard's first professor of art history, "it excites frantic applause."[54]

13

John Singer Sargent Plays the Piano

"grand cosmic chords"

It was the family custom for Charles Fairchild to make the salad at dinner. One evening, when he was late getting home, the task fell to the elder daughter, Satty. It was a disaster—we are spared the culinary details—but, even worse, it was to be dished up to company.

Not least of the guests were Henry and Ida Agassiz Higginson, the Fairchilds's business partner but more celebrated as the founder of the Boston Symphony Orchestra. They were all the nearest of neighbors, for the Higginsons and the Fairchilds lived in the Hotel Agassiz which Higginson had built as one of the earliest apartment houses in America.

The other guest was John Singer Sargent, or John S. Sargent as he signed his pictures during his lifetime.[1] Popular as a society portraitist in London and Paris, he'd really caught on in Boston when the St. Botolph Club—of which Higginson and Fairchild were founding members—gave him his first one-man show in 1888, and now two years later he'd come to stay with the Fairchilds to paint the rest of Boston society.

When Sargent teased poor Satty's efforts—"do you think you can get any of us to eat it?"—the family exacted "revenge": Sargent was told to make salad the next night. He did, "and it was very bad," the next oldest Fairchild, Lucia, wrote in the diary she kept on Sargent's visit that October. She added to it, when they stayed with him in England the next summer, and together they paint a picture of Sargent without a brush in his hand, so to speak, but always engaged in art.[2]

He was good company, and found the Fairchilds the affectionate teasing friends he could gossip to about the slog of portrait painting. They were half a generation older, Charles, 52, and Lily, 45, long married and long

settled in Boston. They talked about books, he defending Henry James, glad he found others who did not like Dickens, and finding Hawthorne "dreadfully morbid." He played Wagner and Brahms on their piano, he giving a running commentary on music, loving Wagner's "grand cosmic chords." They discussed religion, he appalled Lucia had never read the Bible; she had observed at the Bunker wedding "at the prayers in ceremony he prayed, though many men didn't," as she noted in 2 October 1890. They went to art exhibitions in Boston; and, most memorably for Lucia, he took them through the Louvre, disparaging the "Mona Lisa" and telling Lucia her education "shall begin" with Ingres. Imagine Lucia telling her best friend, Pilla Howells, daughter of novelist William Dean Howells, that Sargent thought Pilla looked just like Mary in the Fra Angelico "Annunciation." "Exactly like, not merely the head but the whole character—exactly like." And he painted Fairchilds seven times.

He was then about 34 years old, tall, just over six feet, and lean, though not as spare as his father, who was Jack Spratt to a fat wife. People grow into their faces. The young Sargent was unformed, with protruding ears and pale, pop eyes. He had his father's broad brow but also his weak chin. But his 1886 self-portrait shows nature amended. The peepers are now the beady eyes which are the mark of a painter painting himself and he has grown sleek, luxuriating in chestnut mustache and beard. We can suppose Sargent looked pretty near like this four years later, when he showed them around the Louvre, gave Lucia some painting tips, tried to get her to read the Bible, and stayed up late singing glees. In the English countryside one morning, Sargent turned his studio into a cricket pitch, and they all played. "Over the cricket," Lucia wrote, "he was very gay & boyish—standing round in his wonderful swell loose-jointed poses when he fielded."

He was born a live wire. His "health and energy were totally novel to the Sargent household," writes his sage and entertaining biographer, Stanley Olson.[3] A baby girl died before he was born, and two other siblings would die, leaving only John, Emily with her hampered spine, and their much younger sister, Violet, to grow up. Olson takes four amused chapters to chronicle John's rackety upbringing all over Europe. He was born in Florence on 12 January 1856 to FitzWilliam and Mary Singer Sargent, and named John Singer Sargent. The middle name, as was often the American custom, was his mother's maiden name. An art gallery imposed the triple-decker moniker on him after his death.

Mary Sargent was the family's problem. Her ill heath, whether real (the 19th century was a germy world) or imagined, was the excuse never to return to the family's native Philadelphia. Sargent's portraits of them show her set face and his father as an elderly cherub. FitzWilliam Sargent had been a doctor, who never practiced, but interested himself in the workings

of the eye. His *On Bandaging, and Other Minor Operations* (1848) was of use in the Civil War. They did not have a lot of money; scarcely-richer Americans would choose Italy or France, find a villa or flat, and settle in. The Sargents were in constant motion. They went from hotel to hotel, perhaps six in a summer, three during the rest of the year. They traveled to recuperate, sickened of the new place, and moved on.

"John, alone among the children, was untainted by prolonged or serious illness," Olson writes (in the vein of a novel by Penelope Fitzgerald). "This good fortune made him peculiar. He was unique, in a family that was tightly bound together there was a suffocating want of perspective. They were so self absorbed they had no inkling of normality. His parents did not know what to make of him; they overestimated the speed and level of his development. Instead of being normal, he was perfect, and all because he was the only example of a healthy child FitzWilliam and Mary knew for nearly a decade and a half."[4]

Formal schooling was scant. "Johnny ... is much more fond of climbing & kite-flying than he is of spelling," his father wrote in 1861, "and, in truth, I like him all the better for it." If his writing style was wooden, his vocabulary was electric: sphinx, wizard, weird, fantastic, serpent, and curious, recalled a childhood friend, Violet Paget (the future novelist Vernon Lee). There were lessons. His parents insisted on piano. He probably had art lessons. If not entirely self-taught, he was a quick study. His mother sketched and did watercolor. Olson observes that her view that travel was education matched the restless life she exacted for her family. But she did know the value of Paris training, and John Sargent's talent won him a place in the atelier of Carolus-Duran that produced a generation of fashionable painters. Their time was gone by 1936 when novelist and critic Rebecca West wrote the "Boldonis and de la Gandaras and Carolus-Durans [are] awful examples of that facility with paint which has nothing to do with painting, which is closely akin to the Italian art of winding macaroni round the fork."[5]

So by the time Sargent fetches up in the bosom of the Fairchild family, he has been a man of the world since boyhood—with opinions on everything. Quite how he met the Fairchilds has eluded his biographer, but probably by 1887, and who of us can say when an acquaintance becomes a friendship. Charles Fairchild seems to have made friends easily. It may have been on a trip to England, perhaps to visit his brother, then U.S. Consul in Liverpool, that one introduction led to another, and opportunities spotted on both sides, and Charles Fairchild would become Sargent's business manager in America.

He is still "wired," as we would say. "He is very nervous and tired, though he is so self-controlled that unless one knew him pretty well one

wouldn't know it. But his hands twist & move all the time, & when he sits cross-legged he jiggles his feet." What diarist cannot sympathize with Lucia trying to record Sargent. "He has smoker's throat which gives him an occasional queer half cough, and he says—hmm—ha—and draws long breaths as he talks, often leaving as much to be inferred as he actually says."

He was candid. He had been paid a handsome $3,000 to paint Isabella Stewart Gardner in January 1888, but portraitists cannot choose their subjects. "He characterized Mrs. Gardner as looking like 'a lemon with a slit for a mouth,' & spoke of another lady as 'like a boiled turbot.'" Such was Mrs. Gardner's general notoriety in Boston society that one Fairchild was not above snooping: "Satty had seen a note for him in Mrs. Gardner's handwriting on the hall table ... [and said] tentatively, 'She's written to you, hasn't she? Didn't I see the note'—etc." Whereupon tattler Lucia breaks into a sort of code in Greek letters. John Gardner had not liked his wife's portrait for another reason. As the story went, he bristled at a witticism mating scenery and sex. Upon studying her low cut dress, a wag opined "one could see all the way to Crawford's Notch," thus punning on a noted beauty spot in the New Hampshire mountains and the society novelist, F. Marion Crawford, called Frank, who perhaps buzzed around Mrs. Jack more than her husband liked. As might be pronounced in Yankee Boston, "Notch" was also a hint of India's Nautch girls who danced for the pleasure of men. The offended Gardner withdrew the portrait from Sargent's show at the St. Botolph Club in 1888, and it was not shown in public till after her death in 1924.

Sargent had read everything and heard much. Lucia's diary lets us eavesdrop on conversations about books new (Henry James, George Meredith, George Eliot) and books canonical (Hawthorne, Dickens). Brahms was still new music, as were Fauré and Wagner. One gathers that Sargent, weary after a day of painting demanding clients, might have liked a quiet evening. Happily for us, it was not to be.

"Last night Mig [a Fairchild pet name for their mother, Lily] said to him, 'Let us have some people to dinner tomorrow night. Would you like to see the Higginsons?' 'My dear Mrs. Fairchild,' said he, 'why have anyone?' Mig, 'I thought we should all like to see the Higginsons.' J. S. S., 'Ah—yes—true—it would be very pleasant, of course it would be very pleasant, to see them.' So they came, but nobody else."

At the dinner table, when the conversation turned to Henry James, the ladies made the running. They had all read *The Tragic Muse,* which had been serialized in *The Atlantic Monthly* (1899-1890) before Houghton Mifflin published it in 1890. All his life, James aspired to the theater and this novel about the theater was as ill-received as his only staged play,

Guy Domville (in 1895). The heroine was Miriam Rooth, a rising young actress.

Said Sargent: "'How fine Mrs. Rooth is! Don't you think she's capital? You'll have to admit that she's exactly like Life.' The others had been saying that Henry James was always dead, lifeless, and so on. Mrs. Higginson, 'His characters always seem to me to real people just what dried specimens of plants are to the growing ones. They are quite correct—only no vitality.' Sargent, 'Ah—well—yes—I can see what you mean. He sees life, it seems to me, through the medium of Society—of good form, and all that sort of thing.' Mig, 'Now you have explained to me why I have always hated Henry James' books.' He admitted that he thought the view narrow. To Satty, 'Have you ever read *The Reverborator*?' The title of the 1888 novel comes from a scandal sheet for which the wonderfully named George Flack is the American correspondent in Paris. "Satty: 'Yes, & I thought that the worst of all.' J. S. 'You don't mean to say so! I thought it charming, light comic—a perfect comedy.'"

In those days, people collected *cartes de visite*, studio photographs of famous writers, actors, and musicians, and liked showing them off. It made a nice evening's entertainment, prompting conversation and debate. Not much bigger than today's baseball cards, the photos were thin albumen prints pasted on cardboard embossed with the studio's name. And so on this evening, Sargent ran to his room to get his of the Spanish dancer, Carmencita, whom he hugely admired, to show another *dévoué*, Mrs. Higginson.

Sargent had painted the dancer earlier in 1890, and one hopes he treated Fairchilds and their guests to details from the sitting. For at least a decade he had loved Spanish gypsy music and dance, the *gitano* with its throaty songs and snapping rhythms that seduced many a French composer, and at the 1892 Paris Salon he had showed "La Jaleo," a genre scene now in the Gardner Museum which purports to show gypsies performing for themselves. Some critics dismissed it as "journalism." The Carmencita is a portrait, and masterful, and France would buy it for the nation. Hands on hips, weight back on the left heel of her court shoes, she has pivoted, extending the right toe as though to lunge forward, and she dares the viewer to admire her. She was at the top of her game: growling song as she stalked, lunging as she danced. All art is hokum to some extent. The artist wills us to believe in his or her vision, and Carmencita was as much show biz as folk art. She was vain, and sure of her worth: she charged $150 a show and kept the jewels that women tossed at her; and Satty Fairchild heard from Sargent that the dancer cost him a bundle, some 600 pounds, in the jewels she demanded. She was impossible as a model—in the studio she would not stand still—and Sargent had to wheedle her, even

to painting his nose red to entertain her and eating his cigar to keep her attention. She loved white face paint and frizzy hair. Sargent refined this noise to a mask à la japonaise and stuck a white flower in the topknot. Illusion is all, as real costumes are shabby from use, and smelly, and just as he edited out the trite flowers on the Chinese palace vases that frame the school girls in "The Daughters of Edward Boit," he merely sketched her costume. He lavished golden silk on her, draped that with silvery fringe, and with a long fragrant curve of white satin over the bosom, invited the eye to imagine what was hidden. It's a strip tease. This muffling of movement promises she will dance: she's the theater curtain that opens to the performance.

That evening there were other celebrity photos on offer, and literary figures now take their lumps. The Fairchilds and their guests look at Dickens.

Satty: "'I can't bear Dickens.' J. S., 'I'm glad to hear you say so—I can't, but I should never have dared to say so.' Satty & Mrs. H.—'Why, a great many people agree with you'—Sargent, '<u>Do</u> they? I thought one was always set down as a bad character—something terrible—if one didn't like Dickens.'"

The Higginsons take their leave. They were soon home: They had only to walk down the massive iron staircase that remains the architectural core of the building, the brass railing glinting up six floors to the skylight.

The young Fairchilds are not disposed for bed. A photo of Oscar Wilde prompts Satty to say what Lucia had told her about *The Portrait of Dorian Gray.* Sargent: "'Horrid—isn't it?' I agreed," said Lucia. Sargent: "'yes, dull—unnecessary—it's a book that ought to be thrown out of the window.' I, 'Why did you once advise me then to read Oscar Wilde?' He, '<u>I</u> couldn't have! He's so ridiculous it seems to me'—'But I'm sure you did. You said he was awfully witty'—He, 'Ah, well, his newspaper articles & reviews perhaps—Yes, I remember an essay on the 'Art of Lying' that was quite good—very witty.'"

The evening comes to a close. Sargent "took Meredith's *Modern Love* to read himself to sleep on (which is one of his habits) & talked of it most interestingly this evening (October 15) at teatime." Fans of Meredith the novelist included Sherlock Holmes and Oscar Wilde: "Who can define him! His style is chaos illuminated by flashes of lightning." In 1860, Meredith published *Modern Love,* the 50 sonnets he wrote when his first wife ran off with another man. Lucia, we now know, will break her marriage.

Sargent found Meredith interesting but hard going, "'very involved & difficult to understand. He had a way of beginning his sentences in the middle that was very difficult. Mig offered to read it aloud, & Sargent said he should like to have her. He said it seemed to him unlike any of the

rest of Meredith's work—there was something in it which he had found in nothing else of his, & went on, 'How wonderfully bitter it is. That's just why it is so very good.'"

But he "did not care" at all for Hawthorne on adultery. *The Scarlet Letter* is "so dreadfully morbid, and why should they go on for seven years forcing themselves to endure all this misery? And then decide to toddle away at the end of it? Why, if they were going to do that sometime, not do it at once? I must say all their wretchedness seems very unnecessary. I fancy Hawthorne does better when he is not quite serious."

Next to art, Sargent loved music. By the age of 14 he had learned the standard piano repertory. The violin virtuoso Joachim is supposed to have said, "Had Sargent taken to music instead of painting he could have been as great a musician as he was a painter." He was a demon sight-reader, who never needed urging to play Wagner. He was as excited and spontaneous talking about music as art, and Lucia was there to hear, for he often talked as he played. "How fine it was," he said, "after all the troubled music in *Götterdämmerung*" to come on those "grand cosmic chords." Another time: "I think I must try the *Vorspiel* [*Das Rheingold*] later on—the last part is so fine—but I can never get it." The Wedding March in *Tannhäuser* was "magnificent ... splendid ... very barbarous." *Parsifal* was a favorite, though he once broke off playing the Flower Maidens to give his audience "some good vulgar music." It was *Meistersinger*, and Lucia, startled, asked if he thought it vulgar. "Oh, yes, right here I do. The Butcher, the Baker, the C. Maker—you know the place where they all came marching in. Jolly music. Don't you like it?"

As it happened, the Boston Symphony's concert on 18 October 1890 offered a famous Wagnerian baritone in a famous *Tannhäuser* aria, and Sargent was there to hear Theodor Reichmann sing Wolfram's "Blick ich umher is diesem endlen Kreise" (This noble circle) as knights gather for the best song on "love's awakening" (by which Tannhäuser hopes to win Elisabeth). The BSO program was rather typical of the times, from the first concerts mixing vocal music with symphonic, with the conductor Georg Henschel excusing the orchestra and sitting down at the piano to accompany a singer. So after the Wagner came two lieder: Brahms's 1886 "Immer leiser wird mein Schlummer" (My slumber ever grows more peaceful), set to the cello theme from the second piano concerto (1881), and Schubert's "Am Meer" (By the sea). Except for the Schubert, this was—for many—the "new music" of the time; and the program concluded with the Brahms second symphony composed in 1877, thus giving something to both camps in the great Wagner-Brahms divide. A favorite of Wagner, Reichmann had created the role of Amfortas in the 1882 *Parsifal* and sang in the "Ring" cycle that Mahler conducted at Covent Garden. Oh, to have

heard Sargent fully on the concert! Lucia: "But as he & S [her sister Satty] went together, I don't know his comments on the music. Only I think he liked the 3rd moment of the Brahms best & and didn't care much for the Wolfram."

The music critics were divided, neither the *Traveler* nor the *Transcript* was impressed by the singer, or his choices of repertoire. The "news," to some a scandal, but certainly a first for the nine-year-old BSO, was the behavior of the soloist. Having bowed twice to enthusiastic applause, Reichmann then returned with sheet music in hand. Unheard of, in those days, to sing an encore, and apparently it surprised the conductor, but there was nothing that Artur Nikisch could do but sit down and accompany him. "We think a sterner conductor, [Wilhem] Gericke, for instance would have said 'No!' to that encore," thundered the unnamed *Boston Transcript* critic. This worthy was only warming up. He takes another hundred words or so, of preening sonorous bombast, before clearing his throat to denounce Brahms. He has had 11 years to reflect on the second symphony, which was introduced to Boston in 1879 by the Harvard Musical Association orchestra. "Has not the progress of musical creative art since Schumann been suggestive of decadence upon the whole? What we feel the want of most in this Brahms symphony, in all his symphonies, is the vital spark of inspiration, genius. There is abundant learning, skill and mastery of form; no trifling with art; and there is a wonderful degree of ingenuity. But ingenuity is not genius. A certain heaviness, a certain cloudiness, drowsiness, hangs over the whole curious and shifting dream." Despite the joke "EXIT in case of Brahms," the composer would find his audience. What the *Transcript* said about "ingenuity" might well apply to the kind of painting and sculpture, the classical academic wonderland of myth, that Boston still liked.

Sargent had painted the Boston Symphony's first conductor Georg Henschel in 1889, five years after he left the orchestra. They were good friends; Henschel had left the BSO to found the London Symphony Orchestra, and the two men often went riding together, Sargent a bad but enthusiastic horseman. Henschel, also a noted baritone, joked he didn't "sit" for his portrait: "He made me stand on a platform and sing—from *Tannhäuser* by preference as he worked." Sargent would do two other figures in Boston music, but not till 1903, well after the Fairchilds moved to New York. The portrait of Henry Lee Higginson is either magisterial or ponderous, certainly the Great Man that Harvard students commissioned to preside over the Harvard Union (a Higginson benefaction so boys of all social classes could dine together), and Symphony Hall's portrait is only a copy, done by Peter Pezzari in 1953, the gift of the Misses Curtis. But there is real affection in the quickie Sargent did of the ears-pricked Charles

Martin Loeffler, which he painted in three hours at the Gardner Museum and dedicated to Mrs. Gardner "con buone feste/from her friend John S. Sargent." Loeffler, an Alsatian-born violinist (with the BSO) and composer, was Sargent's fellow champion of Fauré's music.

They played duets, and when Sargent sailed through the perplexing piano part of Fauré's "Swift" Sonata, Loeffler marveled. "Not by any means that he always played all the notes, but better than that, when cornered by a surprise difficulty, he revealed a genuine talent for music by playing all that which was and is most essential." What especially struck Loeffler in an age of exotically colored music was that Sargent's ear "was strangely sensitive for unusual harmonic progressions, in fact he had an unusually fine memory for them. I have known him to be haunted by certain ones, after one hearing, he would not rest there until he had solved the harmonic riddle." He played Albeniz's piano suite, "Iberia," and a piano arrangement of Lalo's Symphonie espagnole. He loved the guttural Spanish songs of Andalucia, "dismal restless chants," part African, and "something between a Hungarian Czardas and the chant of the Italian peasant in the field," he wrote to Vernon Lee in 1880, giving her a learned musical analysis of their composition. "The *gitano* voices are marvelously supple."[6] So he had in his ear the deep noise and color of tavern singing when, in 1882, he painted "El Jaleo."

Then, in 1907, he quit painting portraits. It "would be quite amusing if one were not forced to talk while working," he told the society painter Jacques-Emil Blanche, who soldiered on. "What a nuisance having to entertain the sitter and to look happy when one feels wretched."[7]

The Fairchilds were perhaps not surprised. Staying with them in 1890, he told one horror story after another. He was in demand, but it came at artistic cost, whether to paint the truth or paint a picture, and the sheer volume of requests complicated that further. If he let Mrs. Sears jump the queue, he could not very well chuck Mrs. Mason, who was next in line, and the problem with Mrs. Mason was "she was not at all handsome, which would be another hindrance." When a Fairchild suggested she might be "interesting" to do, he liked that as a way out: "Yes, she might be interesting to do." To postpone sittings more than three days with Mrs. Brooks would be rude "and I should feel so dreadfully lazy & shabby." He painted her wearing Lily's topaz necklace, which he told the Fairchilds, he "tried all over her person & is finally painting on her neck."

As a sitter, old Mr. Peabody was a challenge in another way. He was "a fine-looking old man & very lively—yes, & charming, & tells killingly funny stories." But he meddled: during a resting point, he messed the paint with his fingers, and Sargent caught him at it. " 'Oh, please, don't touch it!' 'Certainly not,' said Mr. P. drawing himself up, 'Certainly not I

should never think of such a thing!' Etc. etc. growing more and more stiff at every moment." When things continued to go badly with the Peabody sittings, Sargent found himself "stamping." Portrait painting, he told the Fairchilds, " 'is very close quarters—a dangerous thing—I must say I had a very disagreeable time of it'" ... "'and when you get to stamping in public,' he said laughing, 'it's about time to give up portrait painting and sail for Europe. ... I shall have to plead nervous disability [to Mrs. Sears and Mrs. Mason]—tell them that I stamp & throw my brushes about, & don't know what I mayn't do next.'"

Only one portrait is known to have been done at the Agassiz. In December 1887, Charles Fairchild's brother came east to be painted as war hero with "the empty sleeve" of a missing left arm. Lucius wrote his wife back in Madison: "Mr. Sargent has been here all morning but certain windows had to be changed so that a proper light can be shed on the manly form and aimable face of your husband ... I put on my warlike chest a whole string of badges." Lucius calls them "brass of badges to offset brass in the face." Seven days later: "a queer old stick is your husband in oil." But he gets to like it, "a splendid work of art."[8]

Not every sitter was pleased with his portrait. Higginson was one, telling Henry Adams there was more truth in the Ming jug that Adams had given him than in his portrait by Sargent.[9] Clothing helped tell the tale. Higginson is all cavalry cape. It spread over his knees, which helped disguise the fact he was only of medium height, and it salutes his war service while linking him to the ceremonial drapery found in 18th-century portraits of kings and grandees. Sargent could make clothes make the man, such as the ankle-length, double-breasted velvet, worn almost *deshabilé*, that made a dandy of the artist Graham Robertson (who painted actress Ellen Terry, as did Sargent), or the overcoat, almost a straitjacket, that seems to encase the first John D. Rockefeller and cannot warm a cold man.

Sargent could be wicked about clothes as a weapon. Advanced women were shucking corsets and draping themselves like figures in Pre-Raphaelites painting. So when, at dinner, the Fairchilds were highly critical of the way the eminent Charles Eliot Norton, Harvard's first professor of art history, treated his daughter Margaret—"on account of her being so ugly," as Lucia put it—Sargent took up her cause. There should be "state aid in teaching unfortunate children to rebel—a farm for vicious or neglectful for malignant parents." If Margaret "were a girl of character what fun she could have, how she could use her looks to irritate him all the time. She ought to dress up in the most Aesthetic style," the uniform of the Pre-Raphaelites, "and be always trailing about in front of him, always getting in his sight, making those things that he loves hideous & ridiculous."

When he used clothing and a color scheme, Sargent could give personal histories of his subjects the drama of the stage. He painted whites almost better than any other color, and he combines it with greys and blacks to make paint the "grand cubic chords" he heard in Wagner. By their pristine linens, his ghostly white suit and the origami of her white skirt, the world would recognize Isaac Newton Phelps Stokes and his wife Edith Minturn as members of the leisure class. That he's in her shadow says much about the couple. But it's Sargent's placing of color, and the ratio of colors, that gives theatrical depth to the picture. If her white skirt takes up two thirds of the canvas, it's capped by her pleated grey blouse and her bouncy black baroque jacket, colors that Sargent also makes sing out. She almost steps out of the frame. When, however, the subject was a single male figure, and as tall as U.S. Senator Henry Cabot Lodge, and wore traditional male attire, the result was "all suit." So says a Lodge great-grandson, who tells with glee how he and his brother, when playing "hall hockey" indoors, lofted a puck into the portrait and ripped the great man's fly.[10]

Sargent would do eight pictures of various Fairchilds. Twice, the youngest Fairchild sat for him. Gordon, aged five in the oil of 1887, is all brown eyes and brown bangs, gazing down, in innocent wonder. When he was eight in 1890, Sargent did him in chalk, cuddling a black-eared rabbit as a rattan armchair cuddles him. Tall Satty, she of the salad disaster, was one of his favorite models. He painted her three times. In the portrait, her bright face flames above her white dress. When she wears a straw boater for "The Blue Veil" he almost disappears her under the netting. Back she comes, in vivid profile, in the impressionistic murk of the 1887 oil sketch. Three years later Lucia records him sketching Satty at the Agassiz. He "said he would like to do her just the way the Monet at [Doll & Richard's Gallery] was done—very good for one." He knew and admired Monet, had even painted Monet painting, and used Impressionism to soften and enrich his earlier style. Looking at Monet meant taking a break from his daily grind, how in painting portraits especially "one got into a sort of way—like handwriting, you know —capital letters and that sort of thing. It's very good for one to get quite away from it once in a while." Later he mentioned Whistler as being remarkably free "from anything like that."

And so for two years, 1890 in Boston and 1891 in Paris and England, the Fairchilds had the benefit of his conservation on art, and Lucia took several lessons from him, and she wrote it down. She was not quite 18, with aspirations as a painter, when Sargent and his 20-year-old sister, Violet, arrived in Boston (for the wedding of his old friend, the painter Dennis Miller Bunker). Almost immediately Violet tells Lucia a "tale." The Sargents were often in Brittany, which his parents found cheaper than

Paris. It would be a part of France that taught Sargent a great deal he would not find in a studio, and he taught this to his sisters, and now Violet passes it on to Lucia, who tells her diary:

> Once when he & Emily & she were walking on the sand at Breton together with a marvelous yellow sunset—yellow reflections on the water—they came upon some old fisherwomen, silhouetted against the sky. "What color are they?" said Emily. "Black," said Vi—"or very dark." "My dear child," said he, "there're the most brilliant yellow." After a moment of looking they saw it was so—the yellow reflections in their eyes, and so on.

There was more comment on color when Lucia and her family stayed with Sargent at his studio at Fairfort, Gloucestershire, in August 1891. She has been painting behind the studio, and he comes over to criticize. "'Very green, those trees,' said he. 'You're under the impression that trees in England are green—whereas they aren't.' I asked him what color do you see them?' There were two fat trees against the sky. He said, 'Oh much <u>blacker</u> and duller, don't you know.' Then he said, 'You know, as a matter of technique, & all that sort of thing, I'll show you a much easier way.'" She adds: "That's not verbatim."

"'Painting it the way you are,'" he continues, " 'is almost impossible to avoid <u>that</u> look.'" She breaks into Greek. " 'Trees aren't ever green against the sky—They are grey—or purple, or whatever, along the edge and [more Greek] I've seen that so often in English pictures—A yellow tree in the fall with patches of <u>green</u> sky—because Blue & Yellow make green—Absurd. As a matter of fact, it always makes the sky look pink, doesn't it? I don't know why it should I'm sure—but it certainly is the fact." Then, after an erasure, she writes: "He is so great."

He goes on: "Haven't you ever noticed with willow twigs—after all their leaves have dropped off when they are quite orange, how very pink the sky looks through them? And later: "I don't know how you see it but the light looks to me very purple when it shines through the trees." She adds: "I have left out all his gaiety [Greek letters] in all this."

Later in the 1890s, Lucia Fairchild Fuller, as she became on marrying a fellow artist, would begin making her name doing portrait miniatures. (Like Sargent she would paint society women.) Boston artists could teach her the "how" of painting and drawing, and she had Boston museums for copying masterpieces. Galleries brought the new in art: Claude Monet's first American show would come in 1892 at Boston's St. Botolph Club. The art photo was a boon; Sargent speaks often of buying them. (He already had a Kodak and was beginning to take pictures.) But with him at

her elbow in Paris Lucia was to see much more of the real thing and hear him say what she should look for. Not just look at, but reconsider. He'd made them look twice at the vast crowd scene that is Veronese's "Wedding at Cana." Sargent: "It's a very funny thing ... You know some days I come in here that picture strikes me as so big & tedious—I don't know why it looks to me so very gorgeous today." And he disparaged the Mona Lisa. " 'There, that's the one they have all written volumes about. What does her smile mean? What is she thinking about? Her unfathomable eyes, and all that. I must say her expression doesn't strike me as particularly profound. Does it you?' " Lucia spoke up: "Not profound, perhaps, but subtle, certainly." Sargent: "Hmmm—I'll show you a much finer thing of his—Much finer to my mind.'" At the Botticelli "Madonna with John and Child," which he admired enormously, he "twirled his mustaches & bent forward to look at it frowning a little—'Wonderfully lovely isn't it' & then touching the red rose, 'beautiful, that.'"

Lucia does not record who was along on the trip to the Louvre, but probably her mother and sister, for the outing began with Sargent's news of his sister's troubling engagement. On that August Sunday, he "was looking wonderfully handsome & tanned & rather thin, with the Legion of Honor ribbon in his button hole. It was one of his very gentle & human days," for on his mind was his sister Violet defying her family to marry a demonic Swiss charmer, Francis Ormond, heir to Ormand Cigars. They were right to worry: Ormand would skip out on wife and children to live a South Seas fantasy. A great nephew, Richard Ormond, would, however, become a Sargent scholar. Violet's choice of husband would lead Sargent and the Fairchilds to a discussion of love, of which more later.

At the Louvre, they began by looking at statues. "The Venus de Milo he wanted to have turned in another way with the light to strike full on her front—he said he had an idea it would suit her better—but the keeper would not let it be done."

On they went to the painting galleries. He pointed to Ingres's "La Source" and said: "There's a man you probably DETEST now—but you must learn to see how fine he is." Lucia: "I was rather despairing & said, MUST I? I went on that I had admired the photos of his drawings immensely & imitated them a lot this winter—& that I had been horribly disappointed in a picture of his in the Antwerp gallery." To which Sargent said: "'But he keeps just the same quality in his painting [as in the drawings]—wonderful, you know—the material part of it, the paint so that the work is quite different—but Ingres is just the same. I'll take you round to see a lot of his things later,' he said laughing '& your education shall begin.'" Lucia: "What surprises one in S. all the time is his charm and gaiety & friendliness; one always thinks of him as far off, & critical, &

immensely great, which is his *fond*." (*Fond* is French for depth, heart, and foundation.)

 A comic interlude followed. On their way to look at more Ingres drawings, he made them look up to a ceiling. It cannot be every tour guide who can point to something in the Louvre and claim not only to have painted parts but appear in it himself—and then be made to disappear. (And disappear again, when the mural was covered by a dropped false ceiling in 1962.) "The Triumph of Maria dei Medici," Henri IV's consort, was commissioned in 1875 from Sargent's teacher, Carolus-Duran, and finally finished in 1878. Sargent told Lucia: "A man having a big thing to do like that gets tired of it—All his pupils I rather think had a hand in it." Lucia saw her cue: "Which did you do?" It was a mammoth picture, with every sort of wonderment that academic painters could do by the yard. Oblique perspective shoots the eye to a herald angel and a tiny, rather generic Marie enthroned in tottering temple. She is knee deep in men, some in armor and some with very little on, and she's attended by scantily-clad maidens, from whom a cross-bearing priest turns theatrically away. There are, however, some portrait faces. Sargent: "There, do you see that old man in armor? I did him. And the dark fellow to his right—that's Carolus himself—That used to be me that he is talking to—that old fellow in the white beard, but Carolus must have changed it since."

 This is not the place to record all of Sargent's enthusiasms in art. A few names will suffice to show what was on view in Boston and the taste of the time. He liked the post-impressionist Dodge Macknight, for whom Mrs. Gardner named a room in her museum to hang his watercolors. Jean Charles Cazin had a certain vogue, and Sargent could admire the poetry and the moonlight. But "after you have seen a good many, they are so much alike ... he does that sort of thing too easily." The painting of Abbott Thayer "always looked ruined & shabby" and he thought it "un-artistic rather to be so awfully fastidious" as to subject. He thought Thomas Wilmer Dewing and even Auguste Saint-Gaudens "fell a little into the same thing, always wanting something angelic, far-away, & thin; the real, flesh & blood, rustical thing (which of course was the point) not being good enough for them." He spoke of [Paul César] Helleu's picture of Mrs. Gardner as very fine, one of the best pictures in Boston, & said "Did you notice in the hand the wonderful lilac finger nail on the brim? ... that's fine—that's what Thayer couldn't do, and to paint a dirty finger nail like that is better than any Madonnas." That Sargent found John Lafarge's pictures "not at all religious though often very beautiful" perhaps explains why Boston's Trinity Church chose him as muralist. By denomination Episcopalian, it was a preacher's church, led by the Reverend Phillips Brooks, which favored The Word over the Anglo-Catholic rituals of the

Church of the Advent, Boston's response to the Oxford Movement's wish to reunite with Rome.

Lily was the first of the Fairchild women to be painted by Sargent, in 1887, probably the same month he did her brother-in-law with the chest of Civil War medals. She was about 42 to Sargent's 31, and one must wonder if she entertained the idea of him as a son-in-law. Satty, his favorite model, was then about 18, and the future artist, Lucia, was about 17. The Fairchilds were not churchgoers; as we will see in the next chapter, Lily spent Sundays writing to Lucia, who'd married in 1893. It would seem from her poetry she found religion in nature and beauty, and she would publish verse in *The Radical*, which was high Unitarian. In October 1890 she was reading *The Perfect Way* by Anna Bonus Kingsford, an English vegetarian and feminist who was also interested in Buddhism and Gnosticism and was active in Theosophy, rising to president of its London lodge.

That Lily had her mystical side was known to close friends, and she believed one could communicate with the dead.[11] When Sargent, rummaging for something to read, picked up *The Perfect Way*, Lily urged a certain chapter on him. " 'Yes, yes, yes, it's very interesting,'" he said but laid it down. He finally explained he thought it "very bad to look at things from the esoteric standpoint," that "one must, if one were an artist, look at things in the simplest way. Such a book as that would be suicidal to one's art." The sentimental was as bad. He had told Lucia that when he was "a young fellow just going to Paris, he was 'sentimental—oh, maudlin sentimental.'" Lucia asked how he got over it, and Sargent said he merely outgrew it. "Paris was not the place for that kind of thing." But he "still thought he naturally took a sentimental view of things." Lucia said she "didn't think so."

He was not sentimental about love. He was worried his sister Violet would accept Francis Ormond's proposal. Lucia said it seemed simple to her. If Violet loved him, she would say yes. Sargent laughed. "Then you think being in love is necessary to getting married?" Lucia said yes. Sargent: "I must say I don't. The chances seem to me much greater for happiness without all that tremendous feeling—You would have to lose your little illusions some time, & then with all this <u>Terrific</u> love & so on, it would be a most awful shock—& there would be nothing left for it but the other extreme—of <u>Terrific</u> hate." Lucia disagreed: "I thought most people were mildly affectionate after they stopped being in love, & sort of tolerant, & used to each other." Sargent was sure there was "nothing for it but hate."

Violet, said Lucia, was much keener on marrying for love than she. Sargent: A pity as Violet is "so emotional, & might so easily get carried

away, & pitch headlong into this very sort of match, when she would be horribly disappointed in the man." Lucia: Violet believes "in separating if that happened." Sargent: "Believes in it—yes, of course,—but practically one can't do that sort of thing."

That evening Sargent put the question to Lily. "Do you agree with Lucia that being in love is necessary to getting married?"

"No," said Lily, "I don't. I really think the similarity of tastes is the great thing—and then starting with that, the other thing will come of itself in time."

14

The Fairchilds at Home

"mousing"

In the new year of 1888, Henry Brown Fuller, called Harry, was in Boston studying at the Cowles Art School. He was almost the only man in the drawing class. "I like little Lucia Fairchild very much," he wrote his sister.[1] Lucia was smitten. Harry was 21, she 18. Personalities clashed with expectations during the long courtship and short engagement. He was her Prince, her Knight. But also: "You are like a Balzac in your schemes of getting a fortune," Lucia wrote to her love. Harry's father was George Fuller, a leading American painter. He had done a portrait of Lucia's grandmother and he thought the Fairchild establishment on Commonwealth Avenue exhibited "what refined wealth can accomplish."[2]

It's said that an old family friend, John Singer Sargent, opposed the marriage. Knowing the struggles of Sargent and other painters, her family worried what they would live on. Lucia got on her high horse. They would make it on their own, she said, and she vowed never to accept a penny from her parents. As for the wedding, "You'll wait till after the Yale game, I suppose," said the brother who played football for Harvard. Her father wanted a real wedding, to make it seem he approved.[3] So marry they did, on 23 October 1893, a month before "The Game" (as it came to be called). Presents flowed in, and another old family friend, Robert Louis Stevenson, sent congratulations from Samoa.

The marriage did not last. They never divorced, but went their separate ways about 1909. "I am zero," Harry wrote Lucia that year. "I am no more a part of your psychological life than a chair."[4] She was the breadwinner. Early in their marriage and looking for her own path in art, Lucia had chanced, at an antiques shop, on the lost art of miniature portraits. These

measured in inches rather than feet, and had the throwaway charm of a table treasure. She was good at it, and, like Sargent, painted her way through polite society. Sargent was on to a truth when he called portraiture "vanity's butter,"[5] and by 1903, she had done almost 200. As Harry struggled to find himself, those commissions were almost the couple's sole income.[6]

Their marriage had started out on a lark. The newlyweds moved directly to the rural Massachusetts town of Deerfield to live in a studio of Harry's father. They were not quite bohemians, and not quite hippies. Harry proposed to do farm work for their board, paint when inspiration struck, and hope to make their fortune by refinishing old Yankee furniture to sell as the Colonial Revival swept America. He would, and did, build a caravan. Drawn by horses, it was home and studio, and they intended to paint their way—Lucia doing portraits—from town to town till they reached their haven, the art colony at Cornish, New Hampshire. This plan soon foundered. Harry had miscalculated the diameter of the wheels so the undercarriage scraped on steep New England roads, and, the rig was too heavy for the horses.[7] Lucia took charge, moving them to New York, to Greenwich Village.

For the marriage, we can be grateful.

Once a week, Lily Fairchild would sit down and write, to her much-missed daughter, a long newsy letter[8] of the family's doings in Boston (and summers in Newport). Every occasion has an afterlife, and, in firm handwriting on blue note paper, Lily brings "Dearest Lucia" up to date. Sometimes "things occur in this household in such a helter skelter way that there never seems to be a clear half hour to sit down and write to you," she wrote on May 1892, when Lucia was not yet married but living in New York City to attend the Art Students League. And so the letters are a tossed salad: gossipy bits, motherly advice on pregnancy, the social whirl, the family pets, opera gone wrong, Harvard football in the snow, art shows and artists, engagements and marriages, a Spanish dancer (fat), Russian princess (very interesting), a French bluestocking (even more so), scandal about nude sculpture in public places (Boston Public Library). And, increasingly, worries about the family fortunes, which Lily asks Lucia to keep to herself.

Through her chronicles of family life, we see the Fairchilds at home in Boston, and Boston liking the Fairchilds. The letters are living history, life as lived, and at different speeds, and in a landscape we can't imagine today. In Copley Square, on the side of Old South Church, was the horse tram stop for the grand new Boston Public Library. Row houses went up at great rate, filling in the grid of Back Bay streets. Children skated on vacant building lots and tobogganed down excavated dirt. The Fairchild

boys played hare and hounds, hide and seek with chalk marks laid down by the hare; and they watched baby squirrels in the Public Garden. There were no leash laws: dogs roamed freely. Public alleys ran behind every house, diverting the commercial traffic to the back doors: wagons brought groceries, ice for ice chests, wood for stoves, and coal for fireplaces (and took away ashes). There were private carriages, and hacks for hire—front door traffic—but it was a walking city. If someone had died, you saw the front door hung with black crape. And before the telephone was in general use, people wrote notes—Lily Fairchild was always writing notes—and afternoon tea was the grapevine. It was accepted practice for friends to drop in.

It is Tuesday 21 November 1893. Lily can finally draw a breath and begins: "Last night I had, I thought, cleared the decks; your papa was in N.Y. & Satty & Jessie [a friend; Jane Norton Grew, later Mrs. J. Pierpont Morgan, Jr.] were going to the theatre—when—in came Mr. Otis to tea—was asked to dinner—declined—staid— said he couldn't wait for a cup of coffee—took coffee—wouldn't smoke—staid with Charley who smoked—said must go to Norfolk House—staid—door-bell rang—jumped out, said hated callers—staid. Dr. & Mrs. Beach came in—So sorry Jessie gone away— staid—Mr Otis went very suddenly saying he would return very soon—Jack came in and moused in library. Dr & Mrs Beach said must go—staid—'Was it the Prélude fantastique that Seidl conducted?' 'Yes, dear!' *Was* it Seidl? 'Yes, dear.' 'Sure?' 'Well—no, dear.' Jack [went] out. Dr. & Mrs. Beach WENT."

The Beaches were more than a musical footnote. She was Amy Marcy Cheney Beach (1867-1924) who, as convention dictated and her husband insisted, played and composed under her married name: Mrs. H. H. A. Beach. He was Henry Harris Aubrey Beach, a Boston surgeon 24 years her senior. We have met him as a younger man helping Henry Lee Higginson, owner of the Agassiz, solve the problem of the stinking toilets. At tea, he's snappish about Anton Seidl (1850-1898), the charismatic Hungarian who conducted the world premiere of Dvorak's "New World" Symphony with the New York Philharmonic. Seidl was one of Wagner's "chosen few," making the first fair copy of the "Ring" and conducting it in Berlin and London. As he was never a guest conductor of the Boston Symphony Orchestra, the Beaches may have heard him in New York. Amy's reaction to the chivvying may be wifely tact. She was the musician. As Amy Cheney she had been a piano soloist with the BSO; now her husband limited her public performances to one recital a year for charity and her time to composing. There was little she didn't compose: earlier in 1893, her "Jubilate" opened the Women's Building at the Chicago exposition that Lucia painted a mural for. If Chicago came up at tea, Lily is oddly

silent.

The Beaches finally leave. "Jack came back. Brought tickets. Talked. Jessie & Satty back, very excited. Talked. *NO LETTER!* And half past eleven: I have forgotten to mention the hours that struck and increased my wretchedness as I counted them. Finally I got the girls to bed. Jack had been put to bed meanwhile with a Pill a Pem and a flannel bandage to break up a cold, and I sat down to write one or two <u>necessary</u> notes before beginning your letter. I had locked up and the lights were out in the parlor when I heard steps then & turning around to see a 'gig.' I saw Uncle G [Gordon] who couldn't sleep and was wandering about in the dark. So then I gave up & went to bed and soothed him. He is not very well & today he has been put on Blair's old dose of [illegible] phosphates."

And five more pages of this and that.

* * * * * *

Of the five Fairchild sons, two were at Harvard and two at day school. The family called the older boys "uncles," and the youngest pair, the "little uncles." Gordon was the littlest, about 12, and Lucia's other most devoted correspondent. The oldest, Charley, 21, was far away learning the mining business in Washington State, and finding train passengers as odd as his mother did. He will not return to Boston. Jack is at Harvard, playing football and rowing, and will be president of the Class of 1896. He will stick around town. Blair, the Harvard freshman who was Ellen Terry's darling, has musical aspirations and will become a composer in Paris and commission Stravinsky's violin concerto. On holiday in France, he writes Lucia that he intends to break into Monet's garden at Giverny to meet the great man.

Sally, called Satty, is the eldest Fairchild, and her life in the social whirl was not the one Lucia wanted. It was expected that like Satty, she would "come out" at 18, be presented to society, a "bud" as debutantes were called. Lucia struck a bargain. If she did a "bud" year she could study art. The bargain was kept. Lily's letters actually begin when Lucia was in New York at the Art Students League, which had accepted women from its founding, and where she could keep company with her future husband.

Satty would have a long and interesting life. "She makes me read my plays to her," said George Bernard Shaw.[9] While visiting Boston, the English philosopher Bertrand Russell was dazzled: "In the face, she was not strikingly beautiful, but her movements were the most graceful I have ever seen."[10] Her "bud" year was 1888, she was budding well into the 1890s. That was not unusual: her contemporary Marian Lawrence was a bud till nearly 30 (when she married Harold Peabody). Invitations flowed in for

Satty. Only Lent interrupted the giving of dinners and dances. Lily is apt to record every play and musicale, every formal tea or informal "studio" party, every "she-tea" which was women only. Satty went to concerts, to the horse show, to lectures, and we know who was there, and who was not invited, who the chaperones were. Did Lucia read this with relief at what she escaped? Was the gush a sort of therapy for Lily? For the modern reader, the most "period" detail may be that in the days before zippers, Satty came into her mother's room one morning at 4:30 to be "unlaced" from her ball gown. No need always to arrange for transportation: The Houghton son who also lived in the Agassiz simply walked down the grand staircase to fetch Satty and take her to a dance half a block away. Rather than go back upstairs, "he is to spend the night here."

To be young was very heaven, as Marian Lawrence Peabody, the bishop's daughter, would borrow from Wordsworth to call her memoir, and Lily relished Satty's young life at home, her acclaim in public. A letter from February 1892 tells of a cotillion with costumes. "The party last night was a *great* success. The favours lovely. Satty will write you about them. They wore wings as big as swan wings—dyed various colors and with a handle to stick down the girls' back so the effect was perfectly angelic." Satty's bouquet was of daffodils. She arrived home at 4:30 in the morning and went to Lily's room to be unlaced from her gown. Then, at 5:30, Lily continues, their old dog Rani "took it into his head to make an early call: so he went into the front hall and *howled* till I flew into my shoes and ulster and went down stairs with him ... I thought he must have an *awful* colic! But no! He only sniffed the morning's breeze a little and set across the lawn at a gallop; his legs as limber as a puppy's. At breakfast time he had returned and pretended to be old and lame—and saw no impropriety in his actions when he was accused."

The Fairchilds were among the first families to live at the Hotel Agassiz. Their best writing paper was engraved, in tiny letters, 191 Commonwealth Avenue, the city omitted because anyone receiving a letter would know which one. They had unusually intricate ties to Henry Lee Higginson, who'd built the Agassiz. They were, of course, his tenants and his neighbors in the building. They were also friends, exchanging visits, dinners, and outings. Ida Higginson, as we've seen, gazed upon thespians Henry Irving and Ellen Terry and trashed Henry James's novels to John Singer Sargent.

Charles Fairchild was in business with Higginson, having joined Lee Higginson & Company, the investment bankers, in 1880, four years after moving into the Agassiz. He often conferred at home with Higginson,

whose row house was tethered to the apartment building, and they would walk to work together. Fairchild had all the gifts of a salesman, and Higginson, in 1919, well after Fairchild's death, would applaud his ability to bring business to the firm. Whether he was "sound" was another matter.

The ventures offered to money men were many and exotic. We have seen how Higginson was asked to invest in the "moving sidewalk" at the 1893 Chicago World's Fair. A daft proposition, perhaps, but any sort of transportation was ripe for capitalization. Take street cars. Once drawn by horses, trams could now be electrified. Higginson and Fairchild looked over three proposals. One was financing the street railway in Mexico City. "This morning Gov. [Oliver] Ames came in, all covered with perspiration," Fairchild wrote Higginson on 14 April 1891, saying the venture "seemed very wonderful to him." It was not to be.

Two other projects were closer to home, one involving an industry giant. Fairchild's letters to Higginson[11] are instructive on the dangerous divide between the great idea behind a company and its corporate management. The case study was George Westinghouse (1846-1914). While a major investor in his own company, United Power and Electric, he needed capital to expand, and so he wrote to Higginson to put together a syndicate of investors to bankroll future ventures. "There is a large demand for electric lights," Westinghouse wrote Higginson in a three-page, typewritten letter on 26 September 1890 from his estate in Lenox. He himself would "underwrite the fifteen hundred thousand of bonds" if the Boston bank would arrange "a million and a half of bonds." Fairchild had turned a deaf ear, hence the letter to Higginson.

Westinghouse persisted, in April 1891 writing Higginson for money to consolidate his company with the flourishing Thomson-Houston Company. Founded in 1883 in Lynn, Massachusetts, by Elihu Thomson and Edwin Houston, it provided the generation and propulsion for Lynn's Highland Circuit, the first electric street railway in the United States. Fairchild was opposed to the merger. On 24 July 1891, from his summer home in Newport, he wrote Higginson seven handwritten pages about the need to depose Westinghouse. Investors should insist on replacing him, as president, with F. Lothrop Ames (1835-1893). Others at Lee, Higginson suggested retaining Westinghouse as president but inserting Ames as "chairman" or "financier." Fairchild disagreed.

"It seems to me that this would be about as bad an organization as we could want," he wrote. "The troubles with the W. Co. have come from bad management. Continuing W. as President will practically continue the bad management. Any attempt to control him will result in constant friction. He will continue to do things beyond his powers & without consultation. The Chairman ... will only know when it is too late. It will prove a failure

and a very disastrous one. It will not modify the one man power and will make endless row. On the other hand, if a change is really made and Ames is made President with a strong executive Com[mi]tee the control of the company will be in their hands. The general policy of the Co. & all financial matters will necessarily come before them at the beginning. The change will work well in the union of the large electrical companies, and to bring this about will require skill & tact in the management of competing business as well as the negotiations when the time comes to trade. The final step will be to build up a disposition to trade—a willingness. Westinghouse cannot possibly do this. He irritates his rivals beyond endurance. So much for the reasons why. We have seen these from the first. We only consented to real benefit. Whatever power Westinghouse has, and I grant that it is great, is mechanical. His forte is in the arrangement and control of a factory & in dealing with the formation of [illegible]. W. is not a financier & he is not a negotiator. In his proper place he will have all the work he can do and important work to[o]. The financial management will be in much stronger hands & the control of the policy after the Co. By policy I mean the conduct of its business in relation to its neighbors. And that all insist in the reorganization and the assurance that a radical change should be made. Westinghouse himself expressed he wished to be relieved of the financial work & all matters of the plan & to confine himself to the work at Pittsburg[h]." If, however, Westinghouse remains President, "I want to withdraw from all consideration with it and I shall want the firm to. That of course I shall not attempt to decide for the firm."

Westinghouse's proposed merger did not happen. In 1892, with J. P. Morgan sorting things out, Thomson-Huston Company, known for it arc light generator, joined with Thomas Edison's electric bulb company to become General Electric. One of Boston's own, Charles Coffin, handled the negotiations, and became the new giant's first president. In 2016, GE announced plans to move its headquarters from suburban Connecticut to Boston's newly-revived waterfront.

Charles Fairchild is the missing man in Lily's letters to Lucia. He was seldom at home for long. "Your poor papa" is a common refrain, and often he was not well. On many a Sunday afternoon he took the train to New York to do business on Monday. He traveled widely. Assessing investments, appealing to investors, he writes or wires from Chicago, Amsterdam, and Berlin. One telegram breaks off English to go into numerical code.

In London, a bout of bad health would put him out of commission. As

he discovered after a week's painful journey at sea, the problem was piles, hemorrhoids that have become inflamed. The life of a salesman is never easy, and, with a position to keep up in Boston society, stressful in family ways. The cause of his physical discomfort may have been emotional, he writes Higginson on 21 March 1887. The London doctor he consulted "is discussing a surgical operation, i.e., putting me in dry dock & scraping my bottom." A surgeon is summoned.

"Sir James Paget came yesterday & examined me carefully (& painfully) and tomorrow he comes to perform the necessary operation—Townsend [Fairchild's doctor] tells me that the trouble has been with me many months probably & that it is due to any blues or depressions I may have had. This being true I have certainly been fortunate in having so little actual physical trouble & in having them finally [illegible] where the best surgical aid is at hand & where an operation involves no worry of discomfort or care or anxiety to my wife. The operation itself [illegible] the trick. It means simply some hours of oblivion, some days of stupor and pain, a rather slow convalescence & that is all. By the time this reaches you I hope to cable you that I am well ahead on the mending. The vision of a surgeon & three assistants—an operating table—a man to administer ether—& a nurse are not pleasant to one who realizes that he is the victim. I'd rather not but here it is & I shall go through it safely easily & all right. Repairing a buttonhole is always a difficult job. I telegraph you today that I shall be absent a few days & this is what it means. C. F."

A family historian, Lucia Fuller Miller, who is Lucia's granddaughter, called Charles "a proud but shadowy participant in the family." From family letters, he also comes across as "somewhat distant and commanding, as a father," never irrational or cruel but a prig.[12] Successful, but at the same time scraping a living. While not extravagant, the Fairchilds had a certain side to keep up, and "probably he was too busy gathering the means to make it all happen," his great granddaughter writes. His first Boston job was at the S. D. Warren Company, whose mills he had managed in Maine. Then he took a chance on investment banking. He left the Higginson firm in 1893 to strike out on his own. His departure from Boston was badly timed: Yet another bank panic year raked America and he was roughed up. In February 1894, it looked so dire that Satty told Lucia "we cannot afford even the cheapest seats at Symphony this season." A good friend offered a ticket "so she will have her music after all."[13] Lily to Lucia: "Your papa still expects ... to sell all of our pictures in the spring, I think, in N.Y. He is in fairly good spirits, but nothing is determined yet or can be until the Nashua [River paper] mill is sold. If that is not done, I don't quite know what we have to depend on—except Satty's kindergarten—but I can't help

feeling sanguine & hopeful."

But her letters, especially when read one right after another, exhibit a desperate gaiety as if sheer activity would make it all go away. But also those were different times. What might look to us like social wheel-spinning was the late nineteenth century's way of making their own home-entertainment systems. There was no Internet, television, movies, or radio. There were Kodaks (Sargent had one) but no smart phones. A general quiet existed, in which the clop-clop of a horse was an event. For the leisure classes, there were elaborate rituals like balls and formal dinners, while all classes enjoyed the impromptu social call, the drop-in. There was even a new word for that: the "gab-fest" in 1895. And for everyone, there was theater for every persuasion from Shakespeare to vaudeville and girly-shows.

Things were looking better that August of 1894, though what must have been a "business lunch," even if at Newport, was a testing time. "Your father & I have been to lunch with Mr. [Alexander] Agassiz and also Mr. & Mrs. Bancroft. It was very pleasant but very quiet, no one inclined to do much talking. Your father was anxious to accept the invitation & I was glad to do what he wished, but he is beginning to feel the reaction and I feel it will be a severe one. The mill property has finally been sold & is now the Nashua River Paper Co., so the name is safe, and so much is secure." Paper mills would pollute the Nashua, which flows from New Hampshire into central Massachusetts, well into the 20th century.[14]

In 1896, the boys safely at, or through, Harvard, he moved the family to New York where he had set himself up as Charles Fairchild & Company, a brokerage firm. He would fail in the Panic of 1907.

Why did he not stay in Boston? Everybody liked him. He belonged to the Tavern Club for the fun, the St. Botolph for the fine arts. Some in Boston society thought him "bohemian" for consorting with novelists, actors, and painters. It may be that his "bohemian" side—not starving but not Brahmin—was enough to block his way in Boston finance. Higginson was no less bohemian. He had wanted to be a concert pianist, went to opera and theater all his life, and knew actors, in fact, importuned Henry James, no less, to help none other than the great Eleonora Duse on a contract dispute with her manager. But Higginson was rich, and became richer, parlaying copper money into telephone and electrical stock and a dozen other ventures. Higginson operated on trust, on the right handshake, the look in a man's eye: was his character "square"? Was Boston's way too conservative for Fairchild, who, despite his Harvard degree, had roots in the thrusting Midwest? Was he a chancer? Was he simply unlucky in his investments, or plain wrong? Higginson did not mince words: Fairchild "doubtless attracted business to the firm; he was less fortunate in the

command of confidence. Those who liked him can hardly have thought him a miracle of prudence." The partnership in Lee, Higginson "ended abruptly… and he took himself to New York."[15]

Students of finance say it was fatally short-sighted of Boston capitalists not to warm to new men and new ideas. They were protective of their own, hunkered down during the financial Panics of which there were many, and, to their astonishment, would find the labor force no longer docile. "The proper and established Bostonian's deepening distrust of outsiders, his suspicion of those cut from cloth of a different color than Boston's own somber hues, worked in tandem with other factors, slowly and surely isolating Boston from the mainstream of productive American enterprise," Russell B. Adams, Jr. has written,[16] "The selectivity of the drawing room and private club was extended almost intact to the business office."

* * * * * *

None of this yet affected the Fairchild children. They were received almost everywhere. Jack will be class president at Harvard, dancing with all the buds. Blair will marry an heiress. Certifiably gentlemen, when that counted, Neil goes into the diplomatic service, and Gordon will teach at St. Paul's. The family went often to Europe. They rented a house in Newport for the summers. In Boston they went to good day schools. For the early grades they walked four blocks to a progressive (for the times) school established by Pauline Agassiz Shaw, sister of Ida Agassiz Higginson, on lower Marlborough Street.[17]

All was not always peaceful in the Back Bay, and Blair can't resist writing Lucia, on 6 December 1894, about a violent crime in the neighborhood. "A lady named Mrs LeBrun who lives at 10 Marlboro' St., Lady's School, you know, was knocked down in the street, and robbed by some footpads. To her wavering shrieks responded two valiant coachmen (hacks) who pursued the robbers, and got shot for their pains. One was killed. Our elevator boy knew them both. This happened on Berkeley Street, and that really comes near home, doesn't it." The crime scene was so proximate to the St. Botolph's clubhouse near the Public Garden, that the purse snatching was seen by two members. William Sumner Briggs, a China merchant, and Dr. James R. Chadwick, chased the perpetrator, and testified at the trial in April 1895 as eye witnesses, Chadwick's portly figure on the stand captured by the *Boston Globe's* sketch artist.[18]

For the upper grades, many girls would stay on at Mrs. Shaw's school but boys had to find a college preparatory school, boarding or day. Except for Blair's year away at school at Groton, the Fairchild boys walked to

Beacon Hill to Hopkinson's—Hoppy's—to prepare for Harvard.

Satty, as bright as her brothers, was marking time, higher education not yet for her social class: Marian Lawrence knew only one girl in her own debutante year who did go to college, and was thought odd. Lilly's letters portray her fondly but a bit spoiled. "She doesn't like simplicity of living and to her the [Newport] Careys with no Victoria [carriage] and only two old cobs when they might have any turnout they chose seem to her little short of indecent," her mother wrote tartly on 24 July 1894.

Still and all, Satty had brains, and smarts: she realized she could attend William James's philosophy lectures at Harvard if concealed behind a screen. What could she to do fill the time before she married? She decided to start a kindergarten. These were new in America, educational enrichment for young children, and Pauline Agassiz Shaw had introduced them to Boston. That October, Satty opened hers, kitty-corner from Mrs. Shaw's day school. As Lily had hinted, in February 1894, she might be the family's breadwinner.

It looked to be a success. In October 1894, Lily helped set up the school rooms: "We scrambled about putting colored leaves in vases, pushing chairs & tables into place, doing a little dusting and arranging until the scholars arrive." There were four the first day, little Betsey Millet, "looking perfectly ravishing in a white frock with a large pink bow tying her fair hair on the side of her head." School must have kept, for in April 1895, Gordon can tell Lucia: "Satty has white mice for her children." The ever-protective Lily talks of a trip to England for her husband: "we are hoping he will take his vacation now, which will explain his absence from the office, etc., and which is necessary for his health."

With the family's move to New York in 1896, and no kindergarten to run, Satty went off to England. She had her father's gift for friendship. The one made in Boston with Ellen Terry's daughter Edith (Edy) Craig led Terry to introduce her to Shaw. Did Edy's brother, Gordon Craig, called Ted or the Scamp, married with four children but ever on the prowl, make a pass at her? Shaw hints at such. Writing on 5 January 1898 to Ellen Terry, the Scamp's mother, Shaw recalled that Satty "had once looked bothered and uneasy when I asked her about Ted … and I said to myself: 'can this very agreeable young man be a petulant little villain, very prematurely married?'" In the event, she never married, but at the age of 70 was cited in the divorce case as the other woman. The errant husband was 45. "If that young woman can't hold her husband, that's her lookout."[19]

Like much of life, letters have a permanent impermanence. Lily's are a sort of diary of what the family did that week. She has nothing like Clover Adams' social cheek or Elinor Howells' social gush. (An elevator installed in the Howells' Boston house in the 1880s "shoots Elinor up to

her bedroom like a rocket, leaving a brilliant trail of conversation behind her," her husband wrote.) From the Lucia letters, the reader would not guess that Lily wrote poetry. Except when she writes about art, she does not reveal much of an inner life. More often she exhibits her practical side, her thrifty side, her prosy side, and her snobby side. She was a devoted wife and mother, and her children called her Mig or Miggy. But of course the letters were for Lucia, not for Lily, and they have the impromptu air of conversation, salted by Satty's tart remarks on the passing scene. The letters are dashed off—even the writing paper is improvised. Tender advice on Lucia's first pregnancy is followed immediately by more social news, as though Lilly must fill the letter to the last scrap of paper. For every day, her stationery was a pale dusty blue, a simple double-fold affording four pages. She usually writes the second page on the back, and the transcriber is grateful when she writes clear across the inner pages. If she's out of space, she continues on the front, cross writing over date and salutation. If the weekly budget of news requires more paper, she tears unused pages from other people's notes and letters. Just when the modern reader gets caught up in Fairchild life and wants to hear how it all turned out, Lily tells Lucia "your father will give you the details when he sees you" in New York.

Whatever Lily's schooling was, it was thorough and correct. While she is more inclined to the dash in punctuation, she can wield the semi-colon; and her grammar is always correct, something no doubt reinforced by her reading of the Victorians. And she undoubtedly talked that way, for the dialogue recorded in Lucia's diary about the family's days with Sargent, is as formal and as constructed as a novel, mannerly, with more idiom than slang. Lily's handwriting is strong, well formed, and headlong: she slaps ampersands onto the next word. Her spelling is the Anglo-American of the times: for example, "staid" for stayed. The expression "to mouse" or "mousing," for browsing, which we met in Clover Adams' letters, survives 20 years later.

One odd thing: Lily always writes Satty's name as "Salty," as though combining her given name of Sally with her nickname. Perhaps codes came naturally to Fairchild women. Lucia wrote diary musings about Sargent in Greek letters. Lily, when forced by convention to find a *nom de plume* for her published poems, became "C. A. Price," or "caprice." She signs the Lucia letters "Affy," a standard abbreviation for "affectionately," or some loving variation, but always her initials, L. N. F., as was the custom. To our eye, initials may seem less than motherly, but woman to woman, yet mother to daughter. We know that Lucia wrote back. Those letters have been lost. On receipt, and read in the family, they were perhaps passed on to others, to the grandmother called "faithful Gam," or family friends.

Lucia kept Lily's. There must be several hundred, and dozens from her brothers.

Lily's news of the family is confirmed by Lucia's other faithful correspondent: her youngest brother, Gordon. His mother may have helped with things to say; his voice is often hers. His spelling is phonetic, and thus we hear a scrap of Boston accent, when, on 11 May 1895, he writes "vasity" for the varsity sports—and varsity politics—that so occupy his brother Jack (and so interested Sargent). Lots of news about the family pets, such as Satty's dog Tug who seems to prefer Blair's company. Tug "has as much affection to Blair as he ever had and unluckily for Blair he has rolled [in dung] and so it is very unpleasant for him." To woo Tug back, Satty feeds him so he gets fat. Gordon draws Lucia a picture of fat Tug sleeping; from his dark spots and dark saddle, he looks like a pointer, perhaps the dog that accompanied Charles and his sons hunting in Newport. We get some idea of house temperature in deepest winter, when Lily writes that all three dogs lie with their noses in the fireplace, a detail that also conjures the early domestication of dogs. As we have seen when the Agassiz first opened in 1874, there were hazards of living a fireplace life. Twenty years later in December 1894, during one snowy night, a downdraft spews ash into the Fairchild library. "Everything was covered with suit." (Gordon's spelling for soot.)

There are other pets. Family friends give the boys a chipmunk. A "cammelian" is promised by one Fillipo. Lily declines the humorous offer of a "Deerfield woodchuck" from Lucia's first married home in Western Massachusetts. Gordon to Lucia: "That little turtle you sent us was very amusing and now he eats and is as gay as any turtle we have had, and I think he is about the next smartest we have ever had."

From Gordon's efforts we feel how trying it is for a boy to fill four pages of a letter. He is about 12 years old, and growing out of his clothes, when he thanks Lucia for "the Brouny cuff buttons you sent me, my suit is just to[o] small for me so I am going to ware cuffs and your present came at the right time." Other thank-you letters—for a cribbage set, a painting of Deerfield, "weapons," which were perhaps toy swords, and of course books—wrote themselves. But generally it was a slog, and his handwriting gets larger so he can make it onto the last page, then tells his sister he must stop writing as it's time to study, time for supper. He laments that his next older brother Neil gallops through books while he plods. Big novels were wearying. "I haven't come up to Rob Roy yet in Scott and I am up to page two hundred and eight but a little further on there is a picture of him so I suppose I'll come to him very soon." One Christmas Lucia sends him *Eric, Or Little by Little*. A most moral tale written by Frederic William Farrer in 1858, it was republished in 1891, by which time it had

accounted for the astonishing popularity of Eric and Erica as first names. Gordon's summary: "Eric the boy first grown up very good then bad then good again, and all the hairs on his balled head have come off again." To help Gordon learn French, Lily reads *Les Malheures de Sophie* every day with him. "How many little children have laughed at poor Sophie's tribulations."

For all the proximity of Henry Lee Higginson himself, the Boston Symphony concerts don't register as music in Lily's letters. She fits the "the Sym" in her own social whirl: after errands in the shops, on "Friday we went to lunch at the May Flower Club." Founded in 1893 for women, it had a reading room and restaurant, and closed in 1931; a successor club with greater social cache was the still-flourishing Chilton, named for Mary Chilton, the first Mayflower baby. "Then to the Concert, then to Cambridge to a tea at the Shalers for a Russian princess very interesting— her mother born in Siberia, her father a Decembrist—then home and a dinner here for the Volkmanns." Arthur L. K. Volkmann was founding headmaster of a leading Boston day school for boys from about 1885 until 1917, when his German name caused enrollment to plummet, and it merged with Noble and Greenough. Another guest that evening was "Joe Smith," the painter Joseph Lindon Smith, who with his wife Corinna Putnam were young playmates of "Mrs. Jack" Gardner in Venice. "This was so amusing that it was 11:45 before they went."

Anything Harvard had its place on the social calendar. In November 1893, the Fairchilds and others packed the Greene cars of the horse tram to travel to Cambridge. "A good time coming & going" with "all the Higginsons, many Cabots, Bancrofts," but only 35 people in all. "We had 60 last year." Harvard lost, and Jack and a teammate "came home about midnight and a sadder pair never breakfasted with us." In a November 1894 game, Jack played both halves, to Lily's surprise. He did not do much: "I suppose they are sparing him & yet they want to see where his limit of strength lies." "The chief feature of the game" was a snowball fight staged by undergraduates but at no "risk to the peaceable spectators's bonnets." Weather was a constant topic, as much a concern as it would be today. The details are different. Dogs flounder in heavy snow but also horses, for the automobile was decades away, and, unless shod with steel cleats, would fall with injury to themselves and passengers. Then, as now, children built snow forts on the Commonwealth Avenue Mall.

There was always space in letters for gossip. "Russell Sullivan had something the matter with his eyes very serious & Mrs Jack [Gardner] is his amanuensis & writes all his notes for him—which is really kind." Olea Bull, daughter of Ole Bull, the Danish violin virtuoso and womanizer who snared a Longfellow as his second wife, is to marry. Mr. & Mrs. Richard

Cabot were "married in the little Swedenborgian church at Waltham which was just big enough to hold the Cabot clan and a very very few outside friends. It was very quiet because both bride & groom were in deep mourning, though everybody else put off black for the day." And there was the sad death of a horse to report: "Poor little Billy had to be killed." It was not dropsy but black tumor, a disease that attacks ageing horses. "The vet said there would be great suffering soon, so of course he was immediately shot." Lily reflects on the loss: "So much of the past seems to go with Billy! Something seemed definitely closed especially as he was the last of our horses."

* * * * * *

Even with their three older brothers somewhat out of nest, and Lucia married, Gordon and his next oldest brother, Neil, probably shared a room. Lily could always find a desirable guest a bed, though the room might be small. There is a teasing exchange between Sargent and Lucia. When he stayed at the Agassiz she heard him talk and mutter in his bedroom, and furthermore, his sister Violet confirmed it. "Vi said I talked to myself? Absurd." And he laughed. "Did you think I was going cracked? But how could Vi have known?" As Lucia told her diary, she reminded him his room was next to Vi's. "I never did. I suppose I may have talked in my sleep—but I never do."

The apartments at the Agassiz were made for entertaining, the Fairchilds' reception rooms showing what "refined wealth can accomplish." As we have seen, the double parlor made a grand space for the reception following the dinner for Irving and Terry. By closing the pocket doors of the double parlor, two more intimate rooms were created. Perhaps the piano where Sargent played Wagner was in one. Lily and Gordon mention a library, which could be the west-most parlor, or, perhaps the first room in from the Exeter Street corner. The library included a set of Balzac. Lucia's diary records Sargent "pulling down all the volumes, & describing them wonderfully." The Fairchilds subscribe to English periodicals; *Punch* was one. Blair and a friend sit "on the divan looking at Leech. 'These jokes ain't much,' says the friend. 'Queer old pictures.'" John Leech (1817-1846) was the *Punch* caricaturist who illustrated Dickens's *A Christmas Carol* and Surtees's hunting and racing novels. To Americans who did not follow English politics, the humor in the satirical *Punch* could be quite obscure. Lily is more approving of the opinion of another of Blair's friends: "*Punch* is a pretty good paper though." She herself enjoyed the caricatures of Max Beerbohm.

Men went into the library to smoke. Charles had his desk there. Lily has

her "little room," probably a boudoir between the library and the master bedroom. There, in the bosom of the family, occurred certain rituals. Christmas 1893 began there "as usual." The dogs had stockings, "Less full than last year but they didn't mind & Turk insisted on carrying each one of his three balls separately to the Siren [Blair]. Your papa was in pretty good spirits, he keeps up wonderfully." Elsewhere in the Agassiz, Mr. Houghton, who was expected to die, has rallied.

Lily's birthday fell in June, before the family went to Newport for the summer, and by custom her family lined up with their presents. "Charley gave me a volume of Shakespeare. He stood between Satty & me and handed us each one from his coat-pockets at the same time. Mine happened to be 'Merry Wives,' S's 'The Tempest.' It was such a funny, nice present! ... It was a small procession! Only the dogs. The uncles & the faithful Gam. The uncles gave me a bit of Venetian glass, Blair a country wallet! Salty, her priceless autograph of Thackery & Gam a beautiful bit of drawn work." Friends were also there. "Mrs. Wadsworth, ever faithful, gave me a very pretty pin (stick) made of feldspar & Mrs. [Annie] Fields a bit of red linen for a pillow cover, which I shall use on the [Newport] piazza."

The Agassiz emptied out in the summer, people going to their country places, the Higginsons to Manchester, or traveling. The Fairchilds had sold Holiday Farm, in Belmont, where the seven children were born, in 1886, and rented a small house at Newport on Narragansett Bay. The boys learned to sail catboats. They rode what Lily called "Western" ponies, probably pintos or paints, on the beaches with their father. He taught them to shoot, Neil given his first gun at 13, and they went bird hunting in the fall.[20] The Newport house was awash with visitors. Lily reports that two of Blair's classmates at Hopkinson's was in love with the same girl. She keeps an eye on one swain, who "when you got to know him is quite a nice boy. He watches very closely to see if he does everything the right way; he has no breeding at home and shows it. Blair says he is to have an enormous fortune and I am sorry to say that is still of a great importance in Blair's eyes." Local transportation was often by the water, when they all piled into the *Cygnet*. There were fireworks over the water. There were sea fogs that came onto the porches. Also heat waves, but it was far worse in Boston where, Lily hears, "175 children under 5 yrs." died in one week.

And there were picnics. Cousin Theodore "meant to give a day's pleasure to the gentlefolks—and we were very ungrateful to hate it as we all did." The drive was long, the carriage springs bad, the roads dusty, the children unruly. Much against her will, the faithful Gam was "pushed into the carriage with her bonnet very much on one side with fury & in a

black stuff dress." Food arrived by pony cart. "Gam sat with her feet on the table-cloth, looking very cross and disgusted and trying to cut up a chicken wing in her lap; all the tomato mayonnaise was spilled on Rose's white dress, and every child sat in" food. Worse, they were stuck there, the driver not returning with the horses till five.

They went back, reluctantly, to Boston for school. At the Agassiz the children had their own playroom, which Baldwin Coolidge photographed.[21] It did double duty. Lily writes, on 27 November 1893, of an artist painting a "vile portrait" in one corner while a seamstress worked in another. As little clothing was ready-made, dressmakers and seamstresses made the rounds, and the right woman could make new the old—such as Lily's old brown dinner dress, which, when lavished with white satin, was "twice as pretty."

Servants seldom figure in Lily's letters. "I have a new cook coming. When Mary (our old parlour maid) heard that Joan was going <u>she</u> came flying back & wanted to be cook—but I felt I <u>couldn't</u> take her back—and I think [another maid] was much relieved when Mary found she wasn't to come," she wrote on 25 June 1894. "Maid servants," as Lily called them, could be trusted to open the Newport house, and she dispatches two along with "the 2 uncles, 2 dogs, 2 squirrels" and her oldest son Charley to keep an eye on things. But she has a generally dim view of servants. In October 1894, the now pregnant Lucia moves to New York from rural Deerfield. "Pray excuse me if I intrude with horrors—this time about your 'janitress,'" Lily writes. "I'm afraid it will give you a great deal to trouble to keep a lookout on her—and if you don't, I feel quite sure she will feed the whole of her family on your supplies! Don't you remember how English tenants are always counting the slices of mutton to see how many the landlady has stolen?—And there is a certain amount of truth in it, for English servants regard honesty in food even more lightly than Irish ones, & they are bad enough. I think you will have to keep her to account <u>very</u> or you will find this the most expensive arrangement possible, especially as you have not agreed on any price." A year later, on 31 December 1895, Gordon will ask after Lucia's domestic arrangements. "I hope you are getting along very well with your cooking; I heard about your unfortunet round of beef ... I supposed you find it much easier, now that you have the negroe to do things for you."

News of Lucia's pregnancy—the first Fairchild grandchild—arrived the summer of 1894. The family is at Newport, and, in late August, Lily interrupts her flood of social notes to write: "Your baby! It is impossible as I write the words down. Of course I can't tell without seeing the Dr. but I should think that nothing uncommon had happened to you. The languor is one of the first symptoms and the nausea that follows <u>usually</u> lasts

three months. It is not unusual to vomit except in the mornings, however; but your case must have been complicated by the tremendous heat. But don't be afraid of moderate exercise—think of all the myriads of working women who go on to the last moment with all that they have to do! You will just have to force yourself to do it probably, because the languor (at least I found it so) is very great. But wonderful as it all is to you—it is the common lot! Nature is divine. She shares each experience with us mortals as if it were a heavenly secret between ourselves and God. We pass the same portals of birth and death and the mystery of love between."

In December 1894, Lily turns her thoughts to maternity clothes for Lucia. A seamstress will make her "a little loose house gown for you to wear from now on." To be made of soft chenille, which drapes easily, Lily suggests a dark red "with a light red scarf *pour déguiser* ... but you are to have the veto power as to colours."

Lucia and Harry's first child, Clara Bertram Fuller, would be born in 1895. Her mother's 1898 miniature of her, a watercolor on ivory, shows a glowing blonde child in her nightie holding a baby doll; it is now in the collection of the Metropolitan Museum of Art. Their second and last child, Charles Fairchild Fuller, named for her father, and called Chas, was born in 1897. His son Blair Fuller (1927-2011) would continue the family tradition in literature as one of the founding editors of the *Paris Review*, celebrated for its interviews of writers.

The Fuller marriage now seems cracked from the start. The reason for their parting can't have been difference in social standing. Harry had gone to St. Mark's School, near Boston, and while Lucia did "marry out of town," as the Boston expression was, she did not marry out of the Agassiz: her husband's mother was a Higginson, a cousin of Henry Lee Higginson, who, in a nice touch, was painted by Lucia's father-in-law, George Fuller, in 1876, the year the Fairchilds moved into the Agassiz.[22]

From her youth, she had often been sick, bedridden for weeks, her vision painful.[23] As dispiriting, the reality of marriage did not live up to expectations. Lucia was ambitious, with Lily's starch to her and a certain snobbism. Her husband might have been called Harry at birth but Lucia made him change it to Henry. Whether he was born conditioned to depression is not known but the bouts were real. He had graduated from St. Mark's School immune to the wealth of classmates, a "committed aesthete but a lifelong theoretical socialist," writes his grandson, Blair Fuller.[24]

Lucia's portrait miniatures paid the bills. Her self portrait shows her stern in eye glasses. His has the face of a dreamer. He went in for the Big Picture, the metaphor, the classical allusion. "The Triumph of Truth Over Error," painted in 1905-1906, was an immediate success, winning

the Carnegie Medal for the finest painting in the National Academy of Design's 1907 show. The title comes from Christian Science founder Mary Baker Eddy's holding that "When Error confronts you, withhold not thy rebuke." The radiant Truth, one lovely pink breast exposed in triumph over cringing Error, derives—critics were to note—from Delacroix's "Liberty Leading the People" (whose fierce nude "Marianne," cresting over the pikes and bayonets of the July Revolution of 1830, remains the symbol of the French Republic to this day). Praised by Mrs. Eddy, Harry's "Truth" hangs at Principia College, the Christian Science school in Elsah, Illinois. So popular was "Truth" that Harry invented a reproduction process called "mellowtint etching" and sold copies, mostly to Christian Scientists, till his death in 1934.[25]

There certainly was a professional tug, both Lucia and Harry wanting to paint, and she needing a New York base to find clients who could pay, and, as Sargent knew, that meant women in society. They leave Harry's Deerfield for New York. Lucia has not told her mother, and Lily's reaction is scathing. On 24 October 1894, she writes: "… to wish you many happy anniversaries of your wedding day so soon at hand." Then: "I do not mean to express disapproval of anything you and Harry do, for that implies too much assumption of authority. But I cannot help expressing my anxiety. I never, till your letter [received the day before] have heard a word of plans except that you should have pupils, you should paint … You told Satty you had no money in the bank and that [bodes] ill for your health." Lucia should settle down, make a home, says her mother. "Staying in N.Y. seemed to me more like the impulse of a moment than a considered plan."

Time has been kinder to Lucia's miniatures than to Harry's paintings. "Illusions" (1905), on a marble balustrade with a purple mountain breasting behind, depicts a child reaching for a large glass ball a young woman has snatched up to her shoulder.[26] The child is naked—Harry's nine-year-old daughter, Clara—and the maiden would be too but for artfully draped see-through netting that dressmakers call "illusion." She is beautifully painted but frozen in art. Some see a moral behind the picture, Innocence reaching for the glittering ball of Experience. As subject matter it was of its time, the era of tasteful drapery in chilly marble halls. As Sargent fathomed, the exciting warmth of Impressionism would put the academic classicists out of business and he learned from Monet how to paint a new way. But the tasteful was a calling card for the likes of Lily's admired Frank Millet (Francis Davis Millet 1848-1912). How the man could paint! In "An Autumn Idyll" (1892) the maidens keep their clothes on but, peekabo, he runs cherry-banded illusion silk across white ankles. His genre scenes are the equivalent of historical novels, interiors a perfect inventory of Colonial Revival icons from spinning wheel to bench-table

and Chinese Export china. Those interiors confirmed the good taste of his patrons.

Before he went down on the *Titanic*, Millet had led quite a life. From Civil War drummer boy to prize-winning academic classical painter, he was sometimes a foreign correspondent and, as an establishment figure in the art world, always on a museum committee or art commission, and, as director of decorations at the World's Columbian Exhibition in Chicago in 1893, he invented spray paint.

Lucia's first exposure was at that same Chicago Expo as a muralist for the Women's Building. Each of the five women muralists chose an era to paint; one shows spunky college girls sporting mortar boards. Lucia's picture looked back in time: "Women of Plymouth." By the sylvan banks of a goose pond, the first settlers tend their babes, teach their children, spin wool, and wash the family pewter. Peaceful, studious, a bit of Eden, like other Colonial Revival themes sparked by the American centennial in 1889, it's nostalgic for a time that never was so immaculate. But she was only 23, and would marry later that year.[27]

Sargent was by no means the only artist the Fairchilds knew. Another houseguest was John La Farge, who'd decorated Trinity Church, and "talked most interestingly about Delacroix and self-expression. I wished, after he had gone, I had the habit of taking notes," Lily wrote Lucia, "But someone has said his conversation is like fairy gold; you can't take it away." A family favorite was the little-remembered Howard Gardiner Cushing (1869-1916), another gentleman painter, Groton and Harvard, Paris-trained, who exhibited mostly drawings at the Paris Salons of 1892-1896, and would specialize in decorative portraits of women dressed about as far from Whistler's Mother as can be imagined. When he sends Lucia a wedding present of a gold dove, Lucia writes: "For besides its own value and its sentiment, we shall have to treasure it as the gift of a *great man!* Our Howard has been so praised by all the Paris critics as "très fort," "un dessinateur suberbe" that it is hard to regard him in the old light. It is perfectly splendid to hear of his successes—and to feel that he is at the beginning of them." A Cushing would marry a Fairchild.

On 4 April 1894, she writes Lucia: "Yesterday I went to the art museum"—then in Copley Square—"to see the Newmans; they were shown first one evening when the contributors were invited to spend an 'evening' 8 to 10 when your papa & Satty went. Your father liked them very much, and Satty, but I'm sorry to say I'm not up to them. They are to me just like (so to speak) Monticelli a mere blur of colour which gives me a moment's purely sensuous pleasure but almost immediately palls. I am sorry! I can also see the biblical feeling in some of them—but they appeal less to me than do *drawings* with the same feeling, or *drawn* paintings.

I mean Blake or Millet who appeal to the imagination and not to the emotion."

The division in the Fairchild household captures Boston taste at the time. Lily would agree with the 2005 opinion of a British art historian that "Monticelli produces screamingly awful art." What attracted Adolphe Monticelli (1824-1886) to Van Gogh (and perhaps Oscar Wilde, who owned a canvas in 1895), was the showy effect that Lily deplores. Impressionism was too severe for him, yet several young painters looked at him for ideas. Cezanne spent six years painting landscapes with him, some in Aix, and on seeing Monticelli's pictures in Paris in 1886, Van Gogh brightened his colors and headed, too, for Provençe.

The polite word for the French-trained Edward Loftin Newman (1827-1912) was "colorist." He was also called "the American Diaz," after the French painter Virgilio Narcisse Diaz de la Pena (1807-1876). Like the young Renoir, Diaz had worked in a porcelain factory painting plates. He was the master of shimmering light, and his Fontainebleau was a perpetual fête galante with Gypsies. Newman had his moody, romantic side, was given to literary and religious themes which made people think of the paintings of A. P. Ryder, and he had his own line in madonnas as well as designs for stained glass. He exhibited seldom, yet had a following among New York collectors, writers, and artists, including the sculptor, Daniel Chester French, and those patrons helped support him, organizing the 1894 show in Boston with its evening reception for "contributors" that drew the two admiring Fairchilds.

What pictures did the Fairchilds buy for themselves, the ones Lily feared would be sold in hard times? Lucia's grandson Blair Fuller says they had some Winslow Homers, a Gainsborough, and there were the Sargents painted of and for them. In 1910, Sargent himself had a hand in selling his portrait of Robert Louis Stevenson, commissioned by Charles for Lily, to Robert Taft in whose Cincinnati museum it hangs. That one picture is the emblem of a friendship that began in patronage and endured to enrich lives. It is the private face of art.

For the Fairchilds, the last decades were shadowed by business failure, suicides, disease, and disability. Charles died at 72 and Lily at 79, ripe old ages for the time. Only one of their seven children made it beyond 60, and that was Satty, who soared to 90.

The first decade of the new century brought changes and realignments. The chronicle of family disintegration by Lucia's grandson, Blair Fuller, is sad reading. The first rupture was Lucia's separation, beginning in 1905, from her husband Harry Fuller. In 1906, the second youngest son, Neil, 27, died in China of a rifle shot that may have been a suicide. Charles Fairchild & Company did not survive the Panic of 1907, and the family

moved to Cambridge, Charles to die of arteriosclerosis in 1910. By 1915 Lucia's eyesight was failing and she developed multiple sclerosis, dying in 1924 at the age of 52. Lily died that same year. In 1932, the youngest Fairchild, Gordon, 50, in failing health, jumped from a boat off Honduras, an apparent suicide. He had been fired from teaching at St. Paul's School when found in a sexual embrace with a student.[28]

The two oldest sons followed their father into the business world. Charles Nelson Fairchild, Charley, died in 1933 aged 60, a suicide, says Blair Fuller. Inheriting his father's seats on the New York Stock Exchange and the Corn Exchange, he sold them. He was a throwback to the old Fairchild stock, more hands-on than desk-bound. He had graduated in the Harvard Class of 1894, from the Scientific School with a S.B. in geology, doubtless because the fortunes of men connected with the Agassiz, such as Henry Lee Higginson and Alexander Agassiz, came from copper. From his third Harvard Class Report: Always had "contracting and mining" laid out before him, and since college had been "railroading, contracting, broking, manufacturing." Now "designing and manufacturing metals. Perfecting inventions a specialty." He is then living in Jersey City, with his wife, the former Mary E. Bartlett of New York City, with five children whom he does not name. His earliest letters home tell of his adventures, sometimes by candlelight, in mines in the west. One contains a charming vignette of America en fête. On 1 July 1897, he writes how Seattle will celebrate the Fourth. Among those parading through wooden arches topped with roofing paper, a squad of old fashioned Antiques & Horribles, costumed to satirize politicians and public figures, a tradition with Yankee roots. "On Sunday there will be a board sword contest between the champion U.S. Trooper of this post and a Russian who claims to be the world's champion. I am sure the swords will be dulled as they will be mounted on good horses."

On the other hand, John Cummings Fairchild, called Jack, is a Boston Fairchild, with a bohemian streak of his own, at least by marriage. President of the Harvard Class of 1896, he was also president of the Hasty Pudding Club, football captain, and a DKE. He soon marries. Charlotte Elizabeth Houston was 23, schooled in Boston and "finished" in Naples, and their wedding at Cornish, New Hampshire, noted as an arts colony, was given a full 12 inches (four alone of Boston society names) in the *Boston Globe* of 28 September 1898. A band escorted the guests to special trains taking them back to New York and Boston. When he died, aged only 50, the *Boston Globe* obit of 2 September 1924, called him a bond-salesman for a State Street house, Tucker Anthony & Co. He'd had his own brokerage firm, Sargent & Fairchild. The June before he died he had married Helen McLeod of Chestnut Street, Beacon Hill. No children are mentioned. Yet his Harvard Class Reports lists three (and one who died).

What then to make of the Charlotte Fairchild, whose web site biography claims that Jack died in 1915, a death which "revealed a complex of financial difficulties that required [her] to find employment to support her three children." This took the form of a photo gallery on Boylston Street, her husband having "indulged her love of art collecting and photography." It was so successful that she moved to New York City and would make her name as a society photographer who really preferred shooting actors and dancers, and whose pictures were published in *Vanity Fair* and *The Theater*. A freethinker, she was duped by the self-appointed leader of a Hindu cult who, she believed, was a lost Austrian archduke, and the story was newspaper fodder for years. When the hoaxer was exposed in 1927, she married the black commander of the 369th Colored Infantry and moved with him to his Wyoming ranch where she died of apoplexy five months later. "Honored by 3 nations" was the *Boston Globe* obituary headline for Jack's namesake son, John Cummings Fairchild, 52 in 1968, for World War II valor, and, making the military his career, he would serve in Korea retiring as a brigadier general in 1962, almost a century after his grandfather fought in the Civil War.

Blair Fairchild was the musical one. He was as much a social butterfly as his sister Satty, and as committed to the arts as his sister Lucia. His letters to her brim with the enthusiasms of the amateur. For Lucia he scouts out reproductions of master painters. He confides his social missteps at the Cornish art colony, and in France when staying with the family of Linda Cabot Perry, the American Impressionist who spent nine summers painting in her studio at Monet's Giverny. After Harvard he studies piano in Italy. He has his mother's sharp eye for human nature and social class. Lily was right to have observed to Lucia he liked money and position. The family suspected he was gay.[29] In 1903, aged 26, he marries Edith H. Cushing of New York, a cousin of the artist whom Lily venerated, Howard Cushing. Later that year she inherits $100,000 from a will that might have benefitted Howard and others but excluded her. "Many persons were parties to the suit, which was an amicable one," the *Boston Globe* reported on 6 December 1903. With enough from her family allowance to live on in Europe, Blair and Edith settle in Paris. Despite a disfigured leg, she was a brilliant hostess. There would be no children—they had several "adopted nephews." He died in Paris on 23 April 1933, aged 56. During World War I, both engaged in relief work, Edith with novelist Edith Wharton and others to supply hospitals in the war zone,[30] and he aiding musicians. His own compositions are perhaps only musical footnotes today, but to him we owe Stravinsky's violin concerto, which he commissioned for Samuel Dushkin in 1931. Choreographed by George Balanchine in 1972, *Stravinsky Violin Concerto* is a staple of the New York City Ballet's repertory.

The first heartbreak was the fourth son, Nelson Fairchild, called Neil. On 23 December 1906, Lily writes Lucia she has sent toys for the children: "I hope they will go into the pillow cases from Santa Claus and not from me." Then: "I had a cable from Blair yesterday asking if we had denied the suggestion of suicide in the papers and I assured that that had all been attended to." "Five-Fold Funeral" was *The Boston Globe*'s 22 December 1906 headline for a wire-service article about the services for Neil, "who accidently shot himself" at Mukden, Manchuria, where he was an American vice consul. The New York City service, at the Episcopal Church of the Heavenly Rest, was attended by his father and two brothers, Jack and Gordon, the latter still at Harvard. Lily and Satty attended a service in Santa Barbara, California; they had been traveling around the world, Lily having abandoned her husband Charles to his final fog in Cambridge and Newport. Blair was at the Paris service, and the Fairchild cousins who lived in Madison, Wisconsin, held one there. Burial was in the nearest Christian cemetery to Mukden. Neil had been there only three months.

"Cut down in the flower of his years," as it was put in the first paragraph of a memorial volume "copyright L. N. Fairchild" privately printed by The Merrymount Press, Boston, in 1907, and presumably written by her. His mother remembers him as a frail child, always tired, very sick with diphtheria when he was four, more given to reading than sports (but on his day school's football eleven). As was the family custom, he was given his first gun and taught to shoot at 13, and was very good at hunting "water fowl" at Newport.

England did not hold Satty forever, and back to America she went, but not to Boston. As a child of 14, she had vowed to care for her mother, and with the Agassiz no longer home, she joined her parents in New York City, where her father had set up on Wall Street as Charles Fairchild & Company, a brokerage firm. When he failed in business in 1907, they all moved to 153 Brattle Street in Cambridge, he to die of arteriosclerosis in 1910. Did he leave them short of money? That was the year Sargent helped Lily sell his Stevenson portrait. The Fairchild sisters had never been close, the elder too commanding for the younger. Lucia's childhood ailments were to trouble her later years. She lost her sight in 1915, was diagnosed with multiple sclerosis, and in 1918, moved to Madison to be cared for by daughter Clara. She died 20 May 1924, aged 52.

Satty was her mother's companion and confident. Up for a lark, in 1924, she took Lily on a cruise to the Orient, where they and their ship were feared lost in a typhoon. When Lily died later that year, Satty wrote Lucia a letter, sad and bitter, that she had never had a life of her own. She would move to Concord, New Hampshire, to keep house while her baby brother Gordon taught at St. Paul's School. After his suicide, she moved

back to Boston, to the Back Bay of her "bud" years, living for a time at 241 Beacon Street, the old row house that had belonged to her mother's adored Julia Ward Howe. One of Howe's nephews may have figured in the fantasy life of Satty and others. He was the society figure, F. Marion Crawford (1854-1909), called Frank, an enormously popular writer, with more than 30 titles to his credit, drama as well as fiction, for every taste: history, romance, horror (one a lady vampire), and exotic lands (he learned Sanskrit in India). A thorough gent, educated at St. Paul's, Harvard, and Cambridge, and married to the daughter of a Civil War general, Crawford was the cause of a great Boston scandal, when, as we have seen, John Gardner withdrew from public view, Sargent's portrait of his wife, Isabella.

As a boy of 11, Blair Fuller would visit his aunt in Boston. Satty lived with a silent, uniformed Japanese manservant and two surly Pekinese dogs. Ten years later, when he was a student at Harvard, the servant, perhaps a casualty of World War II, had vanished, and one of the dogs had gone. Still, she was cheerful.[31]

In 1956, the Museum of Fine Arts put on a retrospective of the works of John Singer Sargent to mark his centennial. A press photo in the *Boston Herald* that January shows Satty posing by her portrait. Erect and chic at 86, wreathed in white hair, she is still Sargent's luminous girl with the piercing brown eyes.

<div style="text-align: right;">

Margo Miller
Château Higginson: Social Life in Boston's Back Bay, 1870-1920

</div>

Acknowledgements

This book is the product of a messy, promiscuous mind, as happy with a factoid as the Big Idea; in short, a newspaper reporter "emptying the notebook," as we used to say on *The Boston Globe*. A compost heap of fact and opinion, received (or not), it is meant entirely for entertainment.

* * * * * *

As a rank amateur in the ways of Clio, the muse of history, I depended on the courtesy, interest and patience of staffs of many New England institutions. Research started in Boston at the Massachusetts Historical Society; surely those holdings would tell me much about Henry Lee Higginson beyond his life in music. But no; and for his complete self, I was fortunate, at Baker Library of the Harvard Business School, to have use of the Henry Lee Higginson Collection. This consists largely of letters to him, which proved as revealing of his interests and his times as letters by him. For the Fairchild family's life at the Agassiz, I delved into cartons of letters at the Rauner Special Collections Library, Dartmouth College, Hanover, New Hampshire. More Fairchild materials were found in the special collections at the Bowdoin College library, Brunswick, Maine.

People and institutions were generous with their time finding the illustrations for this book; among them, old colleagues Lisa Tuite of *The Boston Globe* library and Mark Feeney, who writes on photography for *The Globe*; and Lorna Condon of Historic New England, which, as the Society of the Preservation of New England Antiquities, introduced so many of us to old buildings. Fortunate is the story whose characters were painted by John Singer Sargent. I am grateful to the Boston Symphony Orchestra, Bowdoin College, Stanford University, the Wisconsin

Historical Society, the Taft Museum, Cincinnati, Ohio, and the private collector Richard Jones of Kansas City, Missouri, for permission to use portraits in their collections. That wonderful architectural photographer, Peter Vanderwarker, had to wait out a wet Boston June to shoot the Hotel Agassiz.

In days gone by, for general knowledge and spell-check, I could reach for a Webster's Dictionary or a volume of the Encyclopedia Britannica. All that's just a click away on Wikipedia, for which I owe much to those anonymous writers and editors.

There is nothing like the right company for a journey, and during my Back Bay musings I was lucky to have Elaine Showalter along for the Boston of Julia Ward Howe; Dennis Fiori of the Massachusetts Historical Society and Margaret Burke of the Concord Museum, for general encouragement; Maureen Meister for the Rangeley Place venture in Winchester, Massachusetts, of architect George Dutton Rand, co-architect of the Hotel Agassiz; Anthony Sammarco, the Mister Boston of books on city neighborhoods and environs, for introducing me to his publisher; Jill Kneerim, a book agent who steered me right; architect Elizabeth Padjen for her sharp eye; old Globie Michael Kenney for his knowledge of early Cambridge byways; Jerry D'Alfonso, my first editor for the Living/Arts section of *The Globe*; my niece Emily Miller for picking the right Fairchild letters to transcribe; publisher David Godine for advice; Deborah Johansen Harris as first editor; Jay Wickersham for architectural history; Chris Chesney for explaining fiber optics; poet Kate Gleason for talking about the role of memory; Tally Forbes for her Saltonstall memoir; Brad Rowell for finding the City of Boston's building permit and final inspection for the Hotel Agassiz; and Dan Shannon for his research on Boston art collectors of the era. For firsthand knowledge of the building: Adam Barbor, Tom McMullin, Dennis Gannon, Steve Furqueron, and Cliff Snider. A dunce about the Internet, I relied on Don Stevenson for help with computer sulk, and Lisa Sieverts for technical assistance in transmitting this manuscript to the publisher. Thanks to Jean Jesensky for compiling the index.

I've been lucky in my friends. Over the years they have contributed insights and help I did not know I needed till I sat down to write and edit. They start with my very oldest friend, Lucilla Wellington Fuller Marvel, and continue with "The Finnegans," my beloved reading-aloud group, and "The Core" at the St. Botolph Club. Not to mention Gillian Taylor, Paul Driver, Patrick Shaw, Harry and Elenita Lodge, Henry and Joan Lee, John Winthrop Sears, Esther Brooks, Barry and Karen Tolman, Bob Raley, Chick and Pat Colony, Michael and Mary Cornog, Margaret and Gene Pokorny. Colin and Shamsi Davis, Roland Shaw, Anne Willan and Mark Cherniavsky, Emma Cherniavsky, Simon Cherniavsky, Richard Sachs, Elisabeth and Rupert Evans, David and Angela Boyle, John Saumarez

Smith, Joe Saumarez Smith and Wanda Marshall, Dan and Victoria McCausland, Dick and Kitty Cunningham, Bill Cosel, Kyra and Coco Montagu, Tom Moore, and many others.

My years in the horse world began with Frances Crane Colt (Fran Schneidau) and her father Zenas Crane Colt, for whom we were exercise girls and the official scorer and timer, respectively, for home games at his Pittsfield Polo Club. Thanks, too, to Joe Saumarez Smith for the delights of English racing and the challenge of helping name his horses.

For music: James and Jocelyn Bolle, founders of Monadnock Music in New Hampshire; Richard Buell, Boston critic; Anthony Fogg, music administrator of the Boston Symphony Orchestra; the late Andrew Raeburn, one of his predecessors; Bernadette Horgan of the BSO press office, Bridget Carr, BSO archivist; Marc Mandel of the BSO publications office; my clarinet teachers Jason Koerber, Chris Veilleux, Kathy Olson, and Hal Churchill; Boston impresario Walter Pierce, whose Celebrity Series brought the best to Boston ; and David Elliott of WHRB-FM, the Harvard radio station.

For my introduction to the ways of city living I am indebted to my first Boston landlords, Luca and Aldo Fioravanti. The third floor of their row house, at 249 Marlborough Street, became my first and second apartments. I lived there from 1959 to 1977, first in the cool, north, back rooms, then, as my salary crept up, I could move to the sunny front. (Now a floor-through condo with an elevator installed in the staircase, it was bought, by extraordinary coincidence, by two of my "Finnegans.") After World War II, an aunt of the Fioravantis had bought up a number of Back Bay row houses on their uppers. Into them piled, four to an apartment and two apartments to a floor, college boys on the G.I. Bill, and in need of cheap housing. On the floor below me, in what had been the paneled library, lived two medical residents and their Akita which shed white over the stair carpet. My first apartment had been two back bedrooms. Fitted snugly in a closet in the larger room was the kitchen. There was a little four-burner stove, and under the sink was the fridge with ice cubes the size of Chicklets. I hung pots on pegboard. There was no kitchen door, but a boyfriend from Harvard's Graduate School of Design contrived one from a pair of window louvers. Then he built bookshelves either side of the fireplace (this was the second-best bedroom) of boards on metal brackets. To me, it was a palace, worth the climb to the third floor back. And so was seeded the idea for this book. There must have been a beginning to the apartment house concept, I thought. But where and by whom? Imagine my surprise and delight when I moved into its very creation. It remains only to salute Henry Lee Higginson whose visionary Hotel Agassiz is now home.

Endnotes

Chapter 1: Landlord Higginson

1. Unless otherwise specified, correspondence dealing with Henry Lee Higginson and the Hotel Agassiz comes from the Henry Lee Higginson Collection, Baker Library, Harvard Business School. N. S. Bartlett was correct to address Higginson as colonel. Although he was entitled to that rank, he referred to himself as major, as there was already another Colonel Higginson in Boston. He was a cousin, Thomas Wentworth Higginson (1823-1911), a Unitarian minister who led the 1st South Carolina Volunteer Regiment of free black men.
2. Isabel Hazard Bartlett's family was no stranger to Boston. Her father Alexander Hamilton Bullock (1816-1882), a Whig turned Republican, served three one-year terms as a fiscally-conservative governor of Massachusetts, retiring in 1869. That he was also anti-booze had hurt him in the less puritan precincts of the state but recommended him to mill owners who saw demon drink interfering with the work ethic they expected of mill hands. Bullock's marriage to Elvira Hazard brought him financial comfort. She was the granddaughter of Augustus George Hazard (1802-1868) who had done well in the Civil War. His munitions business supplied 12,000 pounds of gunpowder a day to the Union Army, and, overall, fourteen percent of the war effort. On his death, his descendants became one of the richest families in the state.
3. The Baker Library collection is also rich in letters about Higginson and the horse world he lived in, and those will be found in a later chapter.
4. To put the water damage in a greater economic perspective, workmen who did painting and paperhanging made about $585 a year, according to wage tables in the 1875 Census of Massachusetts.
5. Harvard Class Reports, as they are called, are invaluable pictures of what each graduate wanted known about himself. Those for the 25th and 50th reunion years offer the long view. In general, Harvard men would rather boast of their country estates than describe life—as renters—at the Agassiz. That is why personal letters, usually by women, are the more telling of the Back Bay.
6. The U.S. Census is a mine of information about America, and thus we know the names of the servants who lived at the Agassiz on a specific date in 1880, when the census taker recorded each person "under the roof" of a given dwelling. The census also recorded age, place of birth, marital status, as well as the places of

birth of the occupant's parents. What the servants actually did is seldom recorded in the 1880 census, except, for example, a coachman (who usually did not live in) or, occasionally, a cook or nurse. In the 1880 census we learn that Charles Fairchild was born in Ohio to a New York-born father and a Massachusetts-born mother. The Fairchilds, on that given date, had six female servants, all single: Margaret Dunn, 35, born in Nova Scotia to Irish parents; Mary Ann Kelly, 45, born in Ireland to Irish parents; Jessie Urquhart, 20, born in Nova Scotia to parents born there; Laura Olson, age not given, born in Norway to Norwegian parents; and Ellen Denny, 25, born in Ireland to Irish parents. The Peirson family had but two servants, single white females, both born in Sweden to Swedish parents: Augusta Swanson, 28, and Augusta Carlson, 31, and shared Rosie Christofferson, 27, a nurse, born in Sweden to Swedish parents, with the family of Edward Jackson, who had two other unmarried female servants: Emma Goodnow, 30, a nurse born in Massachusetts to Massachusetts-born parents, and Honora Mahoney, 24, born in Ireland to parents born in Ireland and Scotland. The 1880 Census records nine servants, three male, working for Henry Lee Higginson, either at the Agassiz or at his farm-estate in Manchester.

7. What brought the Townes from Boston from their old home in Philadelphia is not known. There was one tie to Boston: a graduate of the Massachusetts Institute of Technology, when that was but a single building on Back Bay's Boylston Street, John Nelson Towne returned eventually to Philadelphia to serve as a vice president of the Franklin Institute. His widow, another Alice N., was 46, when in 1878, her son, unnamed in young Alice's letters, seems to have negotiated the rental arrangements for the Towne "suite" at
the Agassiz.

8. A sergeant in the hospital service during the Civil War, Beach was an 1868 graduate of Harvard Medical School, where he would "demonstrate" anatomy 1872-1885. He would teach clinical surgery in the "Harvard wards" of the Massachusetts General Hospital, and was noted for "elbow-joint excision" on working men, who had been injured by such jobs as buntering rail cars, jigging tub saws, and jolleying lathes. The verbs are a thesaurus of hard, sweaty labor.

9. Bliss Perry. *The Life and Letters of Henry Lee Higginson*. The Atlantic Monthly Press, Boston, 1921. Pages 48-49. Hereinafter, Perry.

10. Gladys Brooks, *Boston and Return*. Athenaeum, New York, 1962, p. 209.

11. Douglass Shand Tucci, *Built in Boston: City and Suburb*, 1850-1900. New York Graphic Society, and Little, Brown & Company, Boston, 1978, illustration 114, page 105.

12. According to a 2006 study of the Back Bay by two Northeastern University professors, the "basement floors in the new Back Bay houses lay below the level of high tide, only about five feet above the low-tide mark. House drains extended down from the basements into sewers lying at lower elevations under the streets." And these early sewers could not drain except at near-low tide. Hence "the stinking air was compressed in them and forced through the connecting pipes to the new houses." William A. Newman and Wilfred E. Holton, *Boston's Back Bay: The Story of America's Greatest Nineteenth-*

Century Landfill Project. University of Massachusetts Press, 2006, pages 160-161.

13. It was the only house incorporated by Frederick Law Olmsted in his design for his Emerald Necklace of Boston parks, and Alice leased the mansion from Edward Newton (Ned) Perkins, grandson of the first owner. That Agassiz tenants would move to the street car suburbs made Higginson and his brother-in-law Alexander Agassiz fear for the economic future of apartment house living.

14. *Boston and Return*. Page 208.

Chapter 2: "Bully Hig"

1. Alexander Henry Higginson. *An Old Sportsman's Memories: An Autobiography.* Blue Ridge Press, Berryville, Virginia, 1951. Hereinafter, Memories. Page 13.
2. Bliss Perry, editor. *Life and Letters of Henry Lee Higginson.* The Atlantic Monthly Press, Boston, 1921. Hereinafter, Perry. Pages 158-160.
3. Perry, 19.
4. Perry, 50.
5. Perry, 160.
6. This has been a lasting monument, not least of the two trees that frame the bas relief scene of black troops and their white captain, Robert Gould Shaw, riding along Beacon Street to war. Now the oldest English elms in the Western Hemisphere, carbon-dated to 1772-1812, they may have been planted by John Hancock, a Declaration of Independence signer whose Beacon Street mansion (long ago razed) was across from the future site of the monument. Documents from 1780, when he was governor, granted permission to plant elms on the Boston Common. Deeds like that for the Hotel Agassiz (1873) likewise granted homeowners permission to plant trees on their property. Despite a near century of Dutch elm disease wiping out most others, the two English elms have survived. Planting them in the restricted area of the monument's marble plaza has helped protect the roots from parasites and disease, and aggressive pruning removes weak limbs. "Boston Common's Oldest Trees," in the *Boston Sunday Globe*, 23 April 2017.
7. Addressing a packed Symphony Hall on 25 March 1931, with the audience (and Ida Higginson) assembled to mark the 50th season of the orchestra, Perry summed Higginson up as a "man by turns patient and impatient, gentle and obstinate, simple and subtle, wise and foolish." His "moments of self-pity were relatively infrequent. In his old age, particularly, he enjoyed such tributes of honor and affection as come to few men; but he also had fully his human share of bitterness, disappointment and ingratitude. Such things do not and cannot get into the biographies." Higginson was not always the best judge of men: "Some of his swans turned out to be geese, and worse. Professional confidence men found him easy, and his humor was never more delightful than in his stories of how he had been fooled ... He did not always like to take advice himself—holding in that matter, as in others, that it was more blessed to give than to receive ... He undertook, by copious correspondence, to straighten out Presidents Roosevelt and Taft and Wilson, all of whom he liked personally, but whose official policies he frequently disapproved. Yet he was just as ready to hearten up a green office boy, or an over-sensitive

 musician, or a discouraged college professor, or a client who happened to be on the wrong side of the market." *Bliss Perry in The Boston Symphony Orchestra, 1881-1931*, by M. A. DeWolfe Howe. Semicentennial Edition. Revised and Extended in Collaboration with John N. Burk. Houghton Mifflin Company, Boston and New York, 1931. Appendix A, pages 176-182, the text of Perry's speech at the Johan Sebastian Bach Festival in Symphony Hall to mark the composer's 250th birthday.
8. Perry, 13.
9. Perry, 13.
10. Perry, 20.
11. Perry, 20.
12. As friend and public figure he attended his share of weddings and funerals, and civic events at which the good and the great thanked a god who helped them

foster a commonweal that best suited them. The first Higginsons to arrive in America were part of the Puritan diaspora, or the Great Migration, and a rather stern sect it was, rigid and cruel, and as it was unworkable, it did not last. What of its beliefs and practices could be agreed on became the Congregational church, now the United Church of Christ, whose meeting houses still dot most New England towns. Some found Congregationalism wanting, and flocked to the new gathering calling themselves Unitarians, who dispensed with the Trinity and the attendant liturgy, but held Jesus to be a good man, human and worthy, but not a god. Higginson once wrote a friend he found Unitarianism the most tolerant of religions.

13. Perry, 18.
14. This tree was the famous "Pittsfield Elm," depicted on the (highly-collectible) "Staffordshire-blue" china that the English potter James Clews included in his American scenes in 1838. Hawthorne wrote about the elm. So did Melville, when the tree, believed to be 360 years old, fell apart in July 1864, struck again by lightning and its bark fragile, nibbled by horses tethered to it. It was taken down by Sylvanus Grant, 20, a local black wood cutter, and the wood made into cups and bowls.
15. Perry, 26.
16. Louisa Hall Tharp, *Adventurous Alliance: The Story of the Agassiz Family of Boston*, Little, Brown and Company, Boston, Toronto,1959. Pages 157-158.
17. Perry, 23.
18. Readily available on the Internet as *New-Englands Plantation*.
19. These temperaments linger in poetry as well as medicine. If blood dominated, then one was sanguine, hopeful, happy, Milton's "laughter holding both his sides." If phlegm, phlegmatic, and Abigail Adams's plea in 1776: "deliver me from your cold phlegmatic preachers." If yellow bile, choleric, hot tempered, splenetic, Hamlet's "I am not splenetive and rash" of 1603. If black bile, melancholic, and from Milton's 1631 "L'Allegro" again: "loathed Melancholy, of Cerberus and blackest Midnight born."
20. Perry, 3. The Puritan divine Cotton Mather credited Francis Higginson with "a most charming voice, which rendered him unto his hearers, in all his [religious] exercises, another Ezekiel, for 'Lo, he was unto them as a very lovely song of one that hath a pleasant voice and can play well upon an instrument.'"
21. Even the Anglican church preached. When given the task of designing 50 churches to replace those burned in the Great Fire of London in 1666, the architect Christopher Wren insisted on an acoustic that favored the speaking

voice. The church building, while suitably grand, must not be too large. Comparing Catholic and Anglican approaches, Wren wrote the "Romanist, indeed, may build larger churches, it is enough if they hear the murmur of the mass, and see the elevation of the Host, but ours are to be fitted for auditories." From Wren's "Letter of Recommendations To a Friend on the Commission for Building Fifty New Churches," Appendix 2, in *Hawksmoor's London Churches: Architecture and Theology*, by Pierre de la Ruffinière du Prey (University of Chicago, 2000).

22. For those who could not read, an early tabloid journalism existed in Elizabethan news ballads. Printed in Paternoster Row by St. Paul's, they were doggerel set to hymn tunes and ditties. Among the hottest topics were ballads which spoke of dire portents, things in the sky, monstrous calves with two heads, strange fish washed up along the English Channel—events of fascination to Shakespeare's clowns and rude mechanicals. In *The Winter's Tale* (1611) Shakespeare made such ballads the stuff of comedy: "I love a ballad in print o'-life, so then we are sure they are true," says the shepherdess Mopsa. Should she buy the ballad that tells of "a fish, that appeared upon the coast, on Wednesday, the fourscore of April, forty thousand fathom above water … " which might be a woman turned into a fish? Another

shepherdess has her doubts. How can it not be true, the ballad peddler argues: "Five justices' hands at it, and more witnesses than my pack will hold." Author's senior paper on Elizabethan ballads as newspapers, Vassar College, June 1957.

Chapter 3: Money

1. Louise Hall Tharp. *Adventurous Alliance: The Story of the Agassiz Family of Boston*. Hereinafter, Tharp. Endnote on pages 334-335, in which Ida Agassiz Higginson mentioned, in her will, the pearl cross as a "wedding present from my husband," along with later presents of "my necklace of 96 pearls which I have used as a bracelet" and "my necklace of 73 pearls."
2. Tharp, 5-6. Agassiz would have lectured in the American Baptist Church's original Tremont Temple, built in 1827. When this building burned, it was replaced by the much larger Tremont Temple in 1897.
3. Tharp, 8. Agassiz of course was elected to the Saturday Club, a gathering of writers and intellectuals, which met monthly at the Parker House hotel. In 1888, a fellow member, Dr. Oliver Wendell Holmes, would eulogize him in verse: "There, at the table's further end I see/In his old place our Poet's vis-à-vis,/The great PROFESSOR, strong, broad-shouldered, square,/In life's rich noontime, joyous, debonair ... How will her realm be darkened, losing thee,/Her darling, whom we call our AGASSIZ."
4. Tharp, 45.
5. Tharp, 7.
6. Tharp, 5.
7. Tharp, 5-6.
8. Tharp, 108-109.
9. A. G. Agassiz, editor. *Letters and Recollections of Alexander Agassiz*. Manuscript at the Massachusetts Historical Society. Hereinafter, Agassiz. Page 52.
10. Tharp, 69.
11. *Sportsman*, 11.
12. Tharp, 141. She is silver-haired and stern in the Sargent charcoal drawing of 1917, now at Harvard. Her son and only surviving child Alexander (Alex) would remember her tales of growing up in a little apartment in the old quaint cathedral town of Freiburg. [*Sportsman*, 11]. But he was more apt to record in his memoir her disapproval when he forsook a life in science for a sportsman's life with horses and hounds. [*Sportsman*, 50] Yet she was a fond mother, pressing Alex's article on the raising of beagle puppies on his step-grandmother (and founder of Radcliffe College). Tharp, 314.
13. Tharp, 138-143.
14. Tharp, 112. An Agassiz grandson, young Alex Higginson, relished the tale of the bear confined in the coal cellar. *Memories*, 11.
15. These new Mansard roofs meant top-floor rooms with straight-sided walls. Mansards lined the new streets that Haussmann laid out in Paris in the 1850s, and pretty soon they caught on in America. By "raising the roof"—tearing off the old gable and building on a Mansard—many a New England farmstead and village house converted the pinched old attic bedrooms into a useful new floor.
16. Tharp, 138-144.
17. Perry, 7.
18. Perry, 80-81.
19. Perry, 210-213.
20. Perry, 235.

21. Perry in Howe, 175-179.
22. Perry, 81.
23. Perry, 81.
24. Perry, 255.
25. Perry, 262.
26. Perry, 262.
27. Perry, 248.
28. Perry, 259.
29. Perry, 244.
30. Perry, 263.
31. Agassiz, 56.
32. Agassiz, 57
33. Agassiz, 73.
34. Agassiz, 61-62.
35. Perry, 272.
36. Barrett Wendell, editor. *Reminiscences of Henry Lee Higginson*. Fragile typescript copy in the Massachusetts Historical Society. Hereinafter, *Reminiscences*. Page 7.
37. *Reminiscences*, 9.
38. *Reminiscences* 8.
39. *Reminiscences*, 8.
40. Perry, 276-279.
41. Russell B. Adams, Jr. *The Boston Money Tree: How the Proper Men of Boston Made, Invested & Preserved Their Wealth from Colonial Days to the Space Age.* Thomas Y. Crowell Company, New York, 1977. Hereinafter, *Money Tree*. Page 214.
42. Henry Adams. *The Adams Papers*. Massachusetts Historical Society, Volume V. page 332.
43. Henry Adams on Henry Lee Higginson. *The Adams Papers*. Volume V, 437.
44. *The Money Tree*, 267.
45. Perry, 496.
46. Perry, 520-521.

Chapter 4: Water, Water

1. A couplet from a twenty-stanza poem, verse dignified by Emerson's fame that would be doggerel by another name. It commemorated a major cause of the American Revolution, taxation without representation. "Bad news from George on the English throne:/You are thriving well, said he;/Now by the presents be it known,/You shall pay us a tax on tea." The story goes that Emerson (1803-1882) had, for some years, worked on a poem about Boston, where he was born, son of a Unitarian minister, and, briefly, one himself. He would become known as the Sage of Concord, the Great Transcendentalist, who, in "Nature" (1836) wrote that when egoism vanishes, "I become a transparent eye-ball. I am nothing; I see all; the currents of the Universal Being circulate through me; I am part or particle of God."
2. "For the Union Dead," by Robert Lowell (1917-1977), which he read at the 1960 Boston Arts Festival in the Pubic Garden, and was published in *Life Studies* (Farrar, Straus & Giroux, 1964). A startling canvas of modern Boston in decline, the poem also saluted a more moral Boston, the title referring to the black Massachusetts 54th Regiment marching along Beacon Street to the Civil War, its white captain like them to perish in senseless battle. Their officer was Robert Gould Shaw, a friend and Harvard classmate of Henry Lee Higginson, who

commissioned the great bronze bas-relief from sculptor Augustus Saint-Gaudens (1848-1907). Finished in 1884, it was unveiled on 31 May 1897, on Boston Common, down slope from the Massachusetts State House. Racial relations in the Boston of the 1960s would fester further in the 1970s. Some critics think Lowell's reproach, "Their monument sticks like a fishbone in the city's throat," alludes to Catholic Boston having to eat fish on Fridays. "Mackerel snappers," as they were crudely called.
3. Russell B. Adams, Jr. *The Boston Money Tree: How the Proper Men of Boston Made, Invested & Preserved Their Wealth from Colonial Days to the Space Age*, Thomas Y. Crowell Company, New York, 1977, page 197; hereinafter Money Tree.
4. Perry, 282-285.
5. From Boston Populations and Increases, a table in William A. Newton and Wilfred E. Holton, *Boston's Back Bay: The Story of America's Greatest Nineteenth-Century Landfill*, Northeastern University Press, Boston, published by University Press of New England, Hanover and London, 2006, at page 44. The authors are, respectively, professor emeritus, department of geology, and associate professor, department of sociology and anthropology, Northeastern University. Herein after, Landfill.
6. That balloon ride might have produced an overview of Boston not accomplished until the airplane at the turn of the century and the Goodyear blimp that buzzes Red Sox games. But the view of maritime Boston was the only one of the 10-by-8-inch glass plates that Black exposed that produced a clear, stable image. *Boston Globe* article by Sebastian Smee on 13 October 2010 on the 150th anniversary of the flight.
7. A 1908 view of people clamming at low tide in the Charles River, near what would become the new campus of the Massachusetts Institute of Technology in 1916, is in a photo in the MIT archive printed in the *Boston Sunday Globe* 18 December 2016, page 1 of section D.
8. *Landfill*, 29-31.
9. *Money Tree*, 90.
10. *Landfill*, 40-43.
11. Virginia Savage McAlester. *A Field Guide to the American house: The Definitive Guide to Identifying and Understanding America's Domestic Architecture*. Revised and expanded edition, 2013. Pages 62-63 for public transportation as a builder of neighborhoods.
12. As late as 1900, people clammed on the mud flats near the seawall that protected Cambridge from high tides. But in 1916 along came the campus of the Massachusetts Institute of Technology, which is the actual Cambridge terminus of the bridge. MIT got the last laugh, when, in October 1958, the bridge was measured off in "Smoot Marks." These, now protected by historical fiat, were named for Oliver Smoot, a pledge to Lambda Chi Alpha, who was laid down on the bridge's east sidewalk as a human yardstick by his fraternity brothers. He stood five feet seven, and so the bridge is 364.4 smoots "plus or minus" an ear.
13. One such coastal sailor billed John Winthrop Jr. for taking my ancestor Robert Bedell in 1644 from New London to Fishers Island to work as his cattle keeper. My grandfather Kelton Bedell Miller (1860-1941) grew up at New Baltimore, New York, on the Hudson River, son of a farmer who would join a mile-long line of hay wagons waiting to float their surplus crop by barge to New York City.
14. In April 2013 it sold for $14,500,000. Beginning in 2017 it was broken up into luxury condominiums.
15. *Lapham*, 38-39.
16. *Lapham*, 16-17.
17. *Lapham*, 45.

276 *Château Higginson*

18. William A. Newman and Wilfred E. Holton. *Boston's Back Bay: The Story of America's Greatest Nineteenth Century Landfill Project*. Northeastern University Press, Boston, published by University Press of New England, 2006. Hereinafter, *Landfill*. Pages 79-80.
19. *Landfill*, 93-124, with maps, photographs of on-site work and equipment, including trains.
20. I grew up in a mill town, Pittsfield in Berkshire County. There were Catholic churches for every national origin and theological division: Irish, Italian, Polish, Old German, Greek Orthodox and Russian Orthodox, and undertakers for each, the Jews buried by an Italian. The leading Protestant undertaker was the Wellington family. Andrew Wellington, the last Berkshire County sheriff to preside at a hanging, laid out Andrew Carnegie, who died at Shadowbrook, his 96-room Lenox estate, in 1919. For obit writing in Pittsfield, see Rinker Buck's *First Job: Growing Up at Work*, which describes his first job in journalism as a new reporter on the *Berkshire Eagle*, Pittsfield, in 1973. The newspaper was then owned by my family, which my grandfather, Kelton Bedell Miller, founded in 1892.
21. A similar line was drawn in diplomacy. Former Boston Mayor Raymond Flynn was the first Catholic named Ambassador to the Holy See. A Clinton appointment, he served from 1993 to 1997. Until then, only a Protestant—

and, moreover, an Establishment Protestant—hold the post. One was Henry Cabot Lodge, Jr., namesake grandson of "the old Senator," who was called only "personal Presidential representative to the Holy See" when he served occasionally between 1970 and 1977.

22. But for elegant simplicity little can match the engineering of that "first" American railroad, the carts on paired tracks that took dirt 1803 from Mount Vernon to fill in Charles Street. Balance was one such principle. Like clockwork, the dirt-laden cart clanking down its rail to Charles Street caused an empty cart to climb up a parallel rail to Mount Vernon. The empty was filled, and plunged downhill from Pinckney Street across Oliver to Chestnut, launching an empty upward. (Balance was also crucial when using horses. They were hitched to single axel carts by means of a broad belly band that connected to the shafts. If the load tipped back of the axel, the horse would dangle in the air; if it tipped forward, the horse might fall and crush its chest.)
23. *Landfill*, 136.
24. *Landfill*, 94.
25. *Landfill*, 126-127.
26. *Landfill*, 152-153.
27. *Landfill*, 153-154.

Chapter 5: Hotel Agassiz

1. Château Hig was perhaps a teasing reference to another Boston family's palatial residence, the Palasso Barbaro Curtis, in Venice. It was built in the fifteenth century for a Venetian merchant, and, in typical fashion, combined family residence with accounting office and warehousing. In 1465, it was bought by Zaccaria Barbaro, who became Procurator of San Marco, the highest official after the Duke, and was also known as Ca'Barbaro, from Casa, or house. The wing, added in 1698 included a ballroom, decorated by Veronese and Tiepolo. The dual-palazzo remained in the Barbaro family till it was sold in 1858, and fell on sad times. To the rescue came a Mayflower descendent, Daniel Sargent Curtis (1825-1908) of Boston and his wife, the former Ariana Wormeley (1833-1922),

Endnotes

born and raised in London by a land-owning Virginia family. The Curtises left Boston in 1877, and from 1880 on, called the Palazzo Barbaro home. At first they rented just a part. Visitors in 1883 may have included Henry Lee Higginson, his wife Ida, and their son, Alex. In 1885, the Curtises bought, for $13,500, another part of the building, the piano nobile, the upper (or second) floor with its suites of grand rooms, and the upper floors, and began restoring the whole. From then on, Palazzo Barbaro Curtis—or, to Bostonians, merely Palazzo Curtis—welcomed such social, artistic, and literary legends as Isabella Stewart Gardner, John Singer Sargent, and Henry James. Mrs. Gardner would draw inspiration from Palazzo Curtis for her own Venetian fantasy called Fenway Court. At least two movies have been filmed at the Palazzo Barbaro: *Brideshead Re-visited* (1981) and *The Wings of the Dove* (1997).

2. Liber [book] 1150 [volume].
3. Liber, 1412.
4. *Money Tree*, 222-226.
5. *Boston's Back Bay*, 165.
6. Banbridge Bunting's *Houses of Boston's Back Bay*, 58; Newman and Holton, Boston's Back Bay, 166.
7. Maureen Meister. "Rangleley: A Romantic Residential Park in Winchester, Massachusetts." Antiques, 1997. 188-197.
8. In the nineteenth century, a commercial hotel catered to travelers who rented rooms and ate from the menu in the hotel's public dining room. Bathing and toilet facilities were spartan. The first Statler Hotel, which opened in 1908 in Buffalo, boasted the first hotel rooms with ensuite bathrooms with toilet and showerhead over the tub. Boston was considered advanced in 1877 to have hotel rooms with hot and cold running water if only for wash basins. By 1894, a Boston hotel offered bathrooms ensuite for suites; everyone else went down the hall. [Gideon 694-696]. The residential hotel had rooms or suites for long lease, with a dining room for the use of guests. The good ones had bathing and toilet facilities on each floor, the better were ensuite. Servants lived in the attics and used a privy off the alley. The boarding hotel was for "nice people." Considered genteel and safe for ladies, with a table d'hôte menu for dining. The Hotel Vendome anchoring the Dartmouth Street corner of Commonwealth was both commercial and boarding.
9. Colin B. Bailey, "Fragonard: The Heights of Drawing," The New York Review of Books, 9 1 February 2017.
10. Hermione Lee. *Edith Wharton*. Knopf, 2007. pages 272-275, photo following pages 338.
11. Memories, 14-15, with a photo of Alex and the new pony following page 16.
12. Fiedler to author.
13. According to the 1885 fire insurance map of Sanborn Map and Publishing Company, Boston, Volume II, Back Bay and South End, shown at grid 41 on page 39.
14. Memories, 73.
15. Douglass Shand Tucci, *Built in Boston*, 105.
16. *Built in Boston*, 118.
17. *Boston Globe* archival photograph, 15 December 2015.
18. Meister, "Rangeley," 189.
19. "George Higginson, Jr., and the Making of Winnetka." Winnetka Historical Society Gazette, Spring 2011.

Chapter 6: The Fairchilds at Large

1. Ernest Mehew, editor. *Selected Letters of Robert Louis Stevenson*. Hereinafter,

Selected Stevenson. Page 344. To Sidney Colvin on 24 September 1887.
2. Lucia Fuller Miller's family history.
3. *Selected Stevenson*, 35.
4. *Selected Stevenson*, 354.
5. *Selected Stevenson*, 338-339. Fanny Stevenson to her mother-in-law on 23 June 1887.
6. *Selected Stevenson*, 344.
7. Ernest Mehew, editor. *The Letters of Robert Louis Stevenson*. Volume III, 1887-1891, page 17.
8. Stevenson, fond of the phrase, used it in many letters.
9. A photograph of Stevenson, thought to have been taken by Lily Fairchild, is with her papers at the Bowdoin College Library, Brunswick, Maine. The college's museum also owns the 1887 portrait of her by John Singer Sargent.
10. *Stevenson*. Volume II, 113-114.
11. *Stevenson*. Volume II, page 28.
12. The portrait of Robert Louis Stevenson is in the Taft Museum, Cincinnati. The portrait of Lily Fairchild is at the Bowdoin College Museum, Brunswick, Maine. One of the two portraits of Gordon Fairchild is owned by Robert Jones of Kansas City, Missouri. One of the three portraits of Sally Fairchild is at the Cantor Center for Visual Arts, Stanford University, Stanford, California. The portrait of Lucius Fairchild is at the Wisconsin Historical Society, Madison, Wisconsin.
13. But Twain had to beg off another invitation. On 6 January 1883, S. L. Clemens, as he signed himself, wrote: My Dear Fairchild—We Clemenses wish to thank you Fairchildes most heartily for your hospitable invitation, but we have to lose the chance for the same old reason—scarlet fever. It is in our coachman's family, and so we ourselves have gone into quarantine for a spell. We have seldom received so much attention from Providence as this year. If we were not naturally modest we should feel proud. Pray for us," which he has playfully crossed out. "No, don't—it might attract further attention to us. With kindest regards to you both, yrs sincerely, S L Clemens." This letter is at the Bowdoin College Library in Lily Fairchild's papers.
14. Esther Brooks to author.
15. Ginette de B. Merrill and George Arms. *If Not Literature: Letters of Elinor Mead Howells*. Published for Miami University by Ohio State University Press, Columbus, 1988. Hereinafter, Elinor Howells. Pages 183-187. Letters written in October 1877.
16. A set of some 30 letters, most written by Elinor, October 1977to July 1878, during the construction of Redtop, as the Belmont house would be called, are in the William Rutherford Mead Papers in the Amherst College Archives. Elinor Howells, 185 footnote.
17. Elinor Howells, 184.
18. "Ponce," Henry Flagler's luxury hotel had opened in St. Augustine in 1887, and it may be that the young men were more taken with its full electrification (by Edison generators) than by its artful architecture. Lily's "nothing else" speaks of something else, the high Victorian taste for viewing the exotic as educational. What architectural style could be more historically appropriate for a winter resort in a former Spanish colony than Carrère & Hasting's pastiche of Spanish Renaissance and Moorish. In addition to their personal charm they had impeccable credentials, having studied at the Beaux Arts in Paris and worked for McKim, Mead & White, and the Florida hotel would make their name for the grand luxe that attracted millionaire clients, Old World splash adapted for the New World, and as they also employed the latest technologies, such as electricity and structural steel (or the Ponce's concrete), they flattered the captains of industry. To which Spanish splendor and American comfort was added interior

decoration by Louis Comfort Tiffany, master of opalescent art glass. Later on, each firm designed a famous public library, Boston's 1895 Renaissance cloister in Copley Square by McKim, who also did Boston's Symphony Hall in 1900, and New York's lion-guarded marble temple on Fifth Avenue by Carrère & Hastings in 1902.

19. Maria Pasquale interview by the author for *The Boston Globe* article, 7 February 1977, on a quilt showing North End scenes made for the American Bicentennial.

20. Neil Swidey, "Trump's Wall and Prescott Hall: The Anti-Immigration Playbook was Made in Massachusetts a Century Ago by a Boston Brahmin on a Crusade to ban 'the Undesirables.'" *Boston Sunday Globe Magazine*, 4 February 2017, pp.16-25.
21. Perry, 14-15. Henry Lee Higginson's letter to Sarah Orne Jewett.
22. U.S. Census for 1880.
23. An undated watercolor of Holiday Farm in winter by Nelson Chase is at the Belmont Historical Society. An inscription on the frame says the house was built in 1876-1877 by Henry M. Clarke and was known locally as the "Mansion House on Concord Avenue." The frame also notes that the owner of the house and property, in 1884, was Charles Fairchild. The house was torn down in 1918. Chase was known for his watercolors of city scenes. One, dated 1920, shows Boston's Quincy Market. Lily Fairchild's maiden name was Nelson, but there is no known connection between them.
24. John Singer Sargent painted Irving as Cardinal Wolsley in 1880.
25. *The Diary of a Nobody*, Chapter IX.
26. Perry, 259.
27. Lily Fairchild's poems are among her papers in the Bowdoin College Library, Brunswick, Maine.
28. Elaine Showalter: *The Civil Wars of Julia Ward Howe*, Simon & Shuster, 2016, page 211.
29. Sam Ross. *The Empty Sleeve: A Biography of Lucius Fairchild*. The State Historical Society of Wisconsin for the Wisconsin Civil War Centennial Commission. Madison, Wisconsin, 1964. Page 207.
30. Names to live up to? All cultures have them. Lucius was *lux*, light in Latin, one of the philosopher Seneca's names. Nairus remembers the New Testament father whose daughter was brought back to life: "my light who defuses light." Cassius strode from Rome, where the name could mean vain and empty, to London as Shakespeare's consummate politician, and thence to America as a civil rights hero: Cassius Clay (1810-1903) was the Abolitionist for whom the boxer Mohammad Ali was named.
31. Martin Burgess Green. *The Mount Vernon Street Warrens: A Boston Story, 1860-1910*. Page 28.

Chapter 7: Father and Son

1. Alexander Henry Higginson. *An Old Sportsman's Memories: An Autobiography*. Blue Ridge Press, Berryville, Virginia, 1951. Hereinafter, *An Old Sportsman's Memories*. Page 34.
2. Founding the Boston Symphony Orchestra meant starting almost from scratch. While there were some competent musicians in Boston, there were far too few for the demands of the nineteenth century orchestra and repertory. Higginson had been born (in 1834) into the era of the symphonic orchestra and grand opera. The old court concerts, a few dozen musicians playing for perhaps a hundred people, had given way to music for the masses, so to speak, in public concert halls and

opera houses. That was the concert-going that Higginson first knew in his student years in Europe. His first Boston orchestra would number about 80 and play for at least a thousand. By the time the author had her first Boston Symphony subscription, in October 1958, on Saturday night in seat AA19, the ratio was 102 musicians

performing in the 2,606-seat Symphony Hall. At Tanglewood, the Boston Symphony's summer home in the Berkshires—where the author worked the summers of 1954-1959—the same 102 players (plus chorus) played for 4,000 in the Music Shed with countless thousands listening on the Lawn, and for stellar events, might exceed 15,000.

3. *An Old Sportsman's Memories*, 13.
4. *An Old Sportsman's Memories*, 72.
5. *An Old Sportsman's Memories*, 81.
6. *An Old Sportsman's Memories*, 33-34.
7. *An Old Sportsman's Memories*, 147-150.
8. *An Old Sportsman's Memories*, 241.
9. M. A. DeWolfe Howe. *The Boston Symphony Orchestra, 1881-1931. Semicentennial Edition. Revised and Expanded in Collaboration with John. N. Burke.* Boston and New York: Houghton Mifflin Company. The Riverside Press Cambridge. 1931. Hereinafter, Howe *Boston Symphony*. Page 25.
10. Howe, *Boston Symphony*, 18-19. That the concertmaster was to be paid the same as a Harvard professor, Judge Raymond S. Wilkins, an orchestra trustee, to the author. For the 2014-2015 season, the concertmaster was paid $443,715. That ranked fifth among American symphonic ensembles. The BSO base pay for players that season was $143,896. Both figures from Drew McManus in the online Slipped Disc for 3 August 2017.
11. D. Kern Holoman. *Charles Munch*. Oxford University Press, 2012. Page 10.
12. Howe, *Boston Symphony*, 16-20.
13. Howe, *Boston Symphony*, 21-24.
14. Howe, *Boston Symphony*, 11-14.
15. Bliss Perry's address on 25 March 1931 at the Bach Festival in Symphony Hall. Appendix A in Howe, *Boston Symphony*, 181.
16. *An Old Sportsman's Memories*, 36.
17. *Heaven*, 33.
18. *An Old Sportsman's Memories*, 39.
19. *An Old Sportsman's Memories*, 155-156.
20. *An Old Sportsman's Memories*, 3.
21. *An Old Sportsman's Memories*, 13.
22. *An Old Sportsman's Memories*, 244.
23. *An Old Sportsman's Memories*, 3.
24. *An Old Sportsman's Memories*, 239.
25. Bred and developed at their Mount Hope Farm, Williamstown, Massachusetts, by Colonel E. Parmelee Prentice, a Chicago lawyer, and his wife, the philanthropist Alta Rockefeller Prentice. The author remembers seeing, at Grand Central Station in New York City in the mid-1950s, crates of American chickens unloaded from the baggage car for transfer to New Jersey as breeding stock.
26. *An Old Sportsman's Memories*, 131.
27. *An Old Sportsman's Memories*, 95.
28. *An Old Sportsman's Memories*, 166-167.
29. *An Old Sportsman's Memories*, 70-71.
30. *An Old Sportsman's Memories*, 46.
31. A three-story Tudor Revival (1905-1906) designed by Julian Ingersoll Chamberlain (1872-1952), Alex's fellow sportsman. In private hands till 1992, it became part of the Walden Woods Project, and was put on the National Register

Endnotes 281

of Historic Homes in 2005.

32. *An Old Sportsman's Memories*, 70-72.
33. *An Old Sportsman's Memories*, 145-146.
34. *An Old Sportsman's Memories*, 170-171.
35. *An Old Sportsman's Memories*, 275-277.
36. *An Old Sportsman's Memories*, 284.

Chapter 8: Horses

1. Unless otherwise specified, correspondence dealing with Henry Lee Higginson and horses comes from the Henry Lee Higginson Collection, Baker Library, Harvard Business School. In this text, the letters are identified by date written or received.
2. *Boston's Back Bay*, 107.
3. This writer's grandfather Kelton Bedell Miller (1860-1941) would rent a horse and buggy from Bridges Livery Stable in Pittsfield, Massachusetts, to go courting. One time, returning the rig, he claimed he had gone only as far as Dalton. "Well, I don't know, K. B." said Mr. Bridges, "I know Middlefield mud when I see it, and that'll be four dollars." The author's introduction to Latin was "pro bono publico" on a horse trough in Chesham, New Hampshire. Now planted with petunias.
4. Mark De Wolfe Howe. *Justice Holmes: The Shaping Years, 1841-1870*. Belnap Press, Harvard University Press, 1957. Page 25, footnote: Oliver Wendell Holmes, Jr. to Felix Frankfurter on 5 September 1916. Before his elevation to the United States Supreme Court as associate justice, Holmes had been chief justice of the Supreme Judicial Court, the highest bench in Massachusetts. He was a subscriber to the Boston Symphony Orchestra, writing directly to Higginson to ask that his tickets be on an aisle. In other letters, now in the Higginson collection at Baker Library, Harvard Business School, Holmes discusses the investments that Higginson manages for him. As we have seen, Higginson as a boy visited Oliver Wendell Holmes Sr. at his farm in Pittsfield, Massachusetts.
5. T. J. Clark, *Henri Matisse: The Cut-Outs*, London Review of Books, 5 June 2014.
6. Lucilla Wellington Fuller Marvel, *Bear Island Centennial Book, 1904-2004*. Page 12.
7. John Keegan. *The Mask of Command*, 135.
8. *The Mask of Command*, 206.
9. Perry, 389.
10. Lorenz J. Finison. *Boston's Bicycle Craze, 1890-1900: A Story of Race, Sport, and Society*. Page 176
11. *Boston's Bicycle Craze*, 176 chart.
12. Alexander Higginson, *An Old Sportsman's Memories*, Hereinafter, *Old Sportsman's Memories*. Page 16.
13. Perry, 386.
14. Perry, 275.
15. Eayers to author.
16. Perry, 386-387.
17. Perry, 386.
18. Howells, *The Rise and Fall of Silas Lapham*. Chapter one, pages 31-32 in the 1951 Modern Library edition.

19. In the collection of the Boston Athenaeum.
20. Photograph at the Massachusetts Historical Society
21. The last buggy whip of the author's grandmother Eva Hallenbeck Miller was dated 1907 on the handle.

22. I. Tucker Burr to author.
23. Perry, 387-388.
24. Painting at the Clark Art Museum, Wiliamstown, Massachusetts.
25. *The Mask of Command*, 218.
26. David W. Lewis, Jr. *The Norfolk Hunt Club: 100 Years of Sport.* Hereinafter, Norfolk Hunt. Page 57
27. *Norfolk Hunt,* 130.
28. *Norfolk Hunt,* 130.
29. *Norfolk Hunt,* 127-131.

Chapter 9: Entertainments

1. For Duse generally, see Helen Sheehy: *Eleonora Duse, A Life.* Knopf, 2003.
2. Marion Lawrence Peabody. *To Be Young Was Very Heaven.* Houghton Mifflin Company, Boston, 1967. Hereinafter, Heaven. Pages 61-62.
3. Susan and Michael Southworth. *The Boston Society of Architects' A.I.A. Guide to Boston,* The Globe Pequot Press, Old Chester Road, Connecticut, first edition, 1984, pp. 124-125 with photo. Sober Greek Revival in style, it was designed in 1839 by the classicist Asher Benjamin, architect for such other churches as the Charles Street Meeting House and Old West Church, for the First Universalist Church, a sect later to join the Unitarians. It was later home to Temple Ohabei Shalom, now in Brookline, and the Scotch Presbyterian Church, now in Needham, to minister in their native Gaelic to immigrants from Nova Scotia. Theatrical performances at the Charles began in the 1950s.
4. *Times* Literary Supplement review of the one-woman show, "Ellen Terry with Eileen Atkins," 31 January 2014.
5. *Heaven,* 33.
6. Alexander Henry Higginson. *An Old Sportsman's Memories: An Autobiography.* Blue Ridge Press, Berryville, Virginia, 1951. Hereinafter, *Memories.* Pages 43-44.
7. Perry, *Higginson,* 45-46.
8. Letter, 23 October 1881.
9. *Heaven,* 90.
10. *Heaven,* 89.
11. Oliver Wendell Holmes. *The Autocrat of the Breakfast-Table: Every Man His Own Boswell.* Essays first published in the November 1857 issue of *The Atlantic Monthly.* Hereinafter, *Autocrat.* A Common Reader Edition, paperback, The Akadine Press, 2001. Pages 167-169.
12. By the 1870s, novels were affordable in most households, thanks to the manufacture that made books cheap to produce: steel for the printing press, stereotyping for reproduction of test, steam to run the whole, and pulp paper on which to print. In *Times* Literary Supplement, 14 April 2017, review of David Bellos's The Novel of the Century: The Extraordinary Adventure of "Les Misérables." Particular Books, 2017.
13. Perry, *Higginson,* 304.
14. *Boston Globe* feature by Joseph P. Kahn, 13 December 2013.

Chapter 10: Outdoors

1. Lorenz J. Finison. *Boston's Bicycling Craze, 1880-1900: A Story of Race, Sport, and Society.* Hereinafter, Finison. Pages ix, and endnotes to pages 74-79.
2. Reproduced on the cover of Finison's book.
3. William Shakespeare. *As You Like It,* II, 1.
4. Among them, the seven artists known as the Lynn Beach Painters, who flourished

after the Mandatory Drawing Act of 1870 required drawing be taught free in public schools and night evening courses in towns over 10,000 in population. Drawn to Lynn to teach, they also specialized in saleable oils of coastal life, especially fishing, from Nahant to Swampscott.

5. Marian Lawrence Peabody. *To Be Young Was Very Heaven*. Pages 121-122.
6. Peggy Miller Frank. *Prides Crossing: The Unbridled Life and Impatient Times of Eleonora Sears* is the standard biography. Its punning title plays on the North Shore village in the town of Beverly where she had her stables.
7. For a legal analysis of a certain kind of hit, see the delightful article "The Common Law Origins of the Infield Fly Rule" in The University of Pennsylvania Law Review, June 1975, Volume 123, pages 1474-1481, by William S. Stevens (1948-2008).
8. Louise Hall Tharp. *Adventurous Alliance: The Story of the Agassiz Family of Boston*. Page 209.
9. Peabody, 32.
10. Alexander Henry Higginson. *An Old Sportsman's Memories*. Page 15.
11. David McCullogh. *The Wright Brothers*. Pages 111-199.
12. Finison, 75.
13. History of the Fairbanks House of Dedham, from webpage.
14. Finison, 74.
15. Finison, 211.
16. Finison, 180-181.
17. Obituary for David. G. Burwell in *The Boston Globe*, 18 February 2017.

Chapter 11: Taste

1. Unless otherwise specified, correspondence dealing with Henry Lee Higginson and his style of living comes from the Henry Lee Higginson Collection, Baker Library, Harvard Business School. When possible, dates of the letters are given in the text.
2. William Dean Howells. *The Rise of Silas Lapham* (1885). Hereinafter, *Lapham*. Pages numbers are from the 1951 Modern Library edition. Page 146.
3. *Lapham*, vii. From the introduction by Henry Hayden Clark, University of Wisconsin.
4. Hermione Lee. *Edith Wharton*. Hereinafter, Lee. Page 152.
5. *Lapham*, 81.
6. *Lapham*, 187.
7. Henry Cabot Lodge. *Early Memories*. Pages 18-19.
8. *Lapham*, 88.
9. *Lapham*, 190.
10. *Lapham*, 173.

11. *Lapham*, 31.
12. *Lapham*, 190.
13. Lee, 153.
14. Otto Friedrich. *Clover: The Tragic Love Story of Clover and Henry Adams and Their Brilliant Life in America's Gilded Age*. Hereinafter, Friedrich. Caption for photo between pages 128-129.
15. Friedrich. Caption for photo between pages 128-129.
16. Friedrich. Photo between pages 128-129.
17. *Lapham*, 49.
18. Banbridge Bunting. *Houses of Boston's Back Bay*. Hereinafter, Bunting. Pages 280-281.
19. *Lapham*, 38.

20. *Lapham*, 35.
21. *Lapham*, 37.
22. *Lapham*, 36.
23. Bliss Perry. *Life and Letters of Henry Lee Higginson*. Hereinafter, Perry. Page 280. No source given, and none found.
24. Perry, 448.
25. Perry, 460.
26. Luciennes is a misspelling of Louveciennes, a village near Paris often painted by the Impressionists, where, as it happens, the Boston Symphony conductor Charles Munch lived in the 1960s in part of the du Barry estate [from the Tansonville chapter of *The Past Recaptured*, final volume in *Remembrance of Things Past*, posthumously published in 1927].
27. *Lapham*, 23.
28. *Lapham*, 166.
29. Louise Hall Tharp. *Adventurous Alliance: The Story of the Agassiz Family of Boston*. Hereinafter, Tharp. Endnotes, 334-335.
30. Probably William-Adolphe Bouguereau's "Nymphes et satryre" (1873). Now in the Clark Art Institute, Williamstown, Massachusetts, it ornamented the Grand Saloon, the men's bar at the Hoffman House, the frisky hotel on New York's Broadway, till about 1901. Hung opposite the saloon mirror, thus broadcasting the image twice, it was admired for its French classical style in aid of porn. True to the old tale, a blissed-out satyr—man above the waist, goat below—has surprised a bevy of nymphs as they bathe in limpid water. Incandescent in rage, and of course without a stitch on, they pile on him intending to dunk him. Many was the discussion in the bar whether they would succeed. Adams may just have heard that the painting was removed from the hotel upon the death of the hotel manager Edward Stiles (Ned) Stokes on 2 November 1901 and put into storage, as it was considered indecent.
31. *Adams Papers*, V, 265.
32. *Adams Papers*, V, 312.
33. *Adams Papers*, V, 312.
34. *Adams Papers*, V, 393.

Chapter 12: Clover Adams

1. Ward Thoron, editor. *The Letters of Mrs. Henry Adams, 1865-1883*. Little, Brown, and Company, Boston, 1936. With her photographs. Hereinafter,

 Thoron. As they are arranged chronologically, cites will not be given, except for the editorial matter. Page 291.
2. Natalie Dykstra, *Clover Adams: A Gilded and Heartbreaking Life*. Houghton Mifflin Harcourt, Boston, New York, 2012. Hereinafter, Dykstra. Page 49.
3. Dykstra, 57-58. To Charles George Milnes Gaskell (1842-1919), Liberal party politician.
4. Thoron, 89.
5. Thoron, 118.
6. Thoron, 56.
7. Dykstra, 56.
8. Thoron, 87.
9. Thoron, 54.
10. Thoron, 24.
11. Thoron, 41.
12. Thoron, 32.

Endnotes

13. Thoron, 114.
14. Dykstra, 87.
15. Thoron, 22-23. She was no less scornful of Whistler's portrait of Connie Gilchrist. Thoron, 141. His largest piece, "five by six feet, is all that Ruskin could ask to justify his charge that it was 'flinging a pot of paint in the face of the public,'" she wrote. Whistler would sue Ruskin for defamation but received only token damages. The Gilchrist was "harmony in gold and yellow," one of Whistler's color studies. "Connie has a flannel vest reaching her hips, a handkerchief, bag, and satin boots with Louis XV heels; is jumping a rope with red handles. Any patient at Worcester who perpetrated such a joke would be kept in a cage for life." Clover's father, a doctor, took an active interest in the Worcester Hospital for the Insane. The new asylum building would open in 1876, the design credited to Weston & Rand, who had designed the Hotel Agassiz in 1872.
16. Thoron, 156-157.
17. Thoron, 82.
18. Dykstra, 98.
19. Thoron, 179.
20. Andrew Raeburn to the author.
21. Thoron, 27.
22. Thoron, 72.
23. Thoron, 121.
24. Thoron, 172.
25. Thoron, 79.
26. Thoron, 97.
27. Thoron, 131.
28. Thoron, 24.
29. Thoron, 60.
30. Thoron, 59-63.
31. Thoron, 75.
32. Thoron, 47. And in the little world map that Boston is, there would be a connection to a later manifestation of the Boston Symphony. Tanglewood, the orchestra's summer home, sprawls over some two hundred acres, pieced together by gift or purchase, from the Wards' farm, called Highwood, and Tanglewood, the summer place of Hooper connections, the Tappans. Hawthorne who spent a winter on the property with his little son was to name his tales for the estate. Henry Lee Higginson's brother George farmed at Makenac Farm, on the edge of the Ward-Tappen property. When it passed to the Higginson Gould family, its farm buildings were used in the 1950s and 1960 as scene and costume shops for the Opera Department which Boris Goldovsky headed at the Berkshire Music Center.
33. Thoron, 70.
34. Thoron, 75.
35. Thoron, 63-77.
36. Thoron, 58.
37. Thoron, 84.
38. Thoron, 87.
39. Thoron, 97.
40. Thoron, 131.
41. Thoron, 183.
42. Dykstra, 143 *footnote*.
43. "When Materfamilias enters an ordinary upholsterer's warehouse, how can she possibly decide on the pattern of her new carpet, when bale after bale of Brussels is unrolled by the indefatigable youth, who is equal in his praises of every piece in turn? Shall is be the 'House of Lords' diaper, of a yellow spot upon a blue ground; or the

imitation 'Turkey,' with its multifarious colours; or the beautiful new *moiré* design; or yonder exquisite invention of green fern-leaves, tried up with knots of white satin ribbon." And here Eastlake snorts, in a footnote, about the "degradation to which the arts of design can descend."

Back to the warehouse. "The shopman remarks of one piece of goods that it is 'elegant'; of another that it is 'striking'; of a third, that it is 'unique,' and so forth. The good lady looks from one carpet to another until her eyes are fairly dazzled by their hues. She is utterly unable to explain why she should, or why she should not, like any of them."

Enter a helpful friend, "who is appealed to, who, being a strong-minded person (with the additional incentive of a wish to bring the matter to an issue as speedily as possible), at once selected the very pattern which Materfamilias pronounced to be 'a fright' only two minutes ago. In this dilemma the gentleman with the yard-wand again comes to the rescue, states his firm opinion as to which is more 'fashionable,' and this at once carries the day."

The carpet is now made up, sent home, "and takes its chance of domestic admiration together with all other household appointments. It may kill by its colour every piece of *tapisserie* in the room. It may convey the notion of a bed or roses, or a dangerous labyrinth of rococo ornament—but if it is 'fashionable,' that is all-sufficient. While new, it is admired; when old, everybody will agree that it was always 'hideous.'"

44. Thoron, 148.
45. Thoron, 76.
46. Thoron, 86.
47. Thoron, 116.
48. Thoron, 106.
49. Thoron, 112.
50. Thoron, 149.
51. Thoron, 97.
52. Thoron, 103.
53. Thoron, 112.
54. Dykstra, 74.

Chapter 13: John Singer Sargent Plays the Piano

1. This was the age of the triple-barreled name, and, the story goes, his gallery thought inflating John S. Sargent to John Singer Sargent would be good for business. But it was also the fashion of the times for another reason. Sonorous, to be sure. And historical, with genealogies given full tongue. But more to the point, it marked the bearer as Protestant, not Catholic which stressed the names of saints. Thus, among the great and the good in nineteenth-century Boston's orbit: Henry Wadsworth Longfellow, John Greenleaf Whittier, William Cullen Bryant (not to be confused with William Jennings Bryan), Henry Cabot Lodge, Henry Lee Higginson, Ralph Waldo Emerson, Henry David Thoreau, William Ellery Channing, Charles Eliot Norton, William Dean Howells, Oliver Wendell Holmes, Sr. and Jr., Thomas Bailey Aldrich, James Russell Lowell, Frederick Jackson Turner, Frederick Law Olmsted. The one Catholic of "clubbable" Boston was John Boyle O'Reilly. Among the women, the spinsters Louisa May Alcott and Sarah Orne Jewett, and the married, Julia Ward Howe, Harriet Beecher Stowe, Mary Baker Eddy, and Isabella Stewart Gardner. In daily practice, however, men would sign letters with their first initials and surname.
2. Unless otherwise specified, all references to John Singer Sargent in this chapter come "John Singer Sargent in the Diaries of Lucia Fairchild, 1890 and 1891," in the Archives of American Art Journal, 1986.

3. Stanley Olson. *John Singer Sargent: His Portrait*. Hereinafter, Olson.
4. Olson, 10-11.
5. Her "The Thinking Reed," Olson 34 footnote.
6. Olson, 72.
7. Olson, 227.
8. Sam Ross. *The Empty Sleeve: A Biography of Lucius Fairchild*. Pages 209-210.
9. Bliss Perry. *Life and Letters of Henry Lee Higginson*. Page 420.
10. Henry Sears Lodge to the author.
11. Judith A. Roman. *Annie Adams Fields: The Spirit of Charles Street*. Page 158.

Chapter 14: The Fairchilds at Home

1. Blair Fuller. *Art in the Blood: Seven Generations of American Arts in the Fuller Family*. Creative Arts Book Company, Berkeley, California, 2001. 354 pages, including 34 pages of color plates. Hereinafter, Fuller. Page 191.
2. Fuller, 119.
3. Fuller, 191.
4. Fuller, 223.
5. Fuller, 181.
6. Fuller, 211.
7. Fuller, 193.
8. Like the letters quoted from in the chapter "The Fairchilds at Large," the excerpts in this chapter come from the Fairchild Papers at the Rauner Special Collections at Dartmouth College, Hanover, New Hampshire, and will not be further cited except by date of letter in the text. Most were written by Lily Fairchild to her daughter Lucia Fairchild Fuller.
9. George Bernard Shaw writing to Ellen Terry on 9 November 1896.
10. Fuller, 197.
11. This one and those from Fairchild that follow are in the Henry Lee Higginson Collection, Baker Library, Harvard Business School.
12. Fuller, 169.
13. Fuller, 196.
14. John Bidwell. *American Paper Mills, 1690-1832 (2013)*. In May 1897, the Nashua River Paper Co. had acquired the Fairchild property.
15. *Lee, Higginson & Company*, Henry Lee Higginson's reminiscences dictated to his secretary and edited by Garrett Wendell. Typescript in the Henry Lee Higginson papers at the Massachusetts Historical Society. Page 8.
16. *The Boston Money Tree*, 233.
17. Cushing, Elizabeth Hope. *Arthur A. Shurcliff: Design, Preservation, and the Creation of the Colonial Williamsburg Landscape*. In the 1890s came new thoughts on education for children. Margaret Homer Nichols, niece of the sculptor Auguste St.-Gaudens, who became Mrs Shurcliff, learned the Sloyd method of carpentry at Pauline Agassiz Shaw's School on Marlborough Street. Also attended by the Fairchild children, it was considered progressive in part because it was coeducational at a time when most private schools were not. Mrs. Shaw was the first to establish the method in America, and Margaret was immediately entranced. Writing in 1950, she remembered, 'This was all the greatest fun in the world for me and I promptly insisted on buying a set of tools for myself … " In 1898 she graduated from Miss Folsom's School for girls and that winter participated in the events surrounding her debutante year." In her memoir, *Lively Days*, Margret Homer Shurcliff, recalled: "In the new shop in the basement were ten or twelve sloyd benches, a wonderful array of tools, and on the wall, a set of models

which the pupils were to make in as rapid succession as possible. To make each successful model a new tool was required and to learn the use of these tools was the main object of the system." The Sloyd (Slöjd) system originated in Finland in 1865 and was quickly adopted in Sweden. Like the English Arts and Crafts movement later in the century, it was based on a profound respect for handcraft and a conviction that the development of handwork skills improved moral character, intelligence, and rectitude. Designed to teach handcraft in school, the Sloyd method soon leaped the Atlantic when the Swede Gustaf Larsson came to the Shaw School, later founding a Sloyd Teacher Training School in Boston, now the North Bennet Street School. Once widely distributed in American schools, the methods fell out of favor at the turn of the century."

18. An eyewitness account appears in *The Saint Botolph Club* (2017) in the historical narrative by James O'Gorman.
19. Fuller, 198.
20. Lily Fairchild's memorial to her son, Neil.
21. In the collection of Historic New England.
22. In the collection of the National Gallery of Art, Washington, D.C.
23. Fuller, 183.
24. Fuller, 164.
25. Fuller, 212-215, and color plate.
26. Fuller, 212.
27. Mural, oil on canvas, 23 feet high, 20 feet wide, painted about 1893, in the collection of the Pocumtuck Valley Memorial Association, Deerfield, Massachusetts, which also has a group photograph of Lucia Fairchild Fuller, taken in 1895, with her husband, the painter Henry Brown Fuller, and his mother, Agnes Higginson Fuller.
28. Fuller, 221.
29. Fuller, 221.
30. Boston Globe, 31 October 1915.
31. Fuller, 198.

Bibliography

Agassiz, George Russell, Editor. *Letters and Recollections of Alexander Agassiz, With a Sketch of His Life and Works.* With Portraits and Other Illustrations. The Riverside Press of Houghton, Mifflin & Company, Boston, 1913.

Amory, Cleveland. *The Proper Bostonians.* E.P. Dutton, New York, 1947, reprinted 1957 as a Dutton Everyman paperback.

Berwick, Thomas (1753-1828). *A General History of Quadrupeds, the Figures Engraved on Wood by Thomas Berwick."* 1790, 1885. The University of Chicago Press, Chicago and London, 2009, with foreword by Yann Martel.

Blue Book of Boston. Published by the Boston Suburban Book Company, Boston. These annuals were first issued when the Back Bay was called the West End, that is, of Boston proper. Called "carriage directories," they listed residents by their street address, which is invaluable for who lived at the Hotel Agassiz in a given year. Also good for advertisements of shops and services.

Blue Book of Cambridge, 1917, Containing Lists of the Leading Residents, Societies, Clubs, Etc., Street Directory and Map of Cambridge. Published by Boston Suburban Book Co., Boston. Harvard College Library copy that belonged to Prof. G. H. Parker

Booth, Bradford A. and Ernest Mehew, editors. *The Collected Letters of Robert Louis Stevenson.* Eight volumes. Yale University Press, 1994-1995.

Cushing, Elizabeth Hope. *Arthur A. Shurcliff: Design, Preservation, and the Creation of the Colonial Williamsburg Landscape.* University of Massachusetts Press, Amherst and Boston, in association with the Library of American Landscape History, Amherst, 2014. 298 pages, photographs, plans.

Dambrell, Charles S. *A Half Century of Boston's Building, The Construction of Buildings, the Enactment of Building Laws and Ordinances, Sanitary Laws, the Ancient and Modern Building, Building Statistics, Boston's Valuation, a Chapter*

of Boston's Big Fire, Fire Losses, Public Lands Account, Prominent Architects, Contractors and Builders, Building Materials and Their Source of Supply, Inspection of Buildings, the Building and Plumbing Associations. Published by Louis P. Hager, in Boston, 1895. Copyrighted by Louis P. Hager and Charles S. Damrell 1895. Dambrell may be related to the John Dambrell, whose photo appears on page 274 and is described as commissioner of buildings, and a former head of the Boston Fire Department. In a chapter called "Relation of Construction to Fire Insurance," this line: "panics and premiums go hand in hand." In addition to the Great Fire that started on 6 November 1872, there were fires in 1873, 1874, and 1878.

Dykstra, Natalie. *Clover Adams: A Gilded and Heartbreaking Life*. Houghton Mifflin Harcourt, Boston and New York, 2012.

Fairchild, L. [Lily] N [Nelson]. *Nelson Fairchild*. As subtitle: This the people saw, and understood it not ... to what end the Lord hath set him in safety. Wisdom, IV, 15, 17. Privately printed by The Merrymount Press, Boston, 1907. His mother's memorial to her son Nelson, called Neil, along with his letters to family and friends, and letters about his death, believed a suicide. Available online.

Fairchild, Lucia. See Lucia Miller.

Finison, Lorenz J. *Boston's Cycling Craze, 1880-1900: A Story of Race, Sport, and Society*. University of Massachusetts Press, Amherst and Boston, 2014.

Fink, Lois Marie. *American Art at the Nineteenth Century Paris Salons*. National Museum of American Art. Smithsonian Institution, Washington, D.C., Cambridge University Press, 1990.

Friedrich, Otto. *Clover*. On book jacket: "The Tragic Love Story of Clover and Henry Adams and Their Brilliant Life in America's Gilded Age." Simon & Shuster, New York, 1879.

Fuller, Blair. *Art in the Blood: Seven Generations of American Artists in the Fuller Family*. Creative Arts Book Company, Berkeley, California, 2001. 16 pages of color and black and white plates of works by Negus, Fuller, Goodhue, Legler, Tack, Fox, Cowles, and Mayeron.

Grossmith, George and Weedon. *The Diary of a Nobody*. Serialized in Punch, 1888-1889. Published 1892.

Harvard University Quinquennial Catalogue of the Officers and Graduates 1636-1930. Published by the university in the 294th year of the college. Cambridge, 1930.

Higginson, Alexander Henry (1874-1951). *An Old Sportsman's Memories, 1876-1951: An Autobiography by Alexander Henry Higginson*. With a Foreword by J. Stanley Reeve. Blue Ridge Press, Berryville, Virginia. Copyright Blue Ridge Press, 1951.

Holmes, Oliver Wendell (1809-1894). *The Autocrat of the Breakfast-Table: Every*

Man His Own Boswell (1858). A Common Reader Edition, The Akadine Press, Pleasantville, New York, 2001. Repro, which contains Holmes's prefaces of 1882 and 1891, as well as *The Autocrat's Autobiography* of 1858, in which he says the first two chapters appeared in New England Magazine in 1831 and 1832 (containing ruminations on horses and riding), and the others in *The Atlantic Monthly* beginning in 1857. "I was just going to say, when I was interrupted, that … "

Howe, M[ark] A[ntony] DeWolfe Howe. *The Boston Symphony Orchestra, 1881-1931*. Houghton Mifflin Company, Boston, The Riverside Press, Cambridge, 1931. Edition of a book published in 1914 for the 50th anniversary of the founding of the orchestra, revised and extended in collaboration with John N. Burk. Six appendices include lists of compositions, soloists, rosters of conductors and players, and the catalogue of the Casadesus Collection of old musical instruments given by friends of the orchestra in memory of orchestra founder, Henry Lee Higginson.

Howe, Mark DeWolfe. *Justice Holmes: The Shaping Years, 1841-1897*. The Belnap Press of Harvard University Press, Cambridge, 1957.

Howells, William Dean. *The Rise of Silas Lapham* (1885). Random House, The Modern Library, New York, 1951.

Holoman, D[allas]. Kern. *Charles Munch*. London: Oxford University Press, 2012.

Keegan, John. *The Mask of Command*. Jonathan Cape, London, 1987.

Koren, John. *1822, Boston to 1922: The Story of Its Government and Principal Activities During One Hundred Years*. City of Boston Printing Department, 1923.

Lewis, David W., Jr. *The Norfolk Hunt Club: 100 Years of Sport*. Privately published in 1995 for the membership. Period photos.

Lee, Hermonie. *Edith Wharton*. Chatto & Windus, London, 2007.

Levenson, J. C. and Ernest Samuels, Charles Vandersee, and Viola Hopkins Winner, with the assistance of Jayne N. Samuels. *The Letters of Henry Adams*, Volume II, 1868-1885. Volume V: 1899-1905. The Belnap Press of Harvard University Press, Cambridge, Massachusetts, and London, England, 1988.

Livingston, Phil and Ed Roberts. *War Horse: Mounting the Cavalry with America's Finest Horses*. Bright Sky Press, Albany, Texas, text copyright 2003.

Lodge, Henry Cabot. *Early Memories*. Charles Scribner's Sons, New York, 1913.

Lurie, Edward. *Louis Agassiz: A Life in Science*. The Johns Hopkins University Press, Baltimore and London, paperback edition, 1988.

Marvel, Lucilla Wellington Fuller, editor. *Bear Island Centennial Book, 1904-2004*. Privately printed for the descendants of the first owners of the island in Penobscot Bay, Maine, near the town of Sunset.

McAlester, Virginia Savage. *A Field Guide to American Houses: The Definitive Guide to Identifying and Understanding America's Domestic Architecture.* Alfred A. Knopf, New York, 2013, revised and expanded from the 1984 edition.

McCullough, David. *The Great Bridge: The Epic Story of the Building of the Brooklyn Bridge.* Simon & Schuster, 1972.

McCullough, David. *The Wright Brothers.* Simon & Schuster, 2015.

Mehew, Ernest, editor. *Selected Letters of Robert Louis Stevenson, 1850-1894.* Yale University Press, 1997.

Meister, Maureen. "Rangleley: A Romantic Residential Park in Winchester, Massachusetts." In *Antiques Magazine*, August 1997. Pages 188-197. 8 color photographs, 5 black and white photographs, 3 drawings, 1 map.

Miller, Lucia Fuller. "John Singer Sargent in the Diaries of Lucia Fairchild, 1890 and 1891." Archives of American Art Journal, volume 26, Number 4 (1986). Pages 2-16. Reproductions of Sargent's paintings of the Fairchild family, Robert Louis Stevenson, and others, a water color by Lucia Fairchild Fuller, and family photographs, including the Hotel Agassiz apartment house at 191 Commonwealth Avenue, Boston, where the Fairchilds lived from 1874 to 1897 and their summer place at Newport, Rhode Island.

Morison, Samuel Eliot. *One Boy's Boston, 1887-1901.* Houghton, Mifflin Company, Boston, The Riverside Press, Cambridge, 1962.

Newman, William A. and Wilfred E. Holton. *Boston's Back Bay: The Story of America's Greatest Nineteenth-Century Landfill Project.* Northeastern University

Press, Boston, published by the University Press of New England, Hanover and London. 2006.

Papers of the Fairchild family at Dartmouth College, Hanover, New Hampshire, and at Bowdoin College, Brunswick, Maine.

Papers of Henry Lee Higginson in the Henry Lee Collection, Baker Library, Harvard Business School

Peabody, Marian Lawrence (1875-1974). *To Be Young Was Very Heaven.* Houghton Mifflin Company, Boston, 1957.

Perry, Bliss. *Life and Letters of Henry Lee Higginson.* The Atlantic Monthly Press, Boston. Copyright 1921 by Bliss Perry.

Peterson, Duff. "George Higginson, Jr. and the Making of Winnetka." In the Gazette of the Winnetka Historical Society, Winnetka, Illinois, Spring 2011.

Pustz, Jennifer. *Voices from the Back Stairs: Interpreting Servants' Lives at Historic House Museums.* Northern Illinois University Press, DeKalb, Illinois, 2010.

Roman, Judith A. *Annie Adams Fields: The Spirit of Charles Street.* Bloomington &

Indianapolis: Indiana University Press, 1990. Revision of the author's Ph.D thesis, Indiana University, 1984.

Ross, Marjorie Drake. *The Book of Boston: The Victorian Period, 1837-1901*. With Photographs by Samuel Chamberlain. New York: Hastings House, 1864.

Shand Tucci, Douglass. *Built in Boston: City and Suburb, 1800-1950*. New York Graphic Society; published by Little, Brown and Company, Boston, 1978. Published by Little, Brown and Company for the New York Graphic Society, 1978. Foreword by Walter Muir Whitehill (1905-1978).

Social Register, The. The Social Register Association, Bowling Green, 29 Broadway, New York City. First issued in 1885 [thus, 1913 was Vol. XXVIII, No. 5].

Spofford, Harriet [Elizabeth] Prescott. *The Servant Girl Question*. Boston: Houghton, Mifflin & Company, 1881.

Swidey, Neil. "Trump's Wall and Prescott Hall: The Anti-Immigration Playbook was Made in Massachusetts a Century Ago by a Boston Brahmin on a Crusade to Ban 'The Undesirables.'" *Boston Sunday Globe Magazine*, 4 February 2017.

Tharp, Louisa Hall. *Adventurous Alliance: The Story of the Agassiz Family of Boston*. Little, Brown & Company, 1959. Fourth printing. Includes John Singer Sargent's 1917 drawing of Ida Agassiz Higginson, now at the Harvard Museums.

Thoron, Ward, Editor. *The Letters of Mrs. Henry Adams, 1865-1883*. Little, Brown, and Company, 1936.

United States Census for 1880, which covered 1 June 1879 to 31 May 1880. The Census for 1890 burned, and the parts that were reconstructed did not cover Boston.

Warner, Sam Bass, Jr. *Street Car Suburbs: The Progress of Growth in Boston, 1870-1900*. Second Edition. Harvard University Press, Cambridge, 1978. A Harvard Paperback.

Wendell, Barrett. "Historical Account of Lee, Higginson & Company, 1918-1920." From notes given Wendell by Henry Lee Higginson before his death in 1919. Unpublished manuscript. Two typescripts, the originals on pulp paper, deposited at the Massachusetts Historical Society, which also has a photocopy of the original typescript, and at the Boston Athenaeum. 20 pages.

Wharton, Edith and Ogden Codman. *The Decoration of Houses, 1897*. Rizzoli reprint, 2007.

Whitehill, Walter Muir. *Boston: A Topographical History*. The Belnap Press of Harvard University Press, 1963.

Williams, Alexander W. *A Social History of the Greater Boston Clubs*. Barre Publishers, 1970. Barre Publishing Company. Includes recipes.

Index

Note: HLH in this index refers to Henry Lee Higginson.

Adams, Abigail (born Brooks, mother of Henry), 209, 210, 222
Adams, Charles Francis (father of Henry), 53, 117, 208, 213
Adams, Henry Brooks (husband of Clover)
 about, 9, 52, 208, 212, 215, 217
 describing Clover, 209
 friendship with HLH, 62, 234
 Lizzie Cameron and, 204–205, 211
 longing to live at Hotel Agassiz, 61, 212
 marriage and life with Clover, 199, 208, 211–216, 221
 negotiating with Rodin, 190, 204
 shopping, love of, 213, 219, 222
Adams, Marian "Clover" (born Hooper, wife of Henry)
 about, 9, 51, 149, 153, 168, 208–212, 215–216
 connection to HLH, 210
 decor tastes of, 194, 199, 201, 219–224
 letters of, 210–219, 251, 252
 longing to live at Hotel Agassiz, 61, 212
 marriage and life with Henry, 199, 208, 211–219, 221
 photography of, 194, 218, 221–222
 shopping, love of, 199, 213, 218–219, 222
The Agassiz. See Hotel Agassiz
Agassiz, Alexander (brother-in-law of HLH), 9, 22, 29–30, 33, 35, 48–49, 51, 55, 58–59, 81–82, 87, 89, 97, 100–102, 111, 126, 249, 262
Agassiz, Anna (born Russell, wife of Alexander), 22, 51, 58, 83
Agassiz, Cécile (born Braun, 1st wife of Louis), 49, 126
Agassiz, Elizabeth Cabot "Lizzie" (born Cary, 2nd wife of Louis), 9, 48–52, 182

Agassiz, Ida. See Higginson, Ida (born Agassiz, wife of HLH)
Agassiz, Louis (father-in-law of HLH), 9–10, 22, 47–48, 50, 52, 101, 126, 178, 210
Agassiz, Pauline (later Shaw, sister-in-law of HLH), 9–10, 49–50, 52, 58, 112, 126, 250, 251, 289n17
Agassiz, Rodolphe "Dolph" (son of Alexander and Anna), 182
Agassiz School, 50–52, 210
Aldrich, Thomas Bailey, 112
Andrew, John Albion, 34
annexation of towns for Boston, 65–66
apartment living, 13–14. See also Hotel Agassiz
Appleton, Francis H., 138–139
art, tastes in, 103, 204–207, 221, 235, 258–261. See also decor, tastes in

Back Bay, 13–14, 21, 66–67, 68–70, 71, 72–78, 95, 134–135, 277n22
Bartlett, Elvira, 20, 93
Bartlett, Isabel Hazard (born Bullock), 20, 93, 269n2
Bartlett, Mary E. (later Fairchild, wife of Charley), 262
Bartlett, Nelson Slater, 19–20, 21–22, 93
Beach, Amy Marcy (born Cheney), 25, 54, 243
Beach, Henry Harris Aubrey, 25–26, 243, 270n8
Beacon Hill, 71–72
Beacon Orchestral Club, 167
Bell, James W., 87
Bennett, James Gordon, 182
Bernhardt, Sarah, 124, 159–160, 173
Berwick, Thomas, 184–185

Index

bicycling, 15, 137–138, 172, 175–176, 177–178, 185–189
Bing, Gottfried, 219
Black, James Russell, 65
Blake, Mary "Molly" (born Higginson, sister of HLH), 23, 33, 36
Blake, S. Parkman (husband of Mary "Molly"), 23
Blake, William, 223–224
Blodgett, William T., 217
Bordoni, Irene, 125
Boston, 65–73, 74–78. *See also* Back Bay
Boston: A Topographical History (Whitehill), 75
Boston and Roxbury Mill Corporation, 67
Boston Athletic Association's clubhouse, 96
Boston Bicycle Club, 175, 176, 185, 187
Boston Embankment, 78
Boston fire of 1872, 60–61
Boston Latin School, 37, 71
Boston Money Tree, The (Adams), 83, 250
Boston Music Hall, 121, 122, 165, 167
Boston Public Garden, 69, 95
Boston Public Library, 22, 71, 96, 168, 188, 242
Boston Symphony Orchestra, 33, 61, 62, 120, 121, 167, 168, 208, 231–232, 271n7, 280n2. *See also* Symphony Hall; Tanglewood
Boston Water Power Company, 68
Boston's Back Bay (Newman and Holton), 75–76
Braun, Cécile (later Agassiz, 1st wife of Louis), 49, 126
Brookline, 66. *See also* Longwood
Brooks, Abigail (later Adams, mother of Henry), 209, 210, 222
Brooks, Peter Chardon (relative of Abigail), 209, 212
Built in Boston (Shand Tucci), 98
Bullock, Alexander Hamilton, 269n1
Bullock, Isabel Hazard (later Bartlett), 20, 93, 269n2
Bully Hig (nickname for HLH), 32–33, 35
Bumstead, N. Willis, 197–198
Bussigny, H. L. de, 183–184

Calducci, Jeanne (later Higginson, 2nd wife of Alex), 120–121
Calumet and Hecla copper mines, 58–59, 61–62, 65
Cameron, Duncan Elwell, 136
Cameron, Elizabeth "Lizzie" Bancroft Sherman, 204–205, 211
Cameron, J. Donald, 204
Cameron, Roderick, 136
Campbell, Whittier & Co., 29–30
Cary, Elizabeth Cabot "Lizzie" (later Agassiz, 2nd wife of Louis), 9, 48–52, 182

cavalry horses, 139–140, 156–157
Chandler, Alfred Dupont, 186, 187
Charles Fairchild & Company, 264
Charles River, 46, 66, 67, 68, 70, 72, 78, 276n7
Charles Street, 72, 277n22
Chase, E. E., 148, 149, 151
Chase & Higginson, 148
Chateau Higginson, 33, 277n1. *See also* Hotel Agassiz
Cheney, Amy Marcy (later Beach), 25, 54, 243
Christofferson, Rosie, 22
Christophers, Harry, 167
Coffin, Charles, 53–54, 62, 247
Common Landscape of America (Stilgoe), 44
Commonwealth Avenue Mall, 69, 72, 78, 82, 254
Coolidge, Albert L. and Mrs., 23, 93
Coolidge, Thomas Jefferson "Jeffy", Jr., 62, 112, 116, 142
Copley Square, 95–97
copper mining, 48, 58–59, 61–62, 65, 123
Cottenham plantation, 55–57
Cotton Hill, 71–72
Craig, Edith "Edy", 111, 251
Craig, Gordon "Ted"; "Scamp", 251
Cram, Ralph Adams, 98
Crane, William Murray, 166, 188
Crawford, F. Marion "Frank", 173, 228, 265
Curley, James Michael, 158
Cushing, Edith H. (later Fairchild, wife of Blair), 263
Cushing, Howard Gardiner, 260, 263
cycling, 15, 137–138, 172, 175–176, 177–178, 185–189

decor, tastes in, 27–28, 190–207, 219–224, 261. *See also* art, tastes in
Depression of 1873 to 1879 (Long Depression), 65, 77, 82. *See also* Panic of 1873
Dixwell, Epes Sargent, 37
Duse, Eleonora, 60, 124–125, 159–161, 164, 249
Dwight, James, 178–179

Eastlake, Charles Locke, 220
Education of Henry Adams, The (Adams), 208
Eliot, Charles William, 166, 181
Ellis, Charles A., 124, 159, 160–161
Emerson, Ellen, 49, 51
entertainment. *See also* outdoor activities
 concerts, 165, 166–168
 opera, 167–170
 parades, 166
 piano playing, 171, 173–174

reading aloud, 171–173
theater, 159–165, 168–171
Eric, Or Little by Little (Farrer), 253–254
Esplanade, 78
exclusionism in neighborhoods, 76

Fairchild, Blair (son of Charles and Lily), 11, 103, 110–111, 117, 169, 244, 250, 253, 255–256, 263–264
Fairchild, Charles (husband of Lily)
 about, 10, 114–118, 248–249, 261–262
 business career, 22, 59, 60, 103, 107, 118, 225, 245–250
 children of, 110, 244–245, 250–251, 261–265
 marriage and family life, 110–113, 225–230, 242–245, 247, 255–258, 260–261
 personal characteristics of, 248
 Sargent, friendship with, 118, 227
 social life of, 103, 111–112, 254
 Stevenson, friendship with, 103–106
 taste in artwork, 261
Fairchild, Charles Nelson "Charley" (son of Charles and Lily), 10, 105, 110, 244, 256, 257, 261–262
Fairchild, Charlotte Elizabeth (born Houston, wife of Jack), 262–263
Fairchild, Edith H. (born Cushing, wife of Blair), 263
Fairchild, Elizabeth "Lily"; "Mig" (born Nelson, wife of Charles)
 about, 10, 24, 113–114, 261–262, 264
 children of, 110, 244–245, 250–251, 261–265
 letters to Lucia, 111–113, 115, 169–170, 242–245, 247, 248–249, 251–252, 254–258, 260, 264
 marriage and family life, 110–113, 225–230, 242–245, 247, 255–258, 260–261
 mystical side of, 239
 at the opera, 169–170
 poetry of, 114–115, 239, 252, 280n27
 Sargent portrait or, 239, 278n9
 social life of, 103, 111–112, 254
 Stevenson, correspondence with, 103–106
 taste in artwork, 261
 views on love and marriage, 240
 writing style of, 251–252
Fairchild, Gordon (son of Charles and Lily), 11, 110, 165, 173, 235, 244, 250, 251, 253–254, 255, 257, 262, 264
Fairchild, Jairus Cassius (father of Charles), 117
Fairchild, John Cummings "Jack" (son of Charles and Lily), 11, 110, 142, 163, 170, 243, 244, 250, 253, 254, 262–263, 264

Fairchild, Lucia. *See* Fuller, Lucia (born Fairchild, daughter of Charles and Lily)
Fairchild, Lucius (brother of Charles), 11, 108, 116–118, 234
Fairchild, Mary E. (born Bartlett, wife of Charley), 262
Fairchild, Nelson "Neil" (son of Charles and Lily), 11, 110, 152, 250, 253, 255, 256, 261, 264
Fairchild, Sally "Satty" (daughter of Charles and Lily), 10, 110–111, 173, 225, 230, 235, 239, 244–245, 248, 251–253, 261, 264–265
Fairchild & Company, 249
farm animals, breeding, 127–128
Fiedler, Arthur, 95
Fields, Annie, 111–112, 256
Finison, Lorenz J., 185, 282n10
fireproof safety deposit vaults, 60–61
Fisk Jubilee Singers, 96
Forbes, William, 53
fox hunting, 11, 128–129
Fuller, Blair (grandson of Harry and Lucia), 258, 261–262, 263–265
Fuller, Buckminster, 137
Fuller, Charles Fairchild "Chas" (son of Harry and Lucia), 258
Fuller, Clara Bertram (daughter of Harry and Lucia), 258
Fuller, George F., 87
Fuller, George (father of Harry), 241, 258
Fuller, Henry Brown "Harry" (husband of Lucia), 11, 110, 241–242, 258–259, 261
Fuller, Lucia (born Fairchild, daughter of Charles and Lily)
 about, 10, 106, 110, 262, 264
 diary of, 106, 225, 227–228, 230–232, 234–240, 252, 255
 marriage and children, 241–242, 257–259, 261
 portrait miniatures of, 236, 241–242, 258–259
 Sargent, friendship with, 225–240, 255
 Sargent, painting lessons from, 225, 235–236
 studying art, 244–245
 touring the Louvre with Sargent, 226, 237–238
 "Women of Plymouth" mural of, 54, 243, 260, 289n27
Fuller, Wolcott, 137
furnishings, tastes in, 27–28, 190–207, 219–224, 261. *See also* art, tastes in

Gardner, Henry J., 114
Gardner, Isabella Stewart, 166, 168, 214–215, 228, 233, 238, 254, 277n1, 288n1
Gardner, John "Jack", 214, 215, 228, 265

Index

Gardner Museum, 229, 233, 238
General Electric Company, 54, 106, 247
General History of Quadrupeds, A (Berwick), 184–185
Gericke, Wilhelm, 120
Gleanings in Bee Culture (Root), 184
Goss, George, 77
gravity railroads, 72, 277n22
Grew, Jane Norton "Jessie" (later Morgan), 243

hackney driving horses, 141–144, 148–149
Handel & Haydn Society, 167
Harvard Bridge, 70, 276n12
Harvard Medical School, 96, 101
Harvard Stadium, 35, 181
Harvard Union, 35, 166, 232
Hazard, Augustus George, 269n1
Henner, Jean-Jacques, 206–207
Henry, Prince of Prussia, 166
Henschel, Georg, 120, 122, 231, 232
Higginson, Alexander Henry "Alex" (son of HLH and Ida)
 about, 11, 22, 132
 actresses, fondness for, 123–125
 character of, 126–127, 271n7
 death of his parents, 131–132
 interests and passions, 11, 127–129, 132, 152, 154–155, 165–166, 177, 180, 183–184
 Lincoln home of, 130–131
 marriages of, 94, 120–121, 128–129, 167
 relationship with his father, 33, 94–95, 119–123, 129–132
 son of, 120, 131
Higginson, Anne (ancestor of HLH), 39
Higginson, Cécile (daughter of HLH and Ida), 22, 46, 65, 97
Higginson, Cecile (later Murray, granddaughter of Alex), 131
Higginson, Francis (ancestor of HLH), 38–46, 192, 272n20
Higginson, Francis (brother of HLH), 36, 57, 59–60
Higginson, George (brother of HLH), 33, 36, 38, 154–155, 287n32
Higginson, George (father of HLH), 14, 35–36, 61, 66
Higginson, Henry Lee "Bully Hig"; "Hal" (husband of Ida). *See also* Hotel Agassiz
 about, 11, 19, 35, 63, 79
 actresses, fondness for, 123–124, 159–161
 Boston fire of 1872 and, 60–61
 Boston Symphony Orchestra founding, 33, 52, 72, 121–122, 280n2
 building of Symphony Hall, 97
 character of, 63, 249
 Civil War experience, 33–34, 53
 copper investments, 58–59, 61–62, 65
 correspondence, 269n1
 cotton farming years, 55–56
 cycling safety concerns, 188
 decor, tastes in, 190, 198–199, 202–207
 early career, 32, 55, 64
 early life, 35–37
 education, 37–38
 facing ruin, 120–121
 failing eyesight of, 37–38
 horses, passion for, 33–34, 133, 136, 140–144
 inheritance, 57
 as inventor of the apartment house in America, 13
 investments of, 53–55, 65
 as landlord, 19–31
 life disappointments, 34–35, 271n7
 life in Hotel Agassiz, 22, 65
 marriage and children, 22, 46–47, 48–49, 52–53, 126–127
 music, love of, 35, 97–98, 167, 173
 nicknames, 32–33, 35
 partner in Lee, Higginson & Company, 35–36, 57, 59–60
 philanthropy, 35
 physical characteristics, 33, 34
 reflecting on years in investment banking, 53
 relationship with his son, 33, 94–95, 119–123, 129–132
 Sargent portrait of, 232, 234
 stables of, 140
Higginson, Henry Lee, II (grandson of HLH and Ida), 120, 131
Higginson, Ida (born Agassiz, wife of HLH)
 about, 10, 11, 100, 126, 132
 cotton farming years, 55–57
 early life, 49–50, 52, 126
 Fairchilds, socializing with, 103, 112
 family trip to Europe, 119–120
 life in Hotel Agassiz, 22, 65, 97–98
 marriage and children, 22, 46–47, 48–49, 52–53, 126–127
 Sargent drawing of, 125, 204, 274n12
 schooling, 210
 teaching, 51
 views on Henry James, 173
Higginson, James (brother of HLH), 36, 52, 53, 57
Higginson, Jeanne (born Calducci, 2nd wife of Alex), 120–121
Higginson, John (ancestor of HLH), 38–46
Higginson, Mary (ancestor of HLH), 39, 46
Higginson, Mary Cabot (born Lee, mother of HLH), 35–36
Higginson, Mary "Molly" (later Blake, sister of HLH), 23, 33, 36

Higginson, Rosamond (born Tudor, 1st wife of Alex), 120, 129
Higginson, Samuel (ancestor of HLH), 39, 45–46
Hinkley, Bertha O., 59
Hints on Household Taste in Furniture, Upholstery, and Other Details (Eastlake), 220, 287n43
Holiday Farm, 110, 256, 280n23
Holmes, Oliver Wendell, Jr., 136–137, 220, 282n4
Holmes, Oliver Wendell, Sr., 16, 25, 37, 68, 96, 134, 147, 171–172, 191, 222, 273n3, 282n4
Holmesdale, 16, 37, 272n14
Hooper, Edward William "Ned" (brother of Clover), 211, 223
Hooper, Ellen (born Sturgis, mother of Clover), 211
Hooper, Ellen (sister of Clover), 211
Hooper, Louisa Chapin (later Thoron, niece of Clover), 211
Hooper, Marian "Clover". *See* Adams, Marian "Clover" (born Hooper, wife of Henry)
Hooper, Robert William (father of Clover), 211, 212
horse breeding, 147–148
horse sports, 151–152, 180, 183–184
horse trams, 69–70, 210, 242, 254
horseless transportation, 134, 137–138
Hotel Agassiz. *See also* Higginson, Henry Lee
 overview, 14–15, 33
 amenities, 82
 architects for, 79–82, 84, 87–88
 building site, 73
 construction of, 14, 79–88
 converting to condos, 82, 100, 171, 212
 deed restrictions, 83
 early tenants, 21–23
 elevators in, 29–31
 exterior style, 99
 floor plans, 89–93, 255
 Higginson row house abutting, 97–98
 lighting in, 93
 Longwood as rival to, 66, 100–101, 178
 mortgage, 83
 naming, 33
 problems, structural, 20–22, 24–28, 269n4, 270n12
 rent and fees, 20, 28–29, 212
 success of, 93–94
 summer and, 256
 telephone service in, 93
 tenant complaints, 14, 20–22, 23–24, 27–28, 202
 toilets and plumbing, 24–27, 28, 270n12
Hotel Cluny, 26, 96, 98

Hotel Vendome, 99, 100, 111, 187, 278n8
hotels, commercial vs. residential, 278n8
Houses of Boston's Back Bay (Bunting), 75
Houston, Charlotte Elizabeth (later Fairchild, wife of Jack), 262–263
Howe, Julia Ward, 115, 265
Howells, Elinor (born Mead), 107–108, 114, 191–192
Howells, Pilla, 226
Howells, William Dean, 11–12, 73, 106, 112, 133, 191–194

immigrant labor, 69, 109–110
Irving, Henry, 106, 111, 112, 161, 163–165
Isabella Stewart Gardner Museum, 229, 233, 238

Jackson, Edward, 22, 270n6
Jackson, Francis Henry, 81, 84, 87
James, Henry, 106, 214–215, 228–229
James J. Storrow Memorial Drive, 78
Japonism, 200–201
Jewett, Sarah Orne, 111–112
Johnson, Lewis Jerome, 181

kindergartens, 10, 126, 251
Koussevitzky, Serge, 121, 132

La Farge, John, 260
landfill projects, 66–67, 68–70, 71–72, 75–77, 78, 277n22
Lapham, Silas (fictional character), 12, 73–74, 78, 106, 133, 144, 191–194, 195, 196–197, 202, 204
Lawrence, Abbott, 35
Lawrence, Amos, 101
Lawrence, Marian (later Peabody, wife of Harold), 124, 163, 165, 170–171, 179, 180, 183, 244, 245, 251
Lawrence, William (father of Marian), 162–163
Lawrence Scientific School, 35, 51
Lee, George, 60–61, 120
Lee, Higginson & Company, 22, 35–36, 57, 59–61, 65, 103, 118, 120–121, 246
Lee, Mary Cabot (later Higginson, mother of HLH), 35–36
limelight, 168–169
Lincoln, Alice North (born Towne, wife of Roland), 23, 24, 26–27, 141, 153–154, 270n7
Lincoln, Roland Crocker, 23, 154
Lincoln, Solomon, 22, 23
locomotives, 77, 277n22
Lodge, Henry Cabot, 192, 235
Loeffler, Charles Martin, 233
Longfellow, Henry Wadsworth, 48, 178
Longwood, 66, 88, 100–102, 178
Longwood Cricket Club, 179, 182
Lowell, Charles, 52, 63

Index

Lyman, Elizabeth (born Russell), 22
Lyman, Theodore, 22, 66, 101–102

Manning, Robert, 141, 171
Mansard roofs, 50, 99, 274n15
McKim, Charles Follen, 88, 107, 204
Mead, Elinor (later Howells), 107–108, 114, 191–192
Mead, William Rutherford, 107
memorial to Robert Gould Shaw and Massachusetts 54th regiment, 34, 35, 271n6
Miller, Lucia Fuller (granddaughter of Lucia Fairchild Fuller), 248
Millet, Francis Davis, 259–260
Modern Love (Meredith), 230–231
Morgan, Jane Norton "Jessie" (born Grew), 243
Morgan, John Pierpont, Jr., 62, 243
Morgan, John Pierpont, Sr., 62, 106, 247
Morgan, Justin, 147
Morton & Chesley, 84, 87
Mount Vernon hill, 71–72, 277n22
Muck, Karl, 62, 95
Murray, Cecile (born Higginson, granddaughter of Alex), 131
Museum of Science, 76, 96

Nahant, 23, 49, 50, 53, 178
Nelson, Albert Hobart (father of Lily), 12, 113–114
Nelson, Elizabeth (born Phinney, mother of Lily), 12, 113, 114
Nelson, Elizabeth "Lily". *See* Fairchild, Elizabeth "Lily"; "Mig" (born Nelson, wife of Charles)
New England Conservatory of Music, 167
New Riding Club, 141
Newcombe, Mary DeWolf (later Higginson, 3rd wife of Alex), 121, 128, 132
"New-Englands Plantations" (diary of Francis Higginson, ancestor of HLH), 39, 42–46
Nikisch, Arthur, 120, 232
Norton, Charles Eliot, 114, 224, 234
Norton, Margaret, 234

Ormond, Francis, 237
outdoor activities. *See also* entertainment
 boating, 177
 cycling, 15, 137–138, 172, 175–176, 177–178, 185–189
 derivation of, 176–177
 exercise, 177
 golf, 179
 horse riding and sports, 140–141, 180, 183–184
 team sports, 180–183
 tennis, 178–179, 182

Paderewski, Ignacy Jan, 98, 165
Panic of 1873, 65, 72, 77, 191. *See also* Depression of 1873 to 1879
Peabody, Ephraim, 37, 49
Peabody, Harold, 244
Peabody, Marian (born Lawrence, wife of Harold), 124, 163, 165, 170–171, 179, 180, 183, 244, 245, 251
Peirson, Charles Lawrence, 22, 216
Peirson, Emily (born Russell), 22
Pemberton Square, 72, 87
Perfect Way, The (Kingsford), 239
Phinney, Elizabeth (later Nelson, mother of Lily Fairchild), 12, 113, 114
pianos, 173–174
Pickman, Dudley Leavitt, 28–29
Pickman, William, 28
Pinebank, 27, 271n13
Pitch Pine Hill, 221–222
Pope, Albert Augustus, 137–138, 186
Pope, Fred, 84
Pope Manufacturing Company, 137–138, 186
prejudices, 108–109, 118, 215
Public Garden, 69, 95

Radcliffe College, 48, 52
rail trails, 188–189
rail travel, 68, 117
Rand, George Dutton, 88. *See also* Weston & Rand
Raymond, Marietta Sherman, 167
real estate market, 100–101
Reichmann, Theodor, 231–232
Rice, Gladys D. (later Saltonstall), 31, 39, 158
Richardson, H. H., 194
Richmond Court, 98–99, 101
Rise of Silas Lapham, The (Howells), 12, 106, 133, 144, 191–194, 196–197. *See also* Lapham, Silas (fictional character)
Rodin's sculptures, 204–205
Rotch & Tilden, 98
Roxbury, 65, 66, 67
Russell, Anna (later Agassiz, wife of Alexander), 22, 51, 58, 83
Russell, Bertrand, 106, 244
Russell, Elizabeth (later Lyman), 22
Russell, Emily (later Peirson), 22
Russell, Henry Sturgis, 22

S. D. Warren & Company, 107, 118
Salem, Massachusetts, 38, 40, 42, 43–45
Saltonstall, Gladys D. (born Rice), 31, 39, 158
Saltonstall, John L., 31, 39, 158
Saltonstall, Leverett, 158
Saltonstall, Richard, 158
Sargent, FitzWilliam, 226–227
Sargent, John Singer

about him, 12, 226–228
about his painting, 233–234, 265
Fairchilds and, 225, 227
Lucia Fairchild and, 235–238
music interests, 231, 233
paintings of, 60, 103–104, 106, 118, 221, 228, 229–230, 232–233, 234, 235, 239, 279n12
reading interests, 173, 229, 230–231
views on art of others, 237–239
views on love and marriage, 239–240
Sargent, Mary (born Singer), 226–227
Sargent, Violet, 235–236, 237, 239–240, 255
Saturday Club, 48, 273n3
Schenck, Robert Cummings, 213
school founded by Arthur L. K. Volkmann, 254
school founded by Pauline Agassiz Shaw, 10, 50, 250, 289n17
Seabury, Frank, 155–156
Sears, David, 178
Sears, David, II, 101
Sears, Eleonora Randolph, 180
Sears, Evelyn Georgianna, 180
Sears, Frederick Richard, Jr., 178
Sears, Richard Dudley "Dick", 178–179, 180
Sears, Williard T., 141
Seidl, Anton, 243
Sentry Hill, 71–72
servants, 22, 29, 82, 89, 90, 91, 93, 97, 221, 257, 270n6
settlement houses, 109
Shaw, George Bernard, 10, 106, 124, 164–165, 244, 251
Shaw, Pauline (born Agassiz, sister-in-law of HLH), 9–10, 49–50, 52, 58, 112, 126, 250, 251, 289n17
Shaw, Quincy Adams (husband of Pauline), 58
shoeing horses, 146
Smith, J. R., 72
Soldiers Field, 35, 63, 181
Somerset Club, 101
Sparke, Michael, 42–43
sporting horses, 151–152
stable fires, 131, 150–151
stable safety, 150–151
State House, 72
steam shovels, 77
steeplechasing, 126, 129, 152, 155, 180, 184
Steinert Hall, 173–174
Stevenson, Fanny, 104–105
Stevenson, Robert Louis, 12, 103–106, 278n9
Storrow, Charles Jackson, 78

Storrow, Helen, 78
Storrow, James, 53, 120
Sturgis, William (grandfather of Clover Adams), 212
suburbs, lure of, 100–101
Swan Boats, 95
Symphony Hall, 33, 71, 141, 167–168, 204. See also Boston Symphony Orchestra; Tanglewood

Tanglewood, 154, 281n2, 286n32. See also Boston Symphony Orchestra
Terry, Ellen, 106, 110–111, 124, 161, 163–165, 234, 244, 251
theater, 159–165
Thomas, Theodore, 122, 166
Thomson-Houston Company, 246
Thoron, Louisa Chapin (born Hooper, niece of Clover), 211
Thoron, Ward (husband of Louisa), 213
thoroughbred horses, 127
tidal water, 27, 67–68, 78
Tourjee, Eben, 167
Towne, Alice North (later Lincoln, wife of Roland), 23, 24, 26–27, 141, 153–154, 270n7
transporting horses, 156–158
Tremont, 71
Tremont Theater, 161, 163–164
Trevelyan, George, 216
tricycling, 138, 175, 185. See also cycling
trotting horses, 144–146
Troyon, Constant, 190, 205, 207
Tudor, Rosamond (later Higginson, 1st wife of Alex), 120, 129
Tuttle, Lucius, 188
Twain, Mark, 106, 279n13

Vail, Theodore, 53
veterinary hospitals for horses, 138–139

Ward, Samuel Gray and Mrs., 217
water rights, 67
water-powered mills, 67–68
Wendell, Barrett, 59
Westinghouse, George, 246–247
Weston, Frank W., 79–81, 84, 88, 175, 187
Weston & Rand, 79–82, 84, 87–88
Weston & Sheppard, 84, 86
Wharton, Edith, 89, 171, 192, 194, 199, 204, 263
Whiting, Mrs. Nathaniel, 23
Whittier, Charles, 60
Whittier Machine Company, 29–30
Wilde, Oscar, 115, 230, 261
women equestriennes, 153–154
Wood, James E., 150
work horses, 135, 147